LIBRARY OF ART

GEORGIOS RAGIAS, PUBLISHER - DIRECTOR

GREEK SAILING SHIPS

1 (341) Petros Petratzas, GALAXIDI IN THE YEAR 1871, oil, 71×88 cm

Τὸ Γαλαξείδιον κατὰ τὸ Ἔτος 1871
Ἔργον τοῦ Προικήχου ΠΕΤΡΟΥ Δ ΠΕΤΡΑΤΖΑ

Texts:

Vasilis Panagiotopoulos
Nikos A Stathakis
Rodoula Stathaki-Koumari
Elena Lodi-Fé
Spyros Vasiliou
Antonis Theoharis

MUSEUM OF GALAXIDI

GREEK SAILING SHIPS

MELISSA PUBLISHING HOUSE

Editorial Supervision : LAMBRINI PAPA·I·OANNOU, Graduate (Thess) Classics
DORA KOMINI–DIALETI, Graduate (Ath) Classics

Design and Layout : PANAGIOTIS GRAVALOS

Photography : GIANNIS GIANNELOS

Translation : ARIADNE KOUMARI–SANFORD, Graduate (Ath) Classics, MA (Lond)

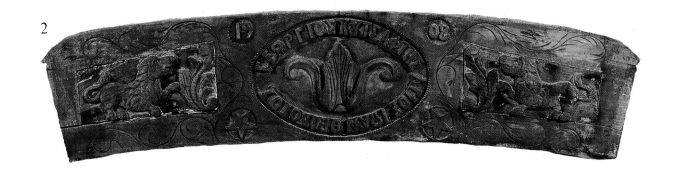

Contents

2 (428) Woodcarving, 27×127 cm, ornament on the stern of AGIOS IOANNIS THEOLOGOS of Georgios Koutsaftis, 1908

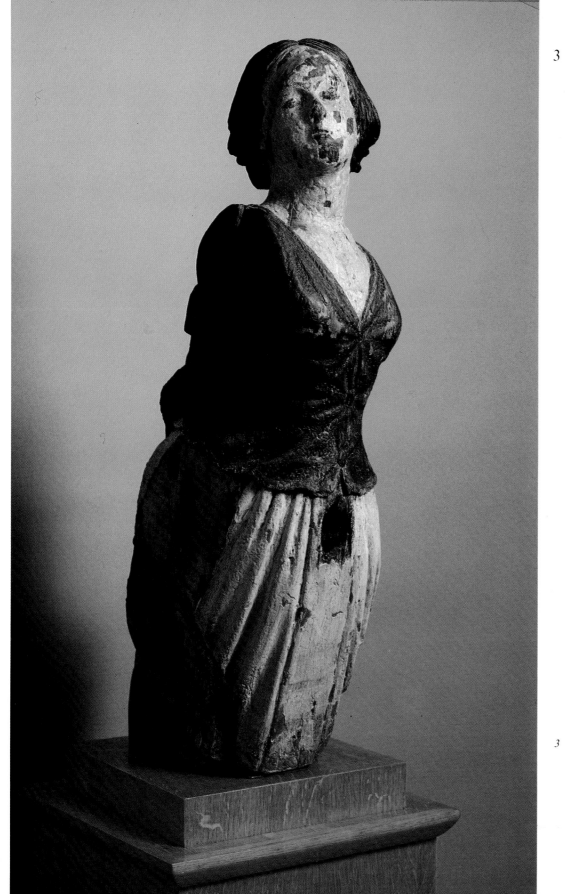

3 (183) Figurehead, height 78 cm

FOREWORD

Along the Gulf of Corinth, below Delphi, there is the town of Galaxidi, a place of great antiquity. The last century, which was still a period of sailing ship navigation, stands out as a splendid landmark in the course of its history, for it was then that Galaxidi became a large shipbuilding and shipping centre. Its renowned sailing ships, built, fitted out and manned by the Galaxidiotes themselves, plied the Black Sea, the Mediterranean, and the Atlantic for about a century, thus bringing prosperity, social progress, and fame to the maritime town up until the turn of the century, when steam-power began to dominate.

For every Galaxidi captain his sailing ship was his pride and joy; he would commission a specialist artist to paint her portrait, since he could then admire her in his own home, too. The 500 or so sailing ships which were built there during the nineteenth century, and whose portraits would probably have been painted, are now represented by only 136 pictures in the Museum of Galaxidi. Of these, 63 were made in the last century and are works of non-Greek painters − Port Painters from Venice, Genoa, Malta, Marseilles, and the Dalmatian Coast, who with their art have immortalized the legendary Galaxidiote sailing-ships. The remaining pictures were made in the twentieth century by Greeks, who were mostly folk painters. The above artists and their work are presented to the public for the first time through this book.

The accompanying original texts were written exclusively for this publication. We thought it appropriate, however, to include text, paintings, and drawings by the Galaxidi painter Spyros Vasiliou, as well as some excerpts from writings of foreign travellers to Greece, who with clarity and elegance have provided important evidence of the life and the activities of the Galaxidiotes in the last century.

In order to give a more complete image of the Galaxidi merchant marine, we are furthermore presenting special informative articles in the second part of this book, besides supplying rich illustrations of items in the Museum − nautical instruments, tools, and rigging, some of which are rare. We have also added a series of documents there, registers, log-books, prints, maps, charts, nautical books, insurance papers, etc, which all help to bring the era of the Galaxidi sailing ships into relief.

The Publishing House of MELISSA presents SAILING SHIPS OF GALAXIDI in its series LIBRARY OF ART in the belief that it is thereby providing a significant historical record of the famous town of Galaxidi, while it is contributing to the history of the specialized art of ship portraits as well as to the history of Art in the Mediterranean in general.

The Publisher

An outline of certain questions in the marine history of Galaxidi

In the wind-swept Gulfs of Corinth and Patras there are two mainland maritime communities, Mesolongi and Galaxidi, that hold just as important a place in the firmament of those dynamic sailing ship centres of traditional Greek merchant marine as do their sister-towns on the islands.

If the roots of the Mesolongi marine can be traced back to historical sources older than those of Galaxidi, the merchant marine of the latter has proved both longer-lived and more effective. For, as it grew to maturity, it displayed creative activity all through the nineteenth century, establishing a considerable nautical tradition in an attractive and friendly little town.

Galaxidi has not been unknown to the writers of Greek history. Contemporary bibliographical aids, mostly the work of love by local scholars, supply us today with adequate material for the study of its merchant marine. We may thus be acquainted with the locality and its people. This is not true, however, when we wish to delve into the financial workings of Galaxidi and its small community.

It is in this area that historical research on Galaxidi lags seriously behind. Although studies emphasizing the economic aspect in the marine history of other parts of Greece may so far not be numerous, they are already beginning to constitute a notable foundation on the strength of which it would be possible to formulate a new synthesis from the pertaining data. Thus, some basic questions in marine economic history are gradually being clarified: the process of both organizing and realizing the voyage of a sailing ship on the island of Hydra before 1821; the methods of raising capital, which were followed by any shipping business on the island of Spetsai at the same pre-revolutionary time; or the procedures of shipbuilding in the yards of post-revolutionary Syros, all this is now part of conquered knowledge in Modern Greek historiography. Beside indispensable questions like these, other more encompassing ones have also been given authoritative answers, for example, the question of the beginnings and de-velopment of the Greek merchant marine as a basic factor of transportation and commerce in the Mediterranean and the Black Sea, as well as that of the rôle such a development has generally played in Greek economy.

A new approach to the history of the Galaxidi merchant marine, within that framework of research, will not only meet the need of local knowledge, but will also contribute another local model into the space of Greek economic history. We must, then, place Galaxidi into the wider context of the Greek nautical world in the eighteenth and nineteenth centuries, before we can correlate its own phases of development with those of the other traditional centres and discern its individuality, briefly, before we can understand its flowering and its decline.

Under what conditions was that small maritime centre actually born, and how did it embark on its career? How did it pass from carrying out meagre shipments within the confines of its immediate surroundings on to a Mediterranean-wide trade exchange? The answer is not an easy one, even if we can make some obvious statements of fact: traditional techniques, finance, and the human element are requisites that were met satisfactorily during the whole of the nineteenth century, when Galaxidi won several battles in the marine economy of that period; not, however, the one of steam-power. One wonders why it did not. And it is only by way of research that there can be any lead towards authoritative answers. Suffice it here simply to extol the significance of the above question. Let it also be noted, as a mere provisional thought, that such failure cannot be considered self-explanatory. Any reasons why adjustment was impossible, perhaps also why the battle itself was impossible, must be sought among the conditions under which the Galaxidi merchant marine had existed and had flourished. Whatever factors prevented Galaxidi from transforming its traditional sea-captains into cosmopolitan shipowners will be the subject of other studies.

This short note is not the place for a detailed documentation

or, even less, for the enumeration of quantitative data. On the other hand, a table[1] that shows Galaxidi sailing ships in the year 1828, and provides indications of capacity, ownership, etc, gives rise to a brief comment here. Facts have been collected on 115 ships (whose ages are not determined, although they must obviously be pre-revolutionary in their majority, if not their entirety). The list certainly does not represent the Galaxidi merchant fleet of that period in its totality; nor is it known how many ships are missing from that statement, which in our point of view may not be too important an issue either. What impresses us more is that they are of limited capacity: they average 11.6 tons per sailing ship. Such a figure for the third decade of the nineteenth century may possibly be concealing a great deal.

'That merchant and naval fleet was the starting point,' writes the local historian,[2] for its further 'magnificent' development. Magnificent development? Why not? In proportion to the size of that small maritime town, a few scores of sailing ships, shipyards, the people of the sailing ships and of the yards — those are what constitutes a flourishing period which justifiably nurtures pride in the descendants. Indeed, what a heavy burden that inheritance of a minute Galaxidi sailing ship must have been in the course of later development; and how difficult the road up to the typical Galaxidi brig of the 200-300 tons, as we find it at the end of the nineteenth century.[3] But even so, such capacity cannot have been sufficient enough for the sailing ship to be financially exploitable at the turn of the century, when competition was already assuming some of its fiercer aspects. The Galaxidi ship with its small displacement found itself once more at a disadvantage — perhaps then for the second time, just as it had at the beginning of the century — against the large displacements and the new speeds that came along with the use of steam-power impetuously spreading throughout merchant shipping.

Thus, however, we again come up against the fundamental issue in merchant shipping, namely, the change-over from sail to steam, which has marked the whole of the economy in the islands and coastal areas of the Mediterranean Basin.

It is a characteristic feature of Greek merchant marine that it has had to face and overcome similar problems, albeit in basically different ways through the entire course of its development from the eighteenth to the twentieth centuries. Between the case of the island of Hydra and its premature decline and that of the sky-high success of the merchant marine on the islands of Andros and of Kasos, there is such a variety of circumstances, that we are challenged into adopting a multivalent approach in our investigation; Galaxidi holds its own place in that scheme. On the one hand, the dynamic human toil of the Galaxidiotes and, on the other, the inability of their society to endure its own transformation signal and even charge with emotion certain phenomena of a flourishing and decline like those of Galaxidi, and turn them into a privileged area of research for the historian.

Let this volume be considered, through both its texts and its illustrations, another effort towards a deepening acquaintance with Galaxidi, the maritime Galaxidiote adventure, as well as its human contributors.

Vasilis Panagiotopoulos

NOTES

1 The Table was set up by Efthymios N Gourgouris, a diligent student of his local history, on the basis of unpublished material found in the General Archives of the State (see *To Galaxidi ston Kairo ton Karavion*, Part I, Athens 1982, pp 24-42).

2 *Op cit*, p 43.

3 Judging from scattered yet reliable data published by E N Gourgouris (*op cit*) the average tonnage of Galaxidi ships in the second half of the nineteenth century must be placed somewhere between these figures (see, for example, relevant data on shipwrecks, *op cit*, Part II, Athens 1983, p 805 ff).

ΓΑΛΑΞΕΙΔΙΟΝ ΕΝ ΕΤΕΙ 1878. Ἔργον Πέτρου Δ. Πετρωτζᾶ

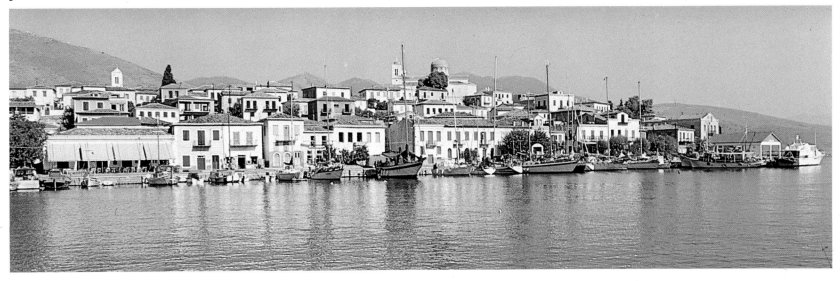

The maritime town of Galaxidi

Galaxidi, the maritime town on the Gulf of Corinth, has had a turbulent history in the course of the centuries. Its destiny was determined by its geographical position — with pronounced geophysical features — on the northern shore of the Gulf, inside the Bay of Krisa. The place has been endowed with a wide and open creek, called Chirolakas and, next to that, with a long and narrow, well sheltered harbour. Small, barren islands encircle its entrance like a wreath of natural breakwaters.

The region is mountainous, vegetation is sparse, and access to the hinterland, difficult. The wood of evergreens we see today on our left as we enter the harbour approaching Galaxidi from the sea is a recently materialized dream by, and through the efforts of, one of the town's more distinguished, and equally obstinate sons. Communication was slow and difficult over snaky paths in ravines and on steep hangs; the required toil helped to discourage people from moving too hastily from place to place. Characteristically, and until 1960, the main contact with the outside world was by sea. In antiquity, moreover, Galaxidi served such pilgrims as wished to visit Delphi via the Bay of Krisa. Ever since the beginning, the inhabitants of the area have thus been subject to most of the features we normally associate with islanders: the sea provided, here too, not only their means of communication, but it was also their main source of survival. Their economy had completely adapted to the element of water, since the population was for the most part made up of fishermen, sailors, boatswains, sea-captains, shipowners, and later, when Galaxidi flourished, ship-carpenters in their famous shipyards.

Meanwhile, the rudimentary connection with the hinterland allowed the Galaxidiotes to avoid complete isolation in winter; but often they also had to pay a heavy price: for enemy hordes would use the same routes to rush down from the mountains and invade them. It appears that in the course of their history they suffered many such invasions, when the attackers would fall on the maritime town like a sudden gale and loot it clean. The ancient fortification wall, a substantial part of which is still in preservation, had undoubtedly been built in order to offer protection

4 *Petros Petratzas, GALAXIDI IN THE YEAR 1878, oil, 46×69.5 cm Galaxidi. Collection of the Lykeion*

5 *Galaxidi, View of the Agora from the sea. Recent photograph*

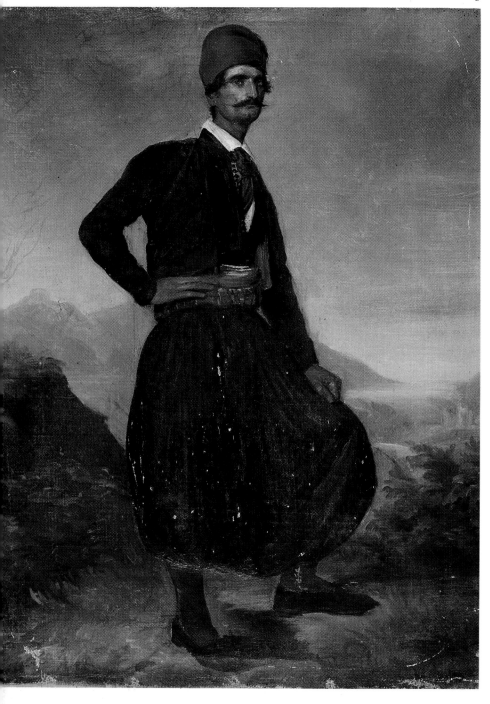

against such raids. Ancient writers mention the existence of a prehistoric settlement[1] in the area at the time of the Ozolai Lokroi. But there has not been much evidence from that period so far, and the archaeologists' spade will have to reveal a lot more of the old habitations. Only recently, in June 1986, a prehistoric unlooted grave was excavated on a plot of agricultural land, which is presumed to have been a mound and a settlement.

When did the town have its name changed to acquire the present-day one? What is its etymology? This has not been clarified yet. But it is historically confirmed by many sources, chiefly in the *Chronicle of Galaxidi* by the Monk Efthymios, that during the Byzantine era at any rate the town was already known by that name.

When the Byzantine Empire was in its decline, Galaxidi suffered a Bulgarian invasion, in which the town was destroyed and the inhabitants were forced to abandon it. After the invaders had left, the Galaxidiotes returned and soon revived their town. Commerce at sea is quite lucrative for 'old salts' who are masters of their craft; so the Galaxidiotes were not long in recovering. However, fate had a new blow in store for them: the invasion of the pirate Düratj-Bey of Nafpaktos, who plundered the town and burned down what ships he could find in the harbour.

The Chronicle of Galaxidi is full with stories of destruction and plunderings, the town burning, the inhabitants finding refuge on the island of Saint George or in their sailing ships. There were many times when the invaders would take hold of the sailing ships in the harbour by boarding, then set them ablaze or else tug them away as a booty. Phoenix, the bird that burns, and then re-appears from its ashes alive and with spread out wings, is not a mere symbolic metaphor, it is the very representation of Galaxidi.

In the four hundred years of Ottoman rule the enslaved Greeks did not only lose in political and economic stature as a nation, but they were also deprived of certain fundamental elements of their culture. It was their religion which like a low flickering flame helped them to preserve national consciousness, identity, and historical memory, thus sparing them from extinction. The rayah had then to contrive means of survival within ever narrowing margins. The sea, where he had been such a prominent master, was forbidden to him. Venetians, Genoese, Catalans, and later the French had amassed all Mediterranean trade and commerce to themselves, so that the presence of Greek

6 *PETROS ARGYROPOULOS, CAPTAIN OF MERCHANT MARINE, oil, 43×34 cm Galaxidi. Collection of Aspasia Varlami*

7 *WALLS AT GALAXIDI, ANCIENT OIANTHE IN OZOLAIA LOCRIS, Engraving. Collection of R Stathaki-Koumari*

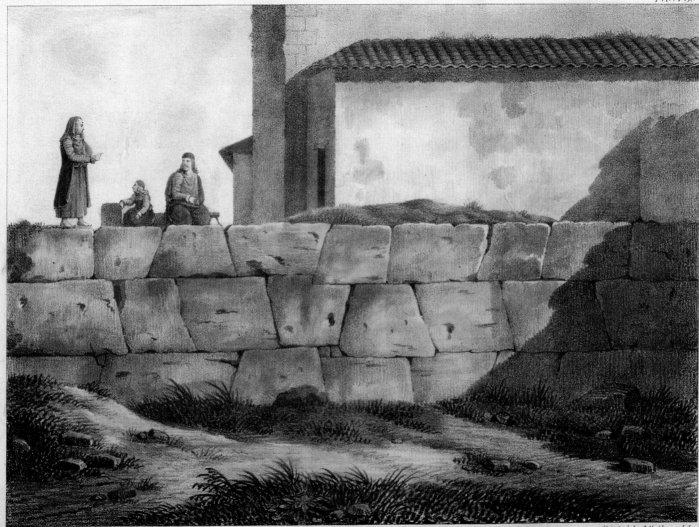

WALLS AT GALAXIDI, ANCIENT OIANTHE IN OZOLIAN LOCRIS.

Plate 30

Printed by C.Hullmandel.

8 (631) *THEODOROS KONTORIGAS, CAPTAIN, M M*

free to enter the shipping arena. Larger and larger vessels were constructed in their small shipyards; they bought brigs and barks from the West, and very soon learned the art of building them, thus creating a whole fleet in an astonishingly short time.

Leaving the Aegean they entered the Black Sea; they sailed on the other side of the Ionian Sea and reached as far as Gibraltar; went to North Africa and to Egypt; they covered the entire Mediterranean Basin. Fear of the pirates forced them to fit their sailing ships with guns — by permission of the powers that be[3]. Through fighting real battles against ruthless pirates they became experienced in naval warfare; the fleet which, later went into action in the 1821-Revolution had come into existence.

In he period when the Greek merchant marine flourished, between the Treaty of Kütchük-Kainardji in 1774, and the year 1818, Galaxidi was among the pioneers, having extended its initial activity to reach everywhere in the Mediterranean and the Pontus. Apart from political occurrences, there were other factors which also contributed to the development and rise of Galaxidi. Namely, when Ali-Pasha of Epirus had imposed restrictive measures on Mesolongi, which was another important maritime centre, exporter Papadiamantopoulos of Patras turned to Galaxidi to negotiate time charters and to give orders for the building of some of his larger sailing ships.

F C H L Pouqueville has a table that gives comparative data on Greek Merchant Marine in his work *Voyage de la Grèce* (vol I, Paris 1813, p 361), where Galaxidi is ranked immediately after the three islands, Hydra, Spetsai, and Psara:

Island	Number of Vessels	Total capacity in tons	Total number of crew	Total number of cannons
Hydra	120	45,000	5,400	2,400
Spetsai	60	19,500	2,700	900
Psara	60	25,500	1,800	720
Galaxidi	50	10,000	1,560	300
- - -	- - -	- - -	- - -	- - -

On the outbreak of the Revolution in 1821 all the inhabitants of Galaxidi in a body joined the fight on land and sea. They suffered a hard fate. Galaxidi in its isolation, without help in the hour of danger, fell into Turkish hands three times: in September

seamen was solely tolerated in the form of cheap hands. The Turks had prohibited the acquisition of ships by the rayahs, who were just wanted for fishing, and to man their fleet. Only when political events[2] had caused a differentation in the international treaties of the period were the Greeks relieved of the terrible restrictions we have mentioned; and then they rushed forward,

1821, in both May and November 1825. The town was burned down, and sailing ships or inhabitants unable to escape were taken prisoner. Those saved scattered to other areas, while the few ships that were spared continued the fight in the Gulf of Corinth. The place had been devastated.

The people of Galaxidi, like those of Psara, gave all they had to the struggle for independence. In the years of their uprooting they were dispersed on the island of Aegina, in Loutraki, around the Saronikos Gulf and the Gulf of Corinth, as well as on the islands of the Ionian Sea. Money was borrowed, so that small vessels might be constructed again, the white 'tourketa' — lower part of masts painted white as a distinctive sign of Galaxidi-built sailing ships — made their appearance once more in the shipping of the Corinthian Gulf, in Mesolongi, and in Preveza. Thus, in spite of terribly adverse circumstances, Galaxidi succeeded in keeping a continuous presence on the maritime scene.

In 1829, after the liberation from Turkish rule, and when Ioannis Kapodistrias had come to Greece as Governor, the Galaxidiotes began their homeward return. They fell to work in an attempt to rehabilitate, rebuild, and re-create their town and their lives. They did not seek assistance from the Government nor did they bargain with their laurels. Instead, all they asked of Governor Kapodistrias was to be allowed a period of grace within which they might pay back those who had lent them money during the war, but who, in times of peace, were exercizing asphyxiating pressure on them for repayment. They did not ask for a cancelling of debts against what had been offered in the struggle for independence, they did not disown their obligations. The letter sent to Kapodistrias on 25th July, 1831,[4] is a very moving document indeed.

On liberation, it was through the sea only that a widening of horizon could bring about quick economic recovery to that small and blood-drenched part of Greek soil. Difficulties and competition notwithstanding, the Greek genius was to excel again. The devastated town took a new breath, the shipyards came to life. In 1831 the population was 2,215 inhabitants; in 1870, it was 4,579 (official census by the Ministry of Interior); and in 1896 there were as many as 5,135 inhabitants. When the town was flourishing (1870-1896), there were more than 150 ocean going ships, some of them exceeding a capacity of 1,000 tons. Galaxidi sailing ships plied not only the Mediterranean and the Black Sea, but they also crossed the Atlantic. That was the time when Galaxidi

9 (514) GALAXIDIOTE SEAMAN

acquired its present architectural aspect, when the grand captain's houses were built, in a combination of Aegean and Italian styles; when the town rose to the status of Dimos (equiv of English Borough), and when its pleasant squares and picturesque lanes were created. It was the time when every shipmaster took pride in having his ocean going sailing ship painted in order to

10 13

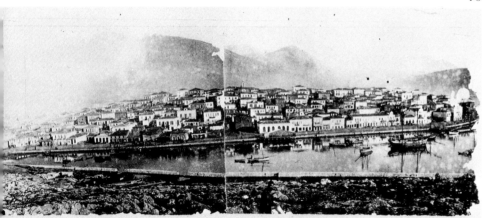

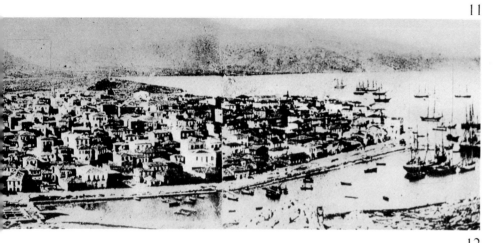

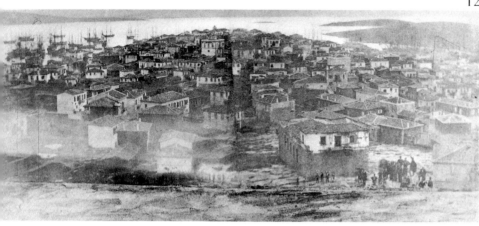

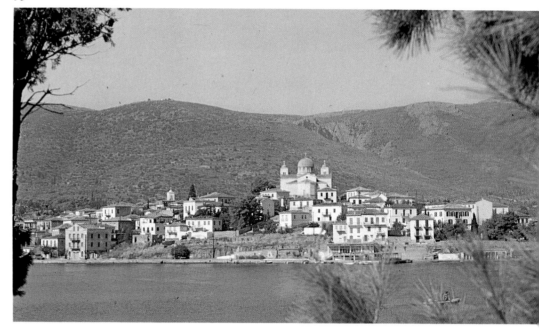

10 (340); 11 (343); and 12 (617) Galaxidi before 1900. One of the few towns in Greece that has preseved its architectural character

13 In 1902, a new building was completed for the church of Agios Niko-laos, patron of the seamen. The church is visible from afar as it domi-nates the town. Over its entrance is written: 'A Haven of Salvation (is the) House of the Lord. This was renovated in the years 1897-1902 (when) K M Papapetros (was) Mayor.' One of the most beautiful icono-stases, an example of nineteenth century wood-carving, is to be seen in this church

decorate the reception room of his house with her portrait. The foundations for a future maritime gallery in the town had thus been laid.

After 1896, decline set in and progressed at a rapid rate. Freight charters decreased, and for want of orders the shipyards came to a standstill. The cause? In the West, the use of steam-power in communications and the transportation of goods had already gained ground displacing the sails. That technological revolution meant in fact that Calaxidi was finished. Eva Vlami, a

talented novelist from the area, described in her book *O Skele-tovrachos* (Athens 1950) all that inner struggle of a mariner ship-owner who could not bring himself to part with the sails. Some of the reasons why Galaxidi did not rise to the technological challenge of the times may be found precisely in that inability to abandon the old for the new, coupled with a general trait in the personality of a Greek, who finds it difficult to enter into partnership — a necessary condition, if the financial dimensions required by the new technology were to be faced. Last but not least, there was the mentality of independence of a skipper who is also the owner of his sailing ship. The town, then, lagged behind, withered financially, and ceased to command a presence on the coastal and open sea Greek Merchant Marine. The place could feed the inhabitants no longer. A great many families left Galaxidi for good, quite a few of them finding refuge in Piraeus. The population shrank in number, so the Dimos was reduced back to the status of Koinotita (equiv. of Municipality). But its seafaring tradition has been kept on. Galaxidi seamen now travel around the world, employed by Aegean shipping companies, that are not committed by the inheritance of a past and have thus leaped forward onto the maritime contest ground, as the successors of Galaxidi.

The swift downfall of Galaxidi does not stop there, however. The finishing stroke was given during the German occupation between the years 1941-1944, when remittances of seamen abroad never reached their families, many of which became destitute; there was not enough land for all to cultivate, everything was falling apart, whatever could be sold was given away at disgraceful prices to secure a mere survival. When liberation came, Galaxidi was practically deserted, in ruins, the doors to its houses unbolted, plaster coming off walls and ceilings, and owls wailing amongst the crumbling buildings. Things were made even more difficult in the period of the ensuing civil war, so that by 1950 Galaxidi was like a ghost-town.

Zoï Tzingouni, a distinguished lady who had her roots in an old Galaxidi family, stood up with indomitable will to stem the tide of hardship that had overwhelmed the maritime town. In 1951 she single-handedly established a professional school of sewing and embroidery[5] for young girls, which attracted people from the surrounding area while helping to halt any further drain of the local population. Her contributions to society were unceasing, she took interest in people of all levels, and was to all a touching example of simplicity and humanity. Later on, in 1959, as en elected President of the Community, she succeeded, through her personal intervention, in attracting the interest of the governing authorities. The then Prime Minister came to Galaxidi on a visit and so a first instalment of funds was approved. It was decided to have a road opened up along the coast between Itea and Galaxidi, and MOMA, the Military Engineering Unit for rehabilitation works of infrastructure, undertook to lay it out. This was followed by the construction — with State funds — of a community recreation centre, and the renovation of the Maritime Museum. Initial repairs were carried out on its large room, and its excellent picture gallery was then inaugurated in a new arrangement that had been personally supervised by the Galaxidi painter Spyros Vasiliou.

Inspiring a desire for home-coming into the hearts of her expatriate fellow townspeople was yet the greatest contribution of Zoï Tzingouni. They were few in the beginning, but soon their example was followed by many more Galaxidiotes who would go back and repair their ancestral houses. Within a short time, Galaxidi had taken on a fresh aspect and, infused with new life, was turned into a summer resort in the Gulf of Corinth. Having been ranged within the scheme of ecological and cultural heritage protection of the Delphi area, Galaxidi was spared the destruction of its traditional architecture and harmony. In this way, the town has on the whole preserved the appearance it had at the peak of glory as a maritime centre. Every summer now it throbs with vitality and vigour, while tourism of a high calibre, as it has developed in recent years, gives it a cosmopolitan air.

Nikos A Stathakis

NOTES

1 Oianthi or Chaleion. It has not yet been reliably ascertained on which of the two ancient settlements present-day Galaxidi lies. The prevailing, and more recent, archaeological opinion favours the latter.

2 Russian-Turkish wars; conflict between Britain and France; blockades.

3 Ottoman authorities had given permission to seafaring rayahs to fit their vessels with guns as a protection against the pirates, who were ravaging the Aegean, but also the shores of North Africa.

4 General Archives of the State, Gen. Secr. File 271.

5 A large part of her substantial fortune was spent on it.

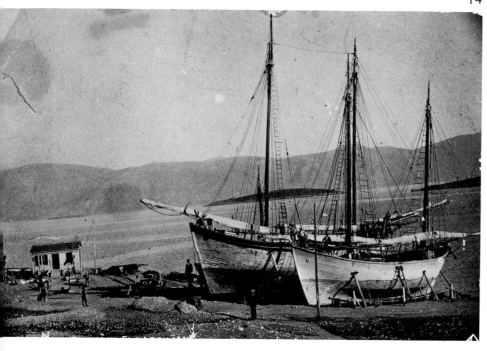

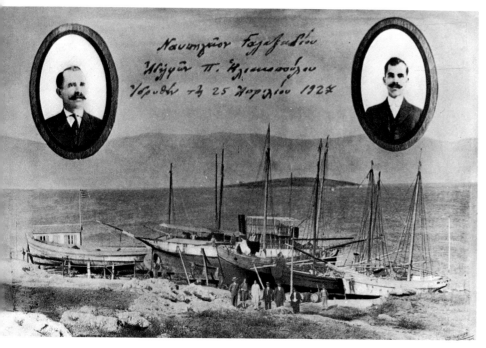

14 (659) Shipyard in Galaxidi

15 (408) 'Shipyard of the brothers P Iliakopoulos. Founded on 25 April 1827.' Photograph by E Machairas. Sailing ships were built in the two ports, the Agora and the Chirolaka in the old days, for they still had natural shores. Later, shipyards were created in various areas with bays, away from the ports, in Vlicha or Kalafatis, Revythistra or Vystrithra, Katalonia, which were divided into 'hither' and 'thither' ones, Kentri or Ammodioskoules, and Giannakis. Shipwrights of the last flourishing period of Galaxidi, 1830-1890, had acquired practical knowledge of their craft, they had not studied in schools. Master-builders were greatly experienced and showed high skill in designing and then supervising the building, launching, rigging, and fitting out of sailing ships. There have been geniuses amongst them. Besides the master-builders there were the ship-builders, who would design and build lesser ships. And then there were the master-workers, as well as various specialized workers, caulkers, riveters, smiths, or carpenters. The shipyard of the brothers Iliakopoulos was among the last to have functioned.

15

16 *Konstantinos M Papapetros (1829-1907) was a highly talented Master-builder. When he stopped travelling as a shipowner and captain, he worked in the shipyards of Galaxidi. Besides the many sailing ships of various types — whose number we do not have, unfortunately — in 1875 he designed and built the barque AIOLOS (Pl 63) of 1150 tons, which was the largest ever sailing ship to have been built in Galaxidi.*

His designs and models of ships gained prizes both in Greece and abroad. Konstantinos Papapetros was elected mayor of Galaxidi three times, contributing several works to the town, such as tracing and squaring of streets, rebuilding the church of Agios Nikolaos, and many more. A marble bust is at his grave in the cemetery of Galaxidi
17 *(386) Praise for his ship designs conferred on K Papapetros in 1876*

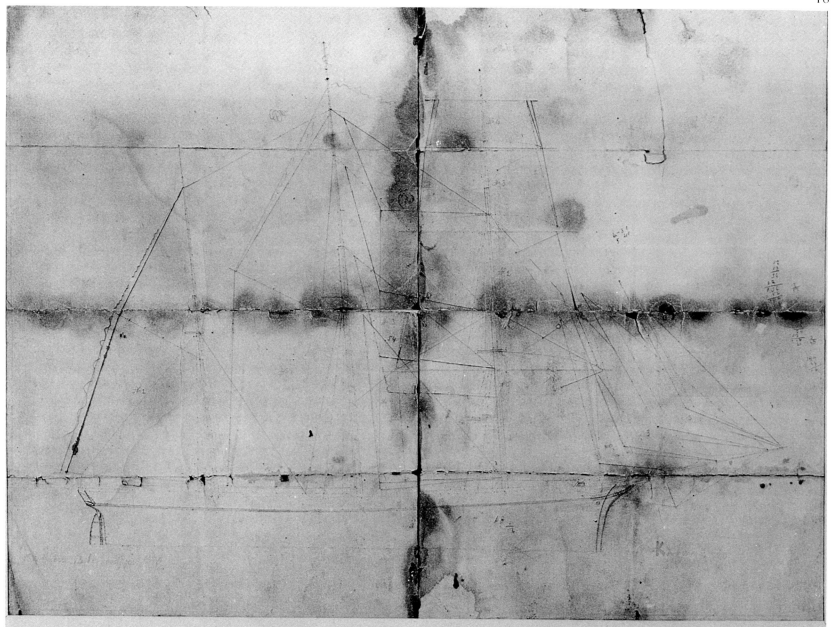

Τὸ μόνον διασωθέν σχέδιον Ἱστιοφόρου μὲ τρεῖς ἱστούς, τύπου δρόμωνος ἡμιολινοῦ (Μπάρκο Μπέστια), ἐκπονηθέν ὑπό τοῦ διεθνοῦς ἀναγνωρίσεως διακε-
κριμένου Ἀρχιναυπηγοῦ (πρωτομάστορα) κατὰ τὴν ἐποχὴν τῆς ναυπηγικῆς καὶ ναυτικῆς ἀκμῆς τοῦ Γαλαξειδίου ΚΩΝΣΤΑΝΤΙΝΟΥ ΠΑΠΑΠΕΤΡΟΥ, τοῦ ὁποίου φέρει τὴν ὑπογραφὴν
κάτω ἀριστερά, μόλις διακρινομένην.

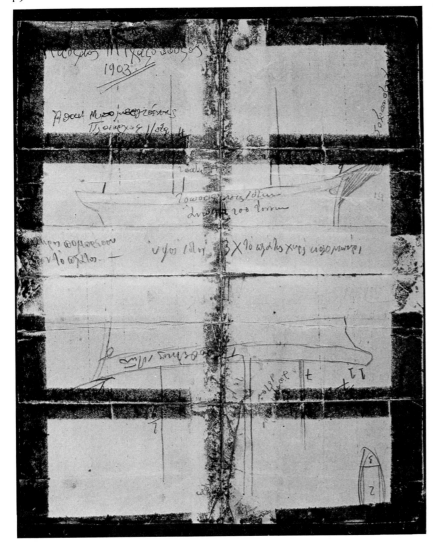

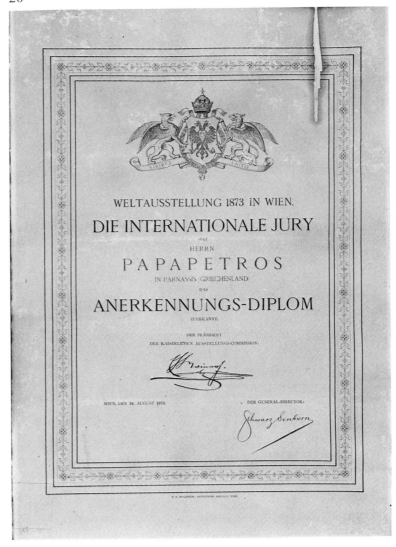

18 (411) The only design of a sailing ship with the signature of Konstantinos Papapetros that has been preserved. It is drawn in pencil on paper, and bears the date 24 January 1880

19 (517) Design and description of building a sailing ship, pencil on paper, by the Master-builder Nikolaos Michalopoulos in 1903, who was one of the last great ones of the time of the large sailing ships in Galaxidi. An assistant to Konstantinos Papapetros, he learned from the teachers of his town, which was then the second most important shipbuilding centre, after Syros, in Greece. When it was his turn to prove his skill in building large sailing ships, fortune was not on his side. Decline had already touched the maritime town. Disappointed, he left Galaxidi, settling first in Patras and then in Kalamata. In both those towns he honoured his craft to an enviable degree. Nostalgia for his home town brought him, an old man, back to Galaxidi, where he met a deserted harbour and the yards overgrown with grass. He died at the age of 93

20 (355) Diploma of Praise conferred on K Papapetros by the International Jury of the World Exposition of Vienna in 1873

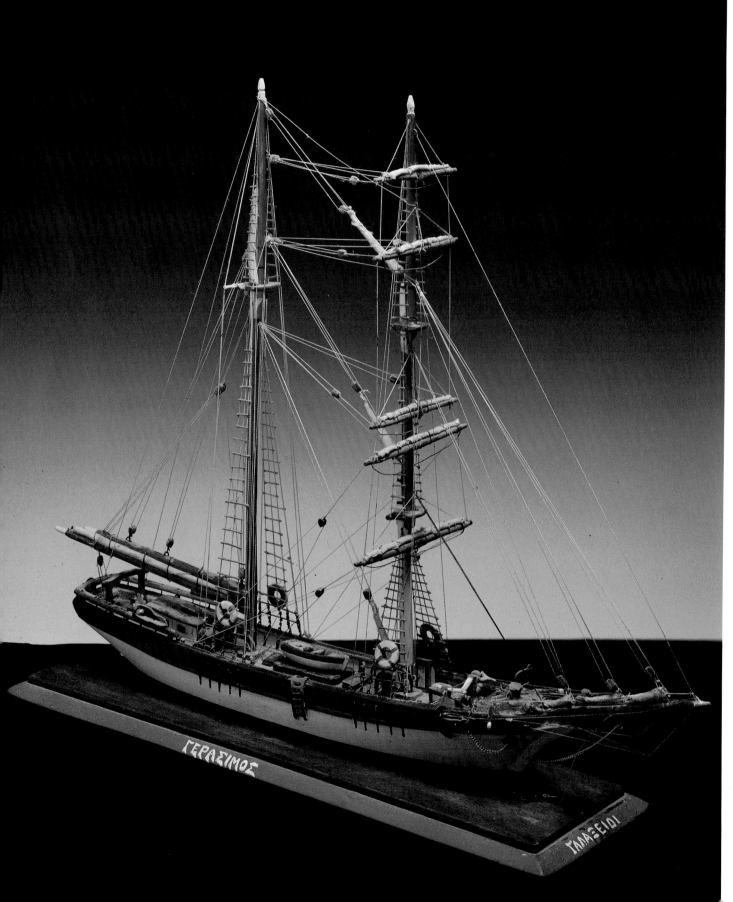

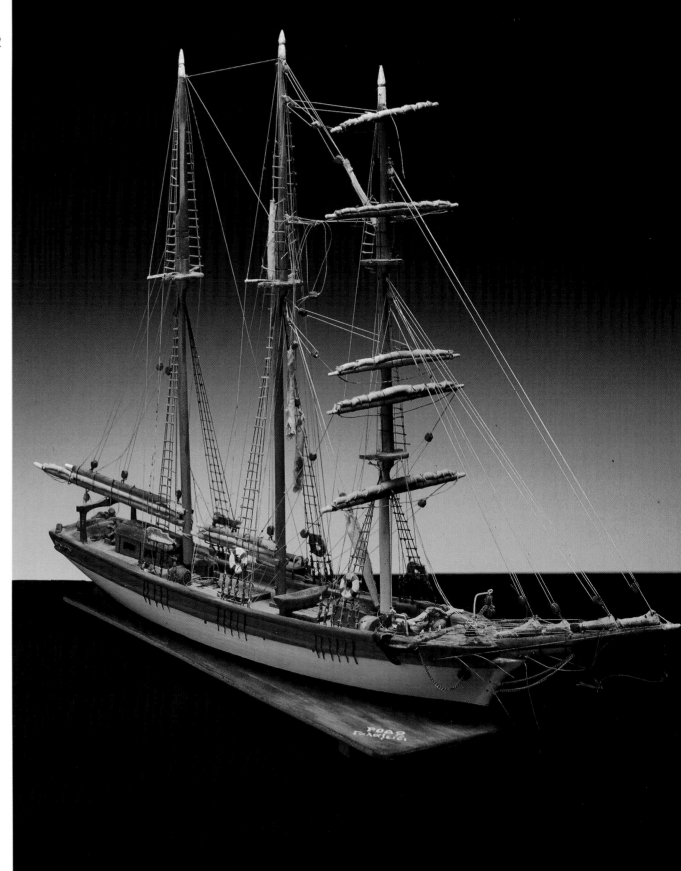

21 Efthymios D Zisimos, model of sailing ship GERASIMOS, Galaxidi. Collection of R Stathaki-Koumari

22 Efthymios D Zisimos, model of sailing ship RODO, Galaxidi. Collection of R Stathaki-Koumari

Efthymios D Zisimos or Chiras (1901-1982), a seaman from Galaxidi, was one of the best craftsmen in the construction of ship models. In an accident, 1940, he lost three fingers of his right hand. In 1945 he started building models mainly of sailing ships using very few implements. His ship-models are distinguished for their accuracy and perfection. A number of them are in the Museum of Galaxidi and in private collections. It is estimated that he must have built about forty models.

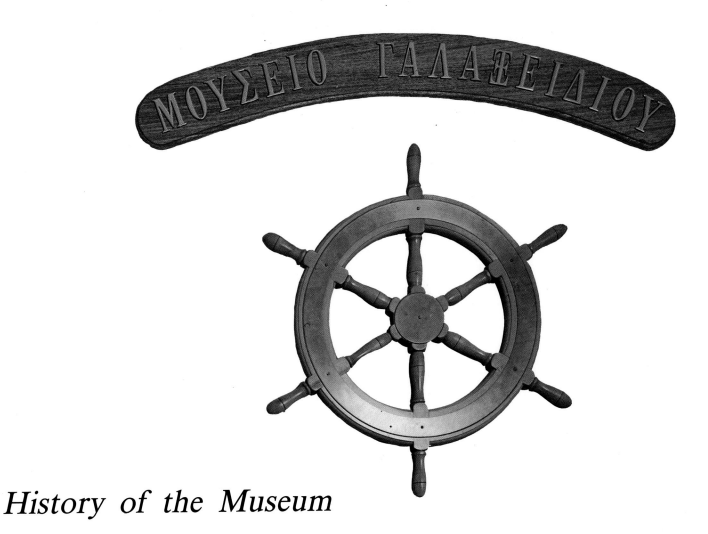

ΜΟΥΣΕΙΟ ΓΑΛΑΞΕΙΔΙΟΥ

History of the Museum

The building where the Museum of Galaxidi is housed today was erected between 1868 and 1870 during the mayoralty of Dedousis E Chardavellas. It contains five rooms and has two entrances (Pl 25), of which the main one is on the street coming up from the sea front (Agora), while the other, the courtyard one, is on a little side-street. The Museum consists of three sections: Archaeological, Maritime, and Ethnological.

The building preserves the form it had when it was built to provide shelter for the Town Hall, Rooms I, IV and V; the Police Office, Room III; and the Primary School for Young Girls, Room II.

Those who served as mayors, Galaxidi master shipbuilders, doctors or lawyers, widely travelled men, trained in schools abroad, progressive and open in their attitudes, have all endeavoured to lead their home town towards prosperity and development. Some were there to see it rise out of the ruins and ashes of the struggles of 1821-1829 to become, after Syros, the second, maritime and commercial town in Greece.

The Primary School for Young Girls remained in that building for the next ten years, and was then transferred to the newly erected, 1880, neoclassical building, when Nikolaos Loukeris was mayor, and its name was changed to Primary School for Virgins.

23 Galaxidi at present

24 (656) *Efthymios K Vlamis, medical doctor (1851-1937), photograph from a painting by Hector Doukas, Municipal Office. A bust is at Kavos in Galaxidi*

Room II was then left unused for several years to come. In 1910 it became shelter for the Trichaptopoieion, which was a school for lace-making instituted by the then Mayor Andreas Levantis.

By 1913 Galaxidi was already in decline, the town was reduced from the status of Dimos (Borough) to that of Koinotita (Municipality), whose offices stayed on in that same. building. Just as the mayors before them, so were the Presidents of the Community (Koinotarches) energetic and most competent men who struggled to preserve the maritime town in existence, even without its sailing ships, and thus to save it from extinction. When the Lacemaking School had closed down, Room II again remained vacant, until it was turned into the carpet manufacturing workshop of H F Kachramanos in 1926, which was in operation until 1940.

It was in 1928 that the idea of the present Museum was conceived by its founder, the doctor Efthymios K Vlamis (1851-1937), who collected the first paintings for what was to become this nautical gallery. Dr Vlamis served as Mayor from 1903 to 1906, and on several occasions as President of the Community after 1914. Thus it was in 1928, while holding office, that he gathered together the paintings of sailing ships which were to form the initial nucleus of the Museum collection. 'Visiting the various homes in his capacity as a physician, and observing that most of them had pictures of their sailing ships hanging on the walls, he was inspired with the thought of forming a gallery. I can still remember him, how despite his advanced years he used to rush from house to house in order to collect paintings, and other items, mermaid figureheads, ship models, etc, ...' wrote Dedousis E Chardavellas in an article for the newspaper 'To Vima' of 23 October 1960. For the Galaxidiotes had responded with great eagerness to the appeal of their President. And so it was that all the objects were brought together in Room I to make up the basis for the Museum's future collections. What had for many years adorned the homes of the maritime town, sailing ship portraits, rigging, navigational instruments and nautical tools, charts, logs, all family heirlooms, were assembled there into a precious historical testimony of the last flourishing period in the life of the town.

In 1932, an association under the name Union of Galaxidi Young Men was founded with the aim 'to promote the intellectual and cultural development of the town, and to found a Museum.' Isidoros P Sidiropoulos, later an active lawyer, only a

student then, became President of the association. At first, their efforts were concentrated on bringing together all the archaeological finds that were scattered in Galaxidi homes and which were mostly funerary gifts found in graves both inside the town and the surrounding rural areas, as well as in the Angona Cave. However, according to the provisions of the Law 'concerning the protection of Antiquities' the collection of antique objects and their possession by private individuals had to be authorized officially; hence, an appropriate space had to be found for the safe-keeping and display of the Galaxidi finds. At that point, the Municipal Council under their President, Dr Efthymios K Vlamis, took the decision (Resol No 11/29.VII.1932) to assign one room of the Municipal Offices for the establishment of a Museum for the town of Galaxidi. The items of the archaeological collection were then arranged in a special display case, which was placed in Room I. The competent Department of the Ministry of Education and Religions approved the founding of that part of Museum (Ref No 60040/3634/31.X.1932) and entrusted its curatorship to the Director of the Primary School, Christos Papaïoannou. And so, a second nucleus of objects became the basis for another of the collections of the Museum.

The enterprising young men of the Union were able to collect several more objects besides the archaeological finds; coins, documents, and guns, from the War of Independence 1821-1829; the latter were stacked in special gun-cases. But the Association ran out of funds and broke up in 1934. Before its final dissolution, the members officially, by recorded minutes handed over the Archaeological Collection and the other items to the Community, which took over the responsibility of their safe-keeping. A three-member committee 'for the curatorship of the Museum of Galaxidi' was set up: the President of the Community, the responsible-by-law Epimelitis (Keeper) of antiquities, and one member. The ex-president of the young men's association, Isidoros P Sidiropoulos, served as the elected member on that committee for the following five years, until 1939. Christos Papaïoannou left the Civil Service in 1935; his post of responsible-by-law Epimelitis was taken over by Panagiotis Portoulas, who served in that capacity until the end of February 1948.

Ancient graves were accidentally discovered on the farm of N Sfetsos in 1939; and N Mamas financed excavations there and behind the S Barliakos house in town, which were carried out by archaeologist I Threpsiades in May and June 1940. He found many objects, some of exceptional interest, which were all carefully put away in crates, and remained in a corner of the Municipal Offices for a number of years, especially because all further activity had to be suspended throughout the war, followed by the occupation and subsequent events. It is to the credit of the town and its people that all the items making up the collections of the Museum were preserved intact. Later, the French Archaeologist L Lerat took up the excavations in continuation of the work of I Threpsiadis, by investigating the ancient remains on the little island of Apsifia. His finds were also put away in crates, together with the previous ones, to form part of the Museum's future archaeological section.

In 1948 the Epimelitis of the collection, Panagiotis Portoulas was succeeded by A Kakavas, and he in turn, by Argyris Konstantellos. After the end of his term, curatorship was taken over by the 10th Ephorate of Classical an Prehistoric Antiquities, in Delphi. On September 18, 1950, the then President of the Community of Galaxidi, G Michos, made an application to the Ministry of Education and Religions asking for all the finds from excavations to be cleaned and classified. The competent Department agreed to the suggestion by letter (Ref No 88154/2639/4.XI.1950) but it was many years before a recording and arrangement of the archaeological items could be realized.

In 1959, Zoï Tzingouni was elected President of the Community. Despite the scarcity of funds, characteristic of that period, Room II was redecorated, and the items of the Maritime Collection were all brought together there. Spyros Vasiliou, the Galaxidi painter, was called in to supervise in person the display of the paintings, and the room was inaugurated on June 17, 1962. The cases of archaeological finds as well as the gun cases remained in Room I. Zoï Tzingouni also saw to it that a Municipal Library was started. That was when Athanasios Bobogiannis, Captain and Pilot of the Merchant Fleet, was made Epimelitis of the Museum for the Maritime and Ethnological Collections. His contributions include a most valuable list of the Galaxidi sailing ships, now an important source for research workers; he was the first to make an inventory of the sailing ship paintings and the objects of the Maritime and Ethnological Collections. In his time, more items were added, their variety was increased, and they were all recorded and classified.

On the suggestion of the Ministry of the Prime Minister, Ref No 12029/23.IX.1963 and instruction of I Kontis, General Director of the Archaeological Service, the Ephoros of Antiquities, Delphi, Archaeologist I Konstantinou came to Galaxidi to receive by recorded minutes all the finds from excavations. Their classification and cataloguing were then carried out by Archaeologist A Lembesi, and were published in the *Archaeologikon Deltion*, Vol 19, Part 2, 'Chronika', Athens, 1966. All the items have now been returned to Galaxidi, and are displayed in the new cases.

In 1964 the activities of the Museum were at a standstill. Much later, when the Ministry of Culture and the Sciences had been established, the Museum of Galaxidi, as did every Museum, asked to be subsidized. Then, however, it was found out, that (except for the Archaeological Collection, of course) it had no official or legal standing anywhere, for there had been no relevant Decree, as was required by law, nor was there a competent Decision by the Nomarchia (equiv of County) sanctioning its existence. The required formalities were seen to by the then President of the Community G Tsandilis and the lawyer Isidoros Sidiropoulos. RD No 542/26.VIII.1972 was issued, and then published in Government Gazette No 163/14.IX.1972, Bul. 1, where we read: 'In the Koinotita of Galaxidi, a legal body is instituted under the name "Museum of Galaxidi".' The instituted legal body is administered by a five-member Governing Council consisting of the President of the Community and four Members called to serve a term of four years, by decision of the Nomarchis ... etc'. The Koinotita voted the 'Regulations for the Administration and Functioning of the Museum' in November 1972.

In August 1974, when I became Honorary Curator of the Museum, the conditions there were disheartening. Room II looked as if it were a store-house, it had also suffered from rising damp, which was destroying the valuable paintings. Wooden objects, especially the figureheads, were being eaten away by woodworm, and rust was making deep inroads on the metal ones. While waiting for restoration experts to take over, we made it our first concern to wipe away the mould from the paintings and to dry them; to paint the wooden objects all over with a special liquid; and to clean the rust from the metal ones. A book of registry was used for the recording of all the items in the Museum, and a card-file was set up for each to have its own number and a full description. During the initial stages of re-organization much profit was derived from the help afforded to us by the Director of the Benaki Museum, Angelos Delivorrias, whose continuing assistance at every difficult step has been greatly appreciated.

In the winter 1976-77 the paintings as well as several other objects suffered much damage from renewed damp. Petros Themelis, Professor of Archaeology in the University of Crete, and then Ephoros (Curator) of Antiquities in Delphi, was asked to come to our rescue, which he did with characteristic promptness and effectiveness out of love for Galaxidi. He literally saved the Museum and lay the foundations for a new arrangement and display of the exhibits. The building, including its roof, was repaired, Room II was completely altered, it acquired a new floor, the walls were lined first with wooden panels and then with gunny, and special cases were made for the display of navigational instruments and the other nautical items.

Then, Efstathios Chatzigiannis, at the time President of the Community, decided to have the Tsalangyras House repaired to house the Municipal Offices and the Library, which had been occupying Rooms I, IV, V, and VI. Thus, the offices have taken up its first floor, and in the Averto (sail-loft) there is now the Municipal Library organized in an exemplary manner by the mathematician Anastasios Skiadas.

Professor Themelis was able personally to supervise the new display of all the archaeological exhibits in especially made cases in Room I, where to the finds of older excavations were added those from more recent ones. Thus, the history of Galaxidi from prehistoric down to Roman times and beyond can be reviewed through the items in the Room of the Archaeological Collection. President Chatzigiannis arranged for new gun display cases to be made for Room III; he also arranged for Rooms IV, V, and VI, where the Municipal offices had been, to be repaired and made ready to receive paintings, photographs, and various objects from the collection.

Under the presidency of Georgios Tseles, in 1984, a certain amount of necessary interior redesigning took place, to ensure a circular progress from one room to the next for the viewing visitors.

The Gallery of Sailing Ship Portraits is also a part of the Maritime Museum. A study of these pictures, which represent sailing ships from the last flourishing period (1830-1905) in the history of Galaxidi, revealed that a large number of them were

the work of foreign, mostly Italian, painters. As a result, it was thought necessary to seek the collaboration of the Italian art historian Elena Lodi-Fé, who kindly volunteered to do the research on the lives and work of those artists, spending quite a long time in Galaxidi. In her text, published for the first time in the pages that follow (p 47 ff), she presents an Italian family of ship painters, the Luzzo, a number of French painters, and several others. Her study on the port painters of that period in the history of sailing ships has proved extremely interesting.

A recent and most valuable contribution to this work has come from Ret Admiral of the Navy Antonis Theoharis, who examined the navigational instruments, nautical tools, rigging of sails, and shrouds in the Maritime Collection of the Museum, and supervised their display in the cases; he further put order to the collection of maps, charts, documents, logs, and books of ships. For this publication he wrote the very interesting and in-

formative texts, in which the use and functioning of several objects in the Maritime Collection are accurately described.

The Governing Board of the Museum is at present composed of Ilias Michopoulos, President of the Community and Chairman, and the Members, Kosmas Dimitriadis, Hadrian Stamatouzas, Aspasia Varlami, and Eumorfia Giannitsi, who all serve on an honorary basis and work diligently for its upkeep and promotion.

The Museum of Galaxidi is in constant need of help. It needs those who genuinely believe that the support of such works is mainly effected through faith and idealism, as was proved by all those who have helped towards its establishment and present status.

Rodoula Stathaki-Koumari

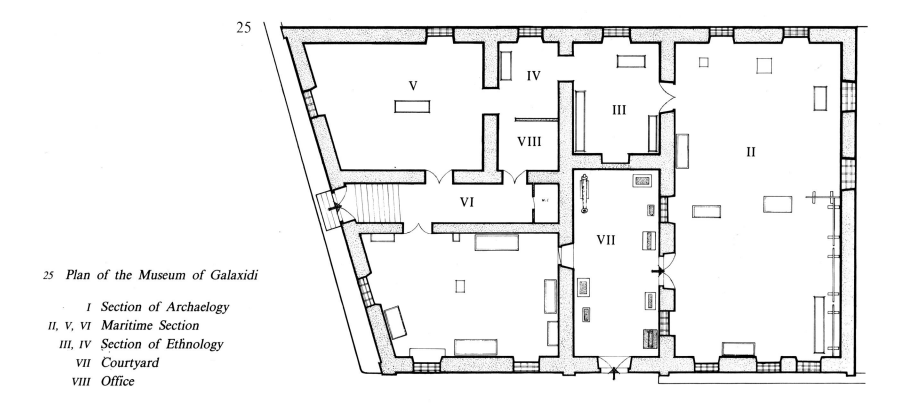

25 *Plan of the Museum of Galaxidi*

 I Section of Archaelogy
II, V, VI Maritime Section
 III, IV Section of Ethnology
 VII Courtyard
 VIII Office

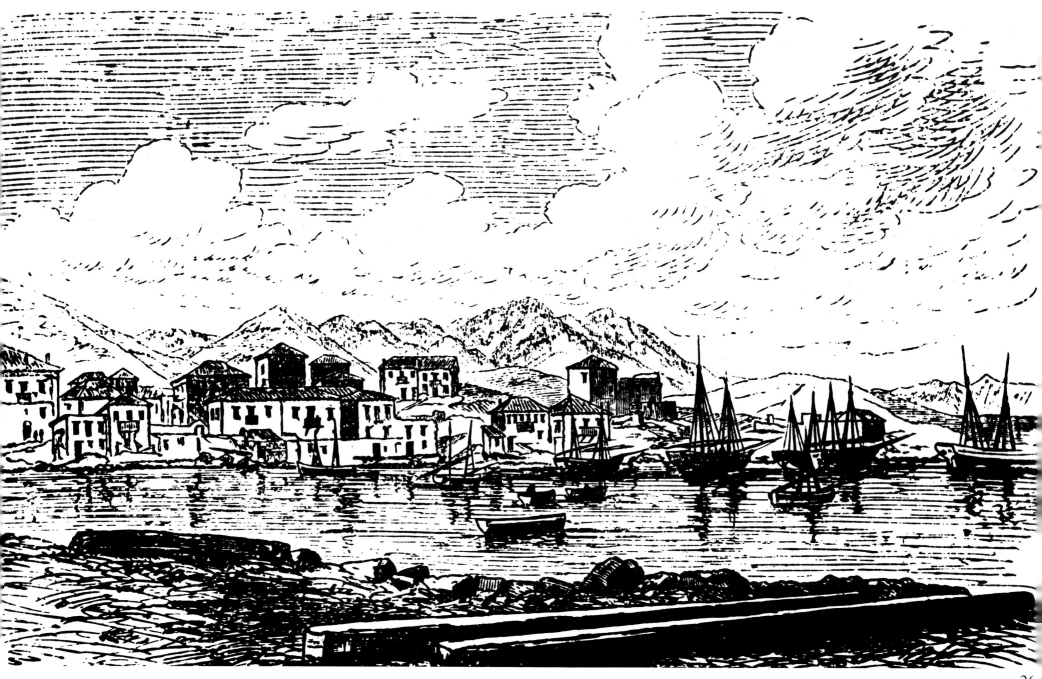

26 *View of Galaxidi. Drawing from the book by Ludwig Salvator* Eine Spazierfahrt im Golfe von Korinth, *München, 1874* 26

Foreign travellers to Galaxidi in the nineteenth century

Foreign travellers who passed through Galaxidi in the nineteenth century have left descriptions which give quite a good idea about the place and its inhabitants at that time. In February 1805, Edward Dodwell,[1] the English antiquarian, classical scholar, and collector, crossed over from Patras to the opposite coast, and ended up in Galaxidi. Here is what he wrote:

'... The village [Galaxidi] stands on a rocky peninsula, having two secure ports, and bearing considerable resemblance to the town of Mitylene, on a small scale. The houses are of earth; some of the best are whitewashed, and have two floors ... The Galaxidiotes have obtained by means of money permission from the Turk to erect a new church, which is far advanced and is dedicated to St. Nicolo, the protector of mariners, and the Neptune of modern days ... Fortunately for the Galaxidiotes, no Turks live amongst them; their industry therefore is not nipped in the bud, and they are beginning to be a commercial and wealthy little community. Their ports are excellent, and their territory affords a sufficiency for the consumption of the inhabitants, and for some trifling exports. They began to trade and to construct merchant ships about thirty years ago. Their commerce was at first confined to the gulph, but they soon extended it to the Ionian islands, and afterwards to Italy, Sicily and Spain. They have thirty small merchant ships for foreign commerce, and fifteen decked boats for the gulph and neighbouring islands. They bear a good character and are skilful seamen.

'We had the good fortune to arrive here at a period of festivity. ... It was the carnival and every bosom seemed to beat with one sentiment of joy. ... It appeared like a transient interval of sun-shine in a gloomy day. They were determined to enjoy the amusement which their religion permitted, and which even their torpid oppressors did not prevent. ... some wore masks, and others had painted faces;[2] they jumped about, shouting and singing, and at last formed into two large circles, one consisting of women, the other of men, ... They at first danced slowly, and moved round in a walking pace; but the music becoming by degrees more animated, the dancers acquired a proportionate spirit, and finished with a kind of convulsive velocity of motion; when, being quite exhausted, a new party succeeded ... The Greeks pride themselves upon their good dancing; and they have a proverb, which they apply to all undertakings, and which signifies, dance well or not at all,

η χορευσετε καλα, η αφητε τον χορον.'

The Italian painter Simone Pomardi,[3] who was accompanying Dodwell, wrote in his personal diary,

'Having arrived in Galaxidi at the time of Carnival, I became a spectator of the dance called Of the Handkerchief, which is performed with much naturalness and simplicity. At the head of the dancers they have a man who beats a large drum with a stick giving one stroke after another, and these are preceded by two other men who are playing a sort of clarinet; after that follows a

long line of men dancing, that is to say lifting the right leg high and walking with the other, and holding each other by the hand, the first of these holds a handkerchief of any colour in his right hand and continuously shakes it, and raises it high. The line of men is followed by one of women, who, as they are dancing in the same way, come to unite with the other, and in this manner a perfect circle is formed, but the two sexes become separated by a little boy or a little girl. He who beats the drum places himself in the centre of the circle and so do groups of women with their children watching the dance in various postures. Around me I had a multitude of spectators dressed in their most gorgeous clothes, especially the women, who had put on the dress in which they had gone to their wedding, and on the belt they gird themselves with were two round or heartlike buckles made out of silver, or gilded. In that manner they continued the dance until the night, and I derived great pleasure from seeing it.'

From Dodwell we learn further that:

'The Arnauts (Albanians) ... wear their hair long behind; and the maritime Greeks are as attentive to that part of their person as their ancestors, the καρηκομοωντες Αχαιοι ...'

He described at length the dress of Albanian men, also worn by Greeks in many parts of the country. In Galaxidi,

'the Greeks of the maritime parts, and particularly of the islands, wear a red or blue cap ...'
and further down,

'Shepherds or sailors sometimes wear the large breeches reaching to the ankle ...'

The dress of the women of Galaxidi, on the other hand, received special attention:

'The Galaxidiote women all wear the Arnaut costume; they have a long robe of a light colour; the sides and bottom are ornamented with a broad border, which is usually black; but in their gala dress it is red, and sometimes dark green, as at Athens. The outer garment is loose, but the under one is girt round the middle by a broad zone ornamented with brass, and sometimes with silver, having two large, circular clasps uniting in front ...

'The head-dress of the women is a white handkerchief, hanging carelessly down the shoulder, and turned round the neck, resembling the ancient Στροφιον or Κεκρυφαλον, ... their hair is plaited behind, and divided into three long tails nearly reaching the ground; the extremities ornamented with red tassels, Turkish piastres, Spanish dollars, and sometimes Venetian sequins, and ancient Greek medals; ... which when they danced made a tinkling discord with the drums and fifes. Their necklaces and earrings are of coral, or coloured glass, with an intermixture of Greek medals, or Turkish and Venetian gold, amongst which I observed some ancient medals of Philip and Alexander ... Those of Alexander were worn as amulets

'The young girls and unmarried women have the red skulcap, which is covered more or less with money, according to the wealth of the person. They sometimes wear their dower upon their head, consisting in Turkish paras and piastres, which are perforated and strung round the cap: in the front is sometimes a row of Venetian sequins; and if the young lady is very rich, some larger pieces of gold coin attract the eyes of her admirers'

The following extract comes from the writings of the Rev. Thomas Smart Hughes,[4] also a classical scholar, who travelled in Greece in 1813-1814, and seems to have been interested in the prosperity of Galaxidi.

'... and took a walk round the interesting town of Galaxithi; I call it interesting, because it is a rising town, and exhibits almost a solitary feature of prosperity amidst a frightful and universal picture of decay: this simple sight of a people comparatively happy, will refresh the soul of the sympathizing traveller ... Commerce had for some time past opened her stores to this enterprising little state whose buildings and population were on the increase: comforts and even luxuries were here enjoyed that are unknown in the rest of Greece, and the stamp of servility was less visible upon the brow of the people. The ardent imagination and busy disposition of the Greeks find a great congeniality in the speculations of commerce, and they flock naturally to any spot where these speculations are encouraged and the fruits of industry protected. The encouragement and protection which Galaxithi at this time enjoyed was chiefly owing to Ali Pasha's desire of creating a maritime power; who, though he has neither liberality nor policy enough to keep his rapacious talons entirely from the produce of their toil, yet sets such bounds to his tyranny as not to destroy the elastic spring of industry; besides, to his credit be it spoken, he never suffers inferior authorities to imitate his example; so that in the dominions of the Epirot those concatenated links of tyranny are broken, which in the rest of Greece fetter the whole body of liberty and destroy all its energies.

'The late war, which diverted the stream of commerce out of old onto new channels, tended very much to augment the prosperity of Galaxithi. It partook largely of the carrying trade, that most profitable of all adventures, in which an almost certain gain is ensured without the possibility of loss. Near 200 ships at this time belonged to the port, which is most advantageously situated for the trade both of Peloponnesus and the north of Greece: its sailors are reckoned the best which the country produces; like the mariners of Hydra, Spezie, and Poros, each indi-

vidual of the crew possesses a share in the vessel or the cargo, and this interest is found to promote not only alacrity and enterprise, but also the most rigid frugality and economy: hard baked bread and olives, a little salt fish and the common wine of the country, is the fare of their sailors, nor have I ever seen a people more patient under toil and deprivation in the pursuit of their advantage.

'A certain generosity of spirit is said to be promoted by success in mercantile pursuits: the truth of this maxim was certainly apparent in the appearance of Galaxithi. They lavish a great deal of money even at present in the gaudy decorations of their churches; taste and elegance could soon follow if liberty were secured. I think it may safely be predicted, that if learning and science ever again revive upon their native land, that the maritime towns of Greece will lead the way in the march of intellect.'

François Charles H L Pouqueville[5] was a French doctor and consul, who spent ten years in Greece (1806-1816), and wrote a tarvel log, the most extensive in volume and variety of all up to that time. In 1815, he travelled in the south of Greece, when he also visited Galaxidi:

'... we entered the port of Galaxidi. The mariners of that seaport ... have risen by their industry to a level of prosperity one was far from suspecting. Their frail little boats, in which they sailed along the coasts, have been succeeded by solid vessels built out of wood from Delphi and Mount Parnassus; in them they now frequently call in ports of Italy, Spain, and Africa ... They also own, under borowed names, fifty ships ranging in capacity from one hundred and fifty to three hundred tons; these are used for long distance noyages; and seventy decked brazzeras by means of which, in the summer, small scale coasting trade is carried out in both the Adriatic and the Aegean. The borough of Galaxidi, composed of eight hundred hearths, rises on a little hill, which is not embellished by any kind of cultivation. The inhabitants, who consider themselves well established, refuse to bring the water here from a spring half a mile away, for fear this might induce the Turks of Salona to come and settle in this place. ... they prefer to drink rainwater, which they collect in ponds, or even seawater after they have boiled it, rather than compromise their liberty while providing themselves with one of the primary necessities of life. As a matter of precaution, fortunes are disguised under the aspect of poverty ...

'The property of the Galaxidiotes in ships of every type is estimated at fifteen million Turkish piastres, and their capital, at about an equal sum. The public wealth of the Ozolai Lokroi has undoubtedly never before reached such heights; and one is surprised to find, under the present circumstances of Greece, a like commercial set up in this region of the Gulf, which until these last few years was practically unknown.'

During the national revolution of 1821, the Galaxidiotes gave all they had, since the struggle was about their country's independence. In a letter by Philip James Green,[6] British Consul for the Morea, we find information about how in October 1821, Galaxidi was destroyed by the Turkish fleet.

'Patrass, 9th October 1821
... The Turkish combined fleet arrived here on the 20th ultimo: it consists of sixty sail of vessels, of which thirty six are Turkish, fourteen Egyptian and ten Algerine ... I will now inform you of the particulars of an expedition sent against Galaxidi. The Algerine division of the Turkish fleet was ordered to proceed up the Gulf of Corinth on this service: they sailed the 2nd instant, and have just returned here, having completely succeeded in their object. Isouf Pasha accompanied the expedition with a few hundred men: arriving off Galaxidi, the town and vessels were summoned to surrender, which being refused, an attack was made: in a very short time the Greeks abandoned every thing, and retired to the mountains. The Turks found in the harbour about ninety vessels, of which twelve or fifteen were armed; the rest consisted of small mercantile craft, belonging to the place. Several Ionian vessels were also in the harbour: two of these were taken possession of as lawful prizes: one had even fired on the Turkish vessels, and had the Greek Independent flag hoisted, with a declaration nailed to the mast, stating the determination of her crew to conquer or die in the Cause. This vessel was owned by Zantiot merchants, and had a valuable cargo of currents on board. ... Thirty-four of the finest Greek vessels were taken possession of, the others were burnt, and the town reduced to ashes.'

The first British volunteer, Captain William H Humphreys,[7] noted the following about that same day in his Journal:

'The next day we heard a heavy cannonading which was the Turkish fleet attacking Galaxidi, the finest town in Roumeli, where the inhabitants made a spirited but fruitless resistance against the overwhelming force of the batteries of so many vessels, the Turks had thirty-four, two of which were frigates. Towards evening, a cessation of firing and a rising smoke informed us of the fall of the town.[8]

In the years that followed, those of the brave Galaxidiotes who had been spared, again offered their services to their country. They constructed new sailing ships in readiness for the fight against the Turks, while at the same time they were rebuilding their ruined houses. That breathing space was, however, cut short by a new disaster devastating the heroic town. A division

of the Egyptian fleet with Ibrahim Pasha himself and about four thousand men on board came to Galaxidi in December 1825 and swept through destroying all that had been rebuilt, taking women and children as prisoners, snatching ships away, spreading desolation and death wherever they passed even shortly.

There were results to the sacrifice. Greece became free after four hundred years of slavery. The few Galaxidiotes left returned to their home town once again, poised for new maritime and commercial activities. In a report of K Metaxas,[9] Extraordinary Commissioner for Eastern Greece, to Governor I Kapodistrias, dated 19th January 1830, there is a detailed description of conditions in the town and its inhabitants, where he mentioned among other things that:

'... the town has all been pulled down, and has 2,815 souls ... shipbuilders there are forty, masons thirty, shepherds four ... the Galaxidiotes are almost all sailors, carrying out petty trade themselves in their ships, some as sailors, some as tradesmen ...'

That sentence alone in the text demonstrates the sort of attitude which prevailed among the inhabitants of the dilapidated town. The many shipbuilders set out to work for what was to be the last flourishing period for sailing ships in that region, commerce started anew, and the 'thirty masons' began to design the grand houses of the shipowner-captains.

Then, Galaxidi entered a peaceful period. In the yards seaworthy sailing ships of beautiful design were launched one after another. They would depart full of merchandise to sail to the ends of the earth and would return laden with Maltese flagstones and rare woods of excellent quality. The seamen brought back everything of the best they could find, for it was their desire to have their houses built strong, comfortable, and rich. Foreign painters, especially from Italy, came to paint in indelible colours the ceilings of the houses, creating patterns and pictures full of movement and harmony. Household goods bought in the largest, most prosperous seaports were brought in by the ships. Furniture, mirrors, clothes

'whatever of the best one could think of... The design of the patrician houses of the period was adapted to the seamen's way of life. The ground floor or semi-basement was used for the storage of rigging and sails when the ship was moored. That is where the water cistern was too; and in general, here was a utility space.

27, 28 Galaxidi. Drawings from the book by Ludwig Salvator, op cit

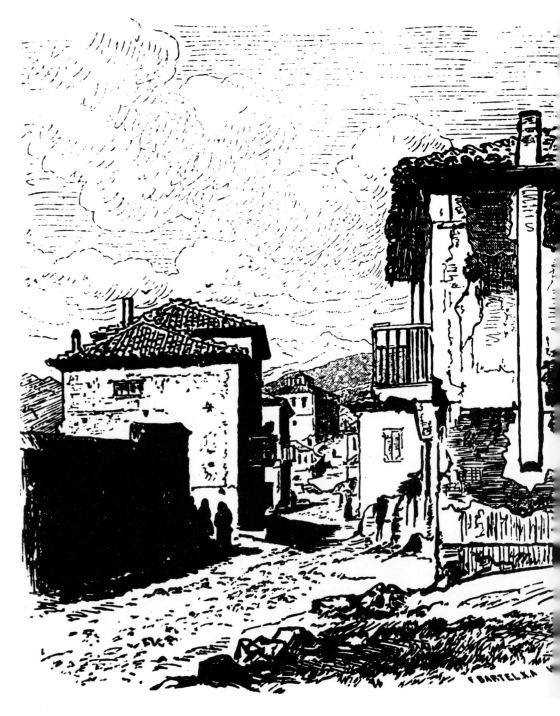

The first floor was taken up by the living quarters; and the second, called 'averto', which means open area, had no partitions at all. The sails to be sewn or mended were spread out in this room, which also served as a reception hall on special holidays, celebrations or feasts.'[10]

Ludwig Salvator, Archduke of Austria,[11] nobleman and explorer, in his book *Eine Spazierfahrt im Golfe von Korinth* (A Pleasure Cruise along the Gulf of Corinth), gave a detailed description of Galaxidi in 1872 as well as the area, the various little isles, the churches and country chapels, and the inhabitants. We quote:

'Galaxidi ... was burnt down in 1821 by the Capudan Pasha after the declaration of Greek Independence; but it has gradually risen from the rubble and already counts 6,000 inhabitants and 1,050 houses. It is situated on a hilly, rocky, ledge of solid conglomerate mass, looking north-east and projecting between the

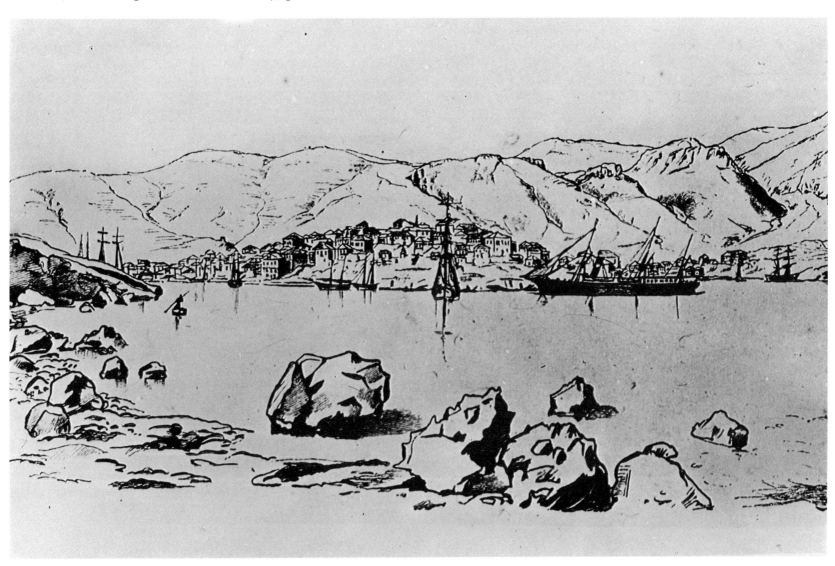

28

two bays that serve as ports ... The houses come down close to the sea; at the ledge they adjoin a natural rough rock-quay, while in the main harbour they come as far as a quay, which is still under construction. This quay has been built on top of a cut rock basis, it is provided with good steps, and also with iron mooring rings, and forms the northern border of the southern or main port of Galaxidi; a square mole is now being built at that quay, which will project into the port to serve as a main dock and disembarkation place. At the bottom end of that harbour the bay extends into a little valley, where there are still à few houses of Galaxidi, and also another quay with two flights of steps and protective walls. But the quay is now completely worthless, since this end of the harbour has been silted up, and all one sees there is a great deal of new oak-wood for ship-building; the logs are fastened with chains to prevent them from drifting away and they are immersed in the sèa in order to harden.

'... This port of Galaxidi may be a good and safe one, but it is not very spacious. The other, the northern one, on that side of the ledge, is even smaller and shallower, and therefore only used by coastal navigators. Its flat shores are surrounded by houses, and its bottom end is a little strand.

'... Let us then return to Galaxidi and look at the life and doings of that little folk of seamen, for that is what the inhabitants of Galaxidi are. Their welfare, their whole riches they owe to the ships only, which are considered, together with those of Syra, to be the best and most enterprising in Hellas. Galaxidi numbers 350 ships at present, out of which 250 are of a capacity greater than 100 tons. Shipbuilding has been quite lively until recently; 12-15 ships would be built yearly, but at least 9 ships. ...

'Galaxidi is a quiet and peaceful little town. The town side of the harbour border is the centre of life nd activity ... People are seen on the marina gravely pacing about dressed in blue baggy trousers and red fez according to Levantine custom, some are wrapped in fur, others are wearing the foustanella,[12] with the fez pertly sitting on one side of their heads.'

But it was not long before the Galaxidiotes took off the baggy trousers, characteristic garment of the islanders, to put on Frankish clothes. Especially at formal ceremonies they wore morning coats and top hats, as they were described at the reception of King Otto I, who was utterly amazed at the progress and civilization of the Galaxidiotes. There is no description of women's dresses in the book of Ludwig Salvator. From old photographs and information by word of mouth, it appears that the women of Galaxidi wore for a time the urban costume adopted by Queen Amalia, which has hence been known by her name.

Soon, however, they followed the development of European fashion. Often travelling with their husbands in the sailing ships, they visited large Mediterranean seaports, where they purchased most of their clothes.

We continue with another extract from Archduke Ludwig Salvator's description:

'As is understandable, it is the liveliest here on Sundays, when besides the usual promenaders there are also numerous sailors, their jacket-sleeves pulled back, roaming merrily through the lanes. To listen in the evenings is very pleasant, as happy songs resound in the quiet of the night coming from the strand or from the anchored local ships which with their tall masts and rigging, present a phantasmagoric picture in the little harbour. The songs are moslty Italian that the sailors, sometimes very young lads who return from abroad, have learnt at Torre del Greco or Castellamare, in Genoa, or on the Sicilian shores. They are accompanied by the Greek airs the boys sing as they are fishing with the trident at a flickering light close to the shore. At times it is boats that sail around one point after another in the light of a torch and looking like spirits; if they are coming home full of booty, then from their side too songs will resound in full and happy chorus.'

At the time when Ludwig Salvator visited Galaxidi, the town had reached its highest point in development. In 1875 and 1880 sailing ships with a capacity of 1,050 and 1,150 tons were built in its yards, their shipwrights earning themselves prizes both in Athens and abroad; and the fame of Galaxidi vessels as being reliable voyagers having spread all over the seas and the ports in the world.

But, as a flourishing never lasts long, the 'phantasmagoria of the sailing ships with tall masts and rigging' was extinguished by steam, which overshadowed sails and prosperity of the community for ever. In the year 1890 decline set in, the construction of ships diminished, until it stopped altogether. Another chapter in the history of Galaxidi was brought to its close. The period of the nineteenth century proved to have been one of the most splendid, when the industry, commercial acumen, and above all the seamanship of the Galaxidiotes had come to the fore.

All that is left of those years are the pictures of sailing ships adorning the Museum of Galaxidi. The shipowners and captains who commanded them are resting either in the little cemetery of

29 Galaxidi. Drawing from the book by Ludwig Salvator, op cit

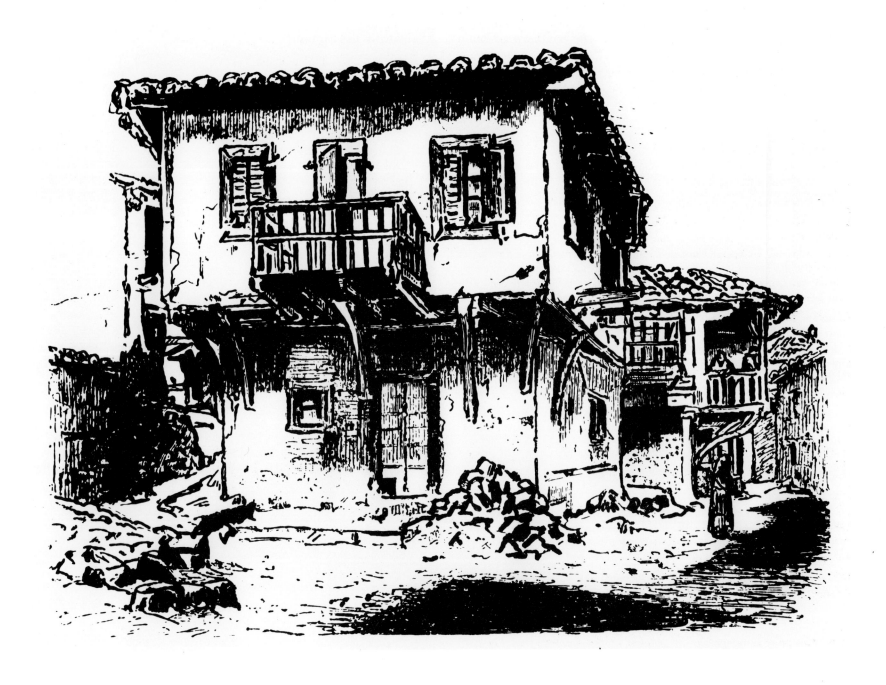

their home town, or else in the limitless grave that is the bottom of the sea.

Rodoula Stathaki-Koumari

NOTES

1 Edward Dodwell, Esq., F.S.A., *Classical and Topographical Tour through Greece,* London 1819, Ch IV, pp 131-42.

2 The custom of blackening the faces with soot on Clean Monday, the first day of Lent, and to celebrate it by feasting and dancing in the streets, still prevails in Galaxidi at present.

3 Simone Pomardi, *Viaggio nella Grecia fatto da Simone Pomardi negli anni 1804, 1805, & 1806.* Roma 1820. Tomo I, Capo IV p 47.

4 The Rev. Thos. Smart Hughes, *Travels in Sicily, Greece and Albania,* London 1820, Vol I, Ch XIII, pp 394-96.

5 François Charles H. L. Pouqueville, *Voyage de la Grèce,* 2ème Edition, Paris 1826, Vol IV, Livre douzième, Ch XI, pp 479-83.

6 Philip James Green, *Sketches of the War in Greece* in a series of Extracts from the Private Correspondence of Philip James Green, Esqr., Late British Consul for the Morea; with Illustrative Notes and an Appendix Containing Official and Other Documents, Relating to the Affairs of Greece. Second Edition. London 1828. Letter XIV, p 60.

7 Captain W.H. Humphreys, *Journal of the Greek War of Independence* (July 1821 - Feb 1822) edited with an Introduction by Sture Linnér, Stockholm 1967, 6, p 54.

8 In his note N° 1 W. H. Humphreys (*op cit*) writes: On October 1st and 2nd, Galaxidi, a prosperous town of some 800 homes, was bombarded and burnt; thirty-four brigs and schooners were taken as prize.

9 Konstantinos Metaxas, 'Mia ikon apo to Galaxidi tou etous 1830' (A Picture of Galaxidi in the Year 1830) in the newspaper *To Galaxidi,* year 1, No 1, Piraeus 1947.

10 Rodoula Stathaki-Koumari, 'Ta archontika tou Galaxidiou' (Patrician Houses of Galaxidi) in the periodical *Nea Skepsi,* No 64, pp 113-17, Athens 1968.

11 *Eine Spazierfahrt im Golfe von Korinth,* Prag 1876, pp 38-52 (unsigned, known to be by Ludwig Salvator, Erzherzog von Österreich - Archduke of Austria).

12 *Foustanella,* long white kilt.

NB Translation from the French, German, Greek and Italian texts, by Ariadne Koumari-Sanford.

30-34 Monuments on graves of seamen in the Cemetery of Galaxidi

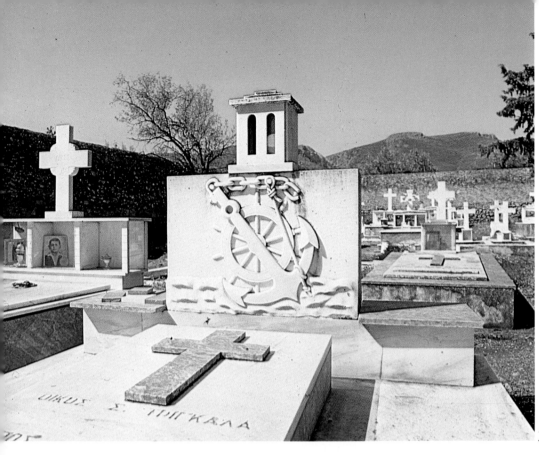

31

33

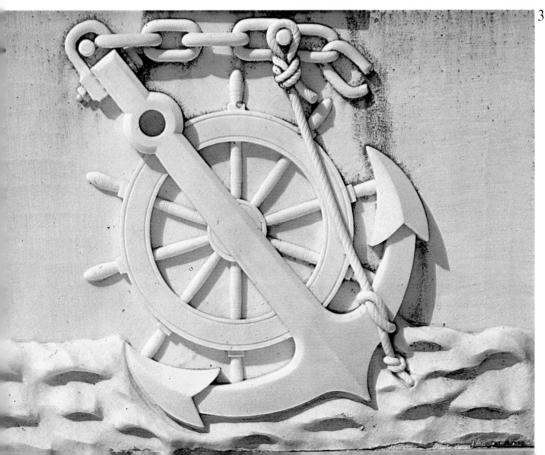

32

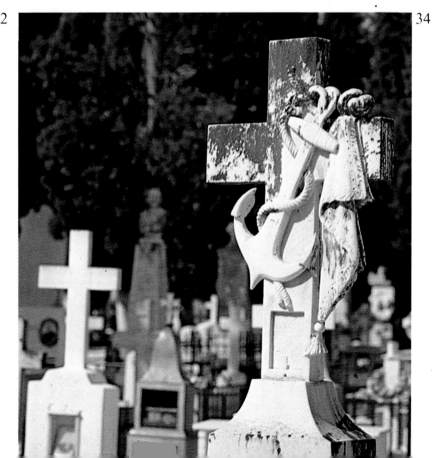

34

41

Figureheads

A figurehead, 'gorgona', would often be attached as an ornament mainly to the prow of large sailing ships.

Such prow-figures made their appearance in Greece at the end of the eighteenth and beginning of the nineteenth century and they usually represented a female form of about life size or smaller, depending on the sailing ship, or even busts of historic or mythical characters.

'It was the most sacred part of a ship, the prow, that harboured her personified soul in the shape of a figurehead, which was there to avert evil, protect the crew, bring riches and abundance of goods, give strength to the skipper-shipowner, and grant victory in times of war.'[1]

The love of seamen for their gorgones, their 'mermaids', is well-known. According to one account, if a captain of a sailing ship happened to die suddenly, the prow-figure and sometimes even the whole ship were painted black. Along with everybody else the gorgona, the mistress of the prow, was thus mourning the loss of her captain and master. By another account, when the time had come for a certain captain to leave the sea and have his sailing ship moored for ever, he took away the gorgona, stood her in his garden, and would sit there for hours on end talking to her.

There are four female figures in the Museum of Galaxidi (Plates 3, 35, 36, and 37), but we do not know where they were made, nor do we know whether there were artists who carved prow-figures of wood at any time in the maritime town. Most of the prow-figures on Galaxidi-built sailing ships represented, apart from very few exceptions, full-length female forms.

Rodoula Stathaki-Koumari

NOTE

1 Petros Themelis, 'Schylla Eretriki', reprint from *Archaeologiki Ephemeris*, Athens, 1979, pp 118-153.

35 (184) *Figurehead, height* 60 cm
36 (181) *Figurehead, height* 162 cm
37 (182) *Figurehead, height* 165 cm

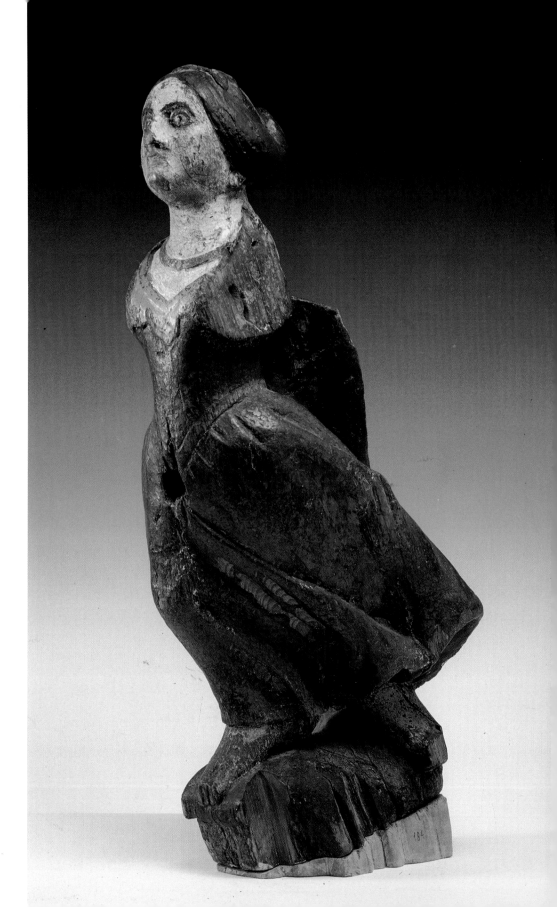

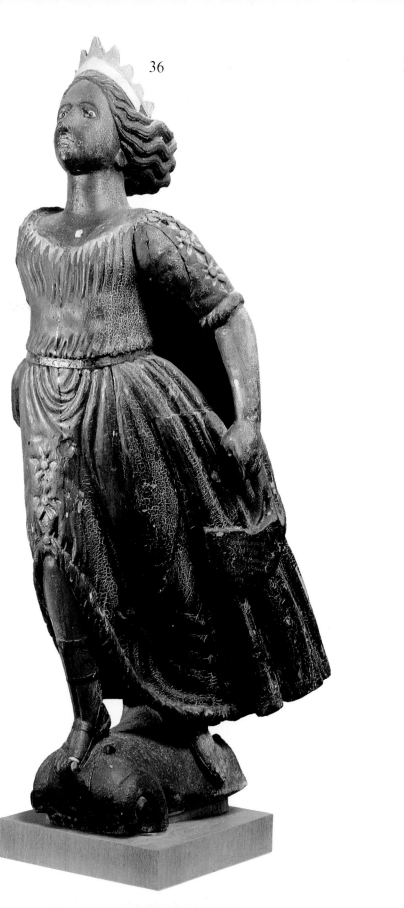

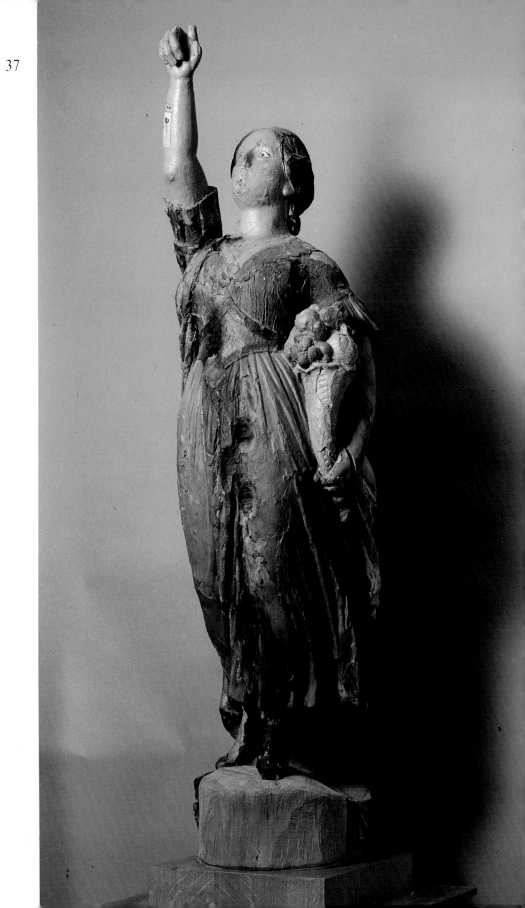

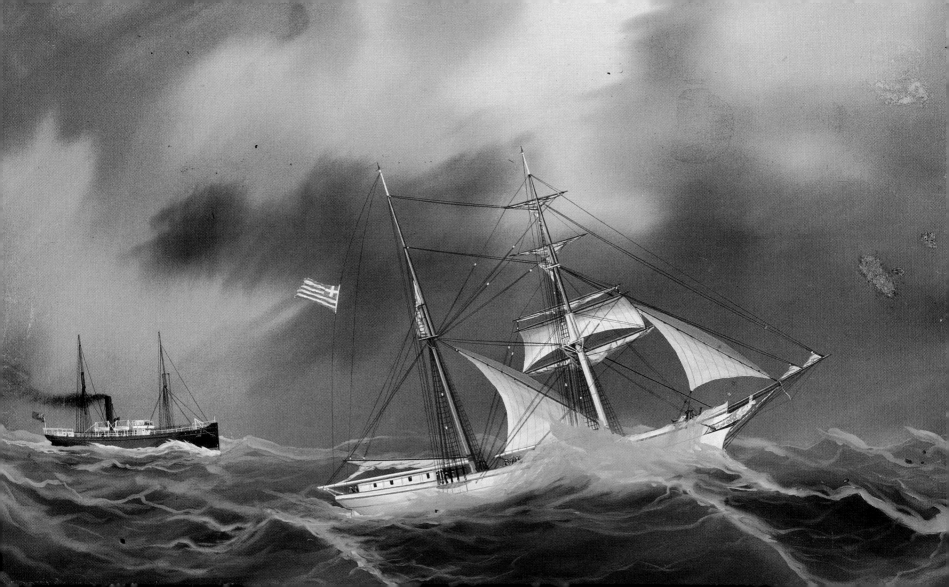

Portraits of sailing ships

In the Museum of Galaxidi there is a most valuable collection of portraits of sailing ships painted by Greek and foreign artists. These are of particular interest not only to students of art history, but also to those involved in the investigation and writing of Greek maritime history, for the portraits have a distinctive characteristic as that they were the property of those Galaxidi shipowners and captains of the last century, who by their activities had become the main contributors to the glory of the last peak of maritime and commercial prosperity their home town was to experience approximately between 1830 and 1905.

This collection of portraits has been brought together by private initiative. They are gifts of Galaxidi residents, to whom they evoke a part of their history full with its joys and its sorrows, and a taste of sea-water. It was a prevailing custom in those days for a shipowner captain to have a picture of his sailing ship in his home. Thus, in almost all Galaxidi houses, just as there were holy icons, there was also a portrait of the ship which provided a livelihood and riches to the family. What joy, what pride, when she was sailing and would return laden with goods of every kind. But what grief, what tears, when she happened to sink in a stormy sea drowning with her the hopes and the loved ones. The portrait was all that was left of her then, a token of daily bitter sadness.

Particulars of the painted ships are frequently mentioned on the pictures: what type of vessel she is, her name, the name(s) of the owner(s), who were usually also the captains, capacity in tons and, more rarely, the name of the master-builder who had designed and built her. On the other hand, short characteristic phrases written on some pictures commemorate important and unforgettable days in the life and the voyages of the portrayed sailing ship. Happiness and satisfaction burst through such little phrases when the ship is setting out from an important port like Venice, Marseilles, Malta, Livorno, or Trieste. But at other times, it is anxiety, when she is fighting with the waves, when rigging and sails are already torn, and there is a fear of shipwreck. We notice in many paintings the habit whereby Galaxidi-built sailing ships had the lower part of their masts painted white as a characteristic feature of identification, so as to be recogniz-

able from a distance. They were often referred to as the ships with the 'white tourketa', or 'white lower masts', or 'white columns'.

Sailing ship painters in the various ports observed and studied the types of vessel, their rigging and distinctive parts in order to be able to represent them faithfully. In that way they became specialized in the painting of sailing ships and were very much sought after in maritime circles. But also the port at which a ship had put in was part of her picture. For each port had its own special marks by which it was known from afar as a familiar and beloved place to the weather-beaten sailors. So it was large buildings as for Venice, or the harbour entrance with the lights on the right and the left, as in Marseilles or in Malta, or even the well-known shores and the lighthouses — that precious help on dark nights. There were also boats in the paintings, seagulls, or other ships encountered during a voyage. However, where there was a ship depicted in a great tempest, the description was naturally based on the stories of those who had actually experienced the violent storm and had fought with the waves of a raging sea.

Today, 136 pictures of sailing ships are gathered in the Museum of Galaxidi. The ships are of various types, all had Galaxidi owners, and all were built there, except one (Pl 58), which was made in Trieste.

A careful study of those pictures has revealed that they are works of foreign and Greek artists from foreign and Greek ports. The artist's name, the port and date of painting appear on some of the pictures, while on others there is not even the slightest indication that could help in the identification of the painter.

This study has further shown that 63 pictures of sailing ships were made by foreign artists between 1861 and 1905, according to the dates written on them. They are the invaluable portraits of actual sailing ships viewed through the eyes of the individual artists, and they hang in Room II. Out of these, 48 belong to known painters, whose lives and work have been studied by the art historian Elena Lodi-Fé. On 15 there is no signature, but they are in Room II with the rest, being close to them in style. All other paintings of sailing ships, which are not portraits, belong to the twentieth century and are found in Room V.

Rodoula Stathaki-Koumari

38 (240) *E Kyriakopoulos (?), KATINA, tempera, 52×72 cm*

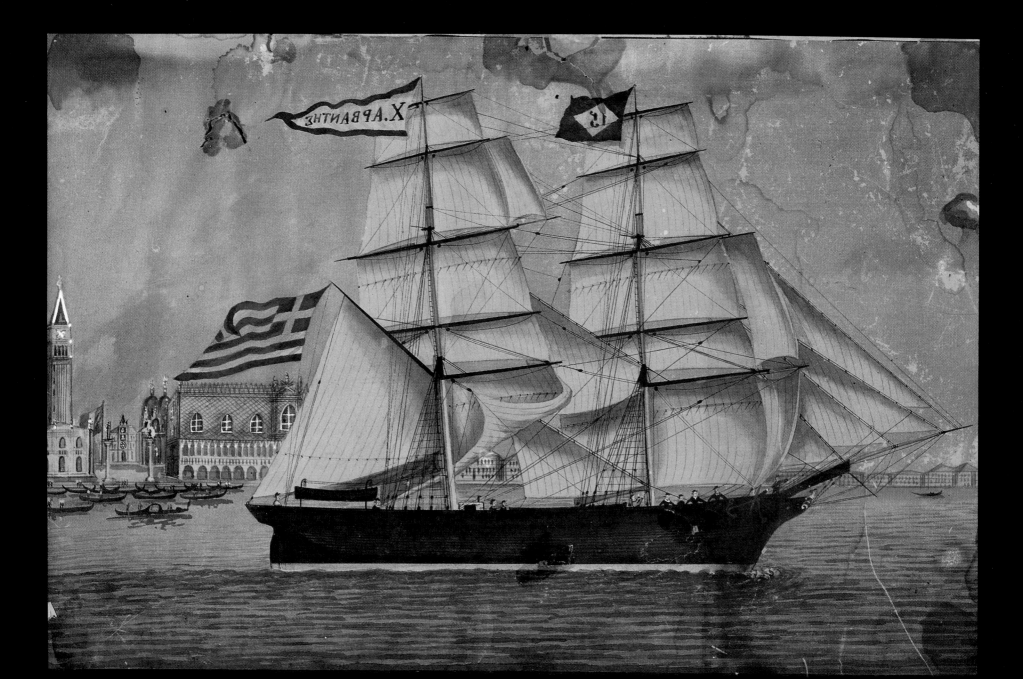

Nineteenth century portraits of sailing ships by foreign artists

Only a few human inventions have survived fifty centuries of history without undergoing radical change. One of them is the sail. The sailing ship has existed for more than 5,000 years but there is no major difference between the sails of today and those hoisted on the ancient Greek galleys described in the Iliad and the Odyssey, and depicted (possibly much later) on the Dipylon Geometric vases of the eight century BC.

By the second half of the fourth millenium BC the Egyptians had discovered how to exploit the prevailing winds in the Valley of the Nile. From this arose the conception of the sailing ship, which was to be the sole means of sea transportation till the advent of the steamship. The first pictorial representation of a sail was discovered on a vase of the late Gerzean period, circa 3100 BC, a primitive but effective drawing. Other depictions of ships from about the same period, 3000 BC, have been found engraved on fragments of terracotta vases on the Greek island of Syros.

It is not our purpose here to analyse the pictorial history of sailing ships, nor to discuss early graffiti or the ancient Minoan Cretan sailing vessels engraved on seals and gems. Let us not forget, however, that it was along the coasts of Greece and in the open sea between the Aegean islands that ancient seafaring developed; from here it spread throughout the Mediterranean.

Odd as it may seem, the nineteenth century watercolour 'portraits' of ships in the Galaxidi Museum can be considered the direct descendants (albeit in romantic or modern guise) of those representations of ships in ancient mosaics and frescoes, on painted terracotta vases or precious jewellery.

The Museum has a very interesting collection of watercolours as well as several oil paintings. There are 136 pictures of ships, out of which 63 are gouaches or watercolours that include sailing ships and steamships, all Greek vessels, painted, however, by foreign artists, primarily Italian, French, and Yugoslav.

On entering the main hall of the Galaxidi Museum the visitor is struck by the passionate feelings the inhabitants of Galaxidi had for their vessels; certainly they thought them the best and most beautiful ships ever to sail the seas. This first, sudden visual impact is quite exciting. Venice, Genoa, Naples, Trieste, Livorno, Marseilles, and Malta confront you and can be taken in with a single glance. It was while the ships were anchored in these foreign ports that their captains, who were in many cases also the owners, commissioned a local ship portrait painter to capture on paper or canvas the faithful likeness of their beloved vessels.

The whole world seems to open out in front of the visitor. Galaxidi suddenly assumes an importance and a vitality which is in contrast with the image it has today, a peaceful backwater far from the hustle and bustle of the mainstream. The Galaxidi Museum, thanks to its ship portraits, the work of both Greek and foreign artists, has an exceptional record of the town's important past, one fortunately not forgotten. Because of these marine artists, the museum is a link in a chain of more than seventy other maritime museums. These are both large and small, scattered throughout the world, from the National Maritime Museum in Greenwich, England, to the Peabody Museum in Salem, Massachusetts, USA, and the Kotor Maritime Museum in Yugoslavia.

Ship portraits of the nineteenth century are a precious record

39 (216) *Luzzo family,* AGIOS SPYRIDON, *watercolour, 43×63 cm.* Brig of Charalambos, Konstantinos, and Panagiotis H Arvanitis. Built in Galaxidi before 1867; 297 tons

of seafaring. It must be remembered that before radar and radio, navigators were at the mercy of every sudden storm or hurricane, and life at sea was therefore, a constant and hazardous adventure. Shipwrecks were part of everyday life. Ex-voto paintings faithfully depicting and commemorating these happenings are numerous; they are a noteworthy but separate chapter in the history of ship painting. They testify to a simple, but genuine religious feeling and are to be found in churches and chapels all along the Mediterranean coasts. The purpose of the classic ship portrait, on the other hand, was to enhance the walls of the houses owned by rich merchants or to be displayed proudly in the home of the captain, who had returned safely from a dangerous voyage. We can easily imagine the interiors of the houses in Galaxidi where the walls reflected the colourful images of family ships, past and present, lying in harbour.

Unfortunately, very little is known about nineteenth century ship painters, or port painters, as they are sometimes called. They have been shamefully neglected by scholars and art historians. Interest has rather been centered on the subject, which is the ship itself. A ship painting is a faithful representation of the side view of her moored or on the open sea. The importance of ship painters and of their contribution to the maritime records of those times has been grossly underestimated; this is probably due simply to artistic snobbery.

Although ship portraiture has a history of its own, and a style unto itself, it is interesting to note that it is along the dark and angry Northern Seas, far from the warm Mediterranean, that we find the first artists of the modern era who specialized in the painting of ships and port scenes. The seventeenth century Dutch marine painting school of the Van de Weldes and the English schools of marine painters that followed were the forerunners of this kind of painting. The powerful maritime republics of Venice and Genoa, in spite of the breathtaking splendour of their achievements during the Renaissance and the following centuries, never produced an outstanding marine painter. All paintings representing important naval victories, such as the Battle of Lepan-

to — a subject that was dear to the greatest Venetian painters of the sixteenth and seventeenth centuries — were records of the historical events themselves and not of the ships that had actually taken part in the battle.

To return to the subject of ship portraiture, we first hear of this particular style of marine art in 1679, in a manuscript by J Jouve, at the Bibliothèque Nationale Française, entitled 'Dessins de tous les bâtiments qui naviguent sur la Méditerranée'. A few years later we come across a print by Sbonski de Passebon (1690), called 'Plans de plusieurs bâtiments de mer avec leur proportions'. In D' Alembert and Diderot's *Encyclopédie Méthodique* we find a drawing of a nineteenth century 'polacca' which is a perfect early example of ship portraiture. Other studies on the matter are: 'Receuil des vues de tous les différents bâtiments de la Méditerranée et de l' Océan' (1770) by Gérault de Pas and the collection of prints published in Paris (1814-1817) by the name of 'Collection de toutes espèces de bâtiments de guerre et de bâtiments marchands qui naviguent sur l' Océan et dans la Méditerranée', designed by Jean Jérôme Beaujean with the drawing of an important 'saccoleva', a typical Greek ship used for sponge fishing. In 1805, two painters of French origin, Dominic and John Thomas Serres (father and son), who lived and worked in England, wrote and illustrated *Liber Nauticus*, an instruction manual on the art of ship drawing. This manual actually states: 'many are the difficulties towards the attainment of perfection in drawing naval subjects ... the artist should possess knowledge of the construction of the ship ... be acquainted with naval architecture ... know the correct proportions of masts and yards, the width and cut of sails, and be acquainted at the same time with seamanship ...' This manual became well-known among port painters. The advice to draw directly from nature, 'carry your palette and colours to the waterside' (Joshua Reynolds, 1789) became general practice. The habit of making use of a model of a ship within the walls of the studio and only later filling in the background was abandoned.

The renowned French family of ship portraitists, Joseph

40 (209) Gio Luzzo, EVANGELISTRIA, watercolour, 48×66 cm, Venezia 1861. Brig of Efthymios N Katsoulis. Built in Galaxidi in 1861; 186 tons

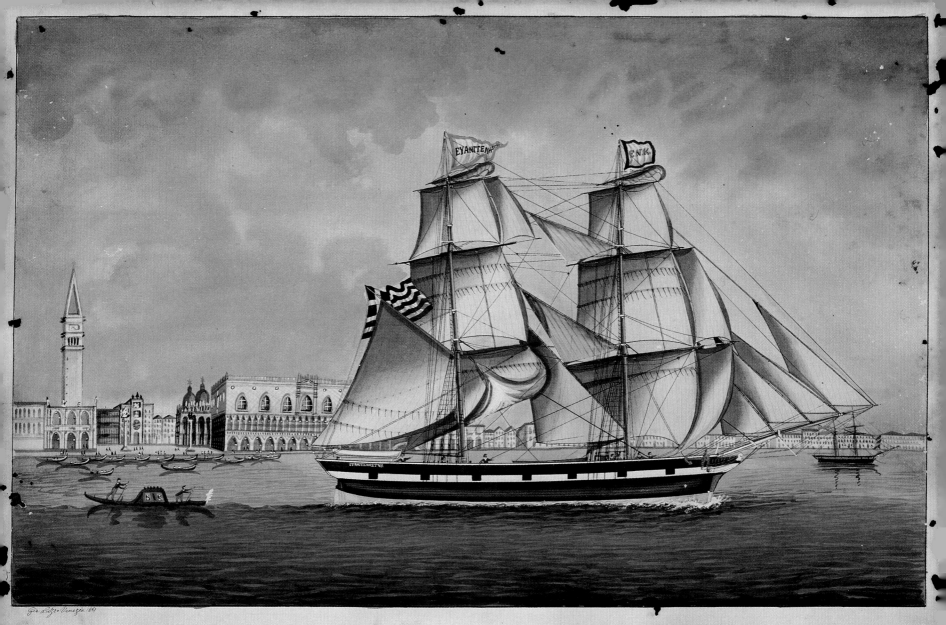

ΕΥΘΗΜΙΟΣ, Ν. ΚΑΤΣΘΥΛΗΣ. ΕΥΑΝΓΓΕΛΗΣΤΡΙΑ 1861.

Ange Antoine Roux and his three sons, Antoine, Frédéric, and François Geoffroy, who worked on the quays of the port of Marseilles during the whole of the nineteenth century, were among the first to follow this practice of drawing from nature. The many artists commissioned by the powerful East India Company did the same. The contribution of these artists to the birth of ship portraiture has been outstanding. As we have already pointed out, the rôle played by port painters in the history of marine art has never been sufficiently appreciated. Their work was, and still is, of inestimable value. Thanks to their meticulous attention to accuracy of detail, it has been possible to build up historical records, to compare merchant ships and war vessels, to find analogies and differences between them, and to study the details of sails, rigging, masts, and hulls. Such details are just as important as commercial data are on tonnage or navigation. Authors of books on marine subjects give lengthy descriptions of sailing ships, of living conditions on board, and of adventures at sea with happy or tragic endings. Sometimes these texts are enlivened by the reproduction of a painting or drawing of a ship, but rarely, if ever, is the name of the artist mentioned, nor credit given to him for his work. It is strange indeed that no one seems to have realized that without ship portrait painters, we would scarcely be able to visualize sailing ships of the nineteenth century. We owe a great debt to these humble but singificant artists.

Usually ship portrait painters were born in a port town and lived along the waterfront; they were very often seamen themselves and had specific knowledge of nautical details. Through daily experience they learned to recognize the difference between ships built in the Mediterranean and those built elsewhere; to understand flags and ensigns, and to pay particular attention to the decorative elements proper to each vessel. They also met, mixed with, and learned from the seamen on board the ship they were painting. Naturally, the captain or the owner would be the first to notice and point out any mistakes. If the client was satisfied, the artist would get more commissions, his name would be passed on from ship to ship, and his reputation established. The Galaxidi shipowners were no exception to that custom.

All the foreign artists represented in the Galaxidi museum are from the Mediterranean and range from the Luzzo family of folk painters to the refined and sophisticated G D' Esposito.

GIOVANI LUZZO AND HIS SONS
THREE GENERATIONS OF SHIP PORTRAIT PAINTERS

Luzzo is a name found in maritime museums all over the world. The Galaxidi museum has 26 Luzzo paintings, perhaps the largest number concentrated in any one museum.

Twelve of them bear a signature. This volume presents three generations of port painters in the Luzzo family line for the first time.

Their name leads us to Venice, Italy, where, during the nineteenth century, an entire family handed down from father to son, for three long generations, the art of painting merchant or war vessels. A complete list of the Luzzo paintings has yet to be compiled. Such a list could be drawn up only with the cooperation of more than two hundred maritime institutions. We are aware of the existence of more than 50 Luzzo paintings along the Dalmatian coast, on the Adriatic Sea, thanks to information provided by Mr Vinko Ivančević of Dubrovnik, Yugoslavia.

Giovanni Luzzo or Gio Luzzo, as he usually signed his work, represents the first generation of the Luzzo family. He was born in Trieste in 1808. He was active as a painter in Trieste and Venice until his death on April 23, 1884. After his marriage he moved to Venice, where ten children, seven boys and three girls, were born. They lived at Number 3228, Sestiere di Cannareggio, in extreme poverty. Four of his children died before the age of five. Vincenzo, his eldest son, was born in Venice on August 6, 1841. Vincenzo married and, in his turn, had ten children, although none of them seems to have followed in his father's footsteps. Antonio, a younger brother of Vincenzo, was born in Venice on November 20, 1855. In 1889, Antonio had a son Giovanni, named after his grandfather; he represents the third and last

41 (247) Luzzo of Venice, AIKATERINI, watercolour, 49×75 cm. Barquentine of the brothers Athanasios and Miltiadis P Grigoriou. Built in Galaxidi in 1881; 224 tons.

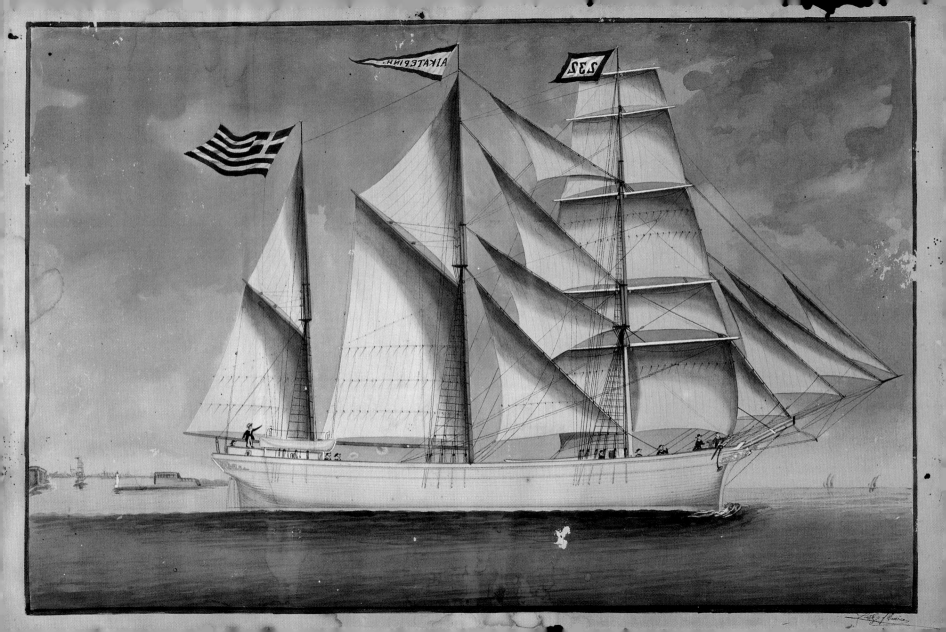

generation of the Luzzo ship painters. He died in Genoa in 1965.

Let us deal with the work of the Luzzo family in chronological order. The first known work of Gio Luzzo is a watercolour dated 1847 found in the church of the Madonna della Misericordia in Dubrovnik, Yugoslavia, and represents an Austrian brigantine caught in a storm off the Irish coast. Many of Gio Luzzo's works are to be found on the Dalmatian coast, in the maritime museums of Korkula and Kotor and in the churches of Boka Kotorska, Yugoslavia. An interesting work entitled 'Sailing ships from Korkula' by Vinko Ivancěvić describes a number of paintings by Gio and other members of the Luzzo family.

The Stockholm Museum of Naval History has a watercolour by Gio Luzzo dated 1849. It represents a Swedish sailing ship lying in the harbour of Venice. The Peabody Museum in Salem, Massachusetts, has a watercolour of the British barque NAUTILUS (1853). The Galaxidi Museum has one painting signed Gio Luzzo (Pl 40), a portrait of the EVANGELISTRIA dated 1861; a precise and neat ship portrait.

Incidentally, the Church of the Madonna di Montenero near Livorno has an ex-voto painting on wood of a Greek brigantine, called the EVANGELISTRIA. It was common for the seamen of the time to pray for help to the patron saints of their home, as well as to the Virgin Mary of the locality, when danger arose. And so it happened with the EVANGELISTRIA, caught in a storm on the 17th of December 1869. In the ex-voto painting the captain of the ship, Telemachos Metaxas, is entreating both the Madonna di Montenero and the more familiar Saint Nicholas for help. There is a legend that the holy icon of the Madona di Montenero, so dear to the hearts of many sailors, was transported from the island of Euboea, in the Aegean Sea, to Livorno, in Tuscany, in 1265. Since the date of the Galaxidi watercolour and the date of the storm depicted on the ex-voto in Livorno, are only eight years apart, the two paintings may be of the same ship.

Works by Gio Luzzo are to be found in the Mariners' Museum, Newport News, Virginia, USA; the Maritime Museums of Troense and Kronborg Castle, Denmark, the Naval Museum of Pegli, the Maritime Museum of Camogli, and the Naval Museum of Venice, Italy.

From 1872, when Giovanni Luzzo was already 64 years old, we have a watercolour of the Austro-Hungarian brigantine GIORGIO which is in the Korkula Museum, Yugoslavia. It is signed 'Gio Luzzo Padre fece' which means literally Giovanni Luzzo Father made [this]. It is clear that by 1872 Giovanni needed to identify himself because a son bearing his name had started to draw and paint. Actually Gio did have a son by the name of Giovanni born in 1858. In 1872, the boy would have been fourteen years old and may well have started working in the workshop of his father and older brother. This is the only time we hear of Gio using the qualification 'padre'. From henceforth it is difficult to distinguish between the paintings done by the father and his sons. They probably worked together: one would draw the ship and its technical details, another would fill in the background with sea or sky. This would explain why towards the end of the century we have a number of watercolours signed generically 'Luzzo Venezia', or 'Luzzo of Venice', which was often written in English.

Misinterpretation has also arisen as to the reading of the name Luzzo. Many Luzzo watercolours found in Galaxidi and in the USA bear a signature written with the first or second 'z' in an elongated form, which can easily be mistaken for the letter 'r'. Up to sixty years ago, this old-fashioned way of writing the double 'z' was quite common in non-scholarly written Italian. This explains why some catalogues of naval museums in the United States list the name 'Luzro' for 'Luzzo'.

The Galaxidi Museum has two watercolours signed 'Luzzo of Venice' (Plates 41 and 42) one signed 'Luzzo of Venezia' (Pl 43), and thirteen watercolours with no signature but undoubtedly painted by at least one member of the Luzzo family (Plates 39, 44-47, and 49-56). There is no mistaking the accuracy with which the Luzzo always sketched the Venetian background, down to the last detail; St Mark's Square, the Palazzo Ducale, the Campana dei Mori, the buildings and bridges along La Riva degli

42 (259) Luzzo of Venice, KALOMOIRA, watercolour, 55×73 cm. Brig of Emmanouil Vlassopoulos. Built in Galaxidi in 1876; 244 tons

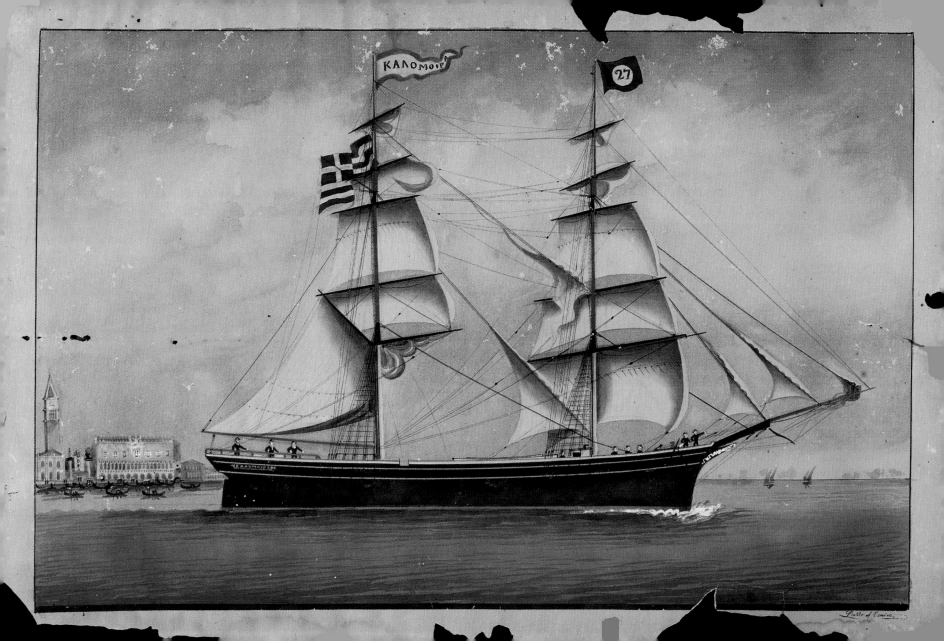

Schiavoni, and the gardens of St Elena and the Arsenale. The practised eye can recognize a Luzzo watercolour at a glance. No one except a Venetian could have drawn Venice and the lagoon with such precision, nearly always adding a small Italian flag in the background after 1861. This detail may seem unimportant, but it is significant if we consider the historical events experienced by countries like Greece, Italy and Yugoslavia who were at that time fighting for their independence. Venice had one short, glorious year of freedom in 1848-1849, after an uprising against the Austrians, only to fall again under the Habsburg yoke in 1849. Gio Luzzo does not hesitate: in the background of the watercolour representation of the ship SIRIUS, now at the Stockholm Maritime Museum, Giovanni bravely hoists an Italian flag in St Mark's Square. This strong national feeling is the same as that which animated the colours of the Greek flag on the vessels in the Galaxidi paintings and set the Croatian flag flying from the masts of the Korkula ships in Yugoslavia. The Luzzos certainly felt kinship with their Greek clients, their fellow sufferers of oppression, and in the fight against foreign domination.

We now come to the eldest son of Giovanni, **Vincenzo**. After having picked up the art, he most likely started working on his own. He did not live in his father's house, the way his brothers Antonio and Giovanni did. His home was at No 982, Sestiere di San Marco. He is the most interesting member of the family and is represented in Galaxidi by eight paintings, Plates 57-64, the largest collection of watercolours by Vincenzo in any museum we know of. Because of the sensitivity and spontaneity of his painting, we ought to classify him (although all classifications are absurd) as a 'primitive artist' rather than as unskilled. A good example is watercolour on Plate 62, 1874, depicting the ship ARISTEIDIS, caught in a storm during the month of November 1873, off the island of Stromboli, south of Naples. The simple transverse lines of slashing rain, beating and curling round and across the ship, and above all the delightful group of six sailors perched all in a line on the central boom, their heads looking like

mere dots against the ominous background of the Stromboli volcano, make the picture worthy of the best folk tradition. His brushwork is natural and spontaneous, direct, always careful, but never artificial, and in its simplicity very powerful. His father Gio was by far a better draughtsman, but not nearly as spontaneous. Vincenzo would never forget the figurehead or any other decorative element. He loves his subject and gets emotionally involved; therefore, his painting is never static. Small pictorial details mark the difference between the work of father and son. Gio underlines the shadows of the numerous gondolas in the background with one heavy semi-circular stroke of the brush. Vincenzo prefers a light, vertical wavy line. The sea waves, although stylized, are also different. The colours are more vigorous and intense in Vincenzo. One typical recurring motif in all Luzzo paintings is the identical setting of St Mark's Square in Venice, always from the same angle, rich in detail, and always lovingly placed on the right hand side of the scene.

Paintings by Vincenzo Luzzo are to be found in the following museums: Naval Museum of Venice, the Maritime Museum of Camogli, the Naval Museum of Pegli, Genoa, in Italy; the Kotor Museum, the Maritime Museum of Dubrovnik, and museums in Orebici and Korkula, in Yugoslavia; the Altonaer Museum, Hamburg, in Germany; the Maritime Museum of Kronborg in Denmark and the Mariners' Museum of Newport News, Virginia, USA.

A watercolour signed by Vincenzo Luzzo, 1865 in the Maritime Museum of Camogli, Italy, representing a shipwreck, strongly recalls a painting in Galaxidi, RESVYTIS (Pl 52). A striking resemblance with the Camogli watercolour, the same brushwork, composition, background, and waves, all justify the attribution of the Galaxidi watercolour to Vincenzo Luzzo.

Antonio Luzzo, brother of Vincenzo, was born on November 20th, 1855 in Venice, and died on February 23rd, 1907 in Genoa. He was active in the ports of Trieste, Venice, and Genoa. We first hear of him in a painting in the Sanctuary of the Church of

43 (278) *Luzzo of Venezia,* AGIOS SPYRIDON, *watercolour, 49×71 cm. Brig of the Dimitrios P Nikas family. Built in Galaxidi in 1858; 285 tons*

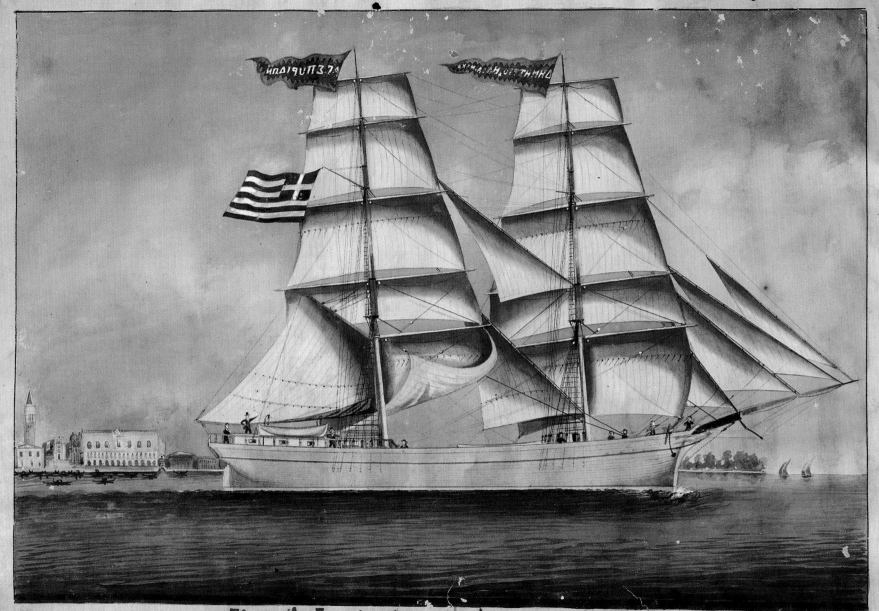

Πλοῖον Ἅγ. Σπυρίδων ὁμογενείας Δημητρίου Π. Νῖμα.

Monte Allegro sopra Rapallo, Italy. Here again a particularly close resemblance is to be found between this watercolour of a shipwreck, dated 1885, and watercolour of Plate 65 in the Galaxidi Museum. Both paintings depict in the same style and manner the stripped hull of a ship tossing hopelessly in a storm torn sea. The only difference is the small Madonna at the top left-hand corner of the Monte Allegro watercolour, an offering of thanksgiving. Antonio painted sailing ships, but he was the first member of the Luzzo family to paint steamships as well, and he was later followed in this activity by his son Giovanni. Works by Antonio are to be found in the Maritime Museum of Kotor and in Boka Kotorska, Yugoslavia; the Peabody Museum Salem, Massachusetts, USA; and the Maritime Museum of Camogli, Italy. Gouache of Plate 182, steamship AGLA·I·A KOURENTI in the Galaxidi Museum, should be attributed to Antonio. The background, the outline of the Venetian lagoon, and the quay of St Mark's Square are identical to other Luzzo backgrounds.

Giovanni Luzzo, son of Antonio, was born in Venice on January 13th, 1889. He lived next to his father at No 1634, Cannareggio, before moving to Genoa where he died in 1965. Most of his work is to be found on the Dalmatian coast.

This reconstruction of the family tree of the Luzzo painters was made possible only by perseverance and patient enquiries, and by a happy coincidence which led to the locating of the grandson of Antonio Luzzo, great-grandson of Gio in Genoa.

His name is Andrea and he is a carpenter who works at No 5, Via della Rondinell. His father, the Giovanni mentioned above, earned his living in the port of Genoa in the same way his father and grandfather had in Venice. Giovanni painted pictures of Liberty ships after the Second World War and earned two dollars a painting. 'Those were rich and happy days', says Andrea, 'but I remember my grandfather, Antonio, walking along La Riva degli Schiavoni, in Venice, every day, with his palette, paintbrushes, and colours, struggling to support his family. I am not ashamed to say that due to our miserable circumstances I was forced as a boy to wander the streets as a beggar. We lived in Calle del Forno, in Cannareggio, like our great-grandfaters, till one day in 1927, the family decided to move to Genoa. The Treaty of Versailles had undermined the importance of the port of Venice, and Genoa offered more possibilities for work and hope for the future. It is here that my father, Giovanni, spent the remainder of his life, painting and drawing ships.'

Three generations of artists, the Luzzos, have at last been indentified, and the official records examined. They are no longer names without a history or background.

Strangely enough, there are few traces of other port painters in Venice, besides the Luzzos. Gavarrone, Arpe, and Camillieri are well-known Italian ship painters, but they were active on the west coast of Italy, especially in Genoa and its surroundings. The Galaxidi Museum can be justly proud of its collection of paintings by the different Luzzos.

SHIP PORTRAITS BY OTHER FOREIGN ARTISTS

Before proceeding to the group of French painters in the Galaxidi Museum, we should say a few words about the technique followed by ship painters. Actually, the term 'watercolour' is in this case inappropriate. One should speak of a mixed technique, watercolour and gouache (tempera), as one of these two mediums is usually employed. Sometimes they are both present in the same painting. In a watercolour, which is a preparation of pigment ground in water-soluble glues, whites are obtained by exploiting the transparency and white colour of the paper. In the gouache or tempera technique (either glue, gum, or egg-tempera) light shades are obtained by diluting the colour. In addition to choosing the paper, which can be either smooth, rough, white, or even coloured, the artist sometimes makes use also of pen and ink, or black, white, or coloured chalk. On rare occasions, the painter may even use an oil medium.

Louis Roux, the **Renault** brothers, and **Honoré Pellegrin** are French painters represented in the Galaxidi Museum.

44 (202) Luzzo family, AGIOS GEORGIOS, watercolour, 49×58 cm. Brig

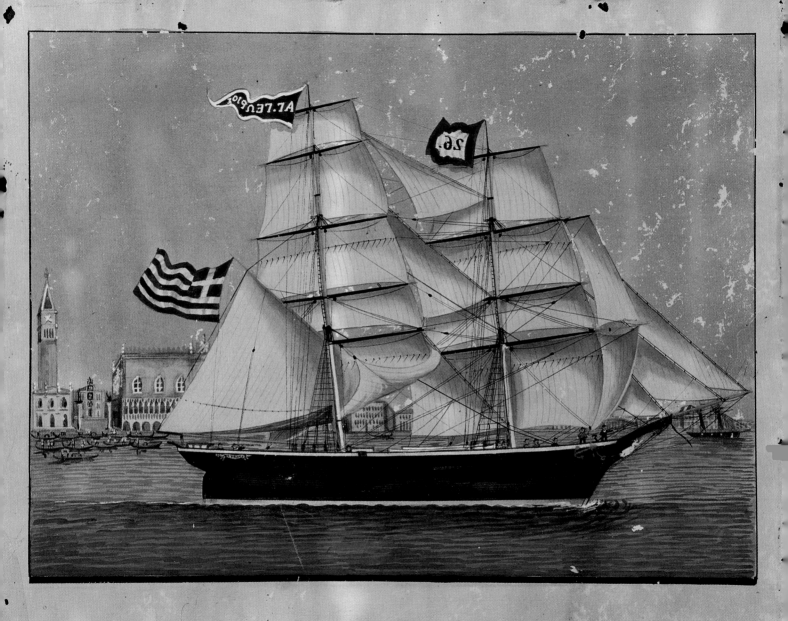

Louis Roux lived and worked in Marseilles, on the 4th floor of 40 rue de Darse. We find his address on the back of his paintings. He was active during the second half of the nineteenth century. His watercolours and gouaches are vivid and colourful. This is particularly evident in the painting of Plate 66 which represents a ship flying a Greek flag lying alongside the quay of what must have been a French colony in Africa. Three strings of nautical flags, eighteen in all, fly happily from bow to stern. The French flag with its bright dashes of blue, white and red, is strewn everywhere over the picture in the midst of miniature palm trees and naked dark-skinned natives. No doubt is left as to who is the master here. However, the overall impression is one of gaiety, and the painting is highly picturesque with the big paddle-steamer in the foreground and the sailors dressed in stylized costume. The painting was probably commissioned to celebrate a particular event. There is no clear date to it.

Two other watercolours by Louis Roux (Pl 67) ALTANA and AGIOS SPYRIDON (Pl 68) are dated 1876 and 1889 respectively. In these watercolours, the ship is paramount, set against a monotonous background. The skies have depth, although the colour of the sky is thin, and a touch of heavy tempera impasto gives brilliance to the white surf of a breaking wave. The pictorial treatment of sea and waves is an element which helps to identify a marine painter. This is also true about a ship portrait painter. One can sometimes recognize the work of an artist more easily by analysing the movement of the waves, than by observing the sails and rigging on the ship. Louis Roux's waves follow an extremely regular pattern, even when the sea is rough. Two of the four paintings by Louis Roux clearly depict the distinguishing mark of the Galaxidi vessels: the lower part of the masts is painted white.

Open to discussion is tempera of Plate 71, AGIOS NIKOLAOS, dated 1880, without a signature. This is a beautiful painting. Both the main ship and the two smaller ships on the horizon are under full sail and the whole picture imparts a vigorous feeling of motion. The colours are rich and generously applied, and there is a three-dimensional quality sometimes lacking in other ship portraits. A painting by Louis Roux belonging to the Auguste Normand collection in Marseilles, LE LEIF AND MERCIN, a Norwegian goletta, recalls very strongly the gouache of Plate 71 in Galaxidi. However, the waves and sails of the AGIOS NIKOLAOS show a great elegance unlike the flatter style of Louis Roux. A comparison with the work of François-Geoffroy Roux, no relation to Louis, might be interesting and helpful.

Louis and **Michel Renault** and the less known **Louis P Renault** were also French artists, natives of Marseilles, although they were active in the Italian port of Livorno during the second half of the nineteenth century. Their work is of excellent quality, and they usually painted non-Italian ships which happened to cast anchor in the port of Livorno. Their fondness for brilliant colours, the variety of small human figures which animate the decks of their ships and a deep blue sea with rather stylized waves are characteristic of their work. Both gouache SOFIA (Pl 70) signed and dated M & L Renault, Marseille 1868 and gouache GALAXEIDI (Pl 73) seem to come from the same hand. The attribution of gouache on Plate 73 to L & M Renault is supported by the inscription on the painting. The ship is 'starting from Livorno, 1865' on its way to Galaxidi. The background of the port of Livorno, the old fortress, the lighthouse, and the rock of the Meloria are typical topographic features which recur systematically in the work of the Renault brothers. The waves, the colour of the hulls, and the sails are almost indentical in the two paintings. Looking closely at the GALAXEIDI gouache one can detect pencil traces of the squaring of the paper: probably the artist had been commissioned to paint a second and larger portrait of the same vessel. The SOFIA flies a Greek flag on a mast partially painted white, the typical mast of Galaxidi, while little figures on board wear the typical French sailor's cap with the pompon. Numerous paintings by the Renaults, of American, Danish, Spanish, and Russian ships, are to be found at the Pegli Maritime Museum, Italy.

45 (210) Luzzo family, AGIOS IOANNIS, watercolour, 49×67 cm. Brig of Petros I Kyriakis. Built in Galaxidi in 1848

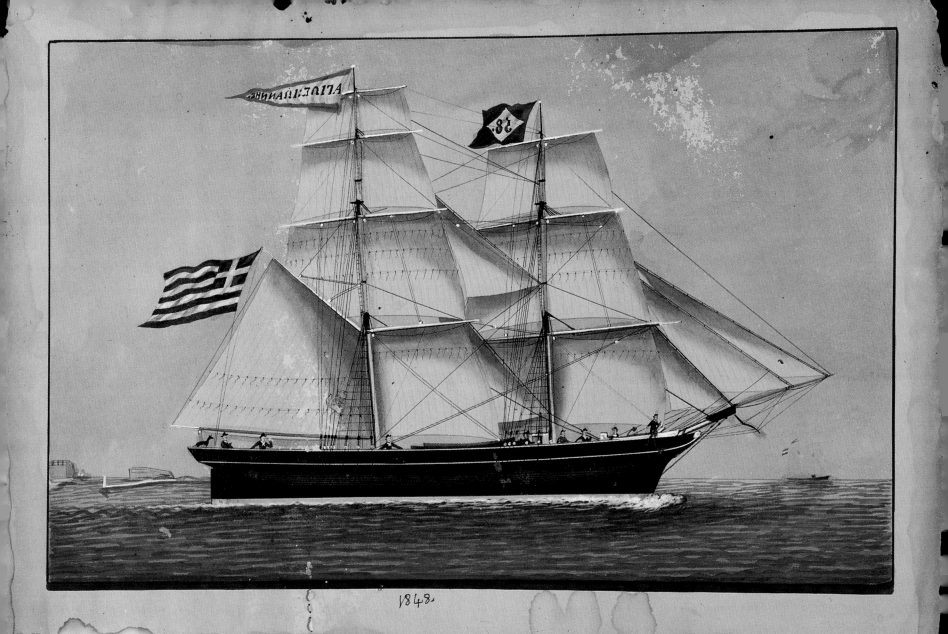

1848.

Joseph Honoré Pellegrin was a French ship portrait painter, active in Marseilles from approximately 1793 to 1870. On the back of his paintings a neat little label states: 'Joseph Honoré Pellegrin, Dessinateur de Navires Rue Thiares 46, IIIe étage - Marseille.' Very little is known about his life, except that his artistic output was considerable. His works can be found in many museums, especially in the United States. The Peabody Museum, Salem, Massachusetts, has a set of twenty-seven watercolours. E H H Archibald, Curator of Paintings at the National Maritime Museum, London, writes in his *Dictionary of Sea Painters*: '... although Pellegrin's work is characteristic of the Marseilles school, it is stiffer than the typical output of the Roux family.' The only watercolour belonging to Pellegrin's brush in Galaxidi (Pl 72) is dated 1859 and represents the ship AGIOS NIKOLAOS. The painting is in very bad condition and therefore difficult to appreciate.

Paintings by Pellegrin are to be found in France at the Auguste Normand Museum in Marseilles, and at the Palais de Chaillot in Paris; in England, in Kingston-on-Hull; in Spain, at the Naval Museum of Barcelona; in Sweden, at the Maritime Museum of Stockholm; and in the USA, at the Historical Society, Wilmington, Delaware, the Mariners' Museum, Newport News Virgina, the Mystic Seaport Museum, Connecticut, the Marblehead Historical Society, Massachusetts; the Nantucket Whaling Museum, Massachusetts, and the Philadelphia Marine Museum.

Another group of foreign painters are the Italians **Luigi Roberto**, **De Simone** and **S Mengucci**.

Luigi Roberto worked in Naples at the end of the nineteenth century. He is represented in Galaxidi by two watercolours, depicting a steamship and a sailing ship. Signature and address can be read in the lower right-hand corner of his paintings: Luigi Roberto, Vico delle Mura Mercato 4, Napoli. This form of what may be devined as commercial publicity was quite usual among ship painters. Roberto allots extensive space to sea and sky: monochrome surfaces of blue, broken by thick strokes of pink and white. His ships are drawn to a smaller scale than is usual in other ship portraits. Vesuvius, the volcano at Naples, lies in the background, mild and mellow rather than dramatic.

Besides the two works signed by L Roberto, that is, steamship PARNASSIS, 1888 (Pl 173) and sailing ship AGIOS NIKOLAOS, 1892 (Pl 74), two unsigned gouaches, PARNASSIS and ANDROMACHI (Pl 175) can be attributed to Roberto. The four works have a similar style and composition and an almost identical placing of Vesuvius. Works by Luigi Roberto are to be found in the Maritime Museums of Bergen and Oslo, Norway; the Maritime Museum of Stockholm and Göteborg, Sweden; the Maritime Museum of the Castle of Kronborg, Denmark; the Maritime Museum of Berne, Switzerland; the Maritime Museums of Liverpool and London, England; the Marseilles Chamber of Commerce and the Musée de la Marine, Palais de Chaillot, Paris, France; in the Mystic Seaport Museum in Connecticut, the Philadelphia Marine Museum in Pennsylvania, the Peabody Museum in Salem, Massachusetts, and the Mariners' Museum, Newport News, Virginia in the USA; and in the Maritime Museums of Pegli and Camogli, Italy.

The gouache on Plate 75 bears the signature of **De Simone**. There is no telling whether it is A de Simone or Tomaso de Simone. Both were Neapolitans and active during the second half of the nineteenth century. The painting represents the ship NIKOLAOS caught in a storm, with heavy grey clouds hanging above, and ugly waves breaking into ripples of white froth. The signature is clear. The painting, which is in a rather poor condition, carries no date.

The two de Simone artists were very active. They painted a number of naval battle scenes in oil, many of which are at the National Maritime Museum, London. Works by A de Simone are at the City of Liverpool Museum, England; the Maritime Museum of Kronborg, Denmark; the Maritime Museum Prince

46 (217) *Luzzo family, DYO ADELFOI, watercolour, 44×62 cm. Brig of the brothers P and A Vlamis. Built in Galaxidi in 1871; 326 tons*

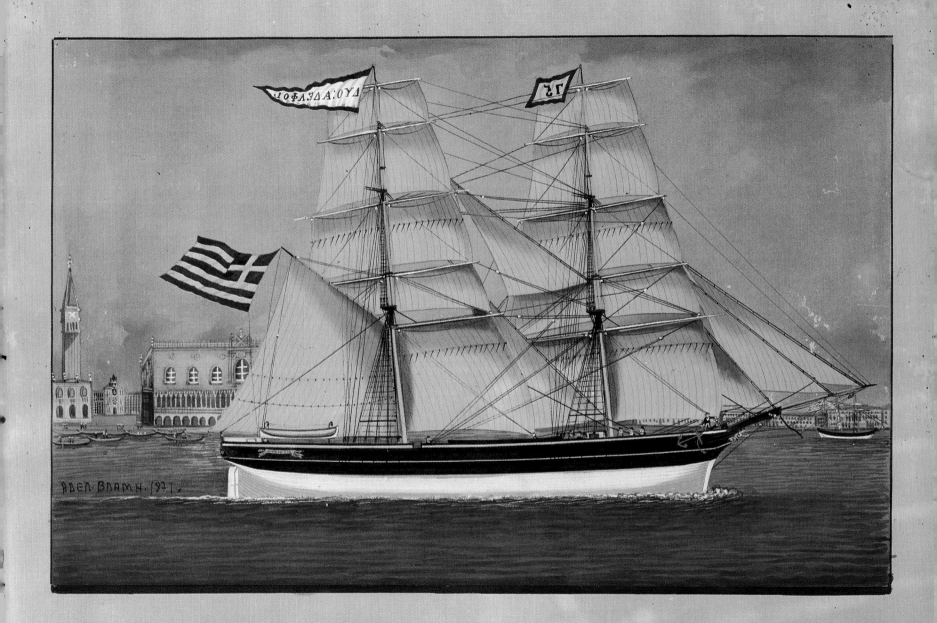

Mendrik, Rotterdam, Holland; the Bergen Maritime Museum, Norway; the Franklin D Roosevelt Library, Hyde Park, New York, the Mystic Seaport Museum, Connecticut, Naval Office Records, Washington DC, the Mariners' Museum, Newport News, Virginia, the Peabody Museum, Salem, Massachusetts, USA; and the Maritime Museum of Pegli, Italy.

The watercolour on Plate 76 by S **Mengucci,** is crudely executed. It depicts the ship KATINA sailing by Mt Conero near Ancona, Italy. Small boats bearing sails common in the Adriatic Sea hover in the background. The only other painting we know of by S Mengucci is in the Camogli Maritime Museum in Italy

G D'Esposito. Judging from the number of ship portraits painted by G D'Esposito during the first few years of the 20th century, there must have been steady trade between Galaxidi and Malta. His ten gouaches, Plates 77-86, are refined and sophisticated, not the work of an amateur. To G D'Esposito the ship itself is important, but not as important as the attainment of a harmonious and balanced vision of the painting in its entirety. Nothing is casual, nor is there even a trace of a nervous or hurried hand. Pictorially and technically they are very nearly perfect. The stroke of the paintbrush is sure and quick. Dashes of white chalk delicately highlight the Maltese houses and other features in the background and are clear evidence of the artist's ability. The sea is transparent, the light, soft and relaxing. The background depicts either Malta, or the open sea, or a pier; the ship is always drawn to the same scale, neat and clear-cut, lying broadside to the viewer, and in the midst of sweeping and delicately fluttering swallows. The quality of the paper is good, sometimes smooth, sometimes thick and grainy. The artist is fond of dark browns and beige colours, and endless hues of aquamarine. His colours are rich and warm. No other painter in the Galaxidi Museum is as sensitive to colour as G D'Esposito. The only possible objection to his work is the somewhat static and monotonous repetition of settings. His art has little room for emotion. Movement and vitality are sacrificed to precision and elegance.

Some marine historians maintain that Gaetano Esposito and G D'Esposito are one and the same person; nevertheless, Gaetano Esposito was born in Salerno in 1858 and died (by his own hand) in Sala Consilina in 1911. The son of a fisherman, he grew up on the quays, led a miserable and difficult life, worked in Naples and Florence, and was an important figure of the Neapolitan post-impressionist school. There is, however, no direct evidence so far that Gaetano Esposito ever drew ship portraits. He may have done so for a living, but there are no records of him having spent any length of time in Malta. Whatever the truth, it is certain that the work of the ship painter G D'Esposito is the work of a highly qualified artist.

Works by G D'Esposito are to be found in the City of Liverpool Museum, England; the Maritime Museum of Kronborg Castle, Denmark; the Maritime Museum of Stockholm, Sweden; and the Peabody Museum, Salem, Massachusetts, United States.

B Ivanković. The one and only oil painting, (Pl 87), by a non-Greek artist in the Galaxidi Museum, is the work of a Yugoslav painter, B Ivanković, who was born in Constantinople in 1815 and was by profession a captain in the merchant marine. He lived in Trieste, had seven daughters, and died in 1898. He lived and died a poor man. He was an extremely prolific painter, producing during the span of his existence more than 400 pictures. Most of these are to be found on the Dalmatian coast, in Kotor, Preanj, Dubrovnik, Orebici, Korkula, Split, and other towns. Exceptionally detailed information on the artist's life and work is contained in a publication by Josip Luetić, 'Kap. B. Ivanković, najistaknuti ji portrtist nasih jedrenjaka', Dubrovnik 1974, and in the booklet, 'Nekoliko Slika Korculanskih Jedrenjaka', Rijeka 1979, by Vinko Ivančević, Dubrovnik.

The painter B Ivanković signed his oils with his surname. His Christian name was Vassili or Vaso. Thanks to Ivanković and to the great number of his paintings, we have an almost complete record of all the ships built in the Adriatic shipyards during the second half of the nineteenth century.

47 (218) Luzzo family, watercolour, 48×67 cm. Brig of Panagiotis D Tsaplaris. Built in Galaxidi in 1858

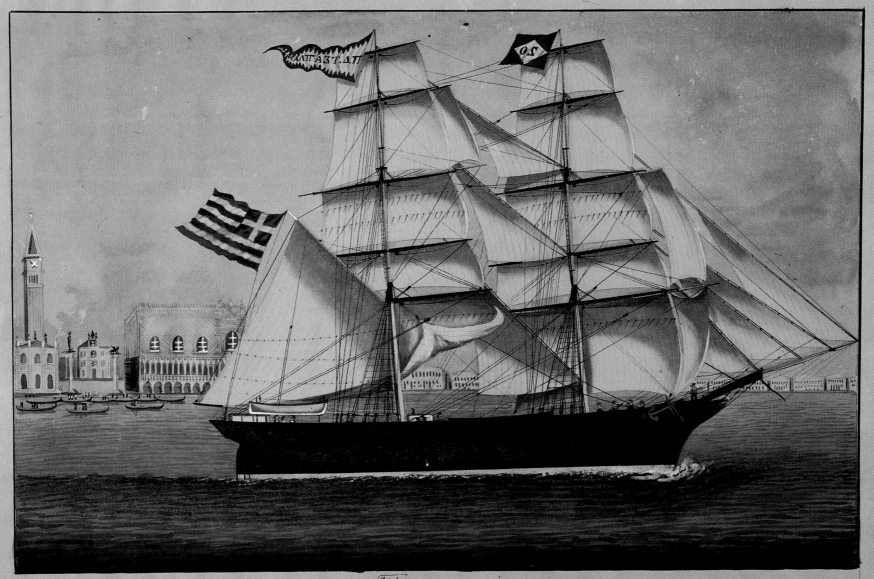

Πάρις
Τα Πλοίαρχοι Παναγ. Δ. Τσαμαρή 1858

The painting in Galaxidi is of the Greek ship ANDROMACHI (Pl 87). The medium used is a very thin oil on a canvas with hardly any priming. Pictorially, the effect is of poor material. Shades of pale blue, grey, and pink merge sea and sails into a sadly romantic atmosphere. This is not only a nautical record, but the expression of a delicate and sensitive hand. In the distance behind the stately sails of the ANDROMACHI are two ships, one flying the Imperial Austrian flag, and the other, the colour of what was later to become the Yugoslav flag. This oil painting has larger dimensions than most of the watercolours and gouaches in the Galaxidi Museum. The frame is the original one, as are all the frames in the Museum. Whether they be simple or elaborate, original frames should always be retained and cared for. They are a part of the history of a painting as well as an indication of the taste of the time.

Elena Lodi-Fé

Acknowledgements

My very special thanks go to the City of Venice, Italy. Likewise, I am indebted to the Curators and Keepers of the following Museums: Mr Ramelli, Museo Navale di Venezia, Italy. Edward H H Archibald, National Maritime Museum, Greenwich, Great Britain; A. Paul Winfisky, Peabody Museum, Salem, Mass; Lois Oglesby, Mariners' Museum, Newport News, Virginia, USA. Jürgen Mayer, Altonaer Museum, Hamburg, W Germany. Jill Sweetnam, Merseyside County Museum, Liverpool, Great Britain. Hanne Poulsen, Danish Maritime Museum, Helsinger, Danemark. Gosta Webe, Statens Sjohihistoriska Museum, Stockholm, Sweden. Marjolaine Matikhine, Musée de la Marine, Palais de Chaillot, Paris, France. I am particularly indebted to Mr Vinko Ivančević, Dubrovnik, Yugoslavia for his extremely kind and continuous help and interest. I should also like to thank Mr and Mrs Sacerdotti, Venice, and Mr and Mrs Alberani, Genoa, for their hospitality and assistance.

E L-F

Translator's Note

'Nineteenth Century Portraits of Sailing Ships by Foreign Artists' is the original text written in English.

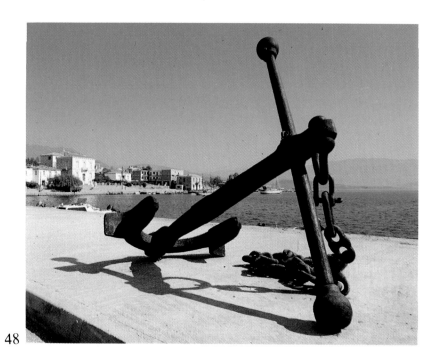

48

48 *Anchor of sailing ship, British Admiralty type. Chirolakas, Galaxidi*

49 *(225) Luzzo family, AGIOS GEORGIOS, watercolour, 48×69 cm. Brig o A G Margiotis. Built in Galaxidi in 1854; 235 tons*

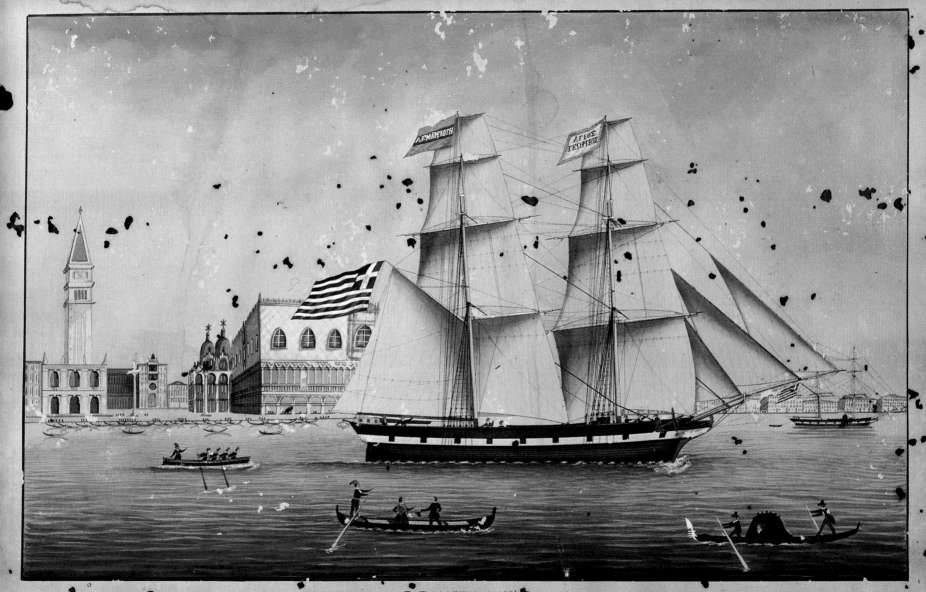

Α.Γ. ΜΑΡΓΙΩΤΗ 1854

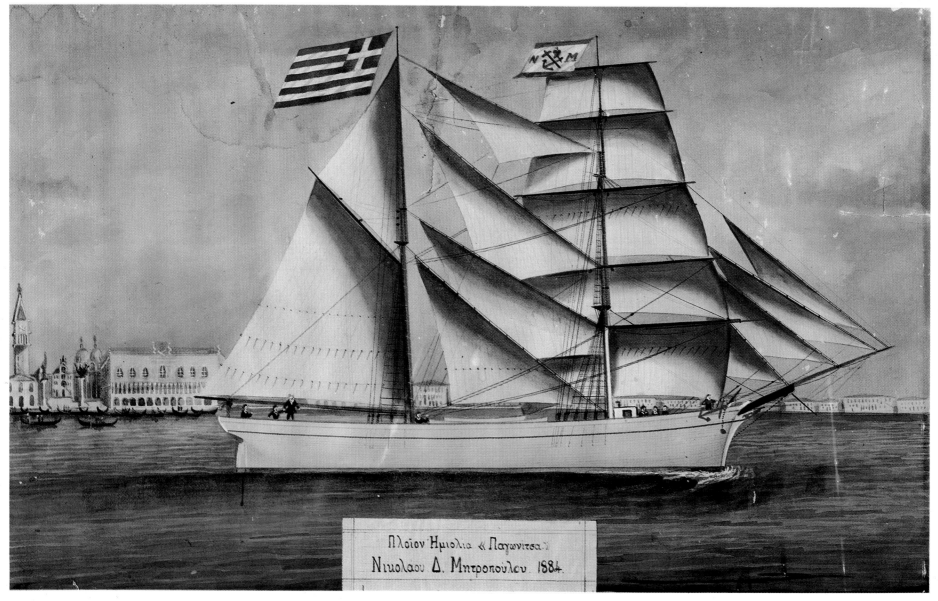

Πλοῖον Ἡμιολία «Παγωνίτσα»
Νικολαου Δ. Μητροπουλου. 1884

50 *(270) Luzzo family,* PAGONITSA, *watercolour, 43×68 cm. Schooner of Nikolaos D Mitropoulos. Built in Galaxidi in 1884, by Master-builder Ioannis Kanatas; 240 tons*

51 *(266) Luzzo family,* AGIOS NIKOLAOS, *watercolour, 39×58 cm, Venezia 1871. Brig of Michail, Dimitrios, Ilias N Lymperios, and Zoitsa, widow of N L Lymperios. Built in Galaxidi in 1856; 180 tons*

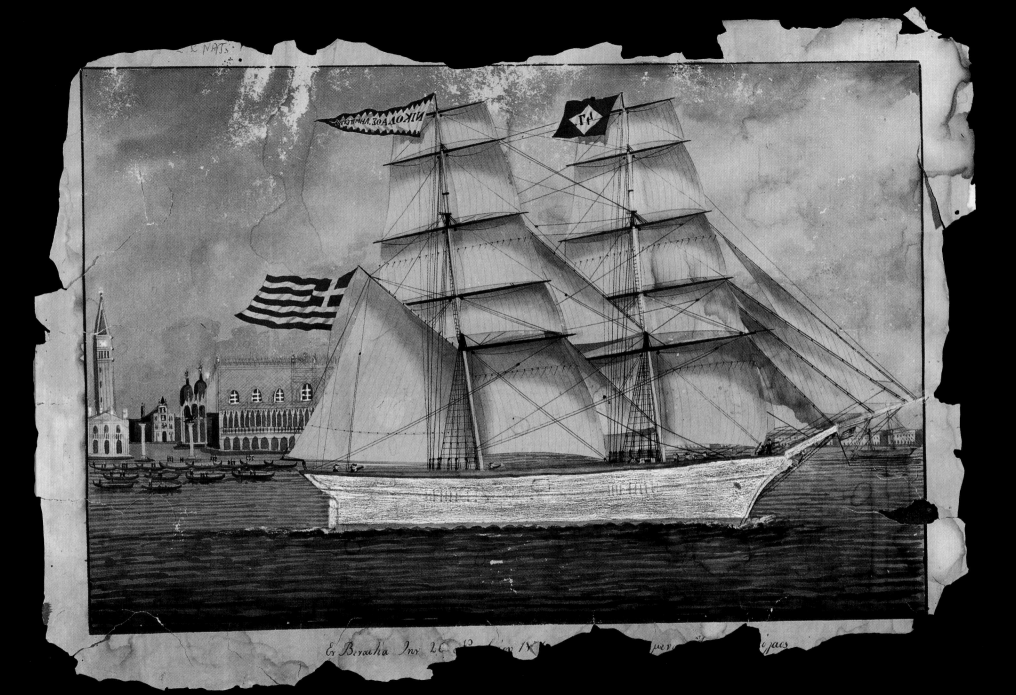

ΝΙΚΟΛΑΟΣ ΛΗΜΝΙΣ

Εν Βεραλια Ινv 2ο 19 1868 μερε

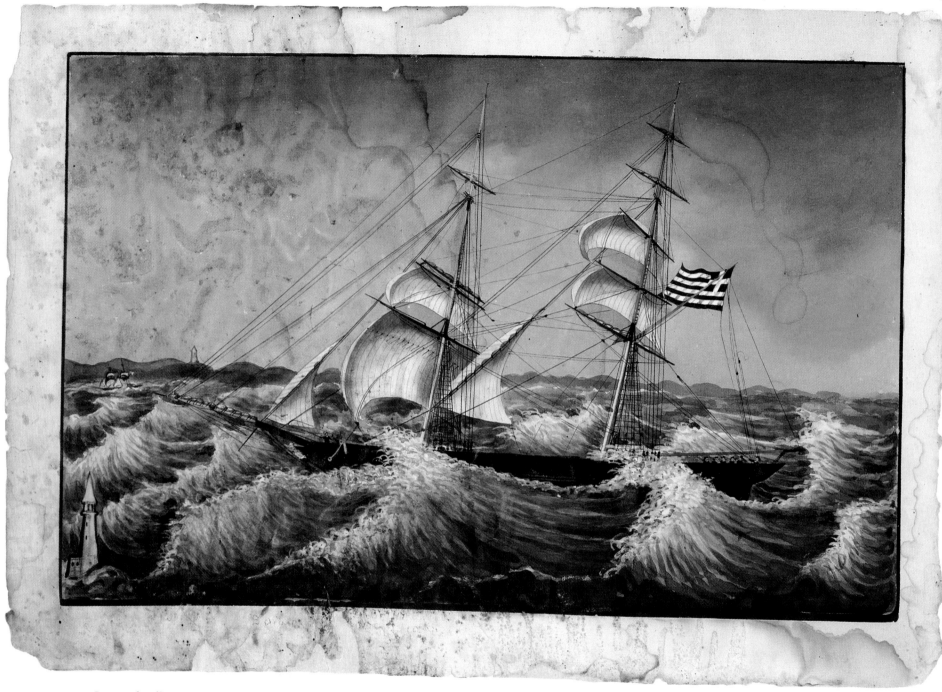

52 (253) Luzzo family, PRESVYTIS, watercolour, 40×58 cm. Brig of Giangi Lymperis. Built in Galaxidi in 1857; 280 tons

53 (275) Luzzo family, AGIOS SPYRIDON, watercolour, 48×67 cm. Brig of Georgios K Tsalangyras. Built in Galaxidi in 1848; 280 tons

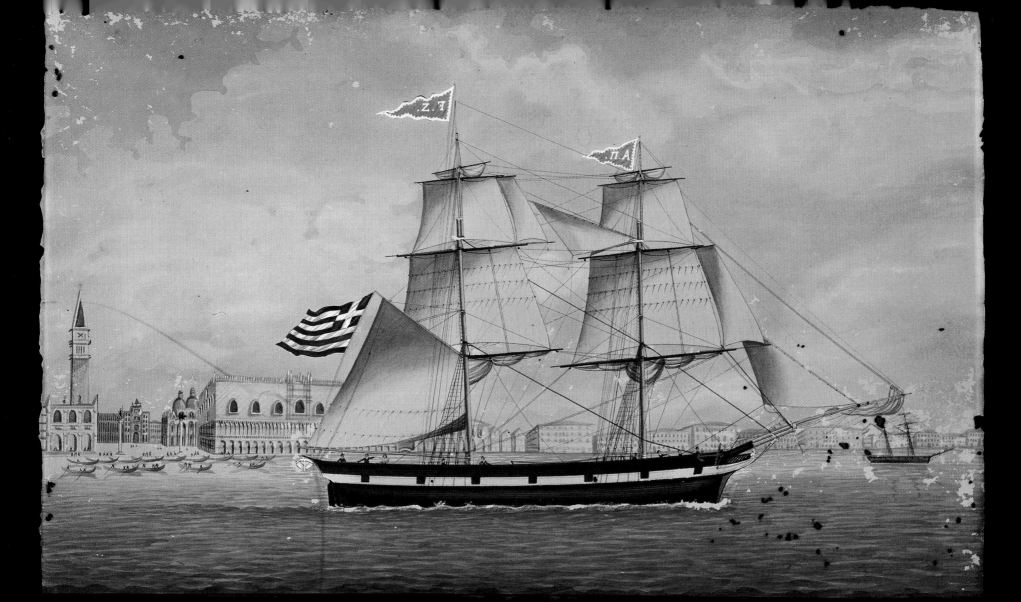

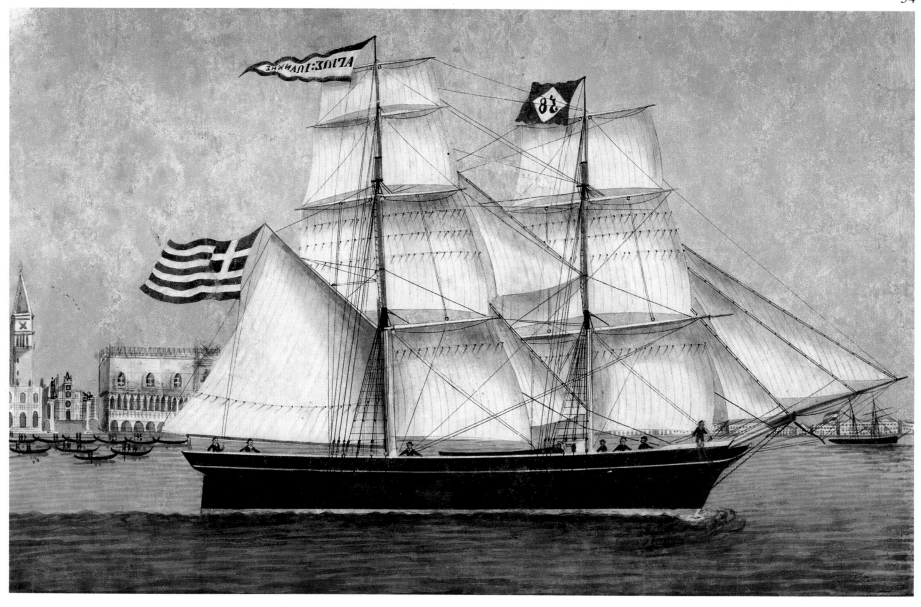

54 (561) Luzzo family, AGIOS IOANNIS, watercolour, 37×56 cm. Brig

55 (273) Luzzo family, AGIOS NIKOLAOS, watercolour, 44×63 cm. Brig of S Charopoulos. Built in Galaxidi in 1864; 240 tons

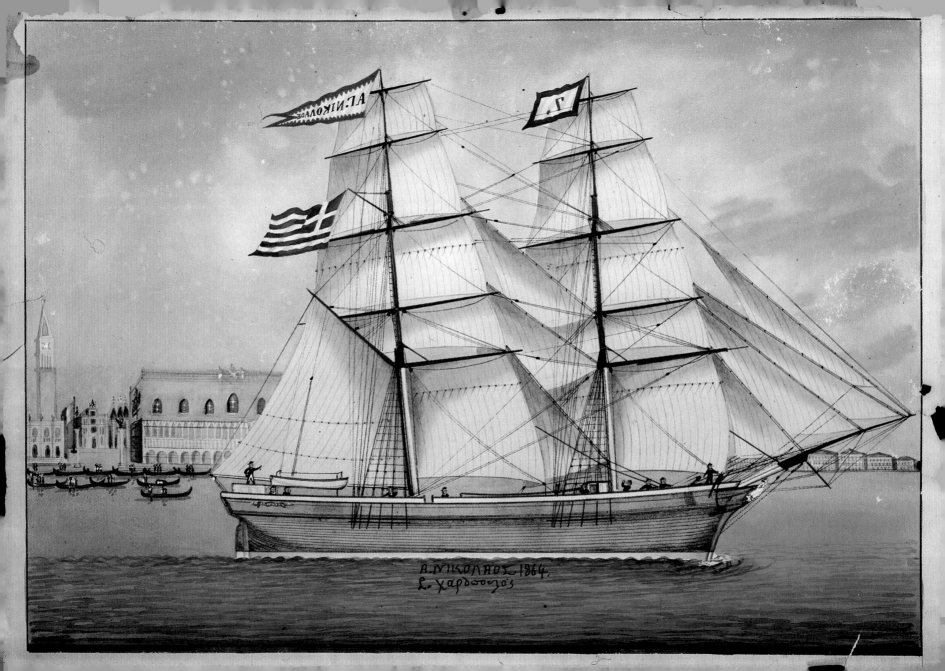

ΑΓ.ΝΙΚΟΛΑΟΣ

Α.ΝΙΚΟΛΑΟΣ 1864.
Σ. Χαρδαλιας

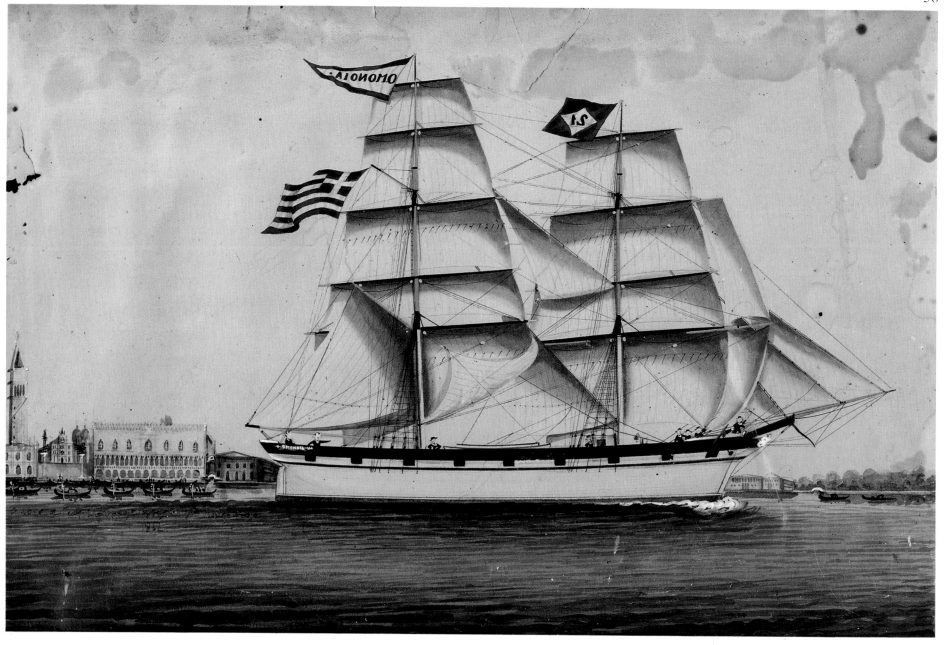

56 (285) Luzzo family, OMONOIA, watercolour, 45×68 cm. Brig of G I Mitropoulos. Built in Galaxidi in 1865; 190 tons

57 (307) Vincenzo Luzzo, EVANGELISTRIA, watercolour, 45×60 cm, Venezia. Brig

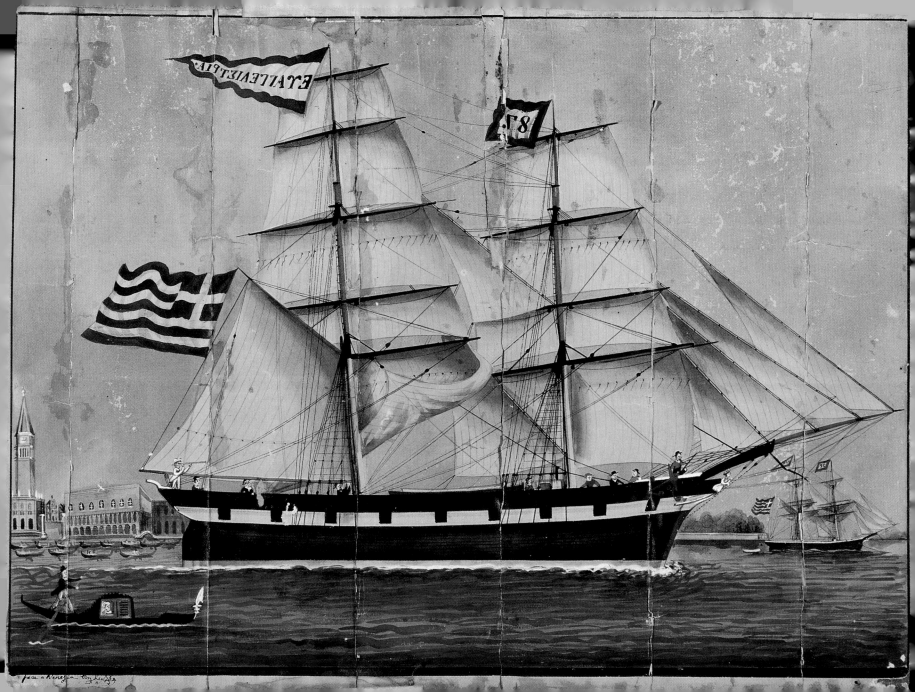

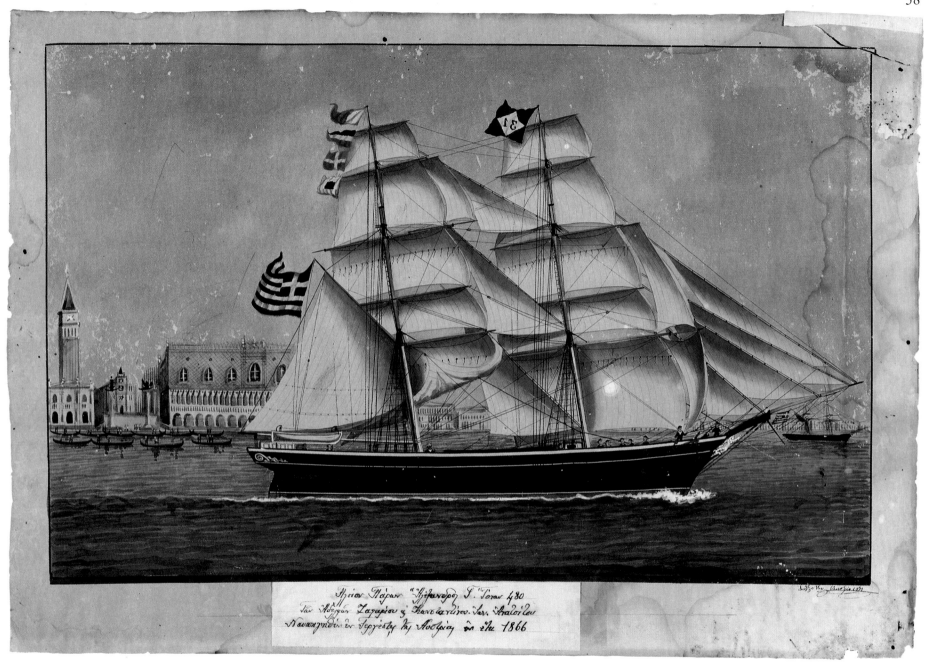

58 (255) Vincenzo Luzzo, ALEXANDROS III, watercolour, 43×62 cm, Venezia 1873. Brig of the brothers Zafirios, Konstantinos, and Ioannis Anatsitos. Built in Trieste of Austria in 1866; 480 tons

59 (219) Vincenzo Luzzo, ARISTEIDIS, watercolour, 48×66 cm, Venezia, 1874. Brig of Efstathios Nikas. Built in Galaxidi in 1858; 280 tons

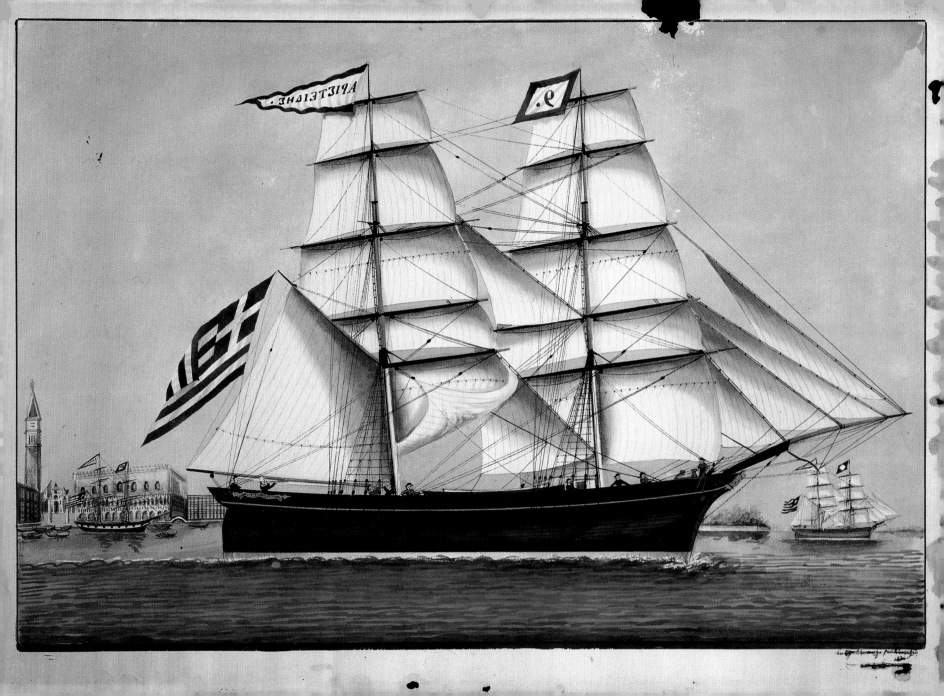

Πάρων Καρτερία Αδελφών Π. Νίκα Ναυπηγηθέν εν έτει 1867 εις Γαλαξείδιον.

60 (204) Vincenzo Luzzo, KARTERIA, watercolour, 44×63 cm, Venezia 1873. Brig of Efstathios, Ilias, and Themistoklis P Nikas. Built in Galaxidi in 1867; 256 tons

61 (234) Vincenzo Luzzo, AGIOS SPYRIDON, watercolour, 53×69 cm, Venezia 1877. Brig

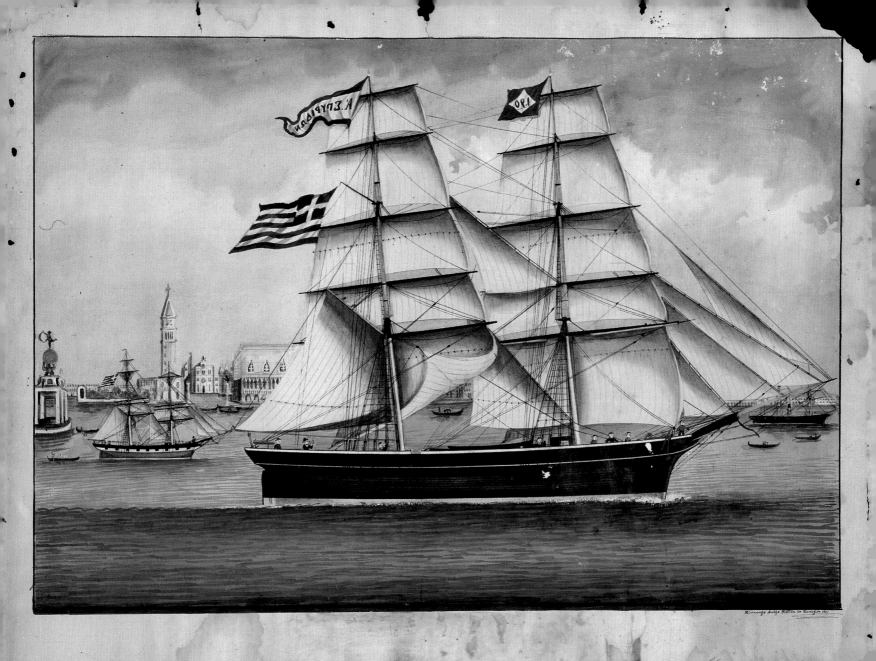

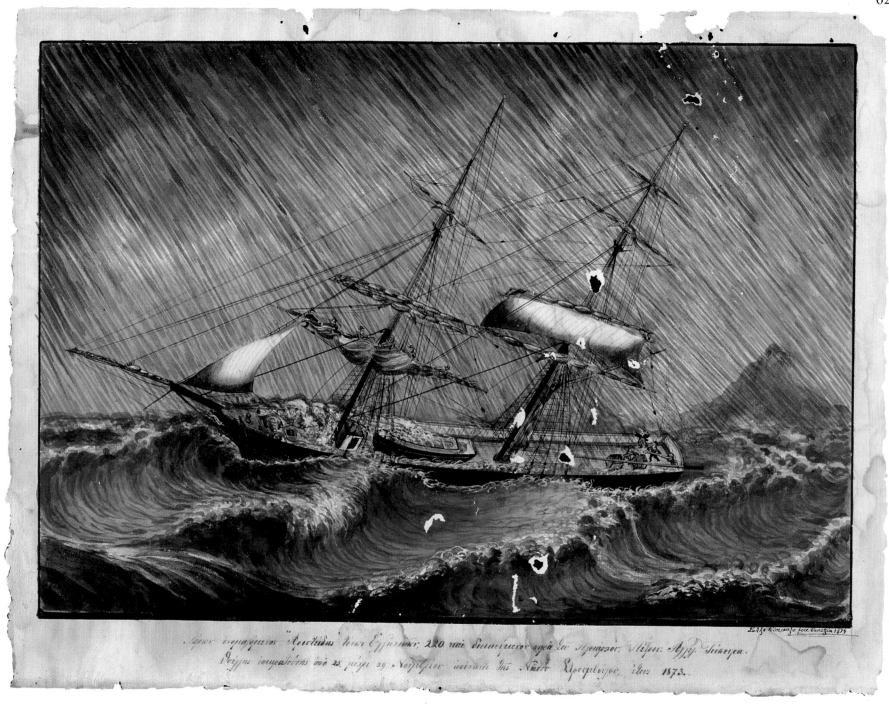

62 (229) *Vincenzo Luzzo*, ARISTEIDIS, *watercolour*, 51×67 cm, *Venezia*, 1874. Brig of Petros A Tsipouras. Built in Galaxidi in 1873; 220 tons

63 (236) *Vincenzo Luzzo*, AIOLOS, *watercolour*, 54×76 cm, *Venezia* 1884. Barque of I Kouzos and G Zagoras. Built in Galaxidi in 1875 by Master-builder Konstantinos Papapetros; 1150 tons

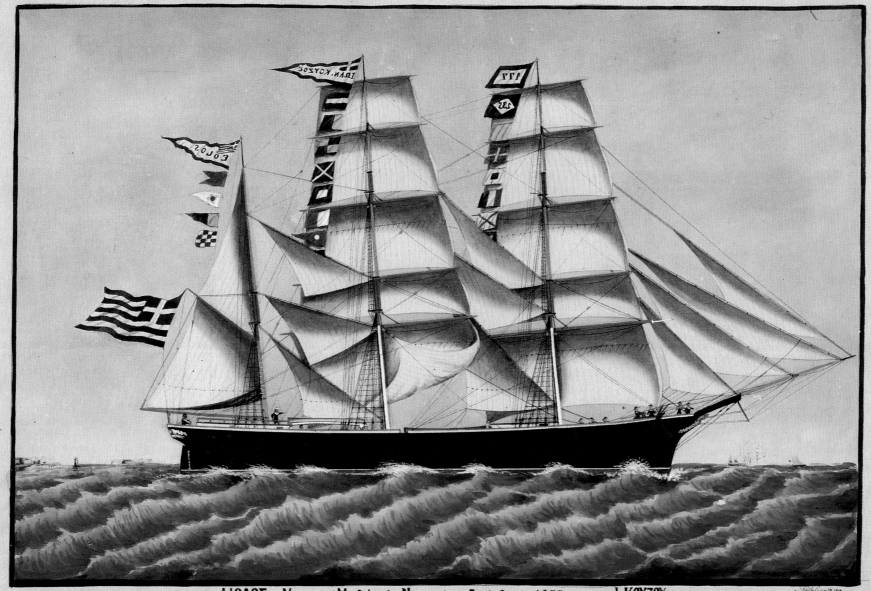

. ΑΙΟΛΟΣ. Μπάρκο «Μυοδρόμων.» Ναυπηγηθέν έν Γαλαξειδίω τό 1875. ίδιωτάτου Ι. ΚΟΥΖΟΥ.
〈Τόνων 1150〉 Πλοίαρχος Γ. Ζαγορᾶς.

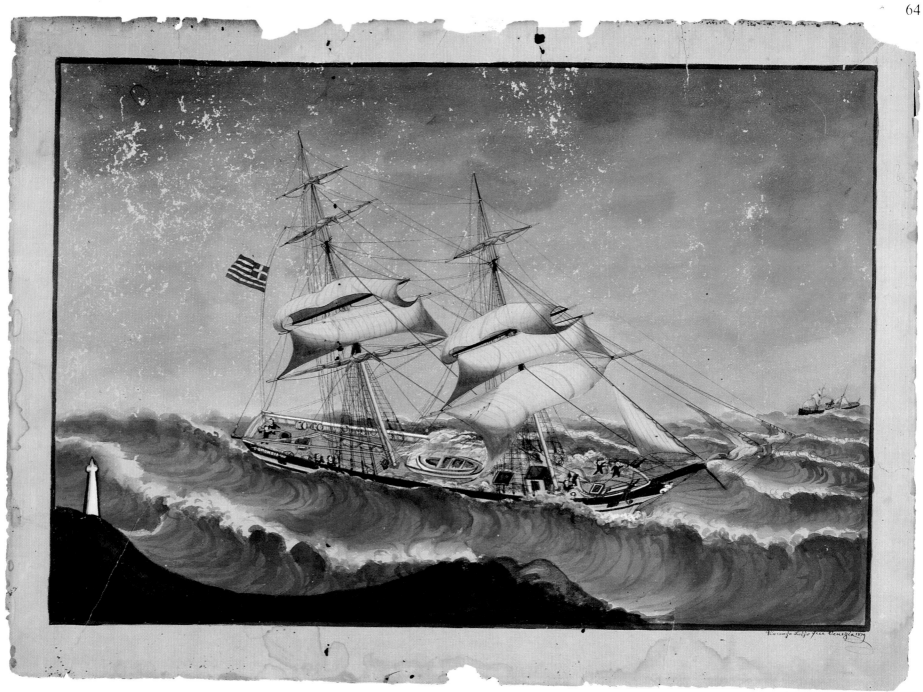

64 (227) Vincenzo Luzzo, OMONOIA, watercolour, 53×74 cm, Venezia 1879. Brig of E G Tsipouras. Built in Galaxidi in 1867; 302 tons

65 (328) Antonio Luzzo, watercolour, 51×64 cm

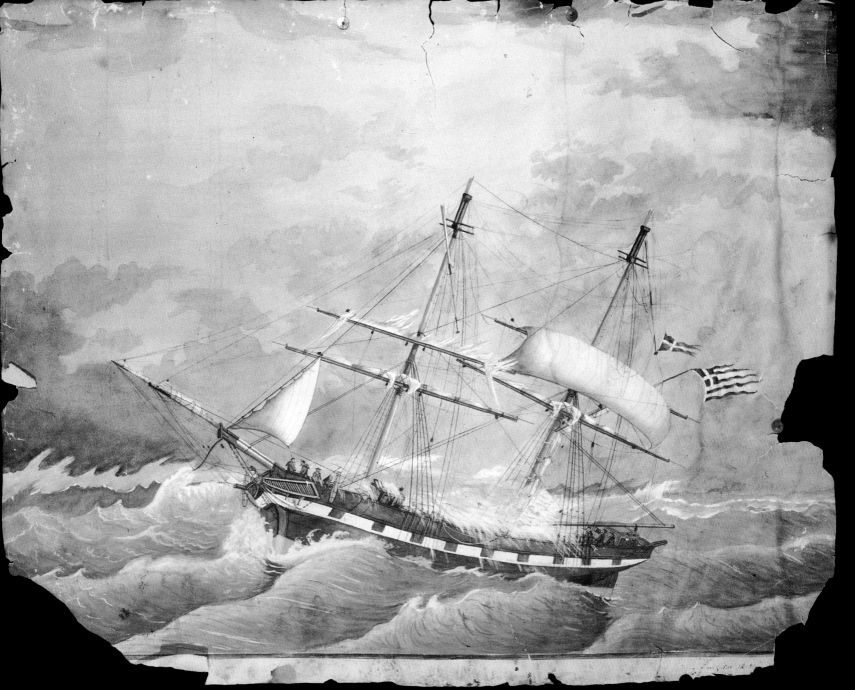

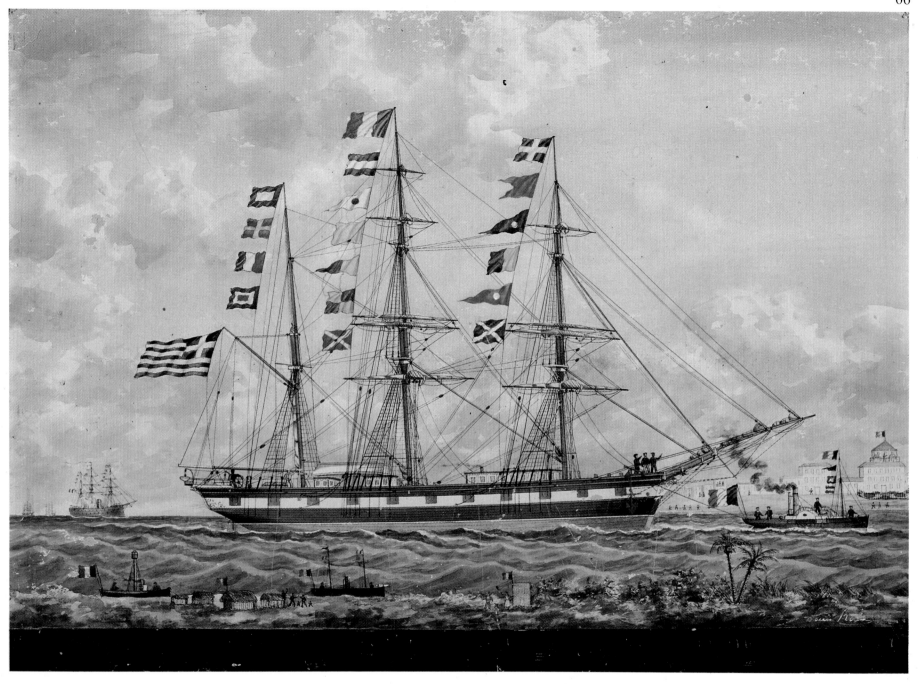

66 (239) Louis Roux, watercolour, 58×78 cm. Barque

67 (119) Louis Roux, ALTANA, watercolour, 60×83 cm, Marseille 1876. Brig of N M Papapetros.
Built in Galaxidi in 1869; 285 tons

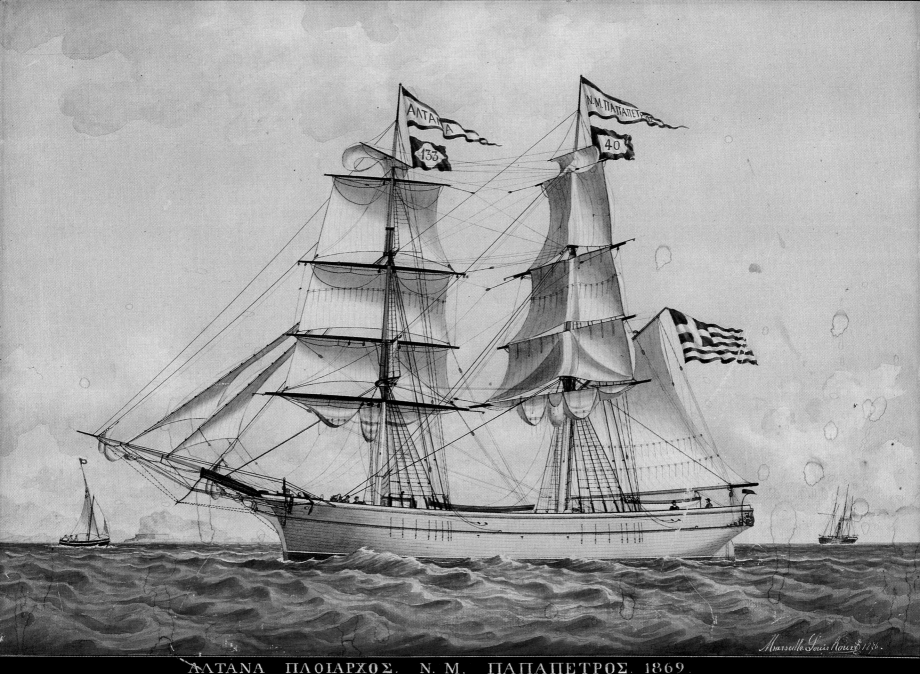

ΑΛΤΑΝΑ ΠΛΟΙΑΡΧΟΣ. Ν. Μ. ΠΑΠΑΠΕΤΡΟΣ. 1869.

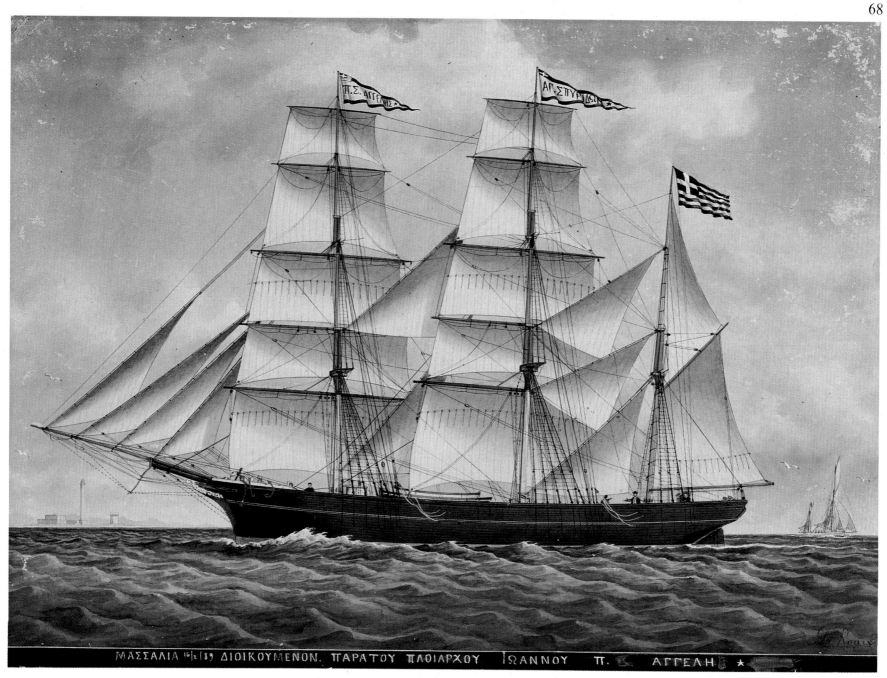

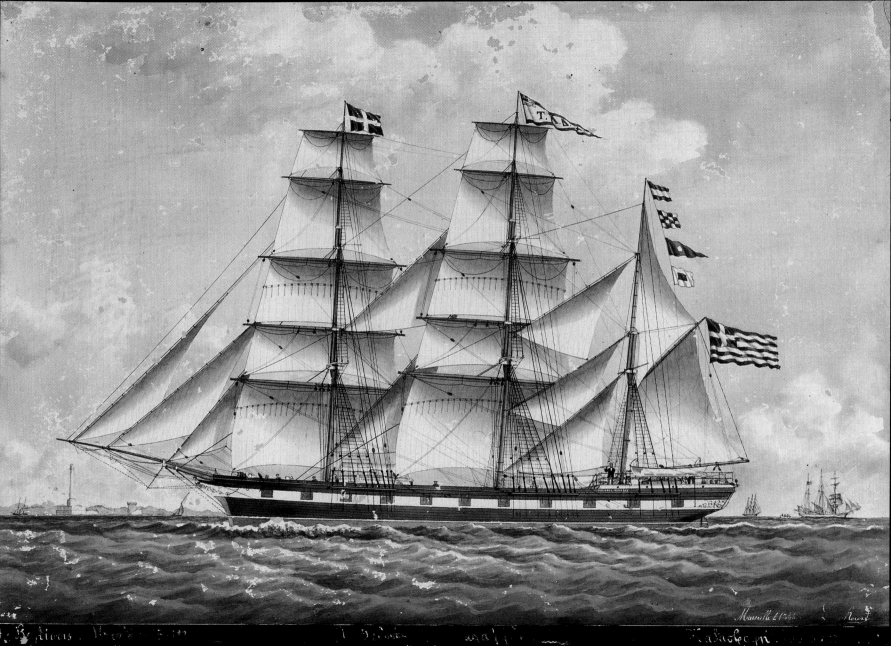

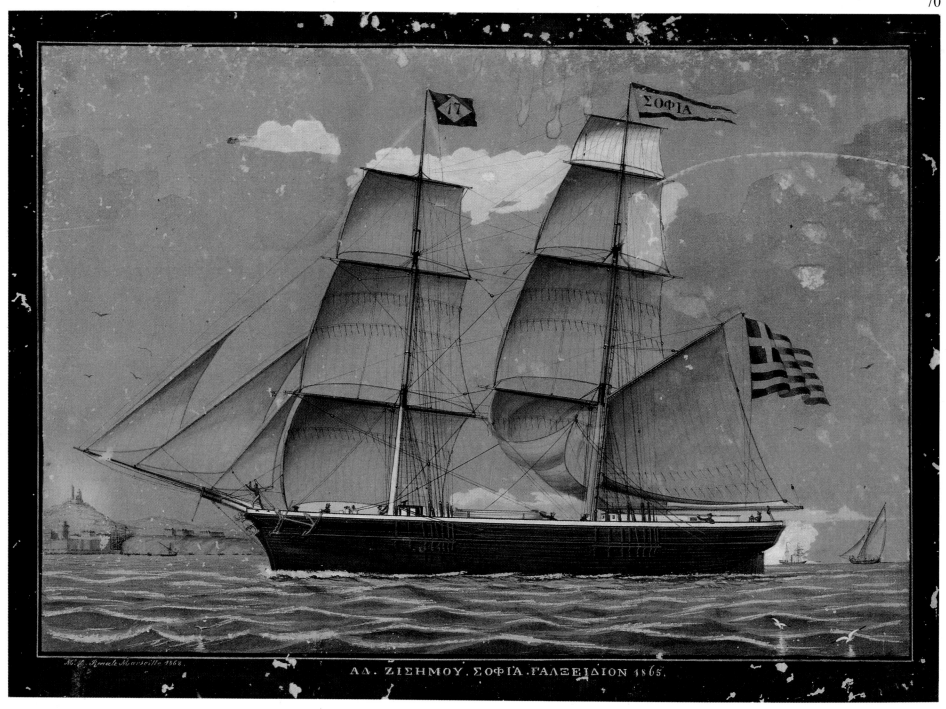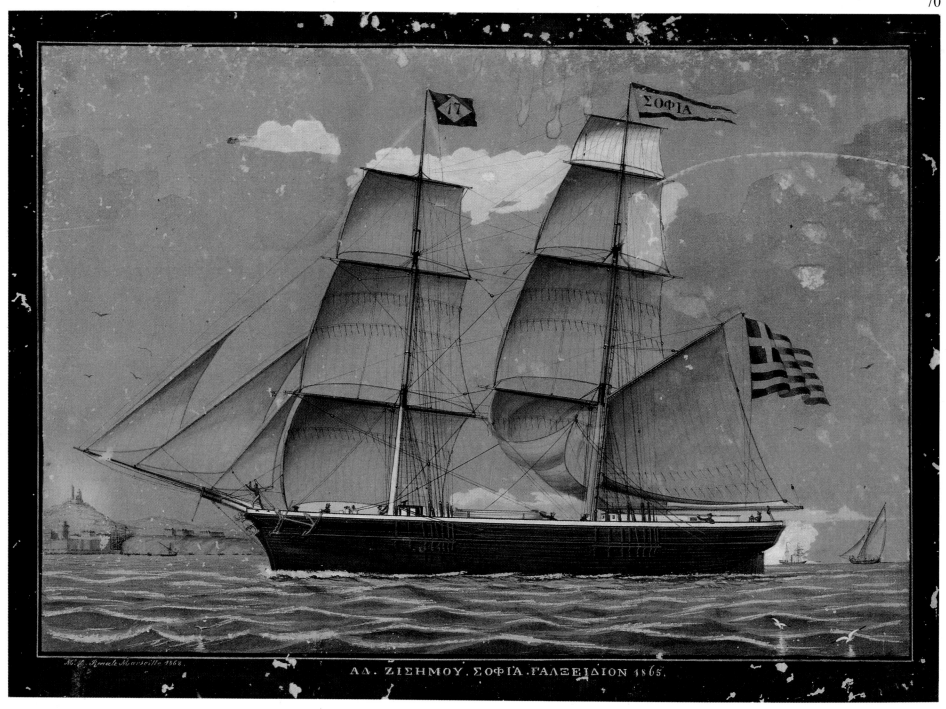

ΑΔ. ΖΙΣΗΜΟΥ. ΣΟΦΙΑ. ΓΑΛΞΕΙΔΙΟΝ 1865.

70 *(260) Michel and Louis Renault,* SOFIA, *tempera, 51×70 cm, Marseille 1868. Brig of the brothers Ilias and Panagiotis K Zisimos. Built in Galaxidi in 1865; 132 tons*

71 *(248)* AGIOS NIKOLAOS, *tempera, 49×73 cm. Brig of K Katharios. Built in Galaxidi in 1880; 285 tons*

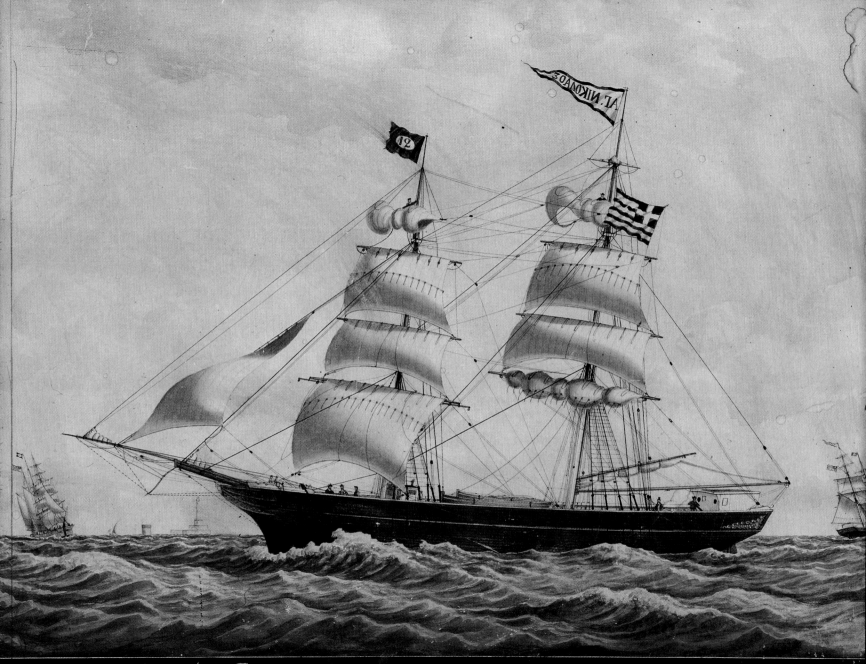

ΚΩΝ/ΝΟΣ ΑΓ ΝΙΚΟΛΑΟΣ ΑΝΑΧΩΡΗΣΕ ΕΚ ΜΑΣΣΑΛΙΑΣ 1880 ΚΑΘΑΡΙΟΣ

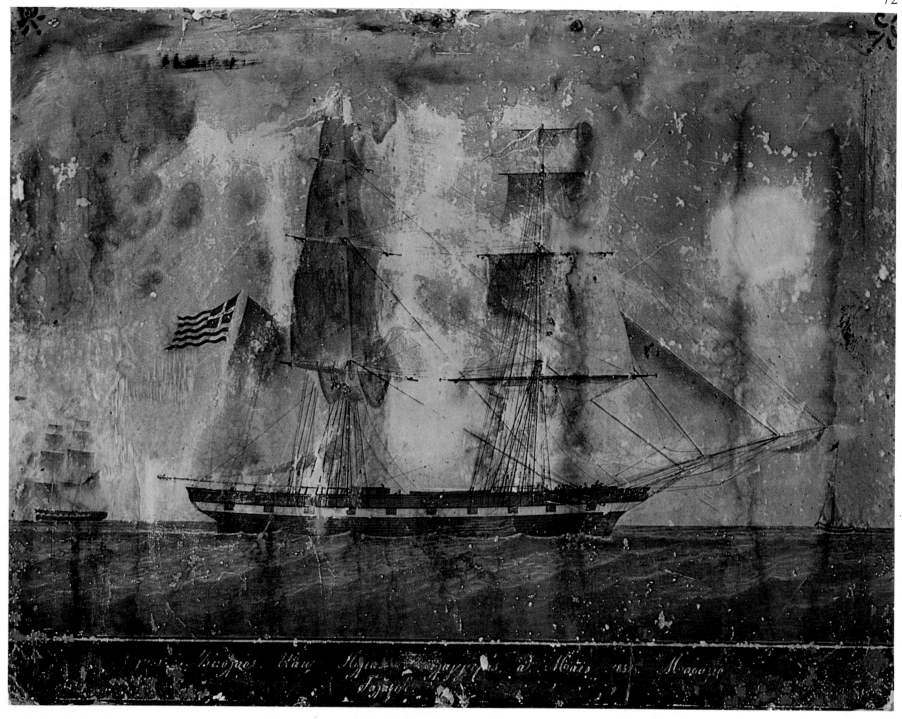

72 (556) Joseph Honoré Pellegrin, AGIOS NIKOLAOS, watercolour, 44×59 cm, Marseille 1852. Brig of Ilias Tsalangyras. Built in Galaxidi; 249 tons

73 (207) Louis and Michel Renault, GALAXEIDI, tempera, 58×77 cm. Brig of Konstantinos, Alexandros, and Panagiotis Vlamis. Built in Galaxidi in 1862; 245 tons

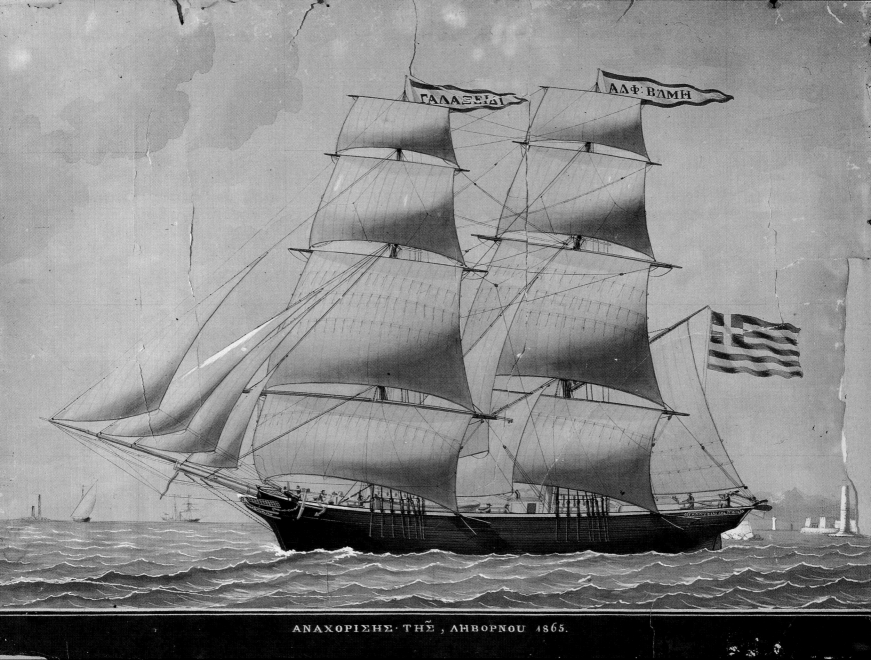

ΑΝΑΧΟΡΙΣΗΣ · ΤΗΣ , ΛΗΒΟΡΝΟΥ 1865.

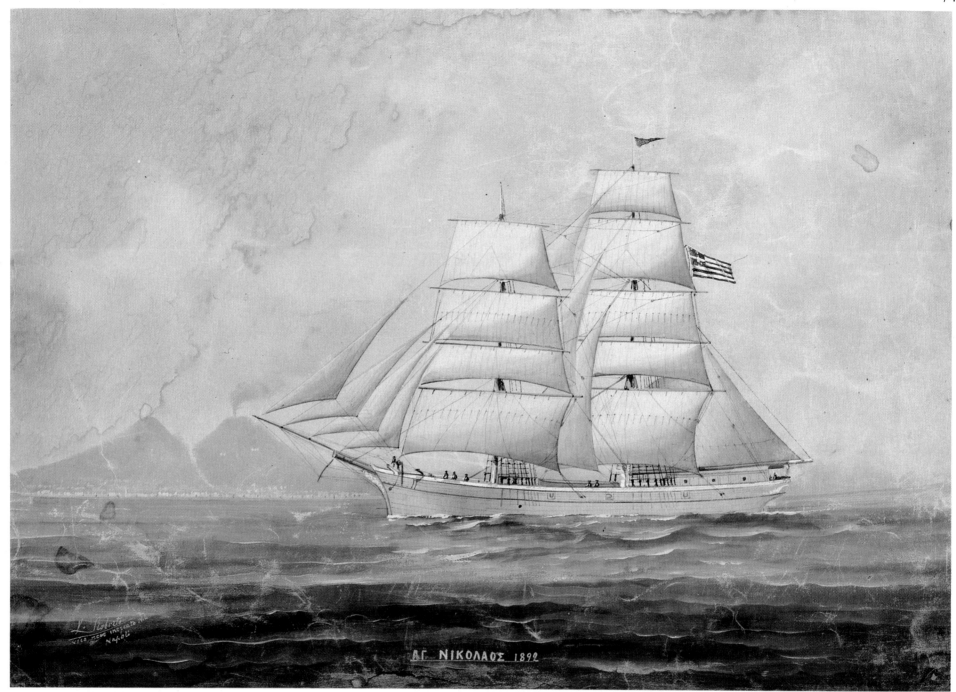

74 *(359)* *Luigi Roberto*, AGIOS NIKOLAOS, *watercolour*, 44×62 *cm*, *Napoli* 1892. *Brig*

75 *(246)* *De Simone*, NIKOLAOS, *tempera*, 52×71 *cm*. *Barquentine*

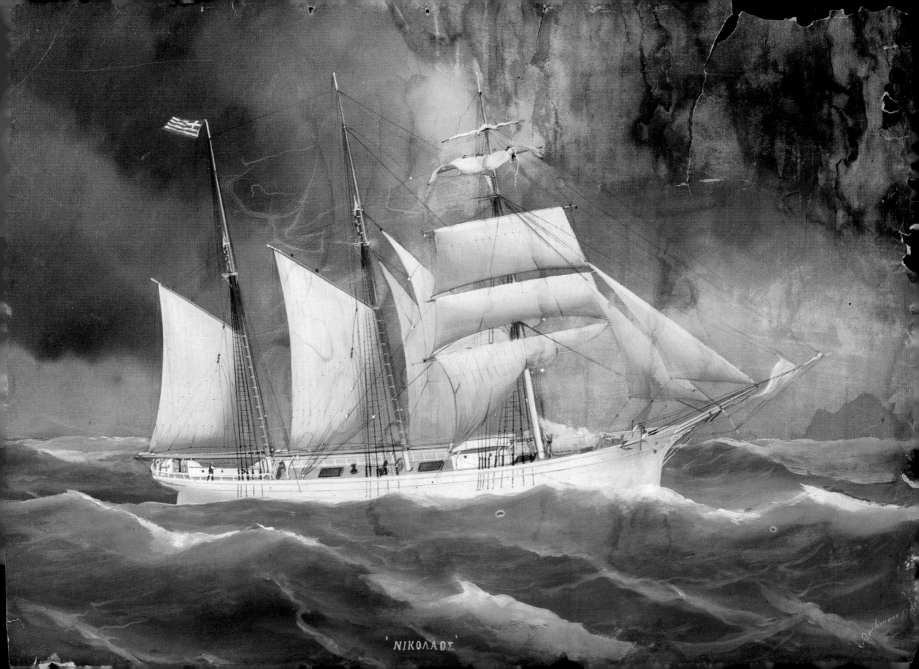

ΝΙΚΟΛΑΟΣ

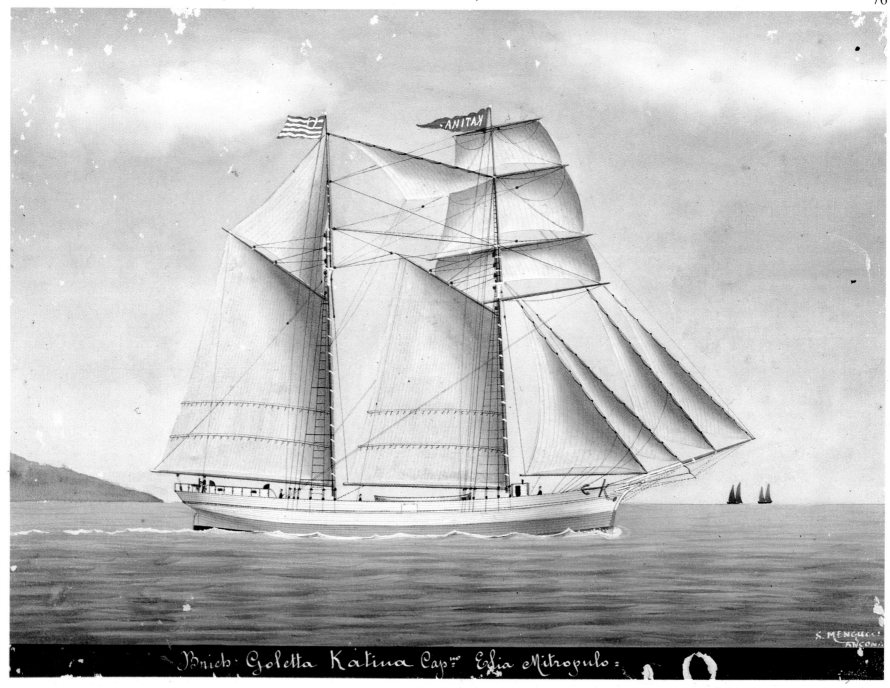

76 (279) S Mengucci, KATINA, watercolour, 47×63 cm, Ancona. Brigantine of I Mitropoulos.
Built in Galaxidi in 1889; 256 tons

77 (244) G D'Esposito, tempera, 49×67 cm, Malta

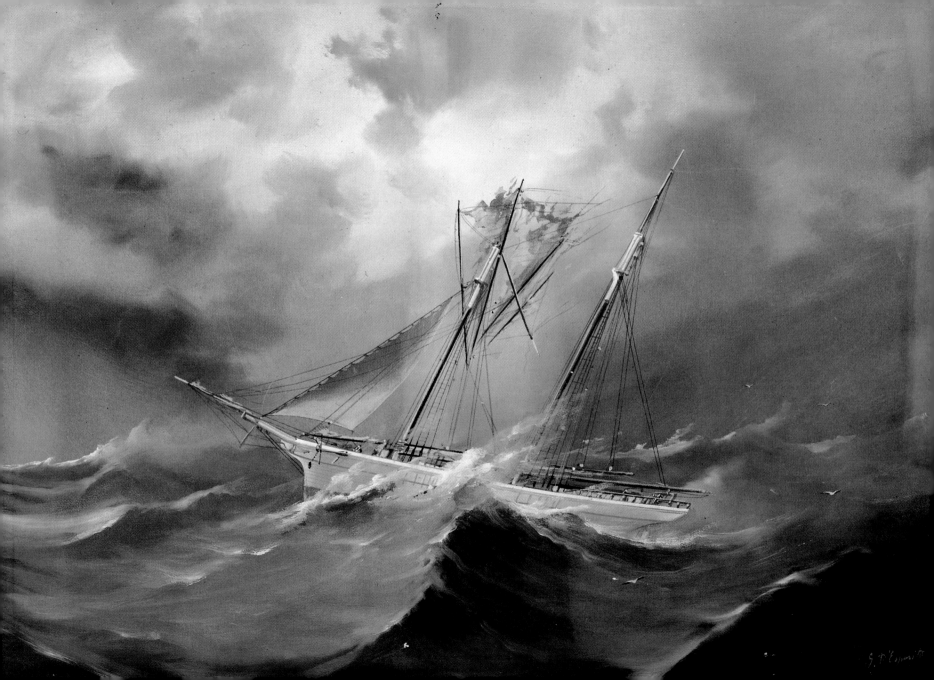

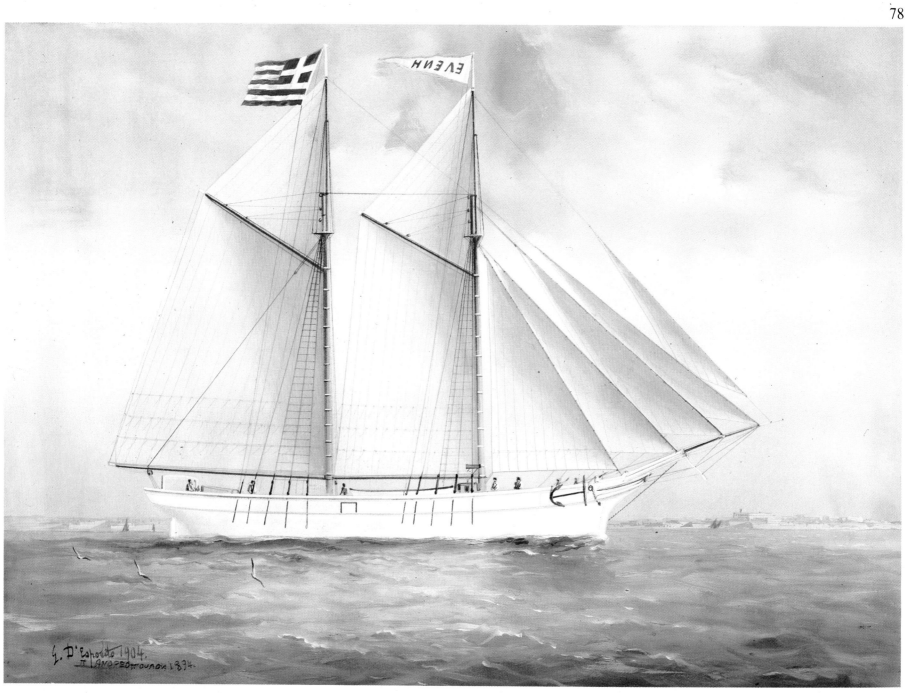

78 *(269)* G D'Esposito, ELENI, *tempera,* 51×67 *cm,* 1904. *Lover of P Andreopoulos. Built in Galaxidi in* 1894; 79.18 *tons*

79 *(280)* G D'Esposito, AGIOS PANTELE·I·MON, *tempera,* 47×65 *cm. Lover of Klaras Loukeris. Built in Galaxidi in* 1903; 98 *tons*

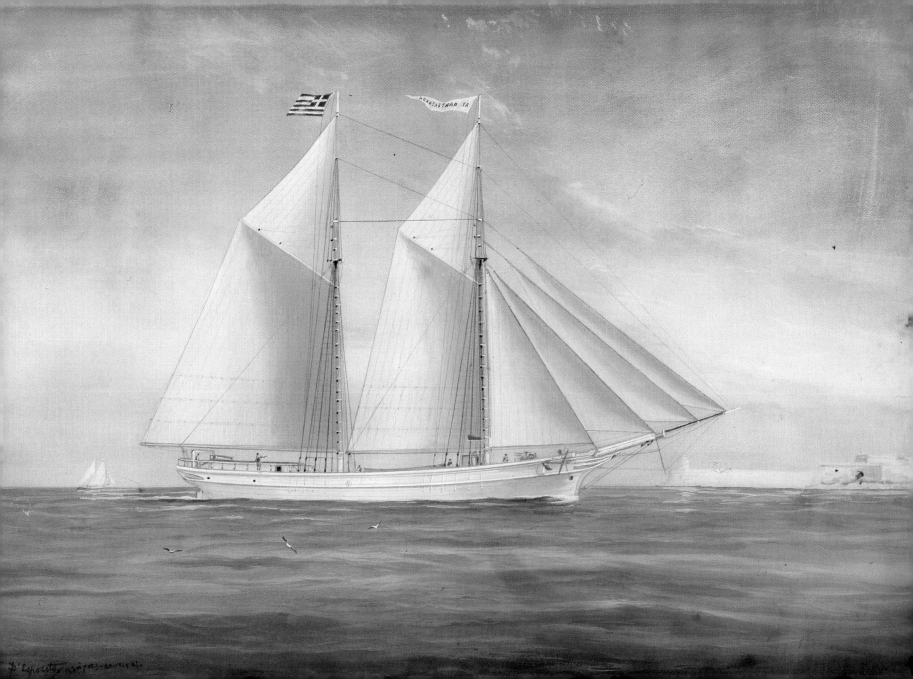

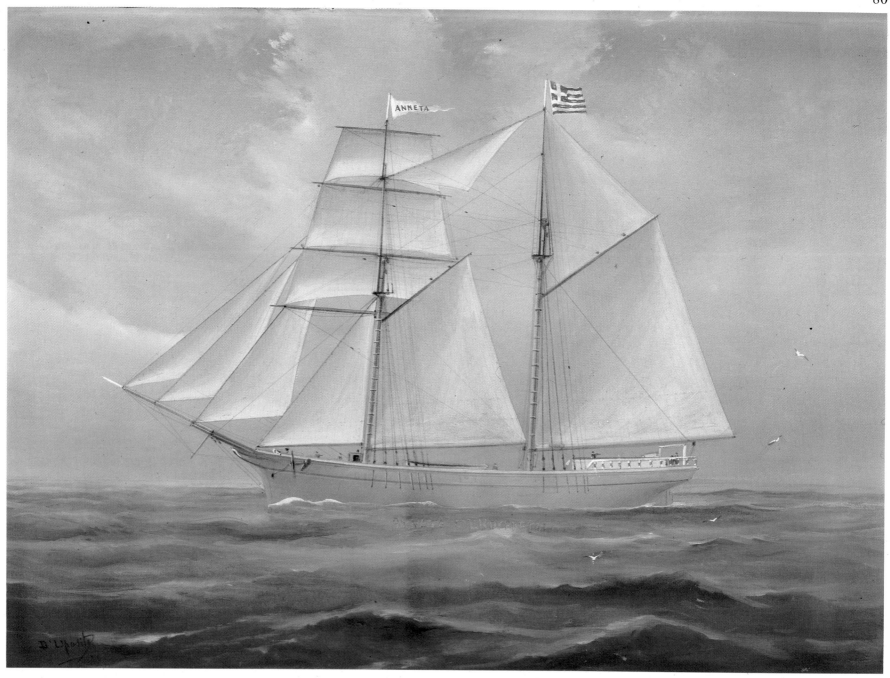

80 *(283) G D'Esposito, ANNETA, tempera, 51×68 cm, Malta. Brigantine of T Skourletos. Built in Galaxidi in 1905; 187 tons*

81 *(284) G D'Esposito, AGIOS ANDREAS, tempera, 49×67 cm. Lover*

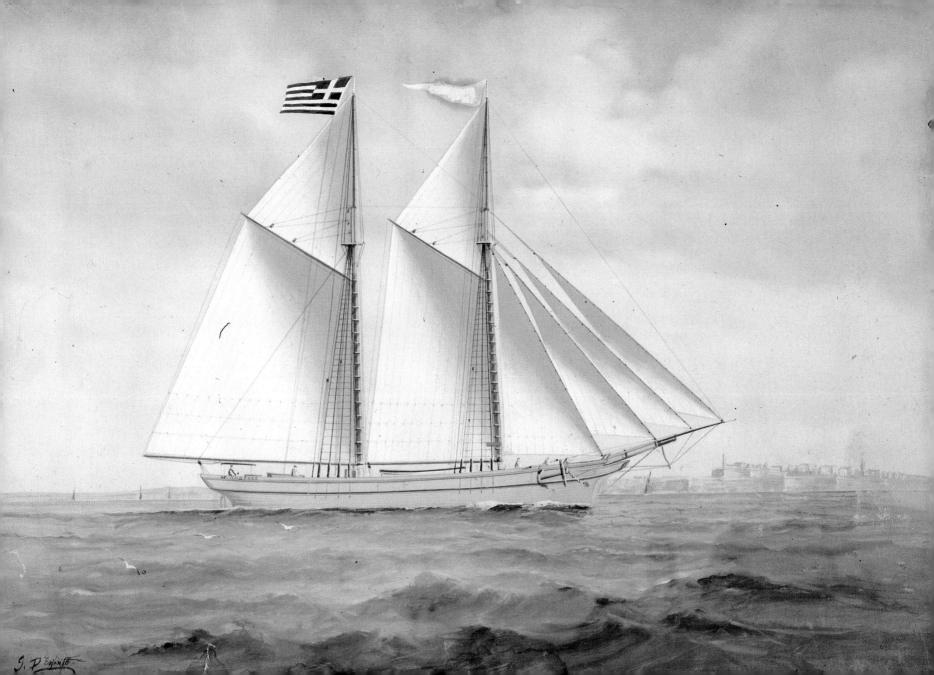

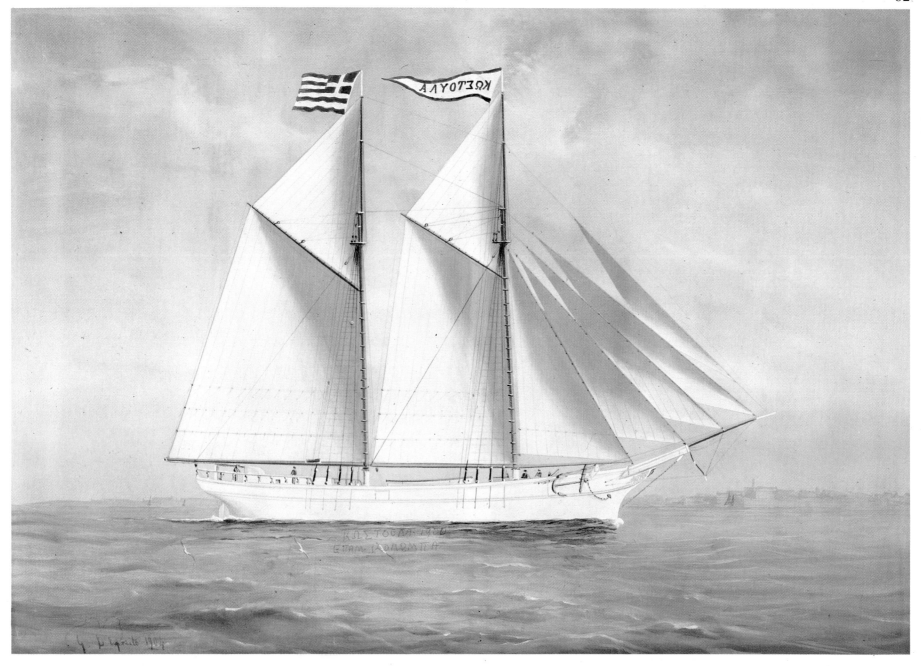

82 *(299) G D'Esposito,* KOSTOULA, *tempera, 49×67 cm, Malta, 1904. Lover of Epameinontas Kolomvas and Georgios Konto-georgopoulos. Built in Galaxidi in 1902; 116.36 tons*

83 *(298) G. D'Esposito,* AGIOS NIKOLAOS, *tempera, 49×67 cm. Lover of Drosos Katikas. Built in Galaxidi; 112 tons*

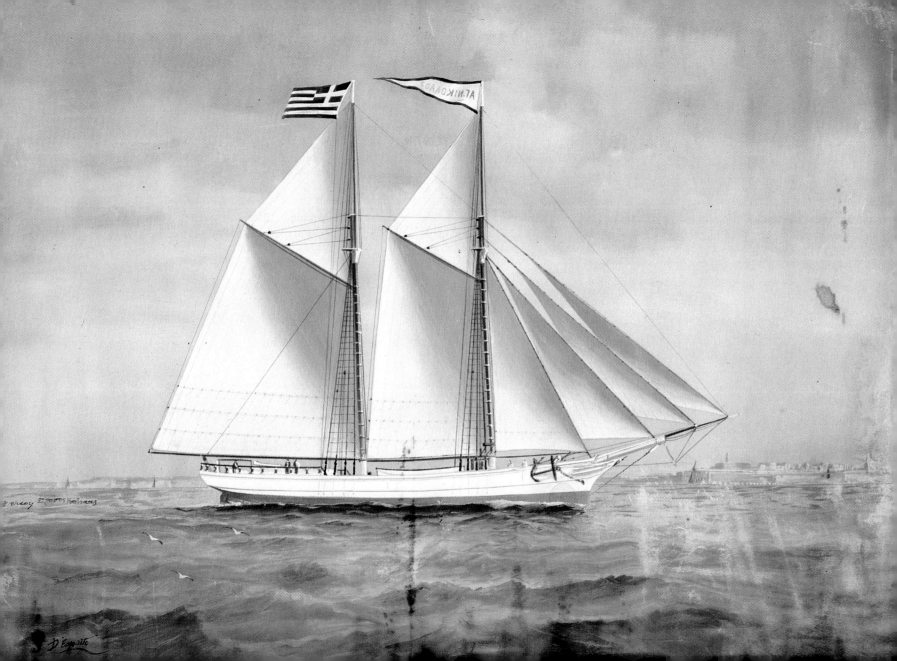

ΑΓ.ΝΙΚΟΛΑΟΣ

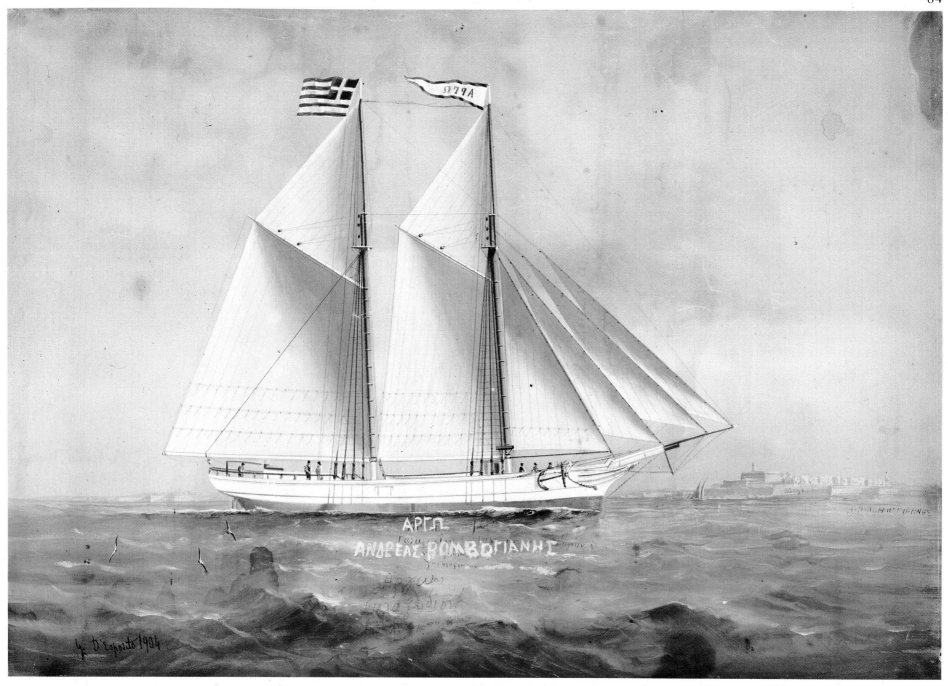

84 (300) G D'Esposito, ARGO, tempera, 48×67 cm, 1904. Lover of Andreas Bobogiannis. Built in Galaxidi in 1903; 95 tons

85 (310) G D'Esposito, AGIOS DIONYSIOS, tempera, 49×68 cm, Malta 1900. Brigantine of Athanasios I Tringalas. Built in Galaxidi in 1900

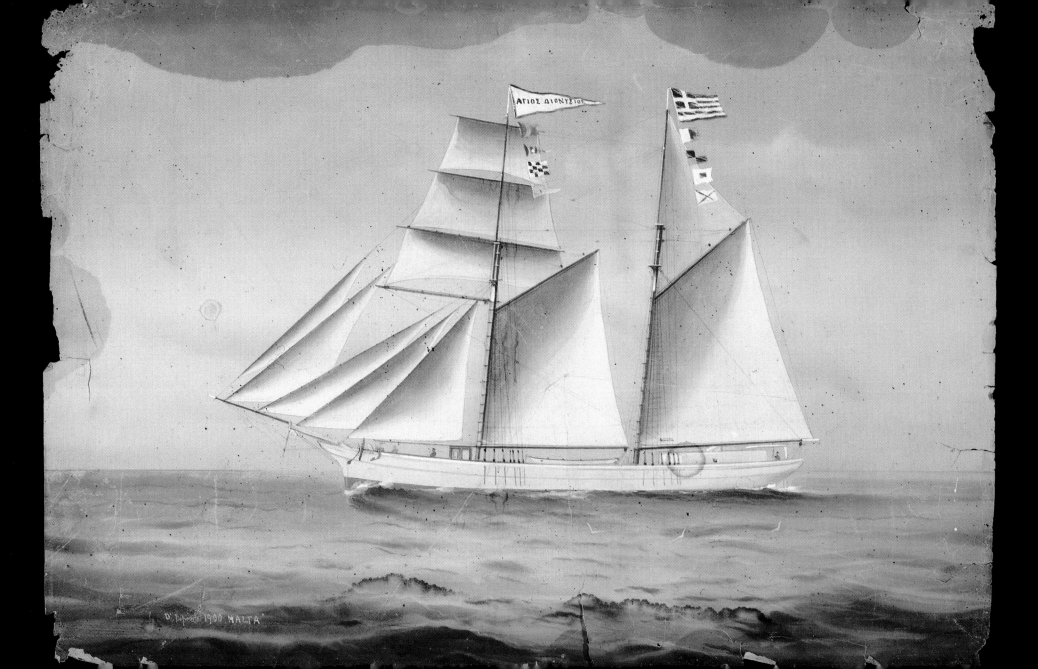

ΑΓΙΟΣ ΔΙΟΝΥΣΙΟΣ

D. Liberali 1900 "MALTA"

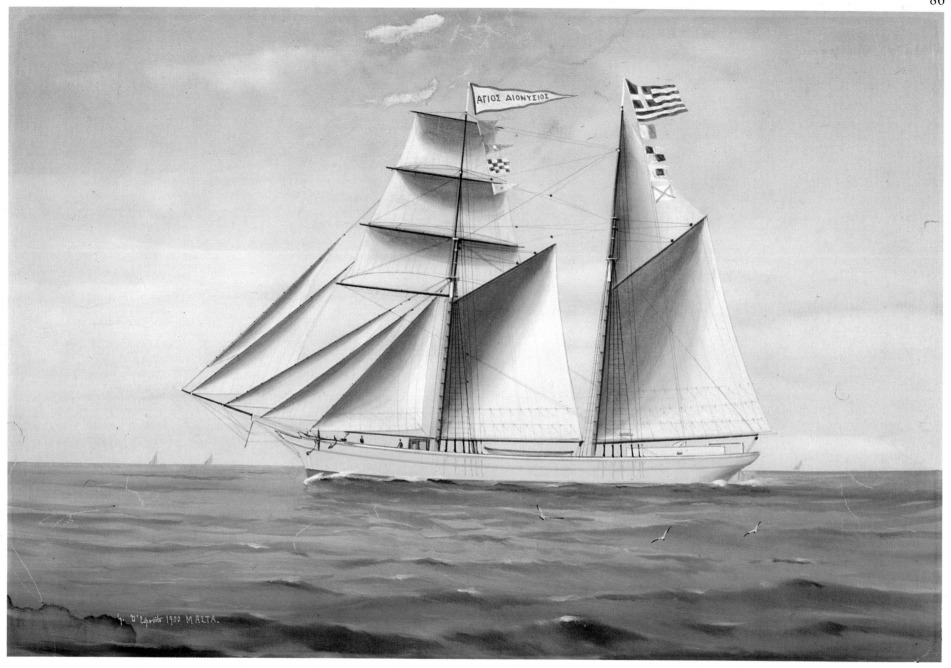

86 (301) G D'Esposito, AGIOS DIONYSIOS, tempera, 49×68 cm, Malta 1900. Brigantine of Athanasios I Tringalas. Built in Galaxidi in 1900

87 (262) B Ivanković, ANDROMACHI, oil, 49×77 cm, Trieste 1892. Brig of A Koutsouleris. Built in Galaxidi in 1866; 238 tons

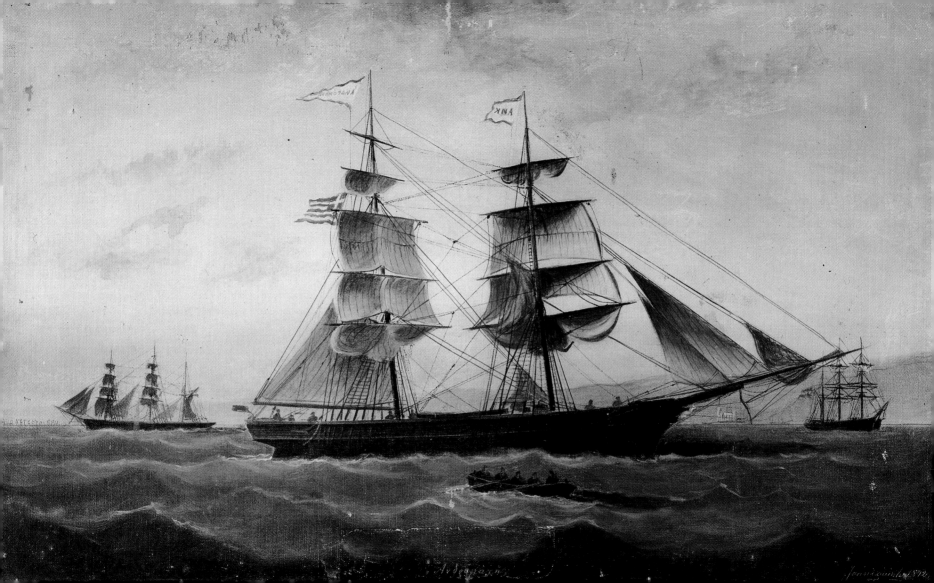

Supplement

The first 8 pictures out of the 15 unsigned ones in Room II (Plates 88-102) have a wide black band at the bottom, where the particulars of the sailing ship are written, as well as important dates in her life. AGLA·I·A (Pl 88) is setting out from Marseilles, and so is ASIMOULA (Pl 92), while AGIOS NIKOLAOS (Plates 90 and 93) is setting out from Malta; on her prow we read in large lettering the word ῾Ελλάς (Hellas). The scenes of the great tempest in the pictures of Plates 91 and 94 are probably by the same hand, as there are similarities in the heeling of the sailing ships, their rigging, and the huge wave breaking on their sides. Unfortunately, the picture of Plate 94 has been severely damaged. The painting of Plate 98 must have been made by an Italian artist; Mount Vesuvius is represented on the prow side with Naples in the background. The paintings of Plates 97 and 100 seem to be characteristic of G D'Esposito, both in the palette and the manner in which the waves and the seagulls are painted. The painting of Plate 95 shows certain similarities with that of Plate 96 in the lines of the waves, especially the wave at the prow. In the painting of Pl 95 the entrance of a harbour can be discerned on the prow side. In the paintings of Plates 99, 101, and 102 there are no indications whatsoever that would allow any identification with the others.

R S-K

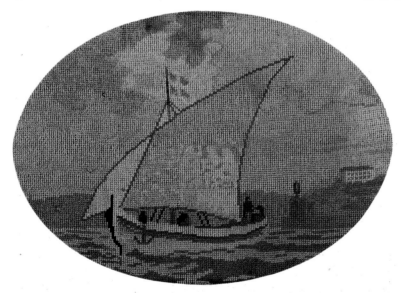

88 (228) *AGLA·I·A, watercolour, 47×65 cm. Brig of the Brothers Drosos Vlamis. Built in Galaxidi; 284 31/94 tons*

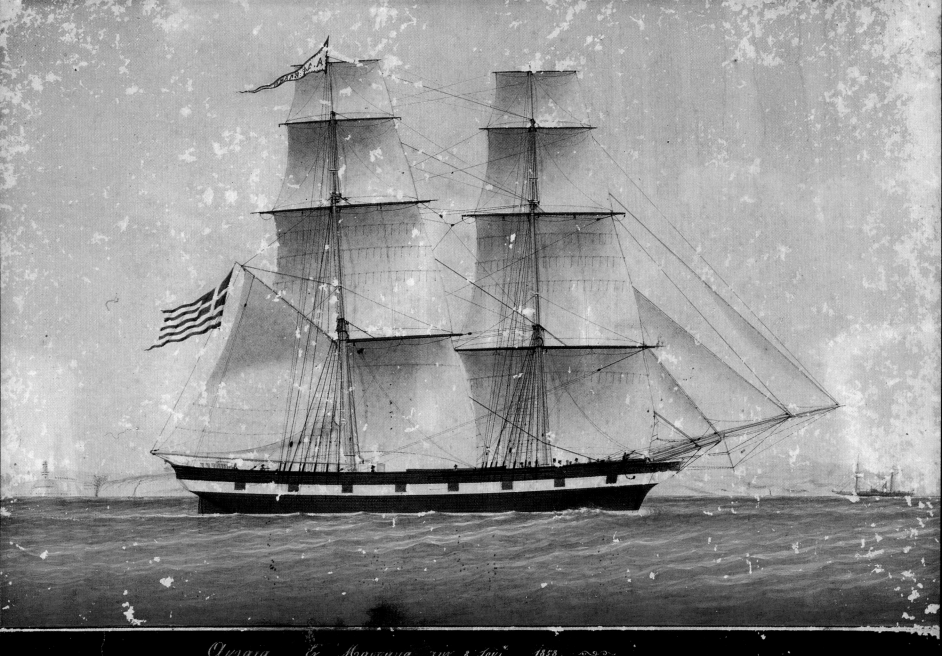

Αγγαία. Εν Μασσαλια την 8 Ιουλ. 1858.

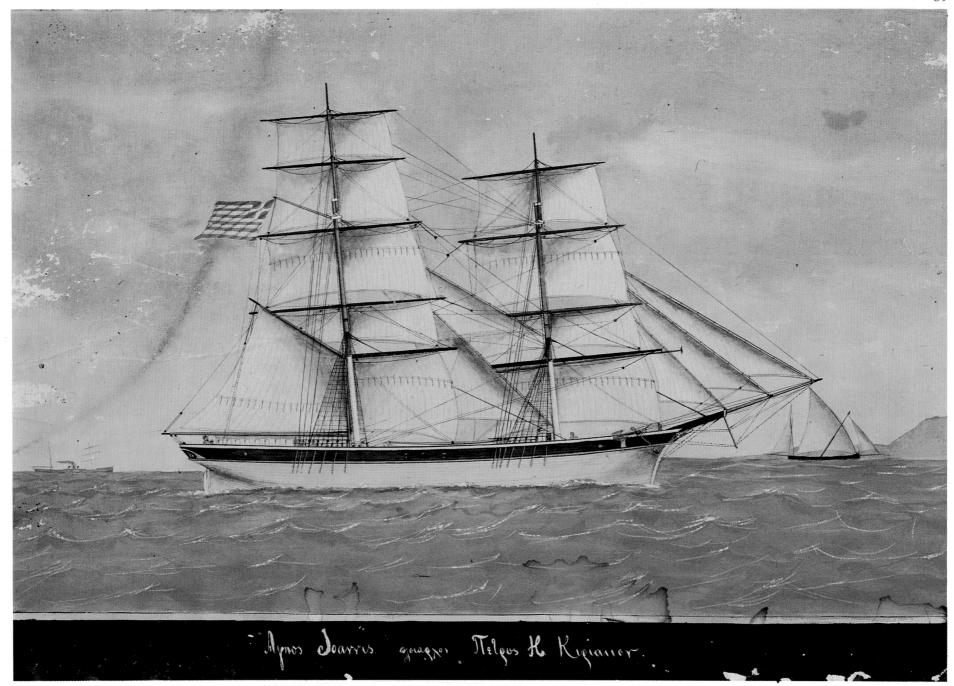

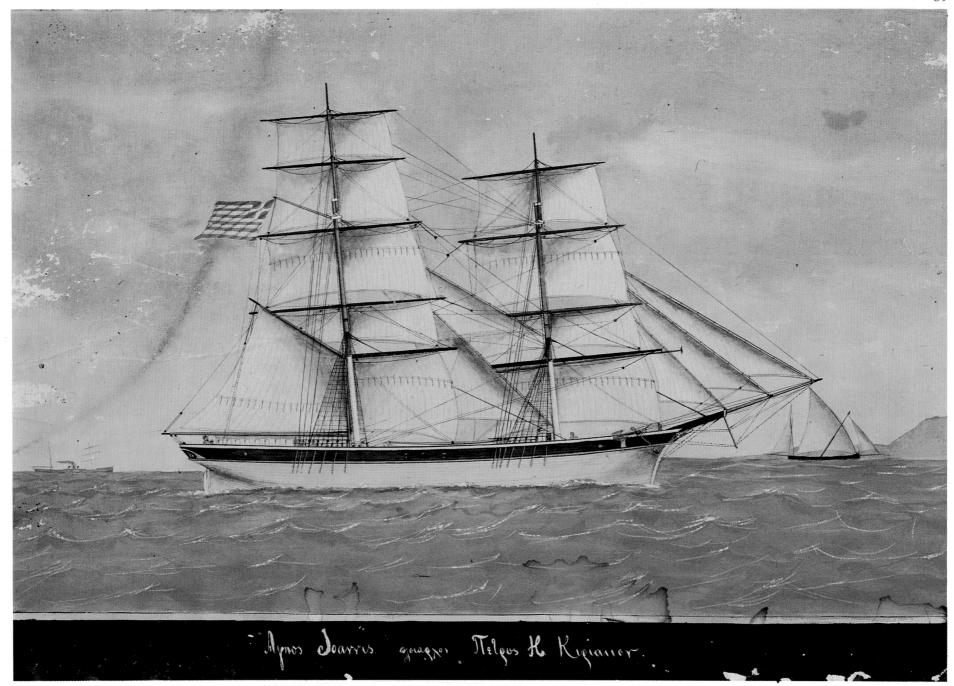

89 (264) AGIOS IOANNIS, watercolour, 49×69 cm. Brig of Petros I Kyriakis. Built in Galaxidi in 1848

90 (205) AGIOS NIKOLAOS, watercolour, 59×78 cm. Brig of the brothers Dimitrios and Ilias Levantis. Built in Galaxidi in 1865; 212 tons

106

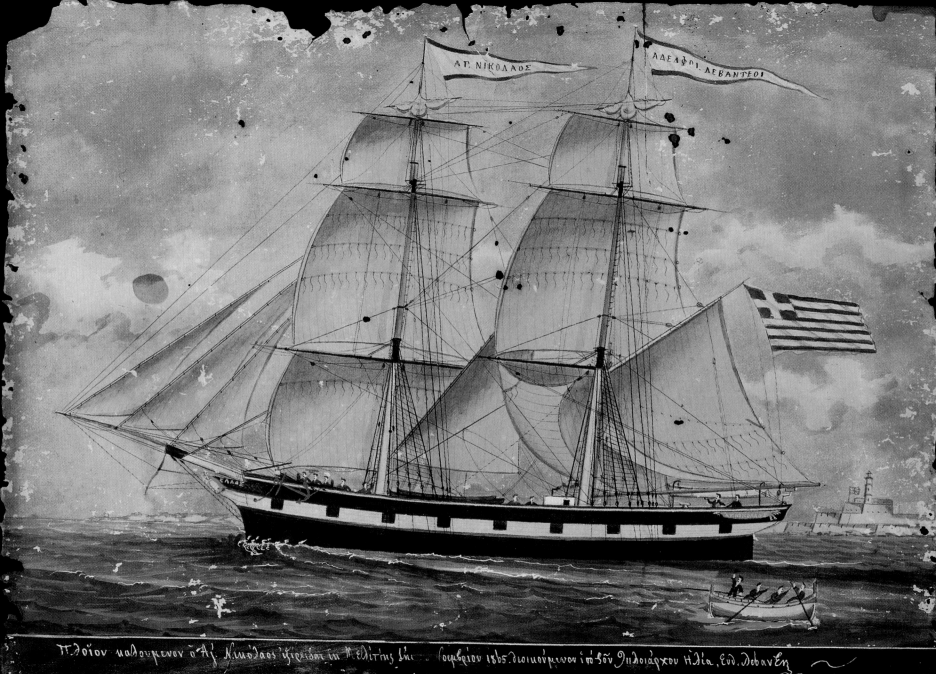

ΑΓ. ΝΙΚΟΛΑΟΣ

ΑΔΕΛΦΟΙ ΛΕΒΑΝΤΕΟΙ

Πλοῖον καλούμενον ὁ Ἅγ. Νικόλαος ἤγειρέν εἰ Μελίτης ἐπι Φεβρoύριος 1865 διοικούμενον ὑπὸ τὸν Πλοιάρχου Ἡλία, Ἐπ. Λεβαντ...

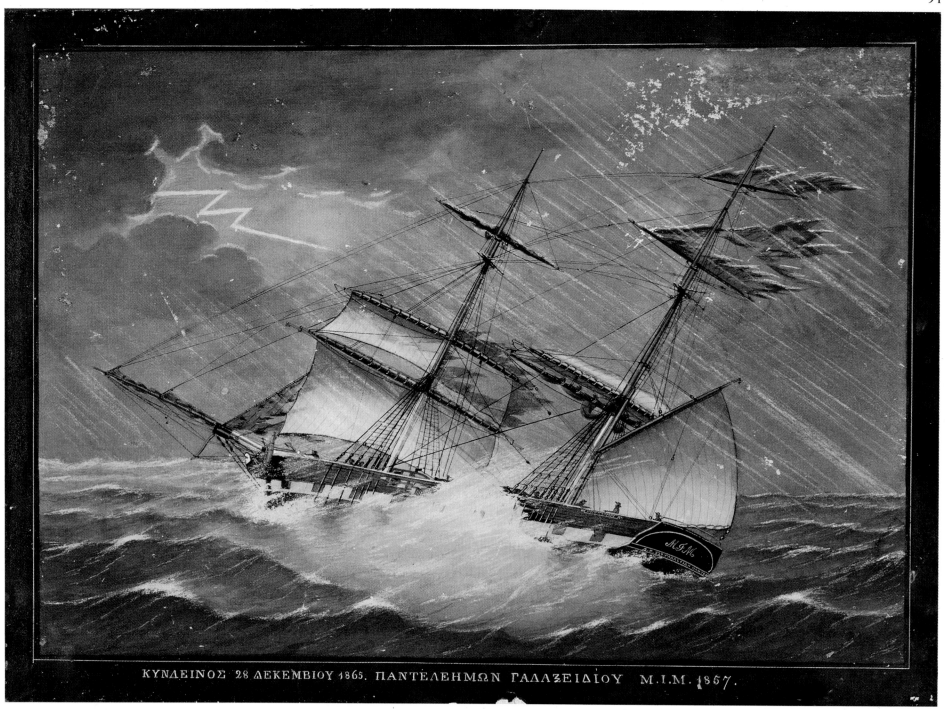

ΚΥΝΔΕΙΝΟΣ 28 ΔΕΚΕΜΒΙΟΥ 1865. ΠΑΝΤΕΛΕΗΜΩΝ ΓΑΛΑΞΕΙΔΙΟΥ M.I.M. 1857.

91 (233) PANTELE·I·MON, watercolour, 52×71 cm. Sailing ship of M I M. Built in Galaxidi in 1857 (?)

92 (208) ASIMOULA, watercolour, 60×87 cm. Barquentine of D E Katsoulis. Built in Galaxidi in 1880; 307 tons

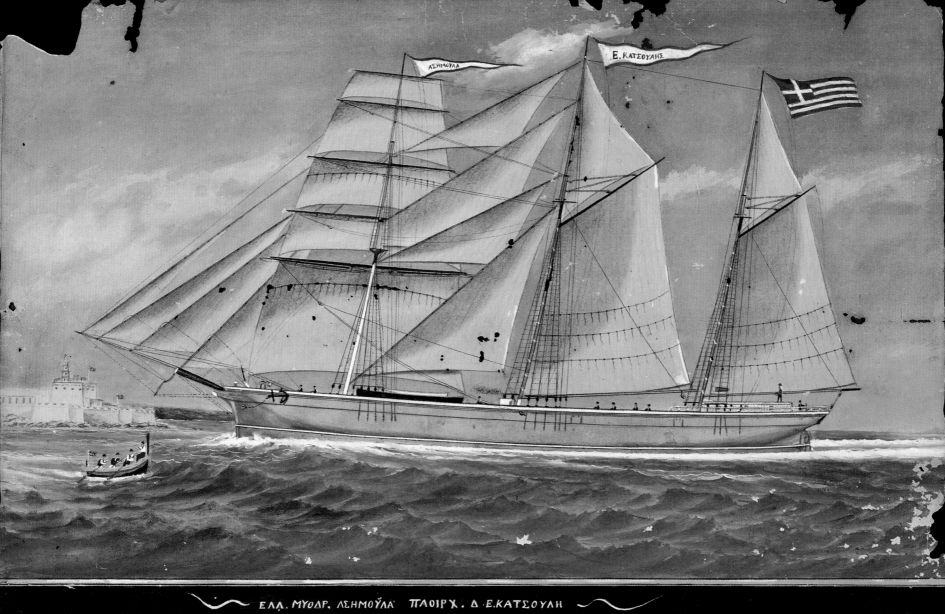

ΑΣΗΜΟΥΛΑ Ε. ΚΑΤΣΟΥΛΗΣ

ΕΛΛ. ΜΥΟΔΡ. ΛΣΗΜΟΥΛΑ΄ ΠΛΟΙΡΧ. Δ Ε.ΚΑΤΣΟΥΛΗ

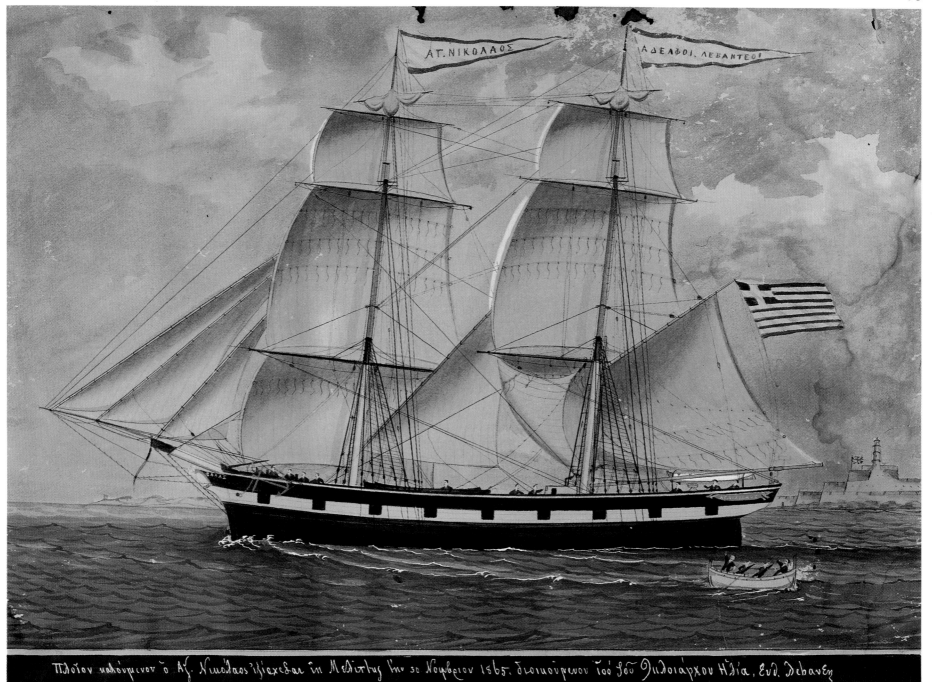

93 (206) AGIOS NIKOLAOS, watercolour, 58×77 cm. Brig of the brothers Dimitrios and Ilias Levantis. Built in Galaxidi in 1865; 212 tons

94 (405) Watercolour, 40×62 cm. Sailing ship of Loukas Visvikis

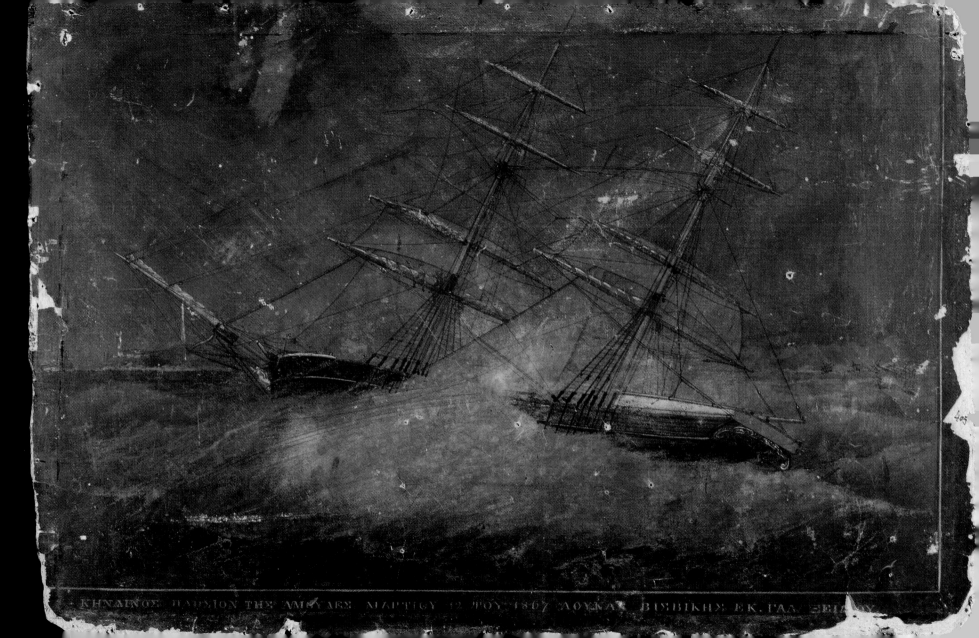

ΚΗΝΔΙΝΟΣ ΠΑΡΜΙΟΝ ΤΗΣ ΑΜΦΥΔΕΣ ΜΑΡΤΙΟΥ 12 ΤΟΥ 1807 ΛΟΥΚΑΣ ΒΙΣΒΙΚΗΣ ΕΚ ΓΑΛΑΞΕΙΔΙΟΥ

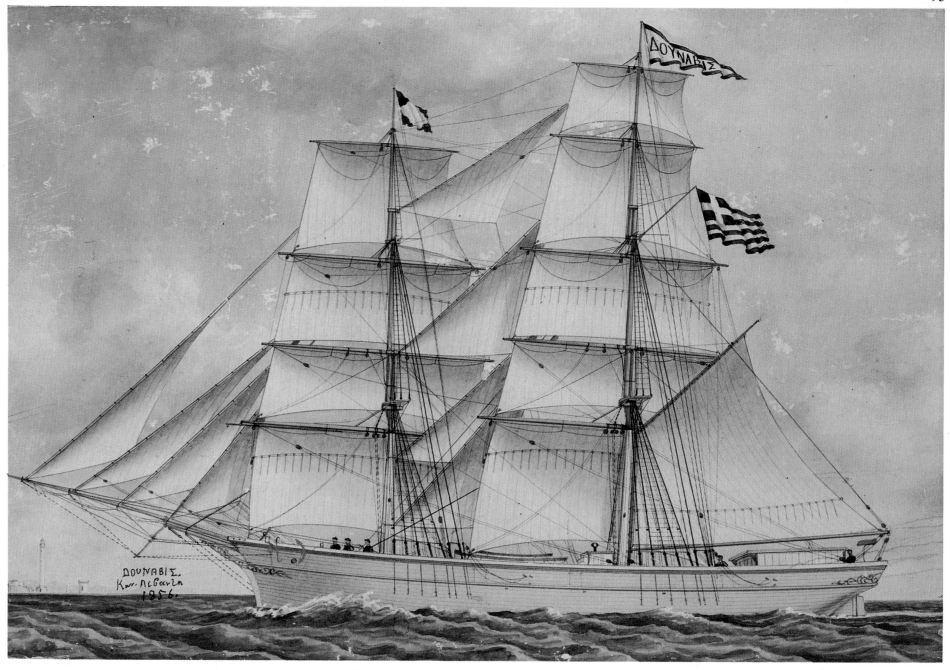

95 (276) DOUNAVIS, watercolour, 48×65 cm. Brig of K Levantis. Built in Galaxidi

96 (220) EUFROSYNI, watercolour, 60×71 cm. Barquentine of N Katharios, Ilias Georgiou, and Ioannis Mitropoulos. Built in Galaxidi in 1872; 302 tons

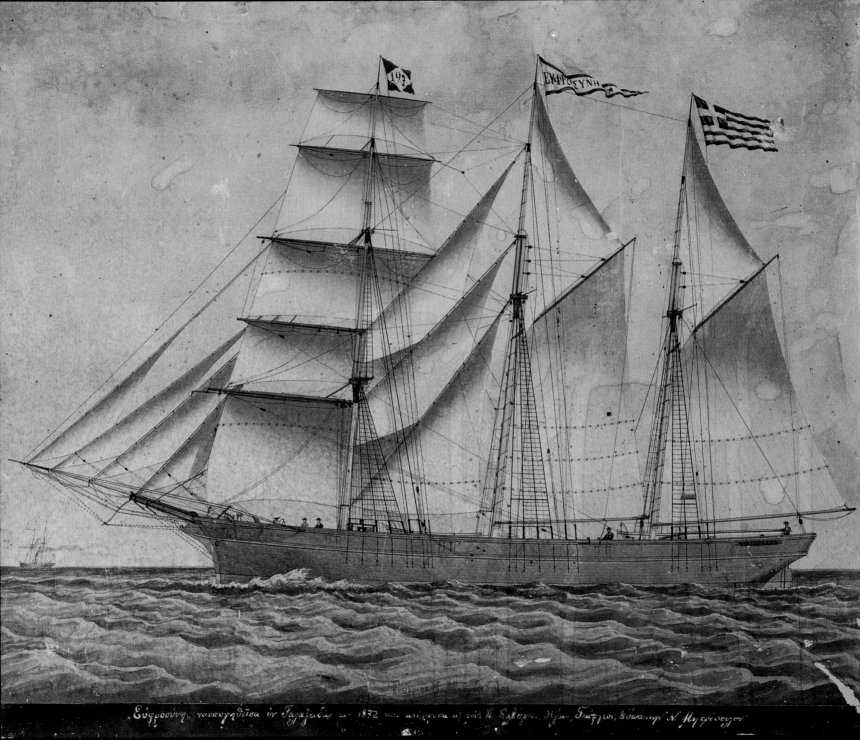

Εὐφροσύνη, ναυπηγηθεῖσα ἐν Γαλαξειδίω ἐν 1872 καὶ ἀνήκουσα εἰς τοὺς Κ. Καλαφάτα, Ἠλίαν, Γεώργιον, & Ἰωάννην Ν. Μυγειάκην

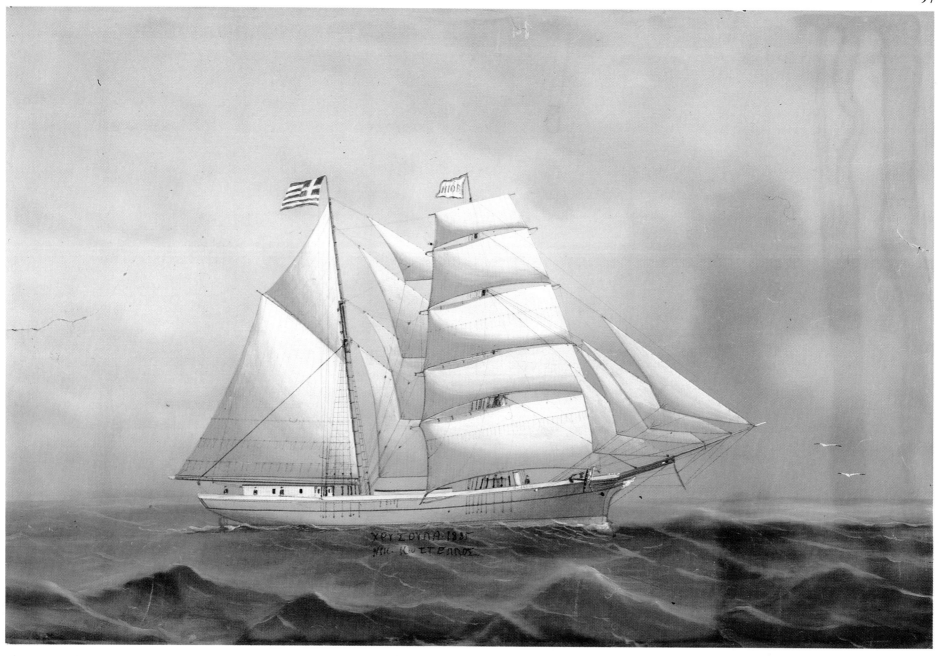

97 (296) *CHRYSOULA, watercolour,* 47×67 *cm. Schooner of Nikolaos Kostellos. Built in Galaxidi in* 1896

98 (200) *EVANGELISTRIA, watercolour,* 50×74 *cm. Brig of Stavros P Petratzas. Built in Galaxidi in* 1862

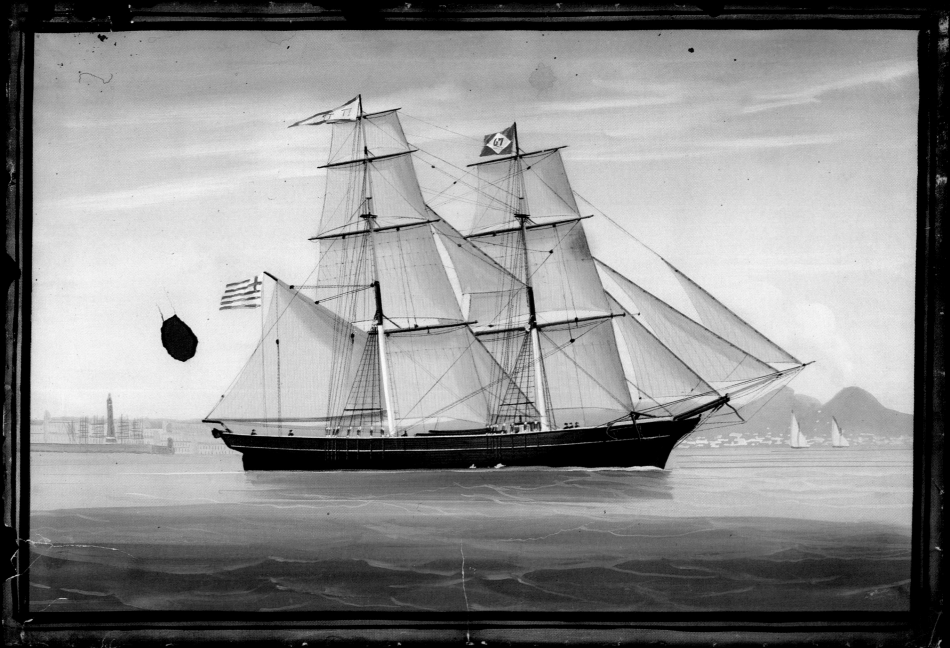

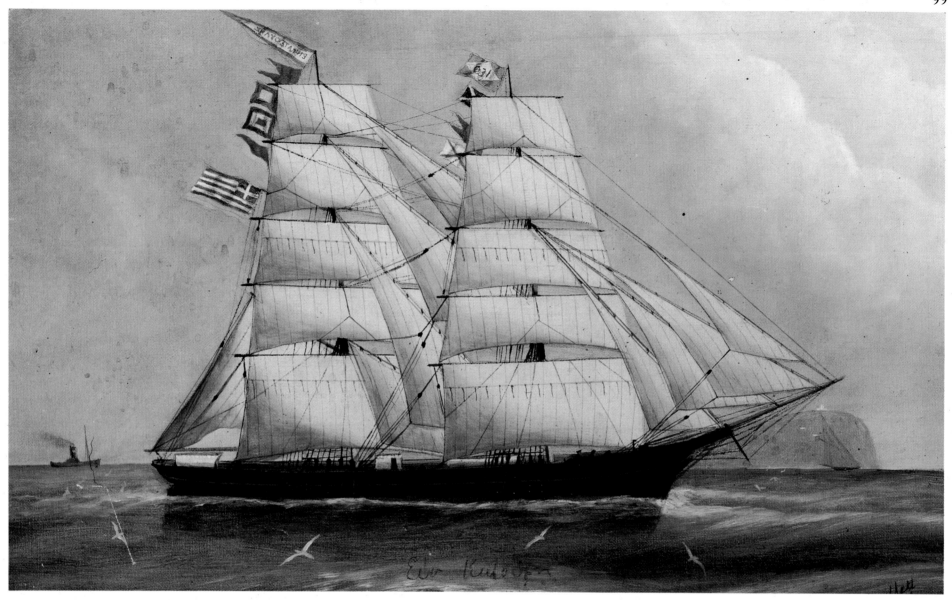

99 (315) Oil, 48×65 cm. Brig of E Katsoulis

100 (303) STEFANOS, tempera, 54×71 cm. Lover of the brothers Nikolaos and Dimitrios Perdikis.
Built in Galaxidi in 1904; 120 tons

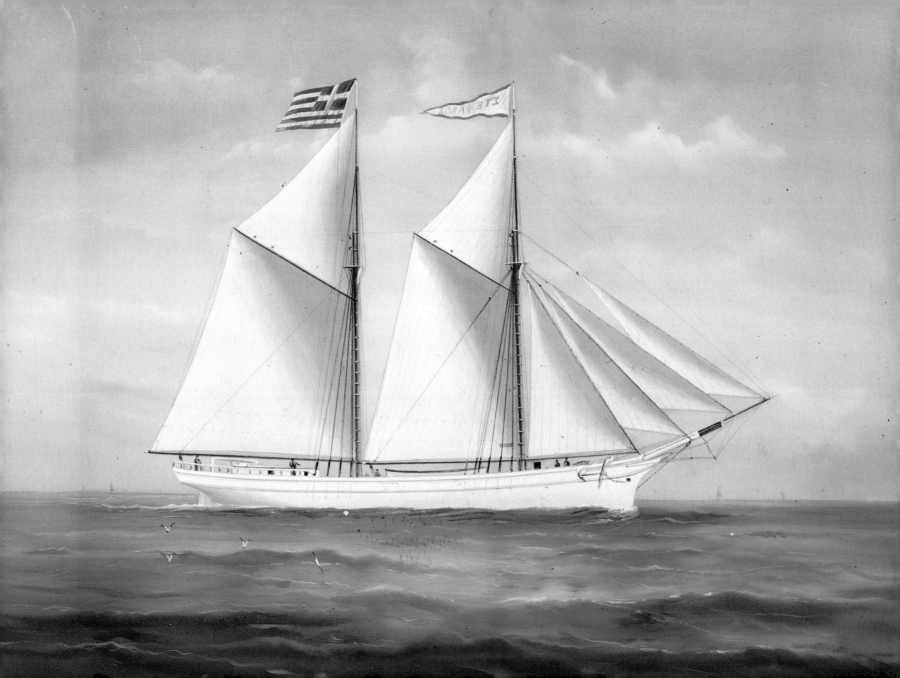

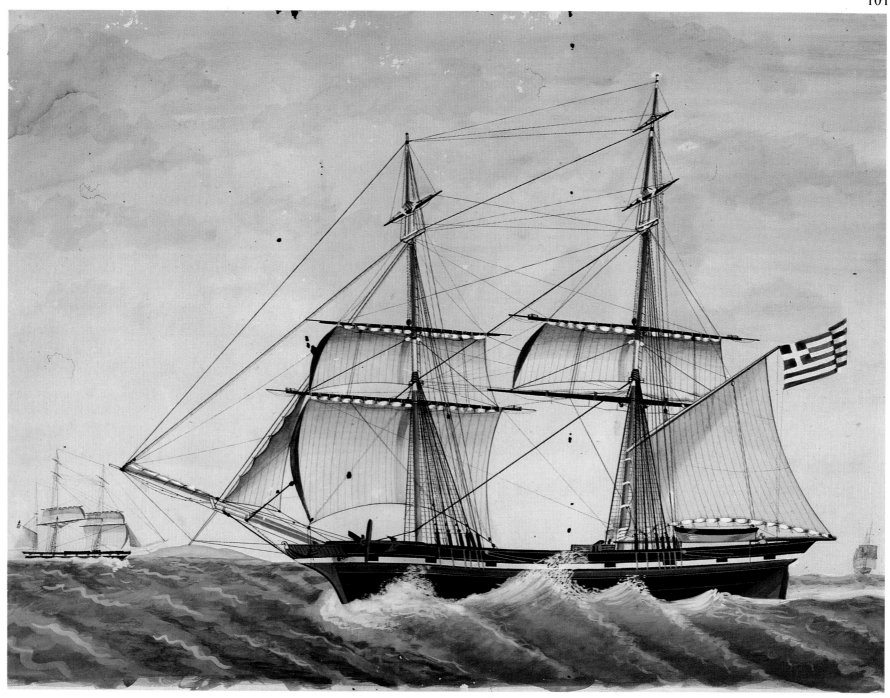

101 (258) Watercolour, 55×71 cm. Brig

102 (249) AGON, oil, 39×51 cm. Brig of Andreas D Mitropoulos. Built in Galaxidi in 1869; 220 tons

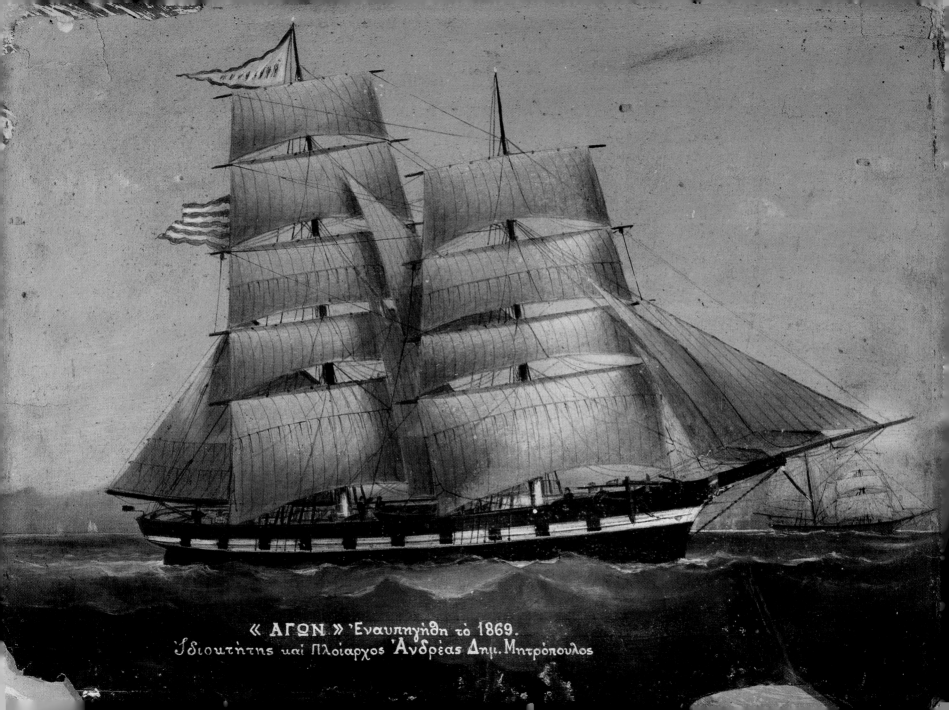

« ΑΓΩΝ » Έναυπηγήθη τὸ 1869.
Ἰδιοκτήτης καὶ Πλοίαρχος Ἀνδρέας Δημ. Μητρόπουλος

ὁ λιμήν ΓΑΛΑΞΕΙΔΙΟΥ

Ἡ ἄφιξις τοῦ Βασιλέως Ὄθωνος εἰς Γαλαξείδιον τῷ 1862 μὲ τὴν φρεγάδα «Ἑλλάς».
Τὰ εἰκονιζόμενα ἱστιοφόρα εἶναι Γαλαξειδιώτικα καὶ ναυπηγηθέντα ἐνταῦθα. Μεταξύ αὐτῶν
εἶναι καὶ τὸ ἱστιοφόρον «Μαδέρα ✝» τοῦ ἐμποροπλοιάρχου Γεωργίου Ν. Ἀρβανίτου,
ὅστις πολύ ἐνεργέτησεν τὴν ἐμπορικήν ναυτιλίαν διότι πρῶτος ἐφήρμοσε τὰς
«διπλᾶς γάμπιας». Ἐφωτογράφισα εἰς ἡλικίαν 83 ἐτῶν 1937. καὶ Δωρεῖται εἰς τὴν
Κοινότητα Γαλαξειδίου εἰς Ἀνάμνησιν τῶν γονέων μου Δημητρίου καὶ
Ἀθηνᾶς Πειραιᾶ. Δωρηταί. Πέτρος καὶ Ἀστέρω Πειραιᾶ.

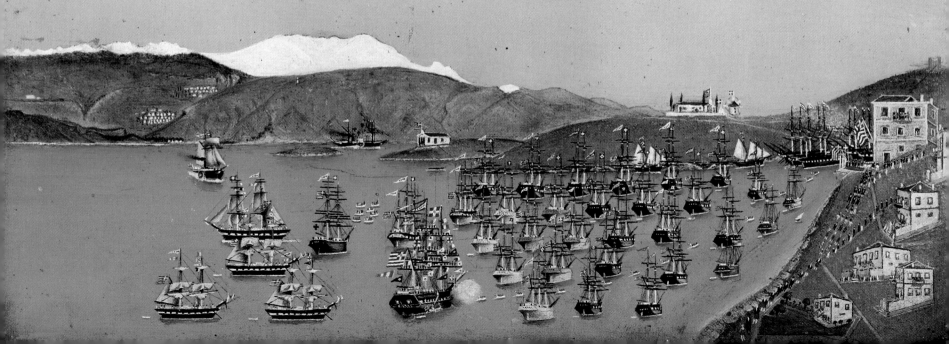

Paintings of sailing ships of the twentieth century

A new period is signalled by the remaining 73 paintings of sailing ships. They were made by Greek artists and are exhibited in Room V. According to the dates written next to the few names of the Greek painters that period began in 1917 and has continued up until recent years. These works are not portraits of sailing ships as such. The pictures were painted either by experienced artists who used imaginatively the information they were given about the ships, or by folk artists, mostly seamen, who rendered in paint from memory, as best they could, that which had been filling their lives for so many years.

A trained knowledgeable hand is easily discerned in the two pictures by Spyros Vasiliou[1] (Plates 104 and 105). One of these is in the Municipal Office and the other, in the Library.

Four sailing ship pictures (Plates 109-112) and a steamship on (Pl 178) bear the signature of Aristeidis Glykas, a painter from the island of Chios (1870-1940), born in the village of Patos Vrontadou. He was very young when he went to sea, and his love of painting seems to have manifested itself quite early. In 1907 he left the sea to devote himself to his art. As he became known, orders kept coming in not only from Chios but also from other parts of Greece. Apart from a very few exceptions, he mainly painted sailing ships and later steamships. In 1916 he settled in Piraeus, where he continued to paint ships. His works can be seen in the Maritime Museum of Oinousai, the Cultural Centre of Vrontades, in the Folklore and History Museum of Milos, the Maritime Museum of Piraeus, and the Museum of Oia in Santorini, as well as in private collections.

Galaxidi shipowner and captain Petros D Petratzas has left behind a rich assemblage of his paintings, a number of which adorn the Museum of Galaxidi (Plates 1, 103, 113, 115, 116 and 117) and private collections. Events from both his own life and that of his home town are represented in his works with added commentary. In the picture of Plate 103 he shows the arrival of King Otto in the harbour of Galaxidi, and he also mentions how Georgios Arvanitis 'has much profited the commercial marine, because he was the first to use double topsails.' In the picture of Plate 115 he describes a personal heroic achievement[2] at Poti on the Black Sea in July 1905: using a tug-boat he rescued all those shipwrecked from the tender *Peter Karbov* of the Russian Navy. GALAXEIDION IN THE YEAR 1871 is the title of the picture on Plate 1, where the location of the various shipyards can be seen clearly; and so can the Byzantine Monastery of Christ the Saviour, built around 1250 by the Despotis of Ipiros, Michaïl Angelos Komninos II, which is indicated by a surrounding white rectangle in the upper centre of the work. It is from the site of that Monastery that he painted GALAXEIDION IN THE YEAR 1878 (Pl 4), the picture which hangs in the Lykeion, the secondary school, and where both harbours of the town are shown.

Captain and Pilot Avgeris A Andreopoulos (1872-1953) of Galaxidi painted sailing ships only. Interesting materials were used for the colours in the picture on Plate 119: chalk for white, indigo for blue, soot for black, black pencil for the rigging, while the sails are the colour of the background paper left blank.

Petty Naval Officer Georgios Kokkinogiorgis (Pl 121), Captain of Merchant Marine Georgios Tsaousakis (Pl 118), and Lias Koutretsos (Pl 120) are also from Galaxidi.

The next two pictures are signed K Zournatzis (Pl 123) and G Georgiou (Pl 122).

There is a note on the picture of Plate 38 mentioning the name of painter E Kyriakopoulos; however, the palette and the sea are reminiscent of G D'Esposito.

Only one of a group of 17 paintings (Plates 124-140) is signed, Plate 127 with the name M T Zachariadakis. It was on the basis of this picture that the sixteen unsigned ones have been considered the work of the same painter, because they all resemble to it in style, palette, movement of the waves, even to the lighthouse,

103 (349) *Petros D Petratzas*, THE HARBOUR OF GALAXEIDION, oil, *41×58 cm*

which always but once (Pl 136) appears on the right hand side. Unfortunately, we have nothing that would indicate who the actual painter was. In any event, this group obviously form a homogeneòus whole.

In another group, out of 12 pictures (Plates 141-152) only two (Plates 141 and 144) bear the name of painter Michaïl Theodosiou, but it is highly probable that they were all painted by him. In most pictures there is land either on both the left and the right or on only one side. The lighthouse, so often repeated in other pictures, is nowhere to be seen. In the picture of Plate 145 a figure touching a pot with a basil plant in it near the stern of the brazzera represents the link with home, longing for a loved one.

A lighthouse is a feature shared in common by seven unsigned pictures.

The lighthouse is on the prow side on Plates 153-156, 160, and 161, whereas it is on the stern side on Plate 157. Perhaps the pictures of Plates 158 and 159 were made by the same painter.

The next ten pictures (Plates 162-171) of varying styles and palettes are also unsigned.

Of the 67 paintings mentioned above only 22 are signed by the Greek painters. The remaining 45 are thought to be due to unknown folk artists, who have left important work behind. For paintings of sailing ships, whether done from life of from the imagination, represent various types of vessels, which used to be built in Galaxidi, and they also commemorate a high peak in the life of this maritime community.

The pictures, on the other hand, of the twentieth century Galaxidi seamen-painters with known names show that a romantic affection mixed with nostalgia for the sailing ships has not been quenched in their hearts. Perhaps some ancestral shipowner captain still dwells therein, much admired and honoured for the way men of the sea in his time fought gallantly against the elements of nature. The pictures on Plates 38 and 169 may serve as characteristic examples of distress at sea. In the picture of Plate 38, we read 'Great tempest in the Ionian Sea from the Taras Gulf on. Ship with a cargo of marble sank and all men (were) rescued by an English steamship, on 2 February 1892;' and in that of Plate 169, 'The sinking and end of the shipwrecked Greek ship of Galaxidi at the destructive place (the island of) Koútali.'

In the nineteenth and twentieth century paintings, the seaworthy Galaxidi vessels of elegant line are now but only silent witnesses of a unique period in the life of the maritime town.

Rodoula Stathaki-Koumari

NOTES

1 Spyros Vasiliou was born in Galaxidi in 1902; he died in Athens in 1985, leaving behind a rich work on a large variety of themes.

2 Captain Petros Petratzas was decorated by the King of the Hellenes George I at the instigation of the Empress of Russia; thus, in appreciation of his brave act 'The Silver Cross of the Knights of the Royal Order of Our Saviour' was conferred on him together with the relevant document.

104 (287) Spyros Vasiliou, SHIPS OF K PAPAPETROS, 91×103 cm, Galaxidi

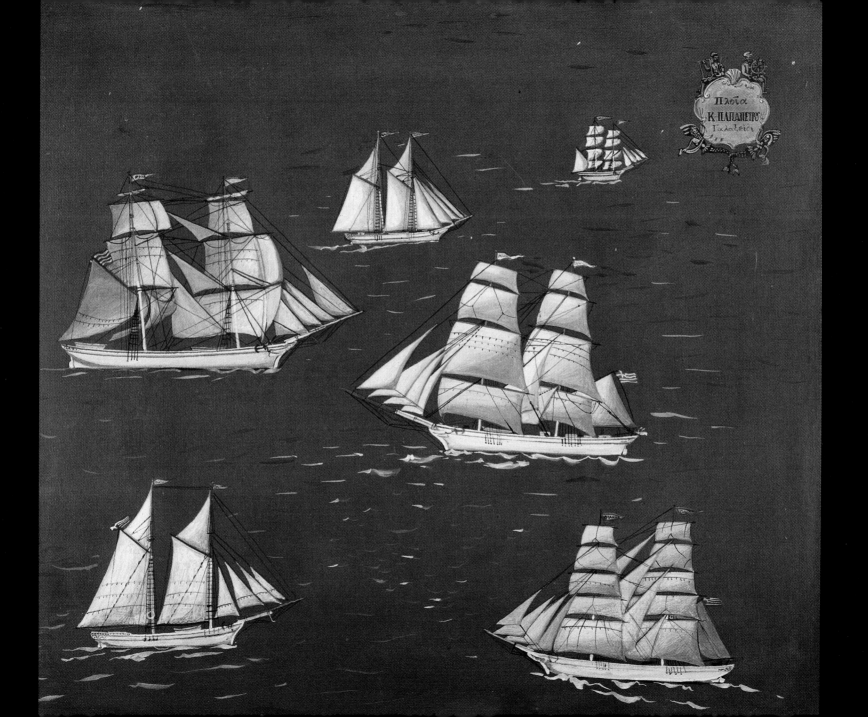

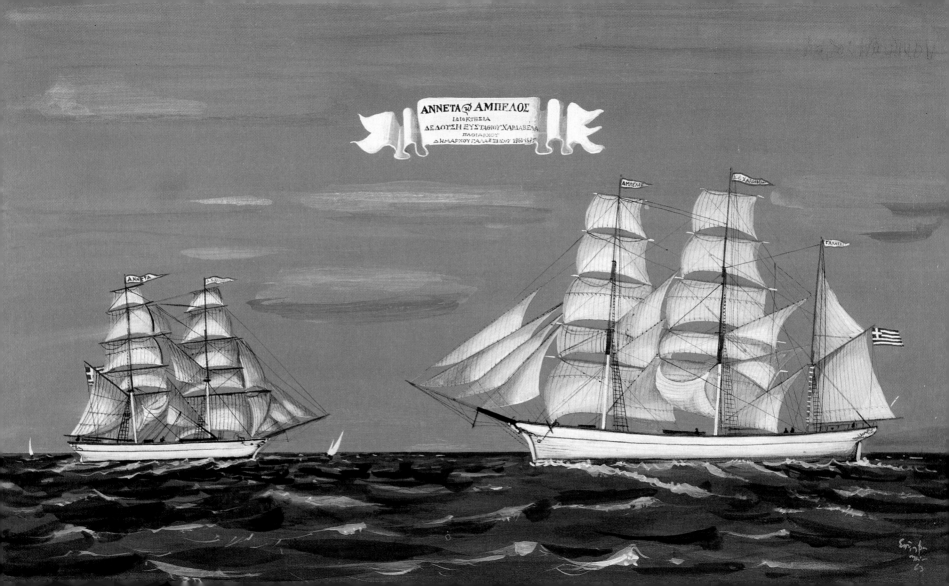

Sailing ships of Galaxidi*

Spyros Vasiliou

Galaxidi 'was built in very ancient times and it was beautifully enclosed in fortification walls, having also a fleet of sailing ships and an abundance of houses.'

Thus the story goes in the Chronicle, which 'was compiled from authentic old manuscripts, parchments, sigilla, and bullae,' and written 'by the hand of Monk Efthymios, in the year 1703, in the month of March.'

. .

There was in truth a period when our village could boast five hundred sailing ships, while a count of souls would add up to more than six thousand.

Now it is a deadened town.

When you come to it from the sea, you feel sad as you become aware of the large patrician houses looking at you as if surprised that you should disturb their lethargic existence.

And when you are sitting high up on the hill, at the Sotira, where there used to be 'the Royal Monastery of Christ the Saviour, which had been built by the then lord and despot Sire Michaïl Komninos,' and look at the view from there onto the vast deserted gulf with its many little coves and its tiny islands, your mind cannot help wandering back to the sailing ships, as they gathered here in winter, adorning the waters of the port with their many and varied designs.

Barques, barquentines, navas, brigs, and schooners were some of the larger vessels; while little lovers,[1] brazzeras, lug-sail boats, randans, and trechantiria[2] were some of the smaller ones.

. .

One by one the Galaxidi sailing ships have started arriving. It is the 25th of November, Saint Catherine of the Tempest's day, and the church service is just about over, as nineteen of them, brigs, schooners, and lovers, one behind the other are entering the harbour from behind Kentri.

105 (235) Spyros Vasiliou, ANNETA and AMPELOS, 76×121 cm. ANNETA: Brig of Dedousis E Chardavellas and Loukas Karalivanos. Built in Galaxidi in 1869; 247 tons. AMPELOS: Barque of Dedousis E Chardavellas. Built in Galaxidi in 1870; 190 tons

106 Spyros Vasiliou, Drawing from his book Galaxidiotika Karavia (Sailing Ships of Galaxidi), Kastalia, Athens 1934

The AGIOS GEORGIOS of Captain Margiotis is first to sail in proudly with single top-sails, an old design, and showing off her waist.

Then follow closely the EVANGELISTRIA of Petratzas, the DOUNAVIS of the Levantis family, and the AGIOS NIKOLAOS of Katharios, which is coming straight from Marseilles. There are also the DYO ADELFOI and her mate the GALAXIDI, of the Vlamis family, coming from Livorno. Behind come the ALTANA of Papapetros, the RODO, the AMPELOS, and the ANETA of Chardavellas, and in a row, the AGIOS SPYRIDON of Papadogiannis, the ZEUS of Zisimos, the ERMIS of Papapetros, the AGIOS GEORGIOS of Captain Giannis Visvikis, all brigs. Then come three schooners, the PAGONITSA of Mitropoulos, the CHRYSOULA of Kostellos, and the ELENI of Katsoulis; and last, in brotherhood, the two fine little lovers of Captain Konstantis Papapetros, the KASTOR and the POLYDEFKIS.

More ships will have come by evening, and even more will gather in with every day that passes.

The MILTIADIS of Primas has also arrived, with her top-masts broken, the top- and topgallant sails in tatters, the ropes and rigging all in a tangle. She had a narrow escape from a tempest in the Ionian Sea.

This year, the Mediterranean too has had its sudden squalls. So, Captain Angelis Tsipouras returned with his brig the ARISTEIDIS a wreck.

'Tempest prevailing from 25 to 29 November, opposite the island of Stromboli.' He too had a good time on leaving Naples. During four days and four nights he sailed under bare poles.

They both have a great deal of work ahead of them mending the damages.

The barquentine of Katsoulis proudly entered the harbour in full sail one morning. She had travelled in the South Seas five times and met with great adventures.

. .

As each sailing ship arrives, she will find her moorings and drop both anchors, veering several shackles of cable to secure her well.

They will spend the winter here and leave again around Carnival.

Joy has by now taken over the town. The violins and the lutes are telling about it day and night. Zwanzige,[3] grossia, colonata,[4] rubles, and napoleons are scattered unsparingly in the market. The shipboys share out the presents to the relatives: black caviar and salt-fish from Odessa for the gourmets, velvets and silks from Marseilles for the girls, whole sets of china from Venice for the newly wed housewives. There is a feast in every house.

But when across the bay Mount Parnassus is scowling and the first snow begins to fall, merriment is silenced and hearts feel tight. Several more sailing ships are still in the Black Sea, and often in the fog, as they come down laden from the Russian ports, instead of finding the entrance to the straits at Constantinople, they hit the shoals and are smashed to pieces.

. .

Five or even up to ten sailing ships are lost one after the other in the straits of Constantinople every winter.

Forty or up to fifty families will then be dressed in black all at once.

Mourning takes its share away from Joy.

In the Chirolakas are heard the dirges, the songs are heard in the Agora. Such is the Fate of Galaxidi.

So it is that the AGIOS NIKOLAOS, the new brig of Old-Kafaërlas, that is Captain Konstantis Papakonstaninos of great fame, will be coming to anchor with the other ships at the Kavos no longer.

She was lost in the Atlantic together with his three gallant young sons, budding captains themselves, Nicholas, Kanellos, and Pantelis by name.

. .

The memorial service took place on the following Sunday. A slow procession of mourners stated from the Kafaërlas family house. There had never been a sadder funeral. In front were carried the three trays with the kollyva,[5] decorated with silver-coated little toffees, three large candles in the bronze candlesticks with the dark purple ribbons, on which were written the names of the three young men in gold lettering, NIKOLAOS, KANELLOS, PANTELIS, then followed the old man, dumb, all alone, like an unrigged mast, and close behind him walked his woman,

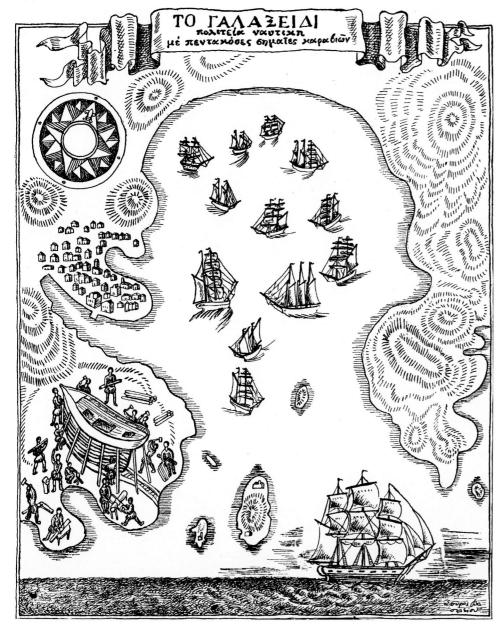

107 Spyros Vasiliou, *GALAXEIDI*, drawing from his book, op cit

his daughter, and his daughter-in-law, murmuring their lament with dirges, bent, shattered, their black kerchiefs deep down to the eyebrows.

People had come in multitudes. In the Church of Agios Nikolaos there was no room even for an apple to fall. And when the service had come to its close amidst a muted sob, which suffocated the breath, depressed the heart, spread, and grew in everybody's chest, rose like the wave of a swell, reaching the amply resounding vaults of the church, just when the cantor had begun the grave, doleful, long-drawn chant 'The Choir of the Saints has found a fountain of Life and a gate to Paradise,' a deep groan was heard as the old man, who had been standing in solitude right in the centre of the church, dry like a burnt out stump, collapsed dead to the floor.

May God have mercy on Old-Kafaërlas. May God also have mercy on his three gallant sons. With the heirs gone, the life of that admirable family was thus cut short while in full blossom.

. .

And then you stop and wonder how it is that all mariners are men of passion and yearning.

Take Captain Petros Petratzas for example.

He has overcome all kinds of sea adventures. It was in Poti of the Black Sea, when with his brig LEONIDAS he rescued twenty men, who had swarmed up the mast of the Russian PETER KARBOV for hours on end after she had run aground on the shoals, while none of the Russian, the English, or the Italian ships that were anchored in the harbour, about twenty of them, had ventured to come out.

Three thousand people were gathered on the shore watching him with admiration and lifted him up shoulder high when he returned with the shipwrecked sailors.

The Minister of the Empress of Russia sent him a medal together with an important paper, where a whole lot of praises had been skilfully joined to each other. He received another medal, too, from the Greek Government.

Now, an old man in his eighties, he sits and paints. He neither plays cards nor any of the other gambling games. He is drawing Galaxidi the way it was in the good times with all the sailing ships. He is also making a picture of the Trafalgar Naval Battle,

two metres long, the fleets in battle array, the British, the French, and the Spanish ones, with their corresponding positions and their courses, as it is all narrated in an old English book. He has painted all the sailing ships with great skill, and now he wants to paint the sea and the clouds. Here he has a little difficulty, but it is certain that he will manage very nicely.

Under the picture he will write, 'The Greatest Events in World History. The Trafalgar Naval Battle,' as well as Nelson's signal, 'Britain expects us all to do our duty.'

He also has in mind to paint the frigate HELLAS, which brought King Otto to Galaxidi, and where the sailors will be lined up in parade on the deck and on the ropes of the yard-arms.

It gives you pleasure to watch Captain Petros Petratzas. If moreover you too happen to like occupying yourself with painting, then you envy him. The amount of love with which this man paints the sailing ships is quite something else. He is happy and he sings over each little pulley, and when you look at the rigging, you think that at a command all will be in order for manoeuvres to begin.

Or, take Captain Ilias Skourtis. He too is an old man and a pensioner, but he has busied himself with drawing the Zodiac with all the signs of the constellations, Gemini, Sagittarius, Aries, Pisces, Libra, and the rest. he made a whole lot of calculations, he used astronomy and several kinds of mysteries, of which I do not understand a thing. And then he had the signs carved on the floor of the Church of Agia Paraskevi, and he opened a hole in its roof, so that a ray of the sun would hit the appropriate constellation according to the season of the year.

. .

One thousand workmen, both local and from the island of Skopelos, and swarms of apprentices are busy in the yards.

The smaller vessels, caiques and brazzeras, are built at Richi, while the larger ones are built at Kentri.

There were yards even at the Mylos, Vistrithra, Kalafati, and Vlicha.

Until the quay was built at the Pantopoleia, the grocery shops, small caiques were also constructed at the Agora, the sea-front.

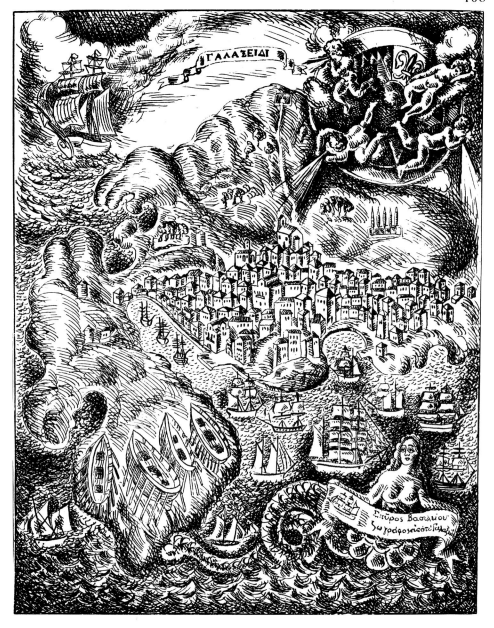

108 Spyros Vasiliou, GALAXEIDI, drawing from his book, op cit

109 (245) Aristeidis Glykas, IOANNIS, watercolour, 48×64 cm, 1917. Schooner of E I Visvikis and Marigo I Visviki. Built in Galaxidi in 1904; 234 tons

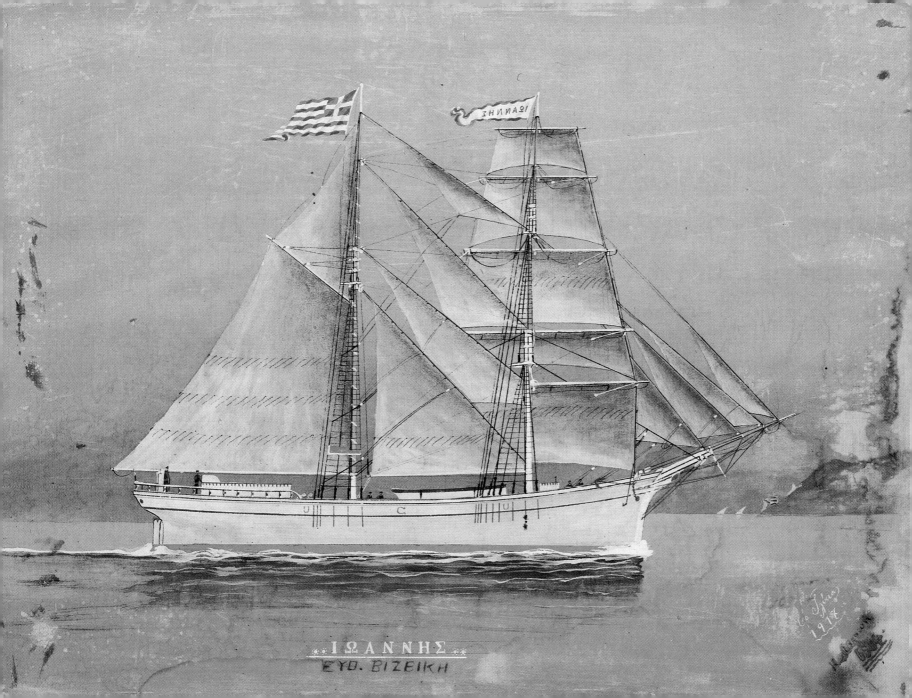

..ΙΩΑΝΝΗΣ..
ΕΥΘ. ΒΙΖΕΙΚΗ

In eighteen thirty-three, when Galaxidi was rebuilt after it had been burnt down during the Revolution,[6] the Galaxidiotes crossed over to the Morea[7] looking for shipbuilding timber, and started work on sea-going vessels. Among the first large sailing ships that were set afloat was the POLYTIMI of Karakostas.

In eighteen forty they counted one hundred vessels, brigs, schooners and brazzeras. The picture of AGIOS SPYRIDON of Tsalanghyras, and that of AGIOS IOANNIS of the Chardavellas brothers, both ships built in that year, are in the Offices of the Municipality.

Master Kaloudis was the very first master-builder, and he came from the island of Aigina. He taught the art of ship-building to old Kanatas, who produced a son, also one of the best craftsmen.

. .

Kaïmakis from Salona was another good one among the old master-builders.

In the same period as Kanatas, there was also Michalopoulos working, who in eighteen eighty-eight constructed the second largest sailing vessel of Galaxidi, the GRAVIA of Mitropoulos, capacity one thousand tons.

Beside him was practising Master Konstantis Papapetros. This one was a captain turned shipwright.

No sooner was he back with his sailing ship than he would keep going to the shipyards. An excellent mind, with the few words he had of each language he kept increasing his knowledge. Thus he established himself as the best craftsman in Galaxidi.

It was in his time, in eighteen sixty-seven, that a ship was first set afloat by end-launching. Until then ships had been berthed and launched with the prow facing the sea.

And people are still talking of his best piece, the AIOLOS of Kouzos, which was constructed in eighteen seventy-five.

That was a gallant barque, the pride of Galaxidi. Covered with copper up to the load-line, she had a double deck, and could take a cargo of one thousand two hundred tons. Wherever she went, they would copy her design. In Buenos Aires, when her skipper, Captain Zagoras, took her out to the dock to have her cleaned, the master-builders of the dockyard kept her for two extra days in order to study her. Let alone that it was the first

time they had seen a Greek flag down there.

Who does not remember the time when they were laying the stocks in Vlicha, where they had made a special yard, because she would not fit in any of the old ones. The yard blocked the way to the villages, so that a new path had to be opened behind the market gardens.

When the crosshead was being fixed in place, as soon as the priest had pronounced the blessing, Master Konstantis fitted the stem-post onto the keel himself, and using the same bronze mallet he nailed a gold napoleon onto it while he made a wish for prosperity:

May even your nails be of gold!

The AIOLOS and the GRAVIA were the largest sailing vessels made. But the GRAVIA was an unhandy ship. There has been no other sailing ship as fine as the AIOLOS to be launched from a Galaxidi yard. An unlucky ship, however. She made three voyages to America and was lost at a collision in the Ocean.

During the good years, from eighteen sixty-seven until eighteen ninety, ten to fifteen sailing ships were launched a year. In eighteen ninety decline set in.

Steam with its strange and unwieldy vessels, and with thick black smoke pouring out of their funnels, got the better of Galaxidi.

Passionate perfectionists as the sailing-ship owners and skippers of Galaxidi were, they did not succeed in owning steam-ships. That's a different kind of a job, you see.

I was told, although I would not take an oath to it, that there were three captains, who shall be nameless, and who went to Marseilles, where they bought themselves a steamship with four parts out of five owing to the Bank. And that on their way back to Galaxidi they had a quarrel over whose wife was to break the pomegranate[8] onto the stern of the ship at the naming ceremony. Not yours but mine, they did not agree, they moored the steamship, the interest bills were mounting, until on one bright morning the Bank came and took her away from them.

It is true, though, that there was a time when Galaxidi counted about twenty steamships, but they did not do well either.

And to say that the number of shipwrecks diminished with steam taking over. Well, ten persons were lost in the straits at Constantinople with Marlas's steamship, where he himself was

110 (272) Aristeidis Glykas, ZETTA, watercolour, 58×78 cm, 1919. Sailing ship of Efthymios I Visvikis

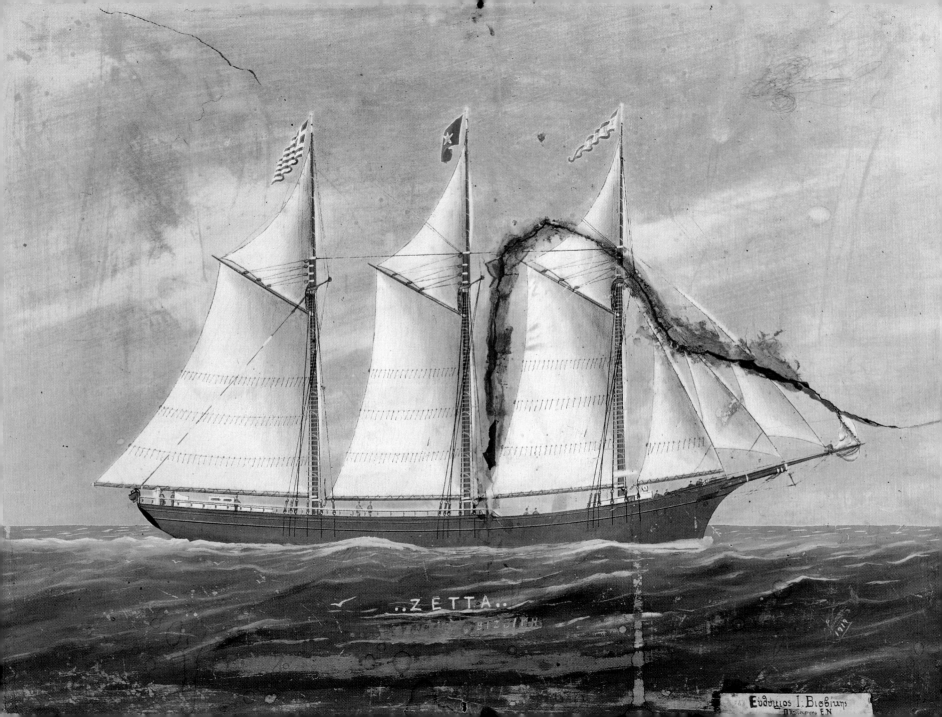

..ZETTA..

Ευθύμιος Ι. Βιοθύνης

skipper. Papageorgis, who was the ship's captain on the way up, was lucky to have disembarked in Constantinople.

'Tragedy in the Black Sea' the newspapers reported in large letters when the shipwreck became known.

And what about the PARNASSIS, the freighter with both steam and sails, didn't she go up in flames like a fire ship in Syria?

The sea, my love, is big, she is five times greater than the land, and she is very greedy, so that man is of a small and helpless stature beside her.

From eighteen ninety onwards, they did no longer construct any large sailing ships. Who would freight them? Freights for sailing ships narrowed down to short distances, Astakos-Amaliada, and Titsa-Vostitsa. Only little lovers were built for several more years, until they too were stopped.

The last large sailing ship to have been set afloat was the barque of Visvikis.

As always happened when a new vessel was launched into the sea, a great feast took place on that occasion too. On the evening before, gifts were brought to the house of the captain from the relatives, pleasure giving presents and sweets like kourabiedes, baklavades, strifta, or revani. The house was shining in fresh whitewash, with the kilims and carpets spread out and with a new corridor-rug from the entrance door to the drawing-room.

At the yard, they were putting the finishing touches on the new sailing ship.

When they were done with everything, they filled her with water to see where it escaped. As soon as the master-builder noticed that she sweated at one or two joints, he asked the caulker to stop the leaks, which he did with oakum and pitch using his wooden mallet and a chisel.

As the sun went down, the builders could finally stop work. There were all kinds, riveters, turners, blacksmiths, caulkers, carpenters, a whole world of them.

Tonight the sailing ship will be guarded by double watches. You never know but that a dark and envious heart might not go with a drill and make a hole to the finished vessel.

. .

At the crack of dawn, the captain with the master-builder, the foreman, and the shipwrights, all arrive at the yard. They make garlands with the multicoloured signal-flags to decorate the deck, and then using poles on prow and stern they hoist the Greek flag.

Then the builders apply ample fat onto the stocks, so that the sailing ship may glide with beautiful ease. The master-builder is running up and down to give everything a good look. The slightest thing may bring bad luck, and even if the misfortune does not occur that she might lean on her side, still there would be fuss for them if she did not glide easily and would need ropes and pulley-blocks and people heaving to set her afloat.

At nine the guests arrive in a jolly procession from the house, the captain's wife, the priest, the Marseilles trays with the sweets on them at the head.

Everything is in order.

That most beautiful vessel is resting her keel on the transversal pieces, and, like a paunched gourmand who has overeaten, her belly rests on the drags, which, with the shores filling them up, are tightly fastened to the ship with thick cables.

With the stanchions supporting her by the wale, she looks like one of those boats the ancient Greeks had, the ones with the hundred oars.

Eyes cannot watch too long nor admire too much that lovely ship from her proud wide-eyed bow and the well-fitted sides to the stern, so finely drawn.

The tide has come in. It is a festive day, summer weather, divinely exhilarating.

The master-builder shouts,

All clear!

All clear, reply like an echo the seamen.

The priest passes the stole over his head and reads the blessing.

When he has finished, the master-builder gives the sailing ship her name, calling her after the captain's wife.

And the name of the sailing ship, Margarenia. May she be of good fortune!

Godd luck to her! Lucky voyages!

The mistress with a smile on the lip, and a tear as big as a plum in the eye, breaks the pomegranate onto the stern of the sailing ship.

All stanchions away! booms the master-builder.

111 (289) Aristeidis Glykas, AGIOS GEORGIOS, watercolour, 42×61 cm, 1924. Brazzera of Paraskevas Zagoras. Built in Galaxidi in 1867; 261 tons

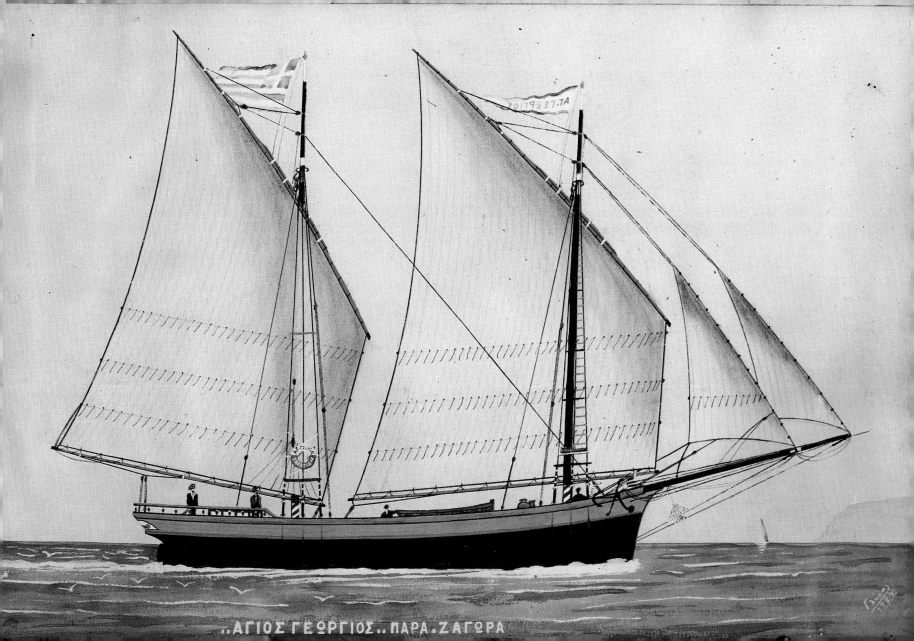

"ΑΓΙΟΣ ΓΕΩΡΓΙΟΣ" ΠΑΡΑ.ΖΑΓΟΡΑ

All stanchions away, respond the builders.

And a hollow sound like a quiver passes along the ship from bow to stern, and before you could say a word, the stanchions are unnailed and they fall off in heaps to the ground.

Drag-wedges away! comes the second command.

Drag-wedges away, repeat the builders.

And with a hit of the sledge-hammer on each wedge the detents that have kept the drags fastened to the big beam of the cradle fly away.

The vessel is at last free to glide. The boys who are on the deck start running to give impetus to the ship, which starts very slowly at first, but with increasing speed, to slide along on her cradle until with a final rush she reaches the sea, that opens her arms to receive the ship giving her a first kiss.

The urchins are busy diving from the rail, all sorts of dives, patrini, duck-dive, koumiza, latza, and one for the captain, and one for the captain's wife, and one for all the people there.

And while there is well-wishing and treating of the guests, while the captain's wife is inviting the closer ones to come by at the house too, and the captain himself is given to a sweet dream watching his ship with pride and having already rigged her in his imagination, two or three of his friends grab him as he is, new suit and all, and throw him into the water, just so, for good luck, as a good omen.

. .

Perhaps because of the light morning fog, perhaps because of the tears filling the eyes, the sea has joined the sky into a vastness of soft pink here or more like pale blue there. And within it have vanished, as in a dream, the white sea-birds with their white sails and the 'white columns' of their masts.

The gulf is deserted again. There is not one ship left, sick nor idle, in the harbour.

They were all bewitched by the seducer sea through her bitter-salt potions, and made drunk with the gorgeous scents of the winds.

She enticed them through spring calm and the caress of south winds and sea breezes, she drew them all to herself charming them with the never ending song of the shores, and put them all to sleep in her dark blue wet bosom, the spacious and great one.

Honour be to the Galaxidi sailing ships that have perished. May they have happy voyages in the ocean of the times.

* Extracts from the book by Spyros Vasiliou *Galaxidiotika Karavia*, published by Kastalia, Athens 1934.

Translator's Notes

1 *Lover* pronounced ['lover] with the [o] as in [got] A gaff schooner type of light two masted vessel with a rounded stern, the same type as the ancient Greek and Byzantine *káravos*. Similar to the Bermuda Schooner. Readers will find pictures of it among the plates of this book.

2 *Trechantiri* is a small sailing ship used for fishing; it has a sharp stern like a brazzera, is swift and very steady, even in gales.

3 *Zwanzige*, Austrian coins of the period.

4 *Colonata*, Spanish coins of the period.

5 *Kollyva*, Boiled grains, pealed almonds, currants, sesame seeds, pomegranate seeds, cinnamon, parsley, breadcrumbs, and sugar, often covered with icing and decorated with silver-coated little toffees. A tray of these is brought to church at a memorial service, blessed by the priest, and then offered to the participants, who respond by saying 'May God forgive him'.

6 Revolution against the Turks in 1821.

7 *Morea*, the Peloponese.

8 A pomegranate symbolizes prosperity.

112 (295) Aristeidis Glykas, EFTYCHIA, watercolour, 45×65 cm, 1920. Lover of Efstathios Kostellos. Built in Galaxidi; 88 tons

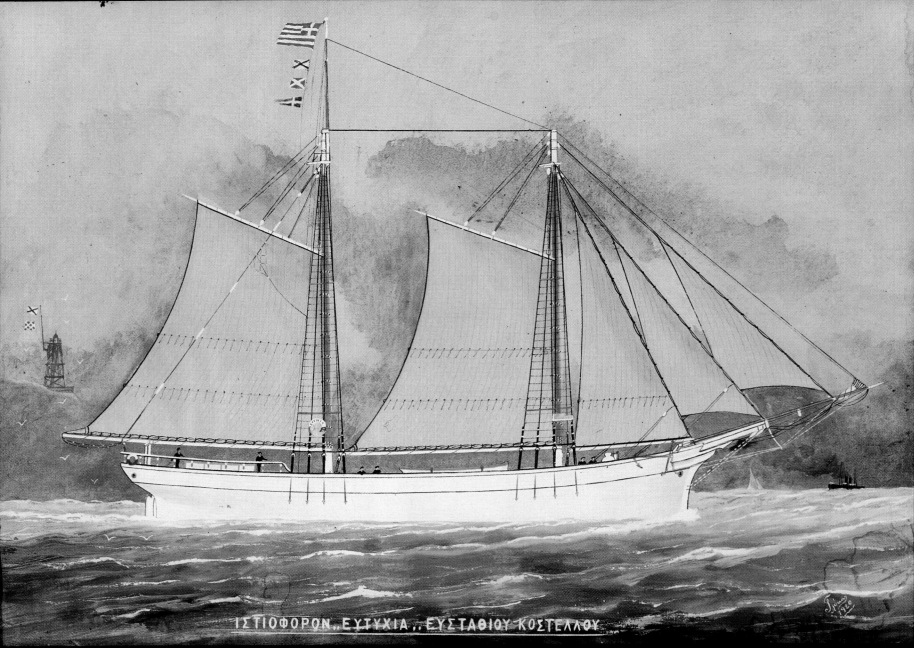

ΙΣΤΙΟΦΟΡΟΝ ,,ΕΥΤΥΧΙΑ,, ΕΥΣΤΑΘΙΟΥ ΚΟΣΤΕΛΛΟΥ

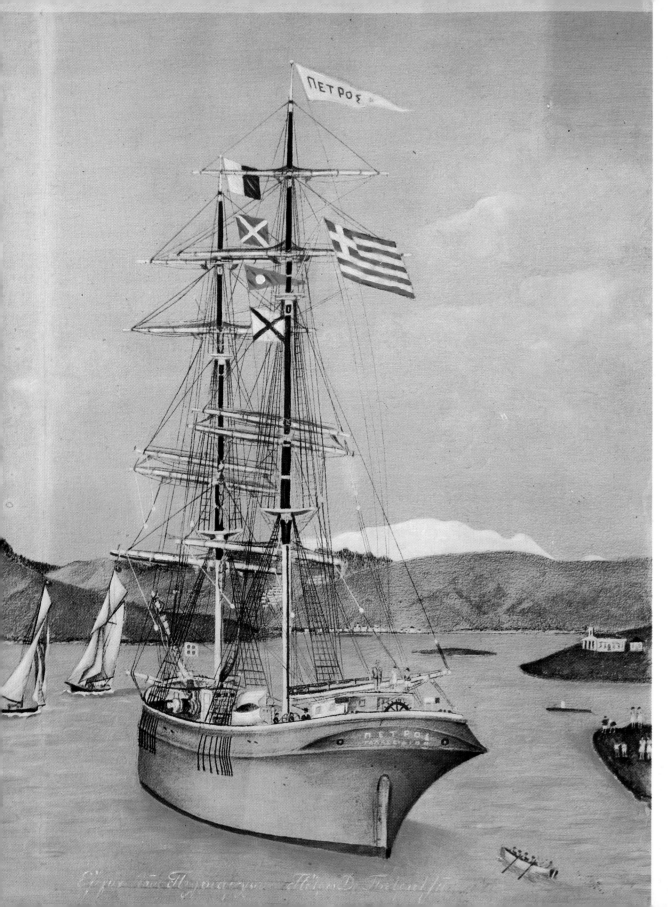

113 (214) Petros D Petratzas, PETROS, oil 70×86 cm. Galaxidi. Brig of P Petratzas. Built in Galaxidi in 1871; 253 tons

114 (688) Photograph of Petros D Petratzas, shipowner, captain, and painter

115 (382) Petros D Petratzas RESCUING SHIPWRECKED MEN IN POTI OF THE BLACK SEA, oil, 30×40 cm

Εὑρισκόμενος μὲ τὸ πλοῖόν μου Λεωνίδας εἰς Πότι ἀνέλαβα μὲ τὸ πλοίρομά μου διὰ τὸν Ρεμουλκον «Μιχυρέλη» καὶ ἔσωσα ἅπαντας τοὺς ναυαγούς ἀπὸ 27 Ὀκτώβρας ὁ Ἐμποροπλοίαρχος ἐκ Γαλαξειδίου Πέτρος Δ Πετρατζᾶς.

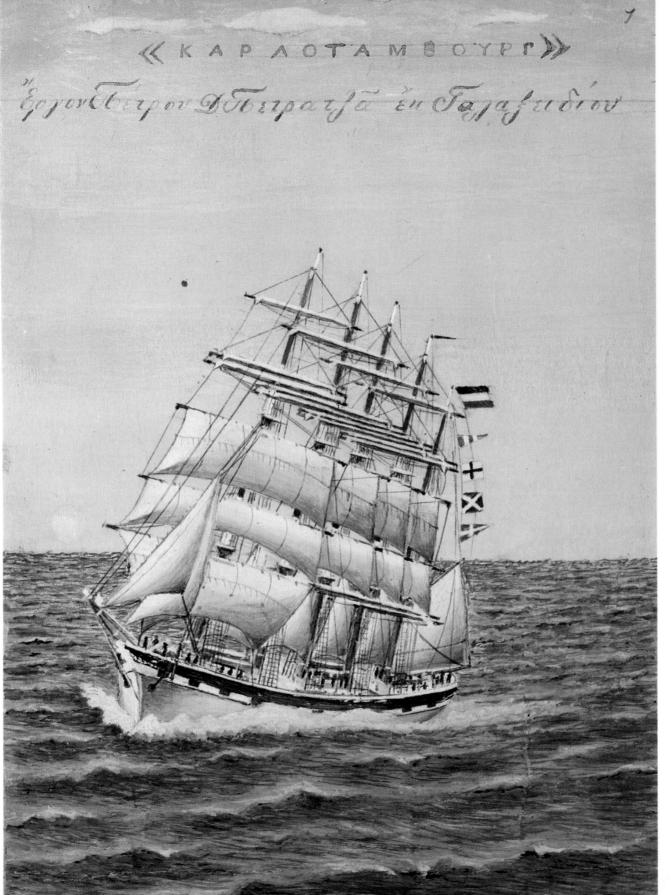

«ΚΑΡΛΟΤΑΜΒΟΥΡΓ»

116 (380) Petros D Petratzas, *KARLOTAMBOURG*, oil, 30×21 cm, (NB *His rendering of Charlottenburg*)

117 (381) Petros D Petratzas, *EVANGELIA* and *GERONIKOLOS*, oil, 30×38 cm. *EVANGELIA: Sailing ship of D Petratzas. Built in Galaxidi in 1844. GERONIKOLOS: Sailing ship of D Petratzas. Built in Galaxidi in 1866*

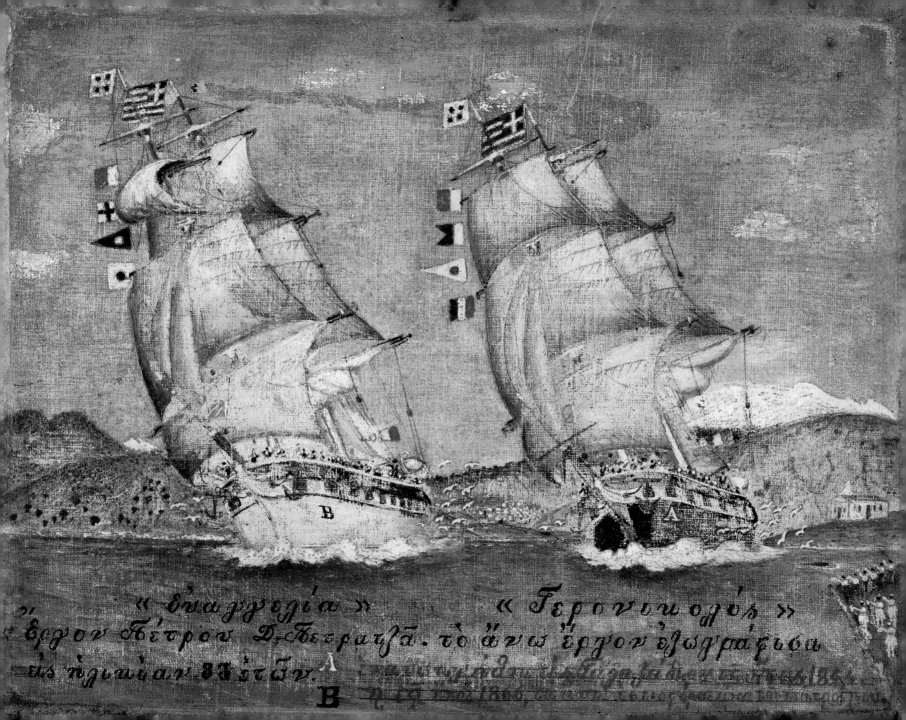

« εὐαγγελία » « Γερονυμοφός »
ἔργον Πέτρου Δ. Πετραιζᾶ. τὸ ἄνω ἔργον ἐζωγραφίσθα
εἰς ἡλικίαν 83 ἐτῶν.

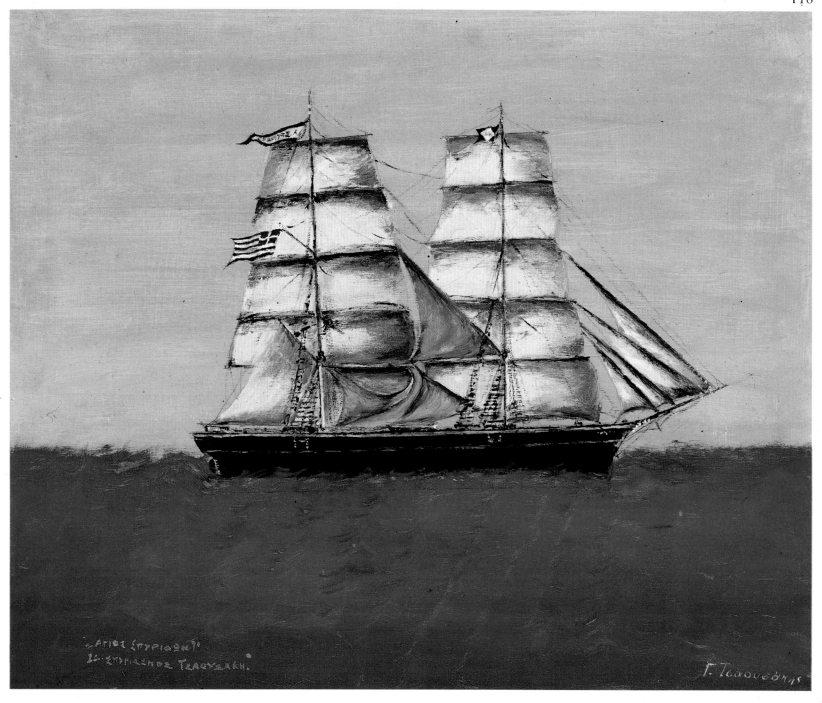

118 (633) *Georgios Tsaousakis,* AGIOS SPYRIDON, *oil,* 46×55 *cm. Brig of Spyros Tsaousakis. Built in Galaxidi in* 1859; 106 *tons*

119 (243) *Avgeris A Andreopoulos,* AIOLOS, *indigo, charcoal, chalk, and pencil,* 51×79 *cm. Barque of I Kouzos and G Zagoras. Built in Galaxidi in* 1875, *by Master-builder Konstantinos M Papapetros;* 1150 *tons*

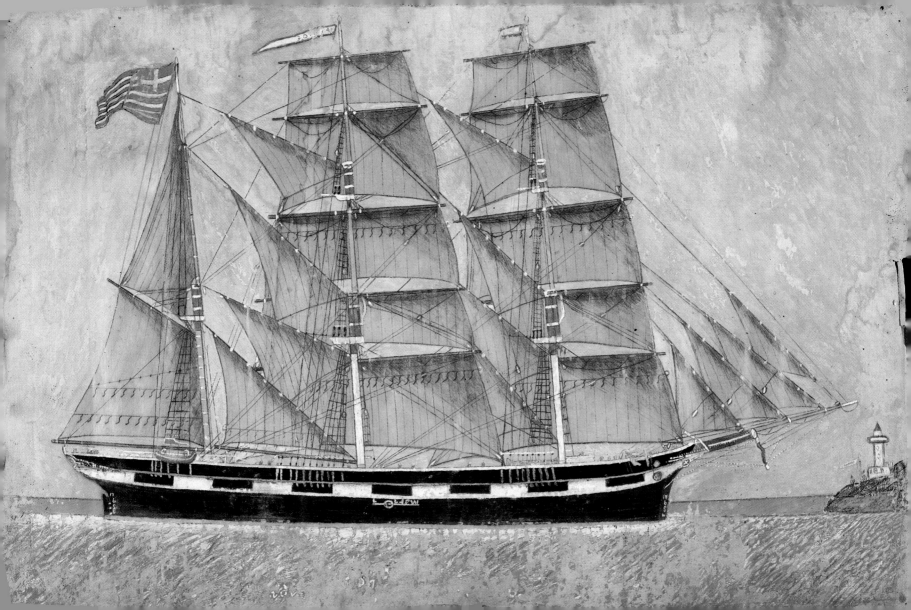

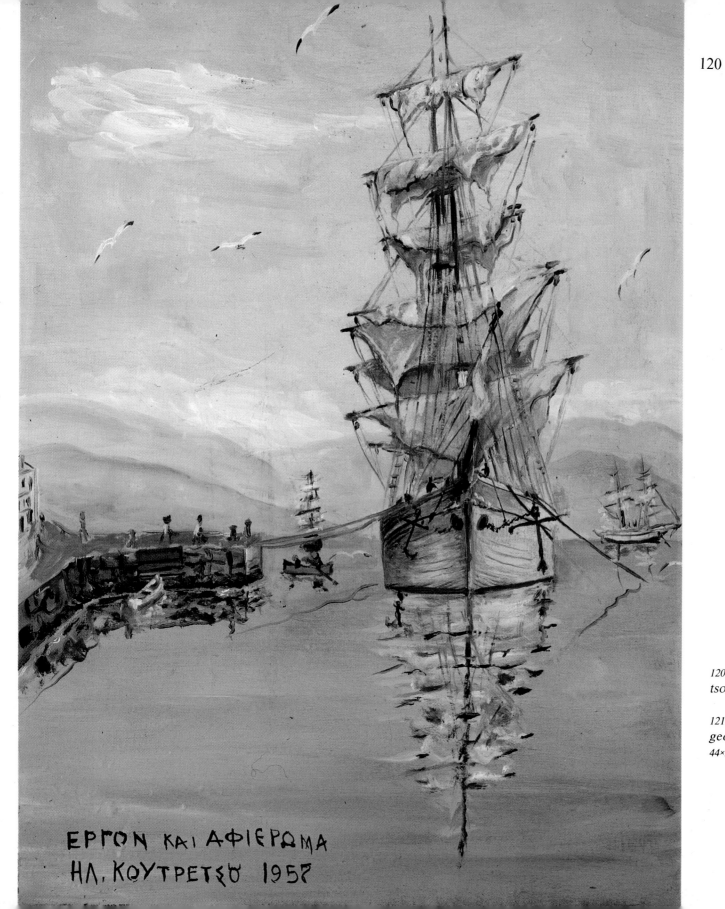

ΕΡΓΟΝ ΚΑΙ ΑΦΙΕΡΩΜΑ
ΗΛ. ΚΟΥΤΡΕΤΣΟ 1957

120 (282) *Ilias Koutre-tsos, oil, 52×42 cm*

121 (292) *G Kokkino-georgis, watercolour, 44×59 cm*

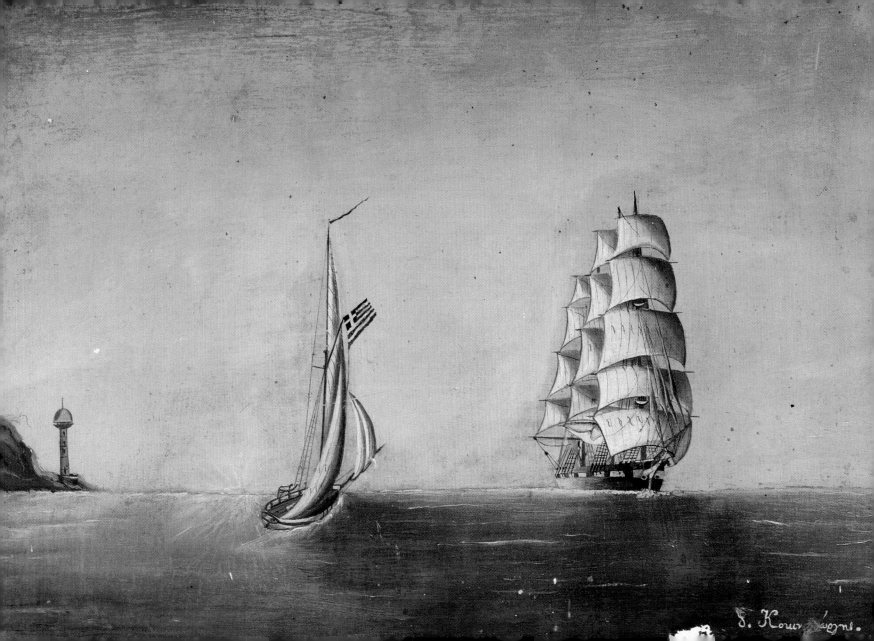
Δ. Κωνσταντίνε.

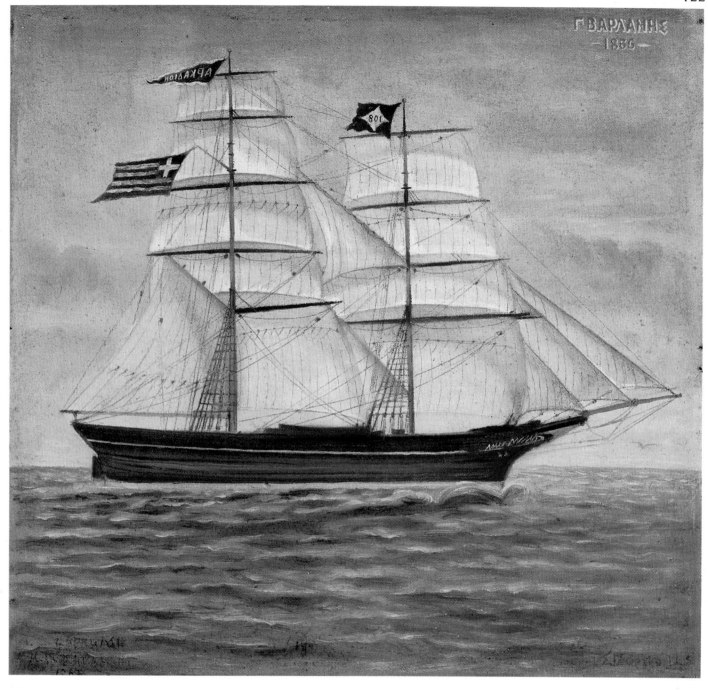

122 (274) *G S Georgiou,* ARKADION, *oil,* 63×66 cm. Brig of G Varlamis. Built in Galaxidi in 1867; 296 tons

123 (226) *K Zournatzis,* NAFSIKA, *watercolour,* 69×86 cm. Barquentine of Konstantinos I Tringalas. Built in Galaxidi in 1890; 297 tons

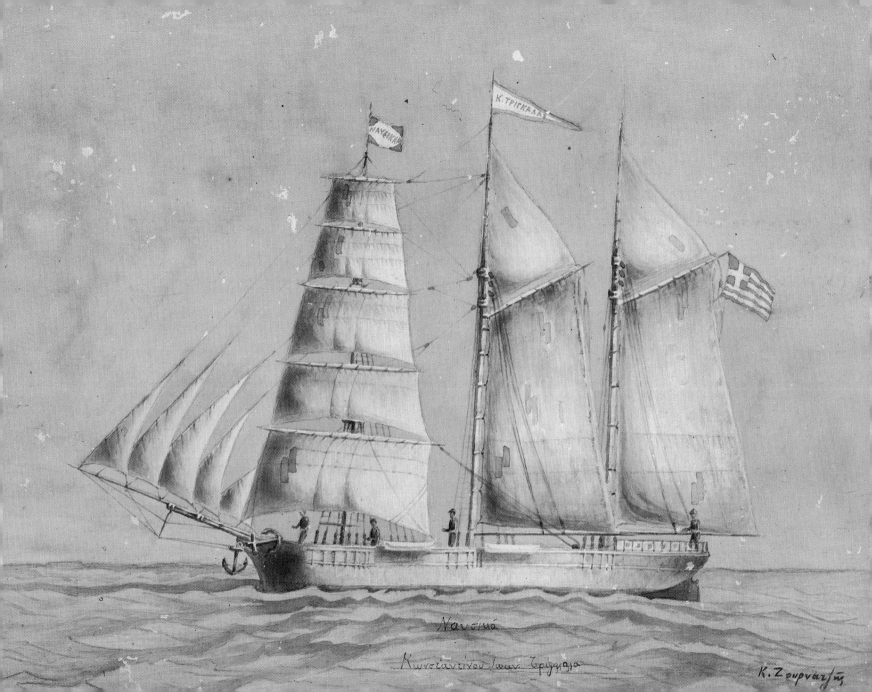

Ναυσικά

Κωνσταντίνου Ιωάν. Τριγκάλα

Κ. Ζουρνατζής

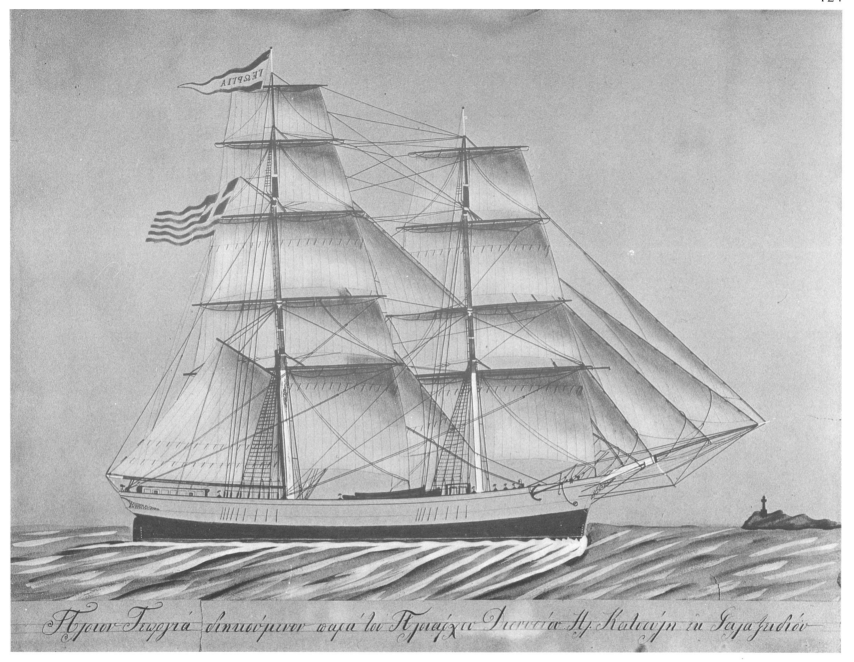

124 (241) GEORGIA, watercolour, 46×62 cm. Brig of Dionysios I Katsoulis and K I Tringalas. Built in Galaxidi; 212 tons

125 (305) AGIOS SPYRIDON, watercolour, 50×67 cm. Lover of Ilias Katsoulis. Built in Galaxidi in 1890; 105 tons

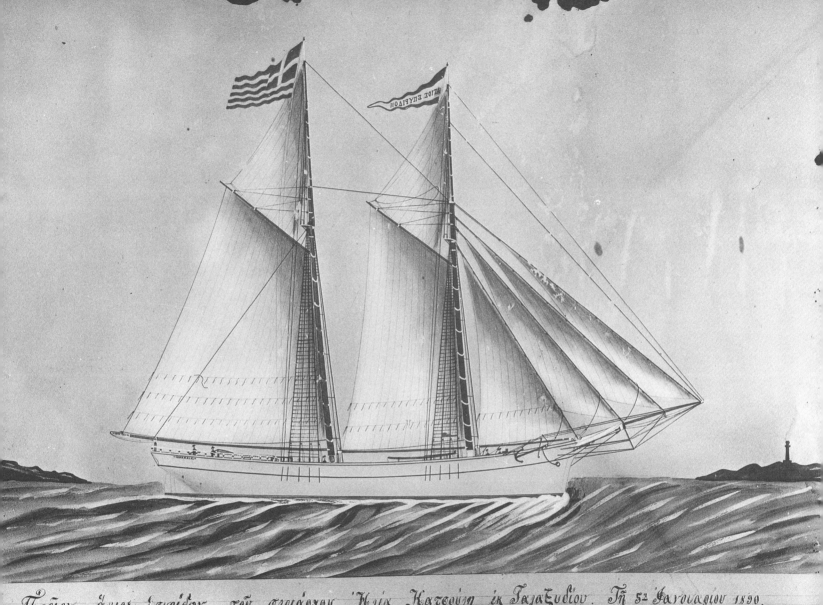

Πλοῖον ἅγιος Σπυρίδων τοῦ ἀρχιάρχου Ἠλία Κατσούλη ἐκ Γαλαξειδίου. Τῆ 5ᾳ Ἰανουαρίου 1890.

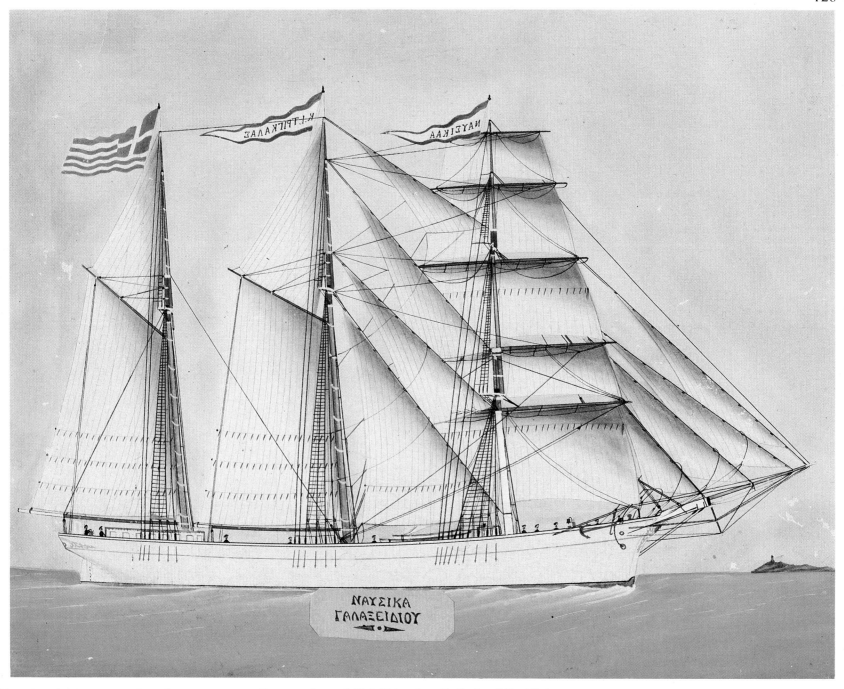

126 (242) NAFSIKA, watercolour, 51×62 cm. Barquentine of K I Tringalas. Built in Galaxidi in 1890; 297 tons

127 (268) M T Zachariadakis, ERMIS, watercolour, 51×70 cm. Brig of P T Papapetros. Built in Galaxidi in 1876; 382 tons

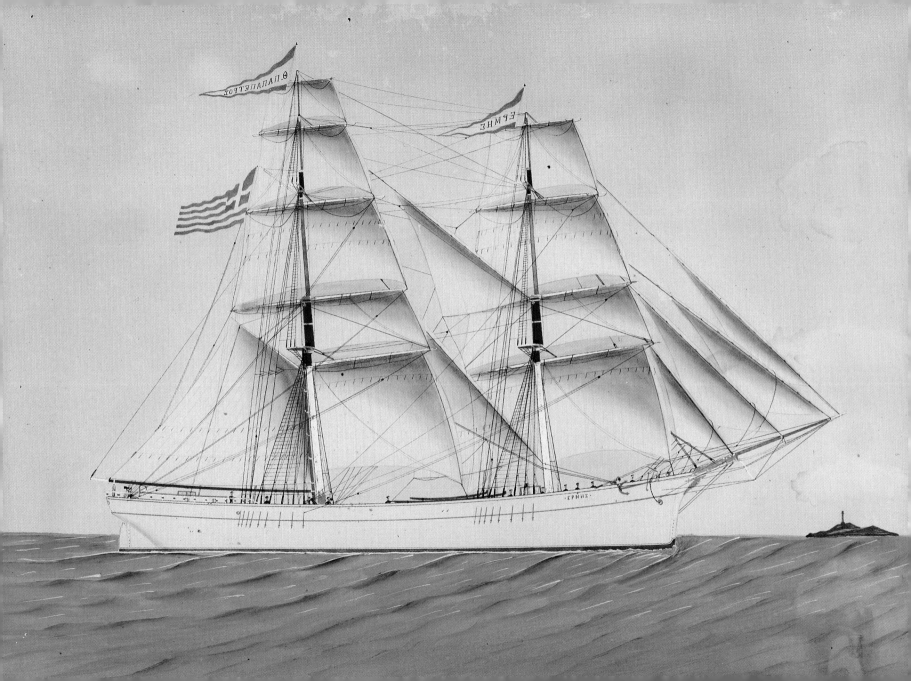

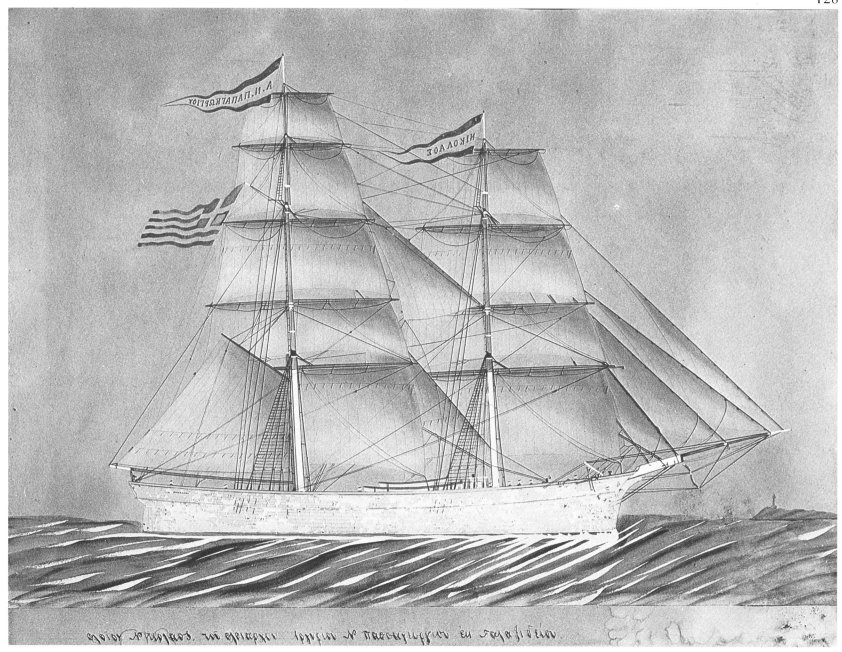

128 (223) NIKOLAOS, watercolour, 47×69 cm. Brig of Argyrios, Dimitrios, Georgios Papageorgiou, and Aikaterini, widow of Ioannis Papageorgiou. Built in Galaxidi in 1866; 241 tons

129 (215) PATIR, watercolour, 47×62 cm. Brig of Efthymios S Oikonomou. Built in Galaxidi in 1873; 251 tons

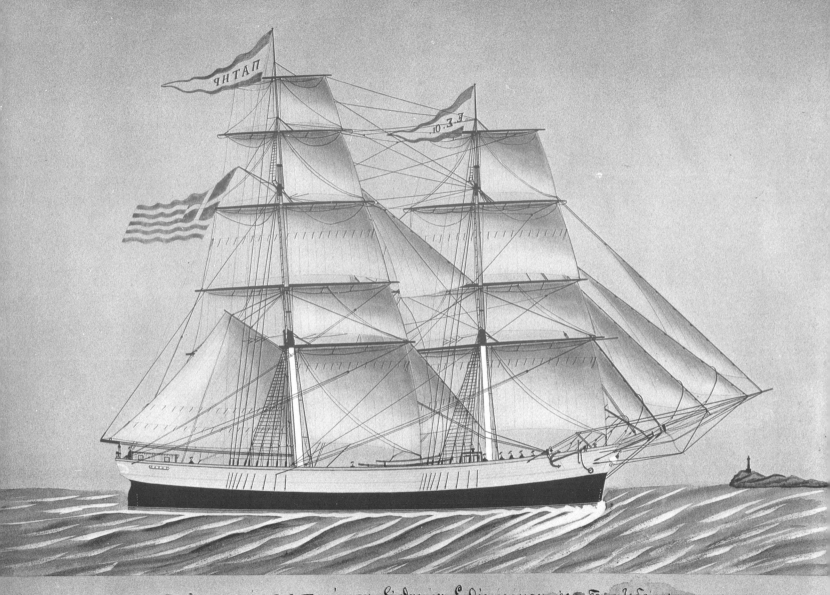

Πλοῖον σατήρ τοῦ πλοιάρχου Εὐθυμίου Σ. Οἰκονόμου ἐκ Γαλαξιδίου

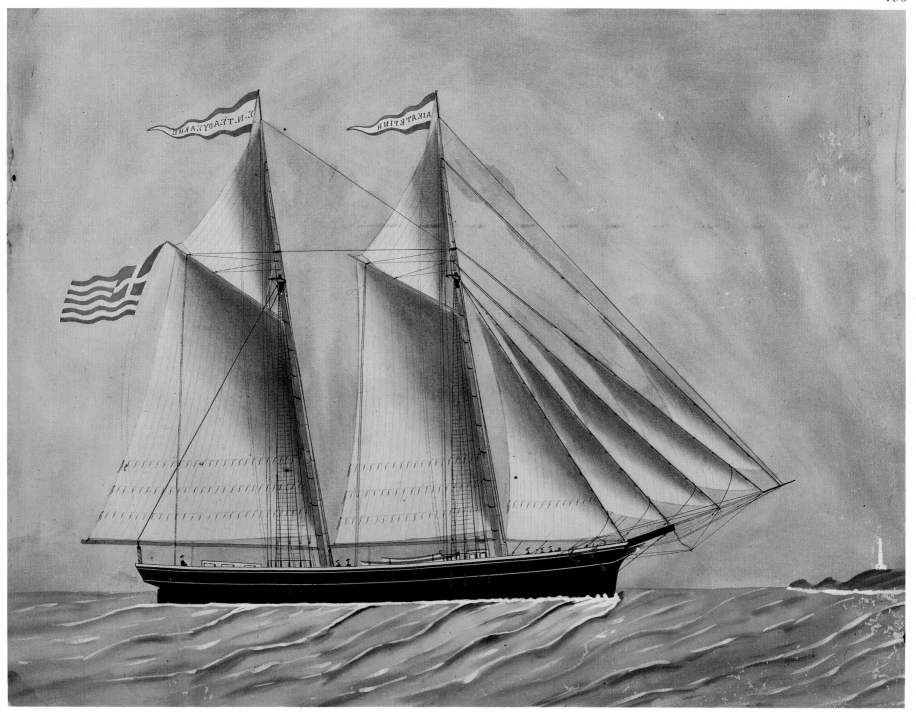

130 (614) AIKATERINI, *watercolour*, 50×65 *cm. Lover of S N Tsaousakis. Built in Galaxidi in* 1881; 60 *tons*

131 (309) PAVLOS, watercolour, 49×68 *cm. Lover of Panagiotis Papadopoulos and D Kavasilas. Built in Galaxidi in* 1895; 116 *tons*

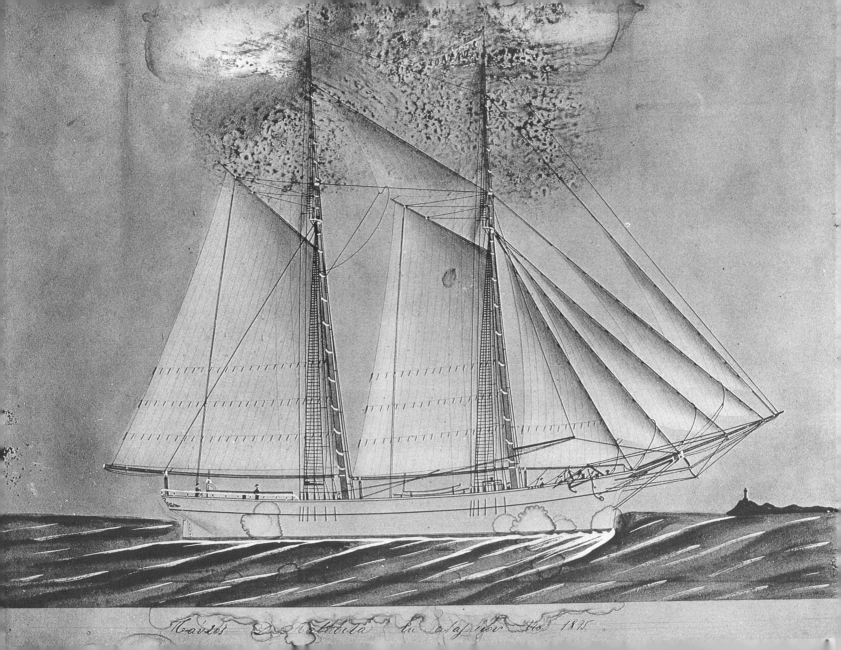

Navío ... la ... 1875.

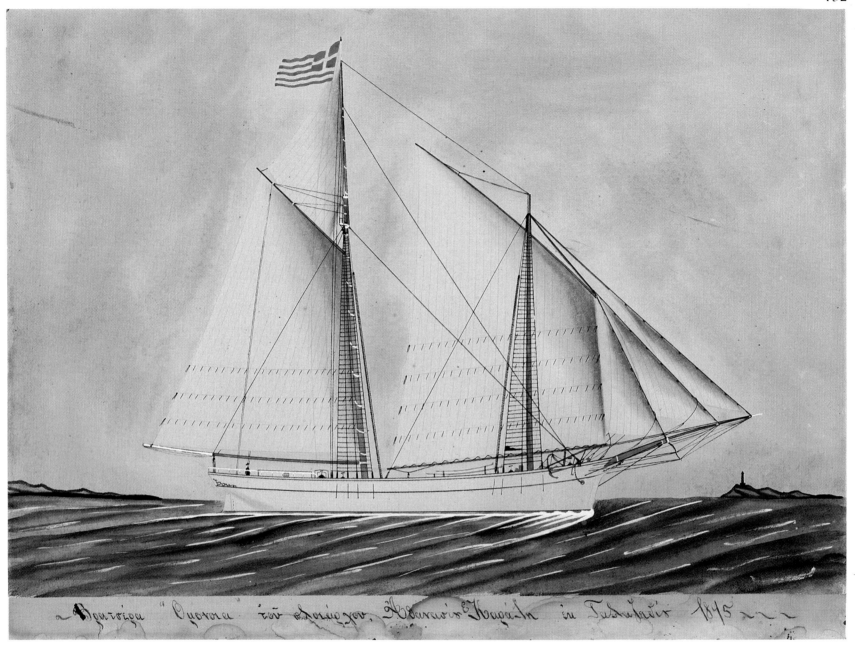

132 (302) OMONOIA, watercolour, 49×68 cm. Randopsathi, lug-sail randan, of Athanasios E Karalis. Built in Galaxidi in 1895; 50 tons

133 (277) PAVLOS, watercolour, 48×67 cm. Lover of Panagiotis Papadopoulos and D Kavasilas. Built in Galaxidi in 1895; 116 tons

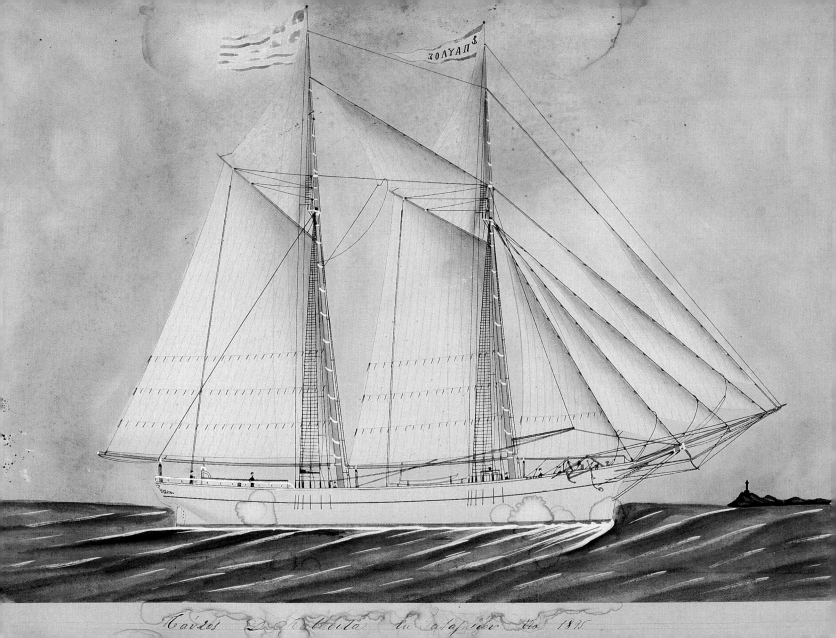

ΖΟΛΥΑΠ

Παΰλος Δ. Καββαδία ἐκ Σαλαμίνων ἔτο 18..

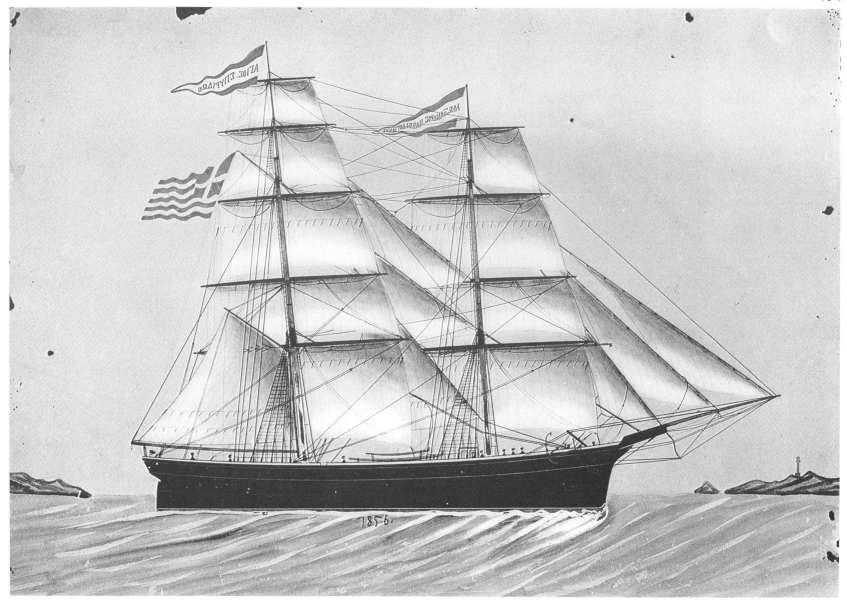

134 (251) AGIOS SPYRIDON, watercolour, 48×66 cm. Brig of Alexandros Papadogiannis. Built in Galaxidi in 1876; 188 tons

135 (252) TREIS IERARCHAI, watercolour, 52×63 cm. Schooner of I G Mitropoulos. Built in Galaxidi in 1885; 277 tons

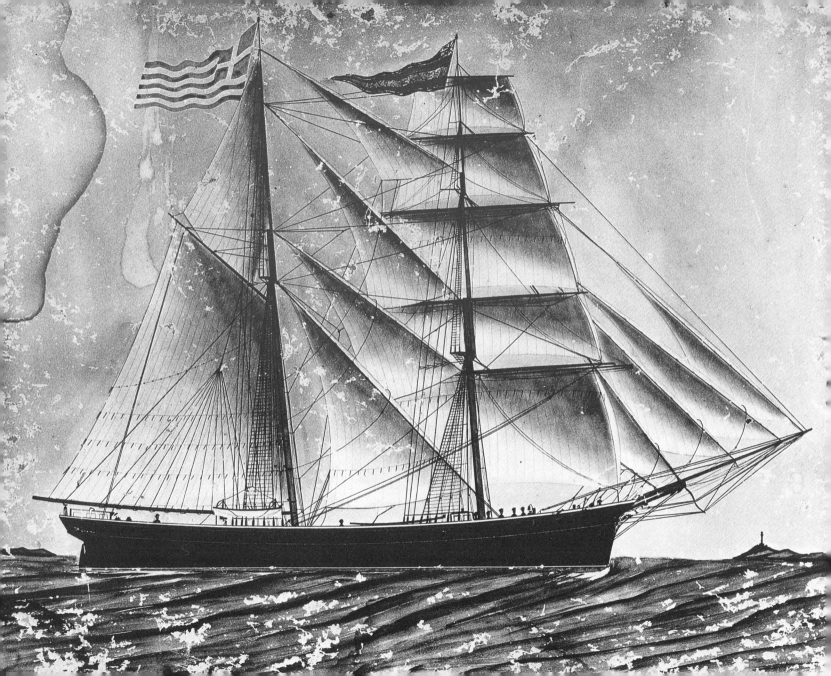

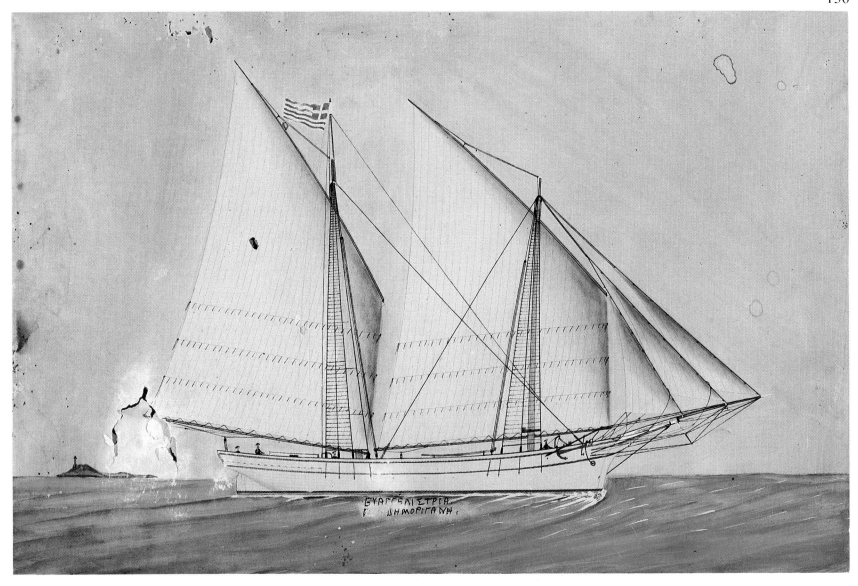

136 (312) EVANGELISTRIA, watercolour, 47×68 cm. Brazzera of Georgios Dimoriganis. Built in Galaxidi in 1897

137 (271) FANEROMENI, watercolour, 48×64 cm. Schooner of Dimitrios Perdikis. Built in Galaxidi in 1893

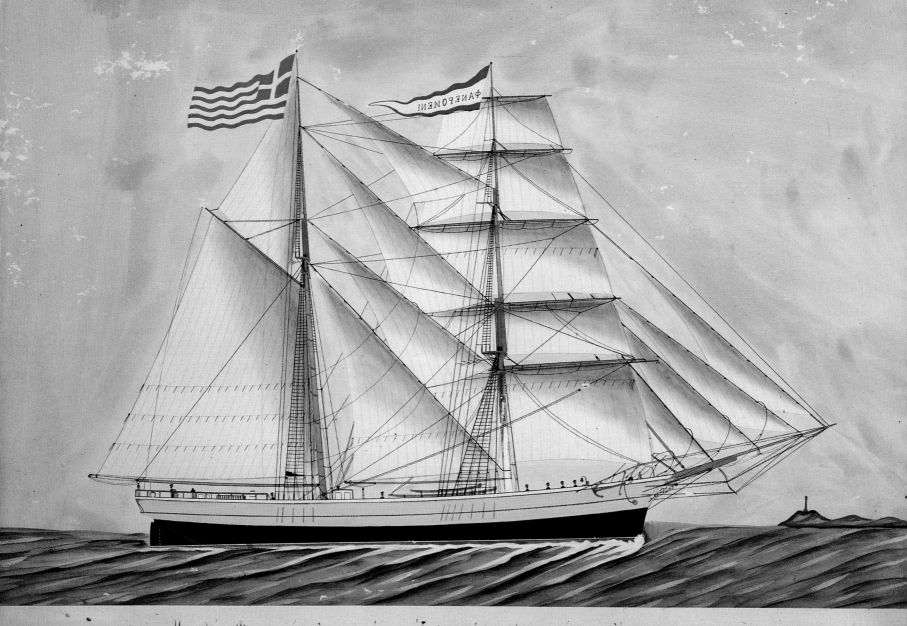

ΦΑΝΕΡΟΜΕΝΗ

Ιστιοφόρον Φανερωμένη 1893

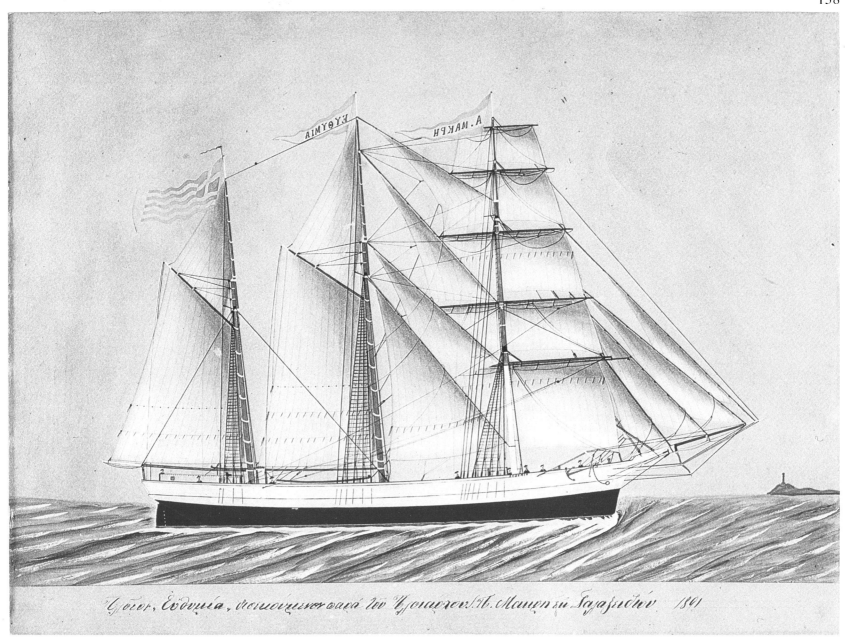

138 (238) EFTHYMIA, watercolour, 50×69 cm. Barquentine of the brothers P Makris. Built in Galaxidi, 1891, by Master-builder Konstantinos M Papapetros; 179 tons

139 (329) ILIAS, watercolour, 50×69 cm. Brig of K I Tringalas. Built in Galaxidi in 1877; 356 tons

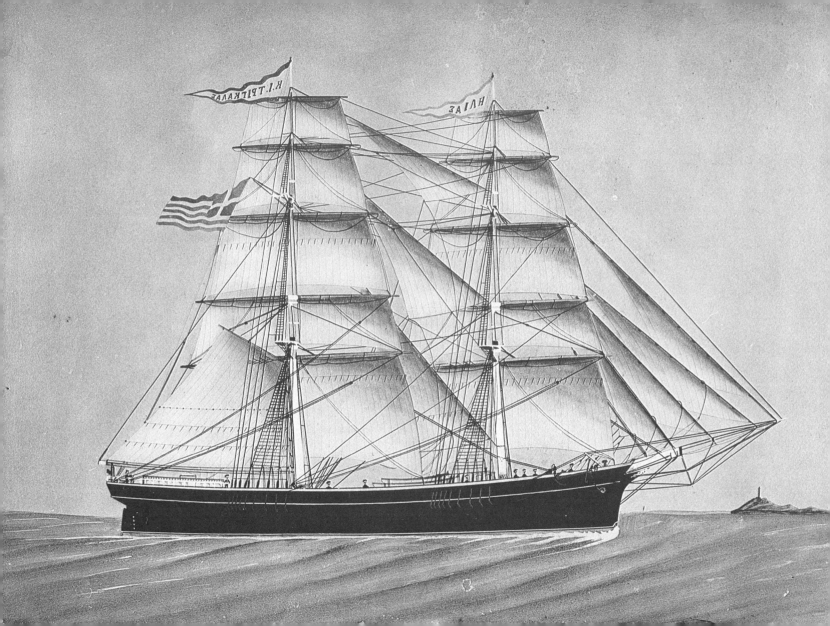

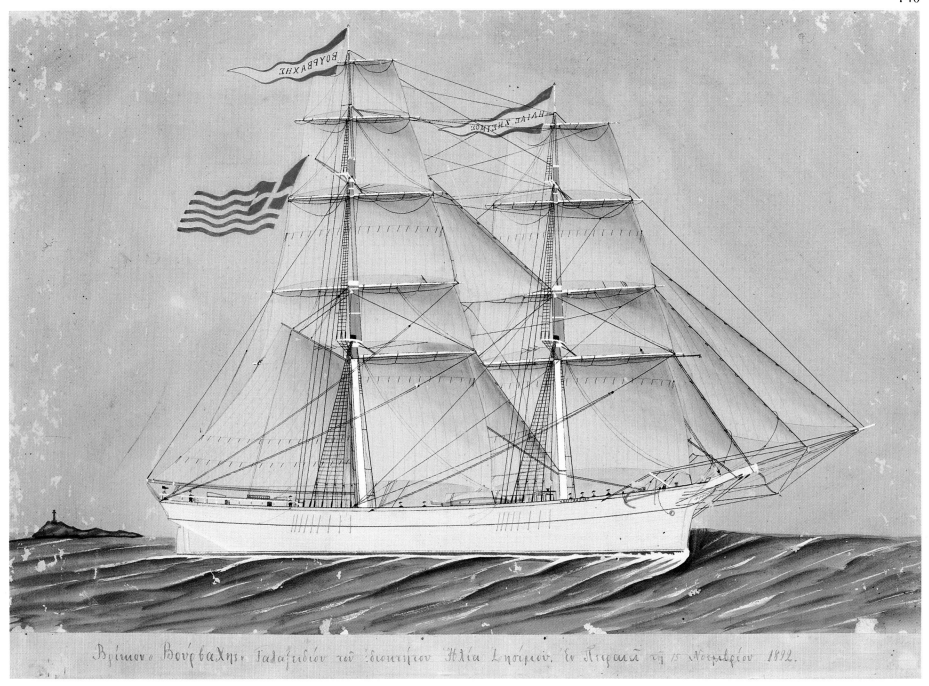

140 (297) VOURVACHIS, watercolour, 48×68 cm. Brig of Ilias Zisimos. Built in Galaxidi in 1890; 340 tons

141 (230) Michail Theodosiou, AGIOS NIKOLAOS, watercolour, 57×71 cm, Smyrni, on 20 February 1887.
Brig of Ioannis I Douratsinos. Built in Galaxidi in 1887; 285 tons

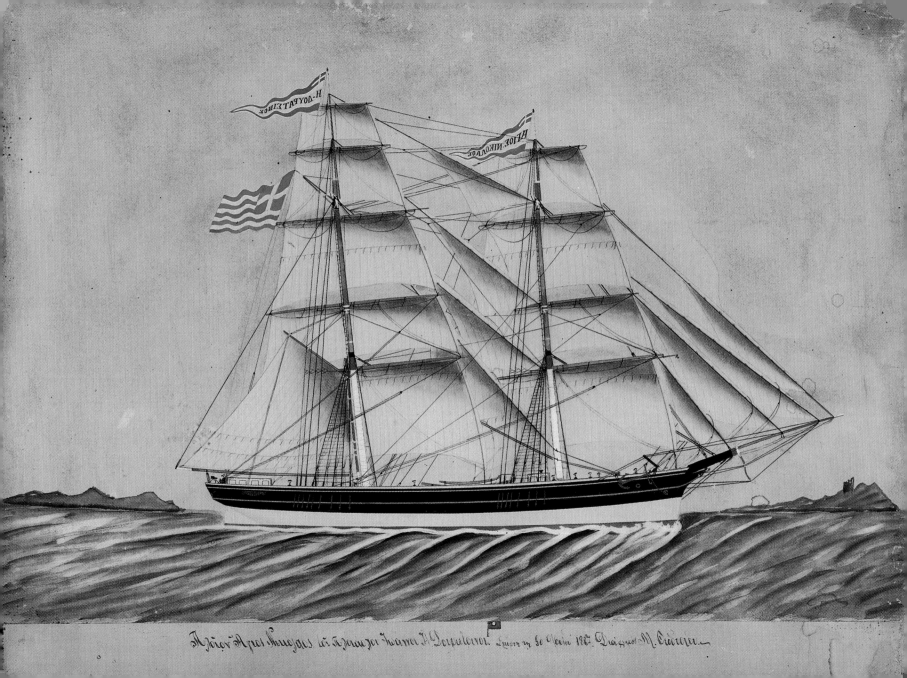

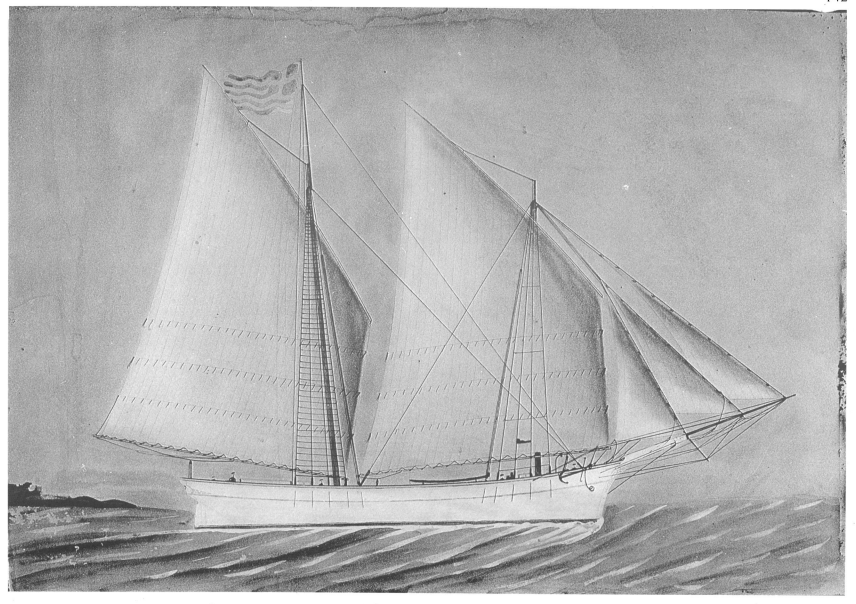

142 (402) *AGIOS DIONYSIOS, watercolour, 49×65 cm. Brazzera of Stavros Georgantas. Built in Galaxidi in 1881; 48 tons*

143 (288) *GEORGIOS TRIANTIS, watercolour, 45×65 cm. Brazzera of Andreas Bobogiannis. Built in Galaxidi in 1886; 46 tons*

Άγιος · Νικόλαος τοῦ Πλοιάρχου Γεωργίου Μέντη ἐν Γαλαξειδίῳ Ἔργον Μιχαὴλ Θεοδοσίου

144 (588) *Michael Theodosiou, AGIOS NIKOLAOS, watercolour, 47×64 cm. Brazzera of Georgios Mentis. Built in Galaxidi in 1881; 48 tons*

145 (267) *TREIS ADELFOI, watercolour, 44×64 cm. Lover of Drosos Drosopoulos. Built in Galaxidi in 1882: 61 tons*

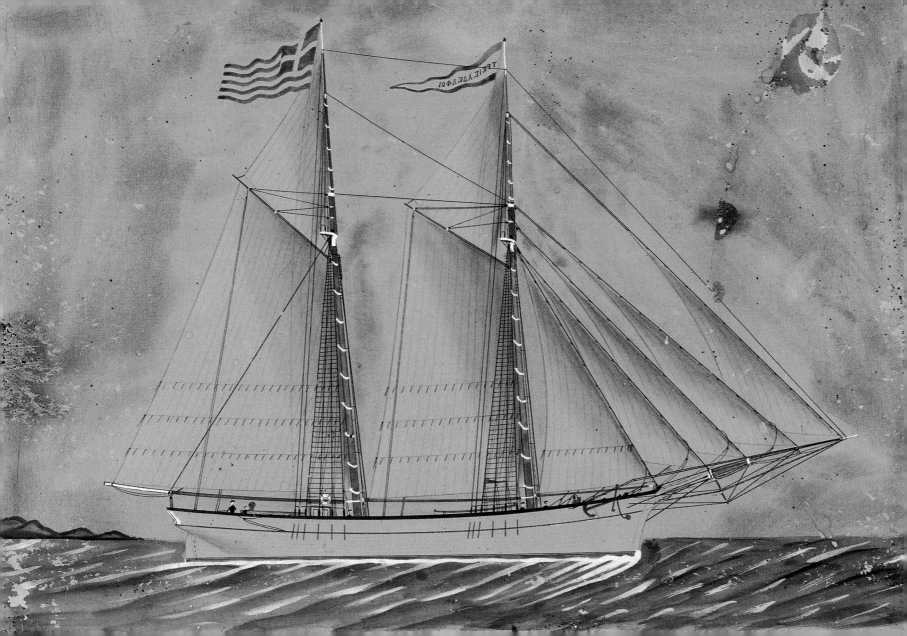

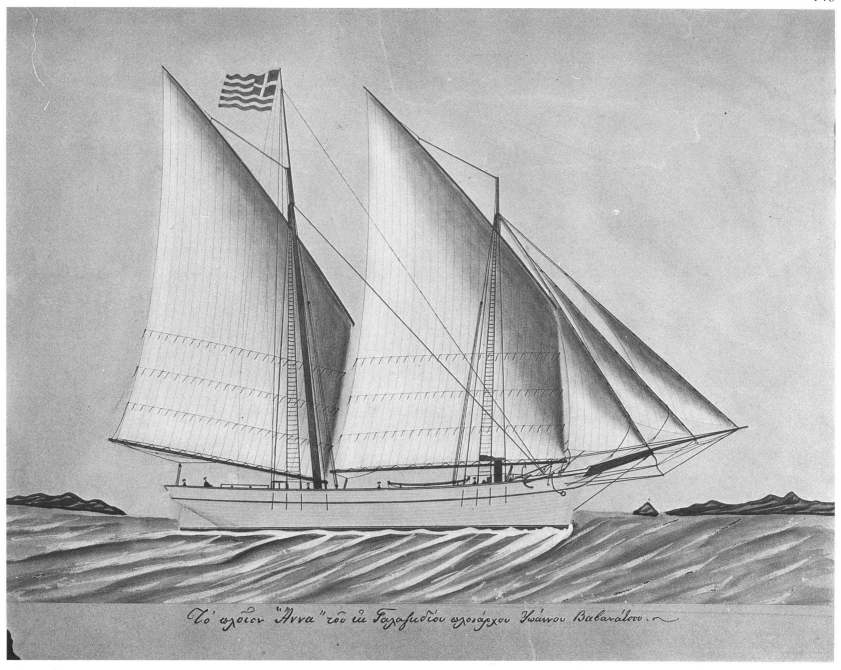

Τὸ πλοῖον "Ἄννα" τοῦ ἐκ Γαλαξειδίου πλοιάρχου Ἰωάννου Βαβανάτσου.

146 (281) ANNA, watercolour, 48×63 cm. Brazzera of Ioannis Vavanatsos. Built in Galaxidi in 1892; 50 tons

147 (256) SOFIA, watercolour, 48×67 cm. Schooner of Anastasios Loufas. Built in Galaxidi in 1892; 337 tons

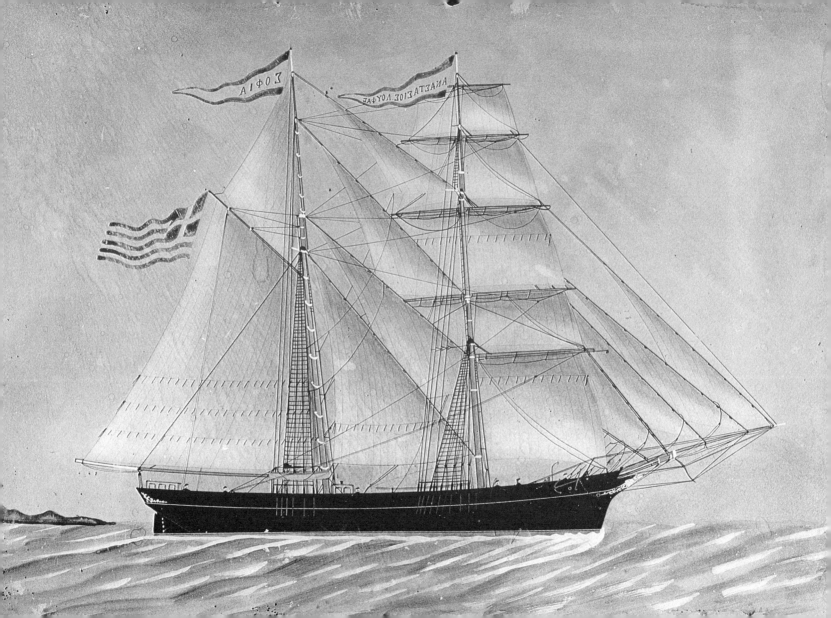

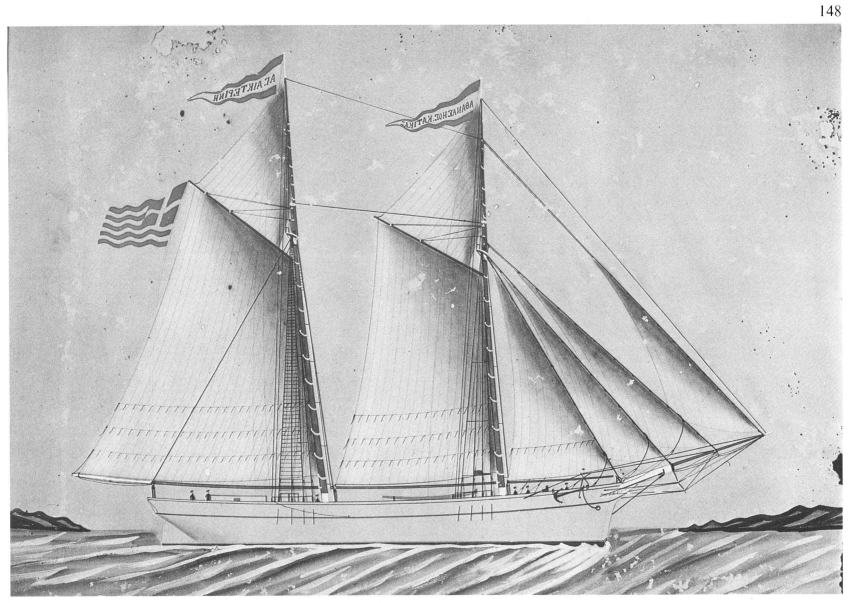

148 (306) *AGIA AIKATERINI, watercolour, 48×63 cm. Lover of Dimitrios A Katikas. Built in Galaxidi in 1887*

149 (575) *KARTERIA, watercolour, 45×65 cm. Brazzera of Konstantinos S Zagoras and Sideris K Zagoras. Built in Galaxidi in 1876; 44 tons*

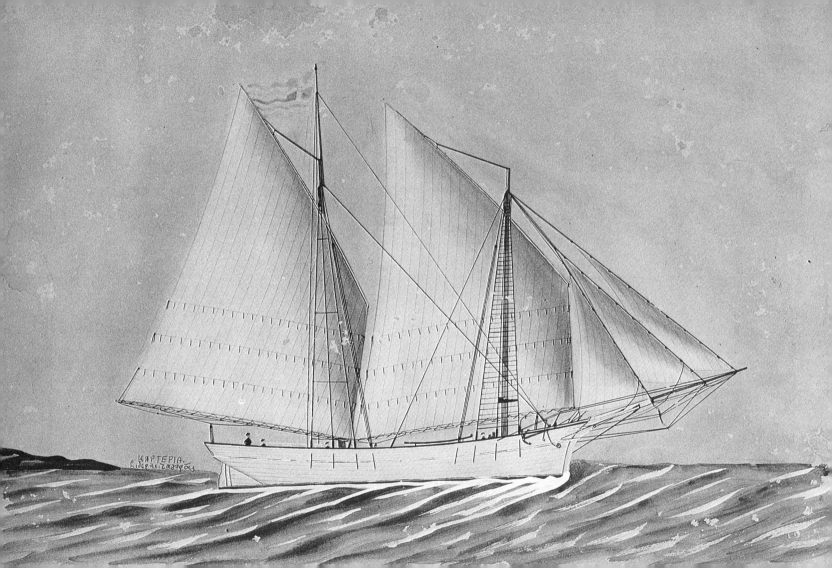

ΚΑΡΤΕΡΙΑ.
Σιδέρης Ζαφείρης

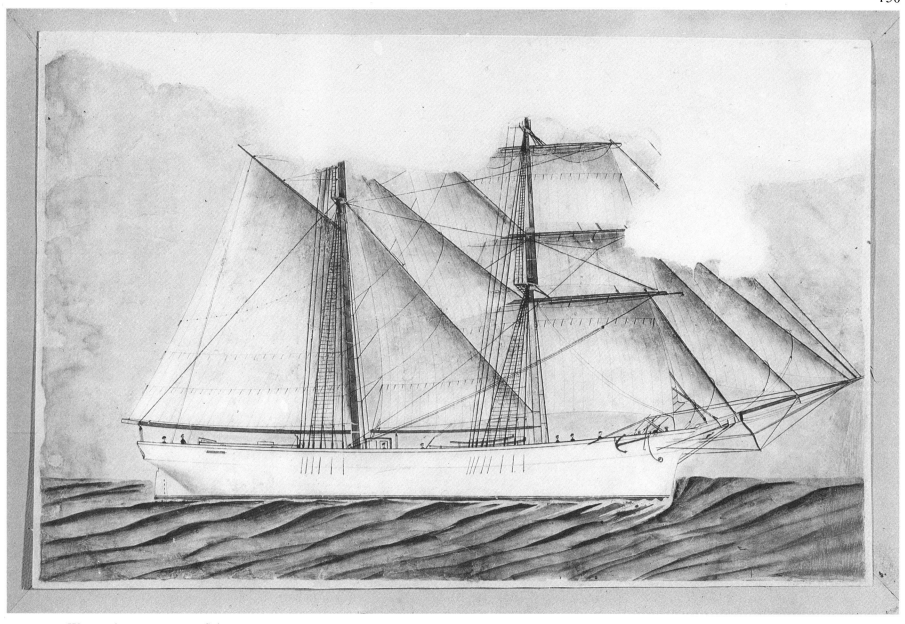

150 (523) Watercolour, 37×60 cm. Schooner

151 (222) GEORGIOS, watercolour, 47×63 cm. Schooner of Ilias A Andreopoulos. Built in Galaxidi; 182 tons

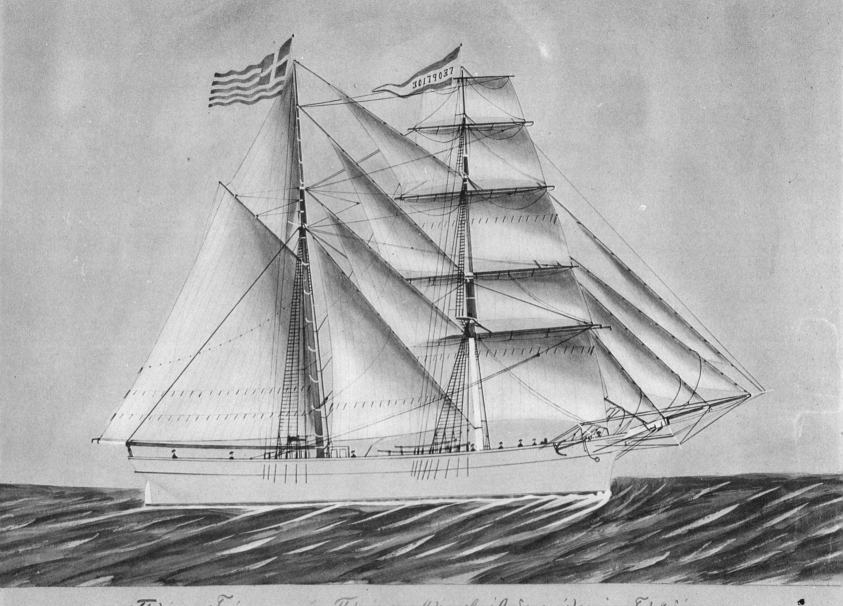

Πλοῖον Γεώργιος τοῦ Πλοιάρχου Ἀθα Δ. Ἀνδρεοπούλου ἐκ Γαλαξειδίου.

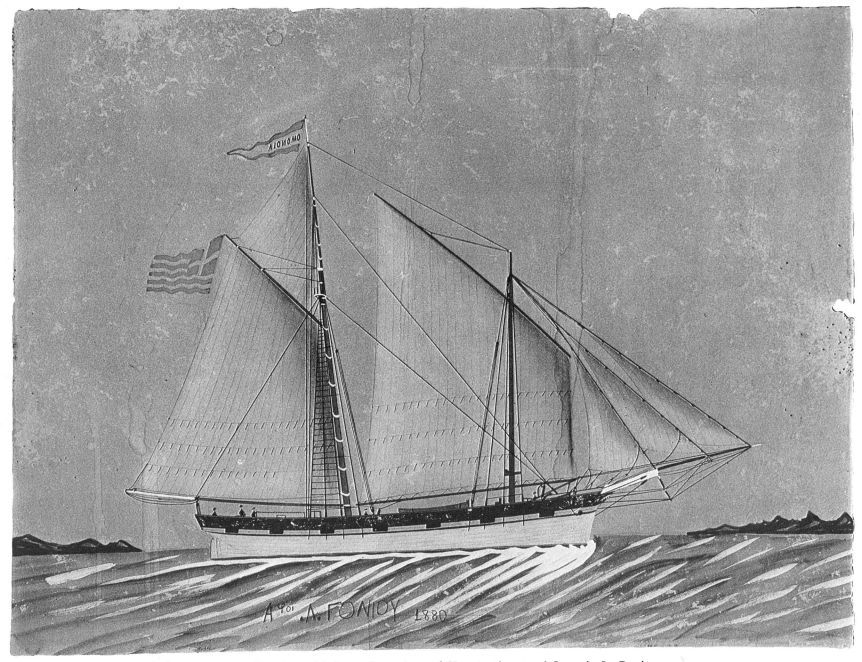

152 (311) *OMONOIA, watercolour,* 50×65 cm. *Randopsathi, lug-sail randan, of Konstantinos and Ioannis L Gonios.*
·*Built in Galaxidi in* 1880; 50 tons

153 (250) *AGIOS KONSTANINOS, watercolour,* 51×73 cm. *Brazzera of G Gaveras. Built in Galaxidi*

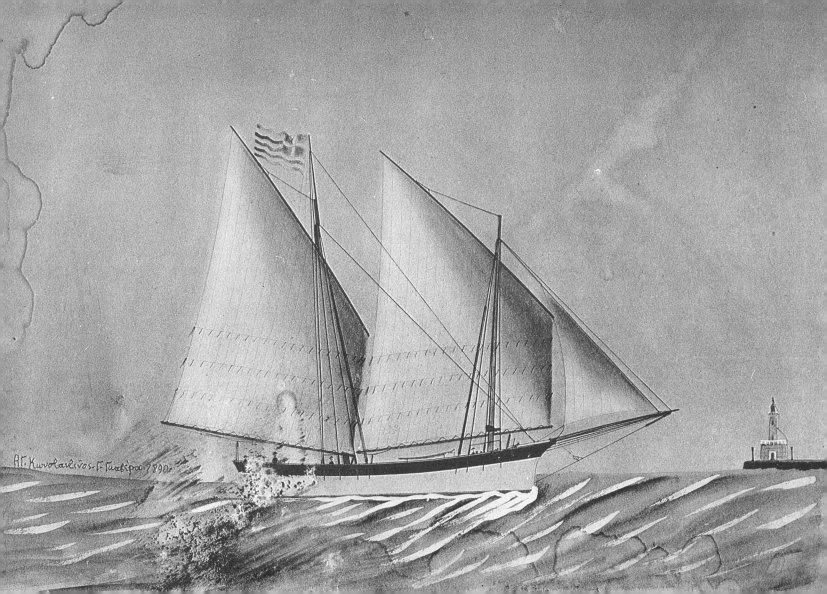

Α.Γ. Κωνσταντίνος Γ. Γολέτα 1890

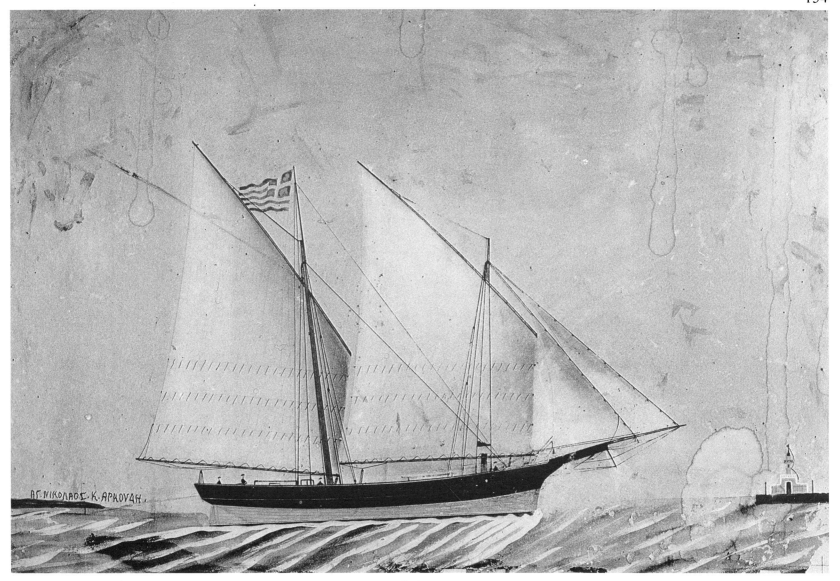

154 (291) AGIOS NIKOLAOS, watercolour, 41×62 cm. Brazzera of K Arkoudis. Built in Galaxidi

155 (314) AGIOS NIKOLAOS, watercolour, 49×64 cm. Brazzera of the brothers Chaldeakis. Built in Galaxidi in 1856

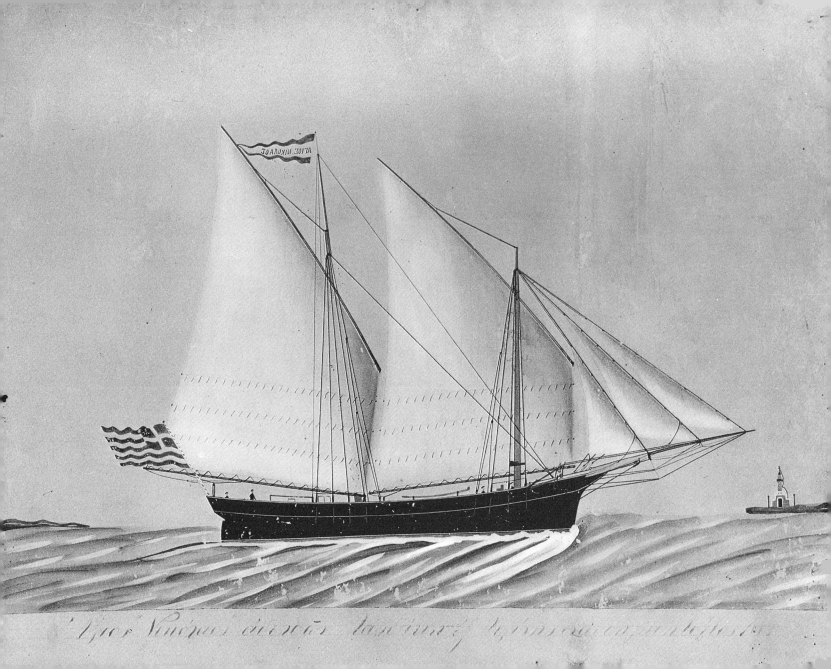

ΑΓΙΟΣ ΝΙΚΟΛΑΟΣ

Πλοῖον Γεώργιος Ἀδερφοὶ Μπουμπογιάννη ἐν Γαλαξειδίου. Μαΐου 21. Ἔτους. 1889.

156 (290) GEORGIOS, watercolour, 46×64 cm. Brazzera of the brothers Boubogiannis. Built in Galaxidi in 1877; 35 tons

157 (593) AGIOS PANTELE·I·MON, watercolour, 41×58 cm. Brazzera of Panagiotis A Koutroulias. Built in Galaxidi

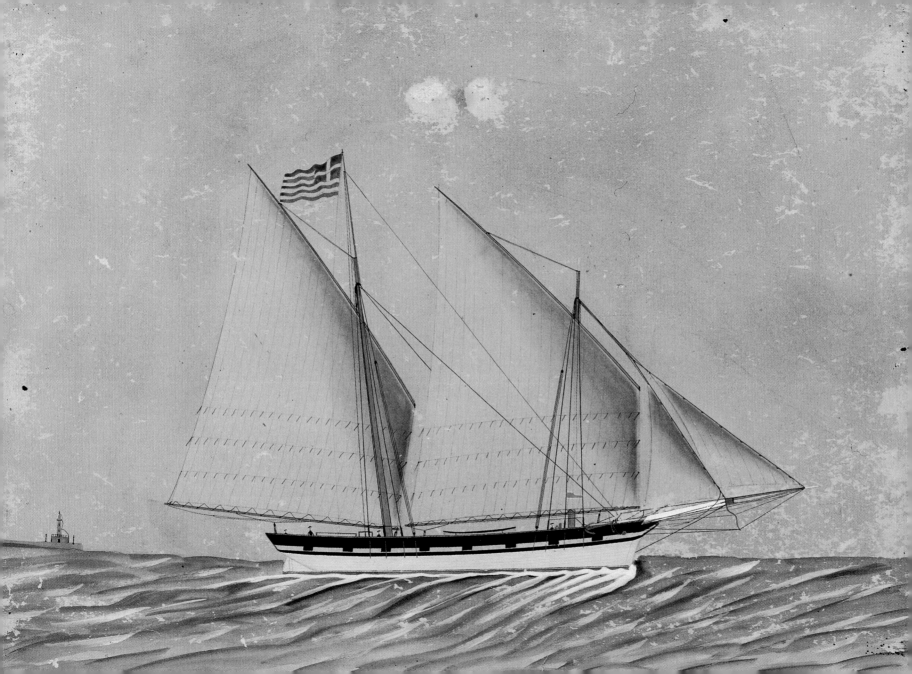

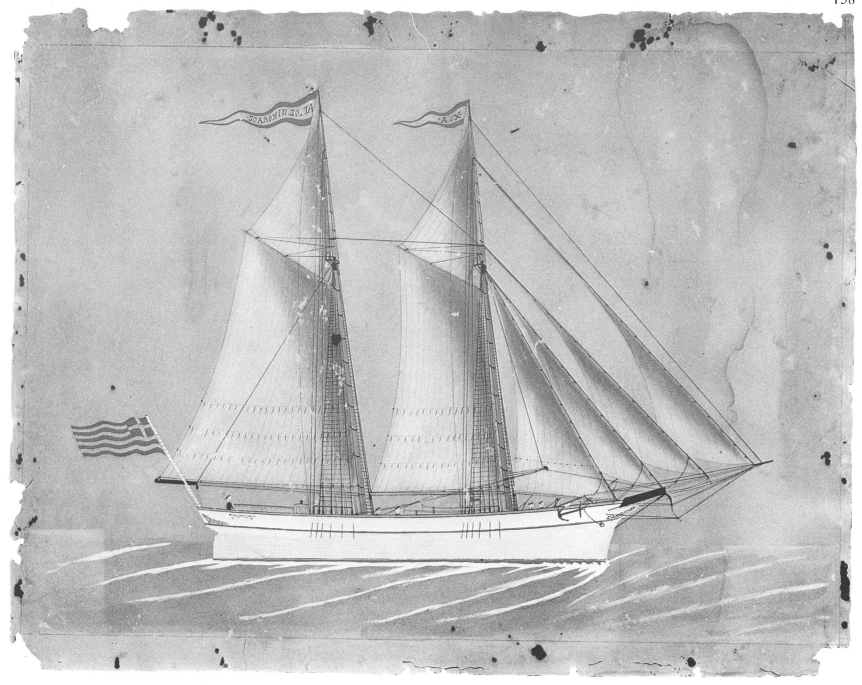

158 (304) *AGIOS NIKOLAOS, watercolour,* 50×65 *cm. Lover of Charalambos N Anatsitos. Built in Galaxidi in* 1879; 57 *tons*

159 (308) *ZEFS, watercolour,* 45×65 *cm. Brig of Ilias Zisimos. Built in Galaxidi in* 1876; 116 *tons*

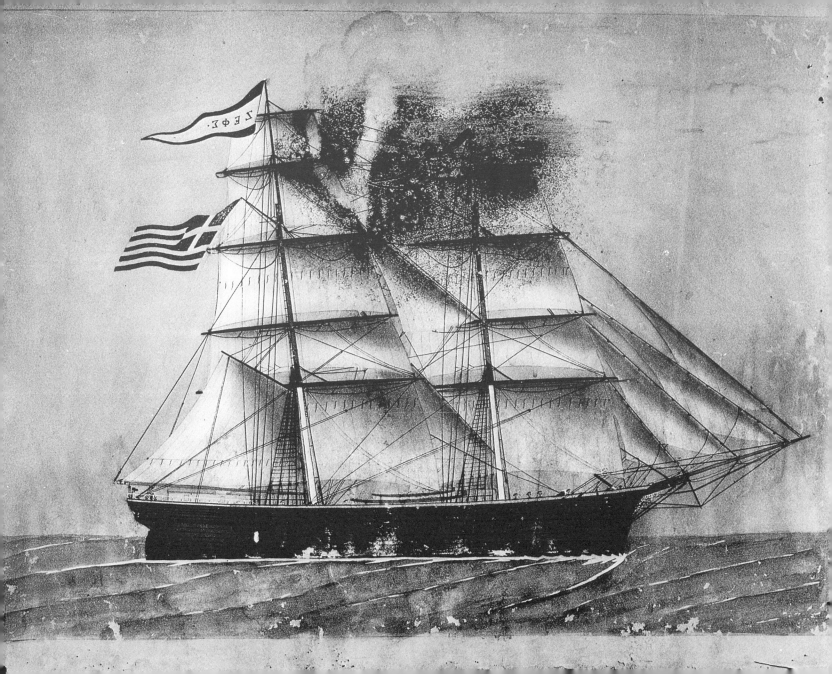

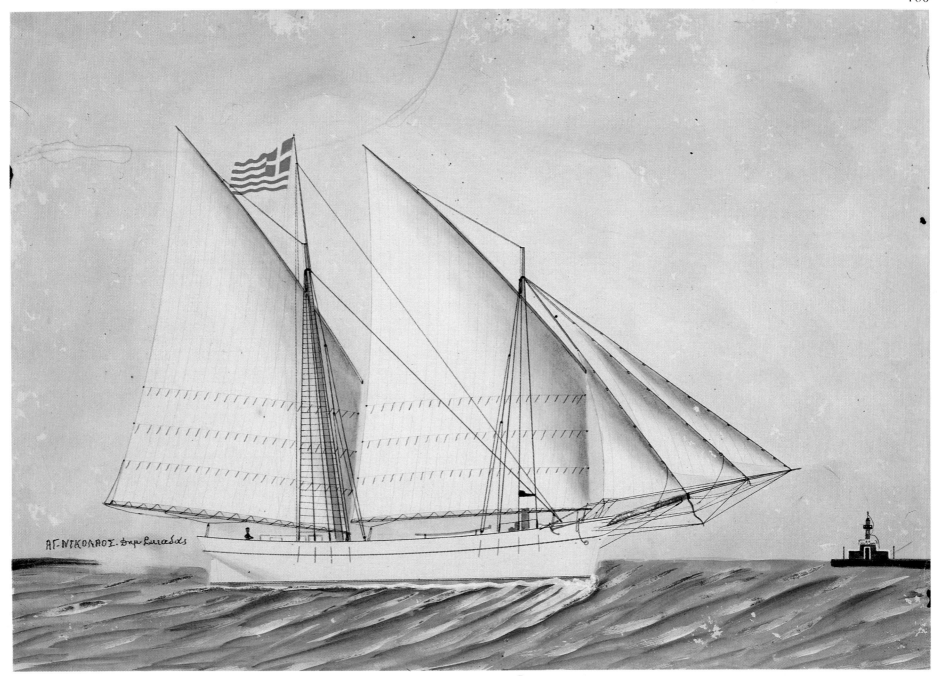

160 (313) AGIOS NIKOLAOS, watercolour, 49×66 cm. Brazzera of Dim. Skiadas. Built in Galaxidi in 1895; 57 tons

161 (254) AMFITRITI, watercolour, 40×64 cm. Brig of Efstathios Berestianos, the brothers Lialios and Rigopoulos. Built in Galaxidi in 1875; 216 tons

182

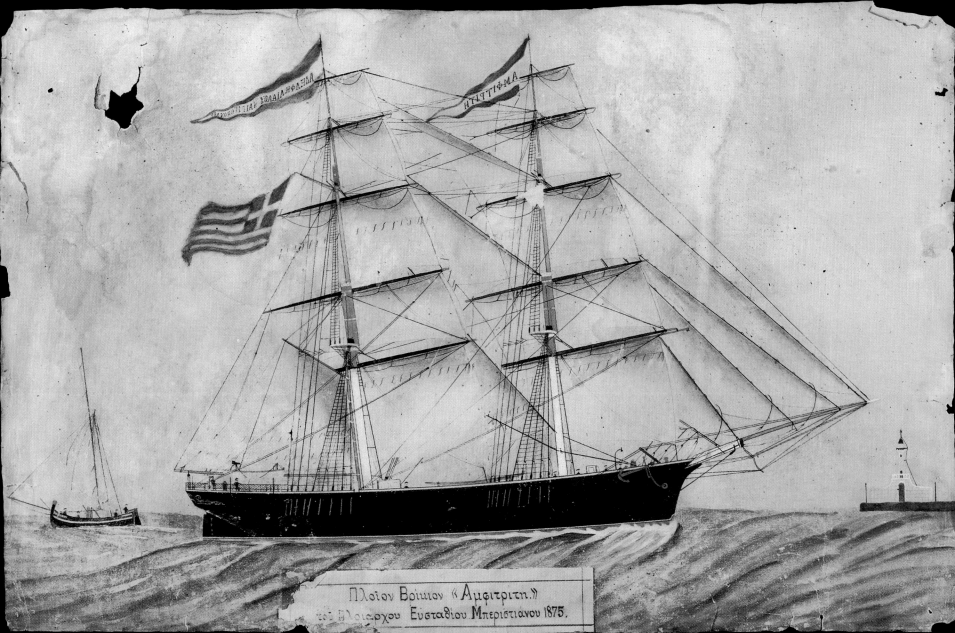

Πλοῖον Βρίκιον «Ἀμφιτρίτη.»
τοῦ Πλοιάρχου Εὐσταθίου Μπερίστιανου 1875.

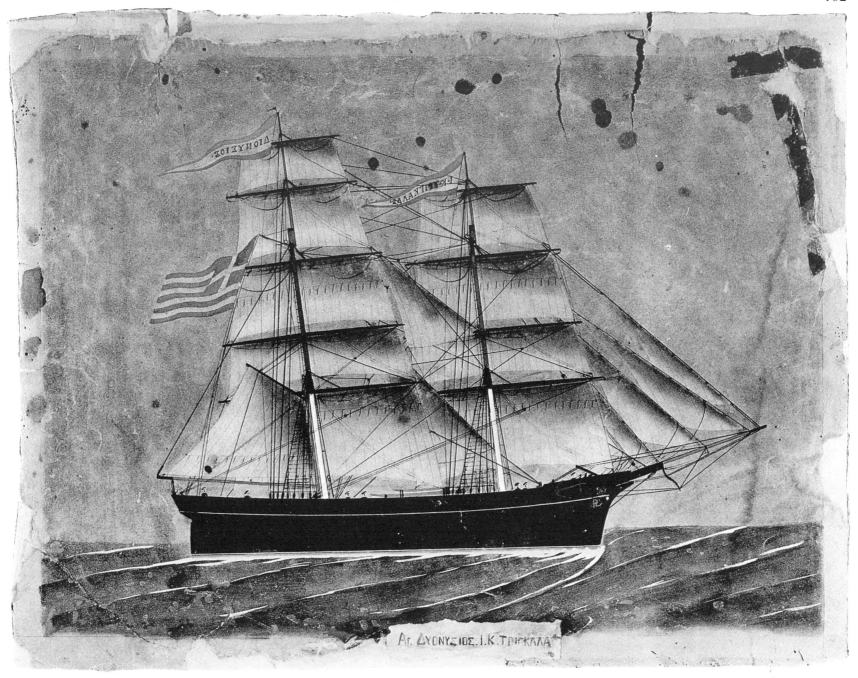

162 (360) *AGIOS DIONYSIOS, watercolour,* 41×55 *cm. Brig of I K Tringalas. Built in Galaxidi in* 1875; 127 *tons*

163 (203) *PATRIS, watercolour,* 38×58 *cm. Brig of Loukas Visvikis. Built in Galaxidi in* 1873; 281 *tons*

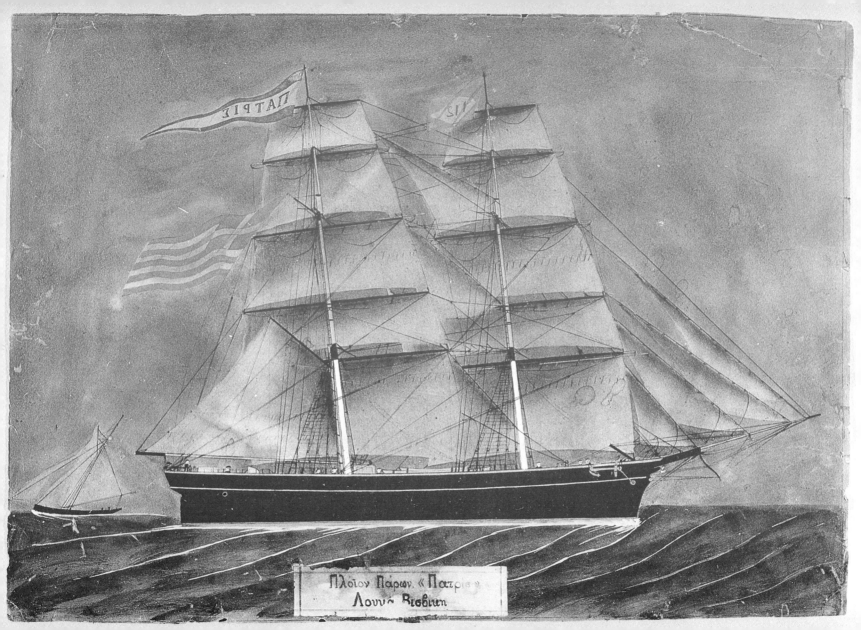

Πλοίον Πάρων «Πατρίς»
Λουης Βεσβικη

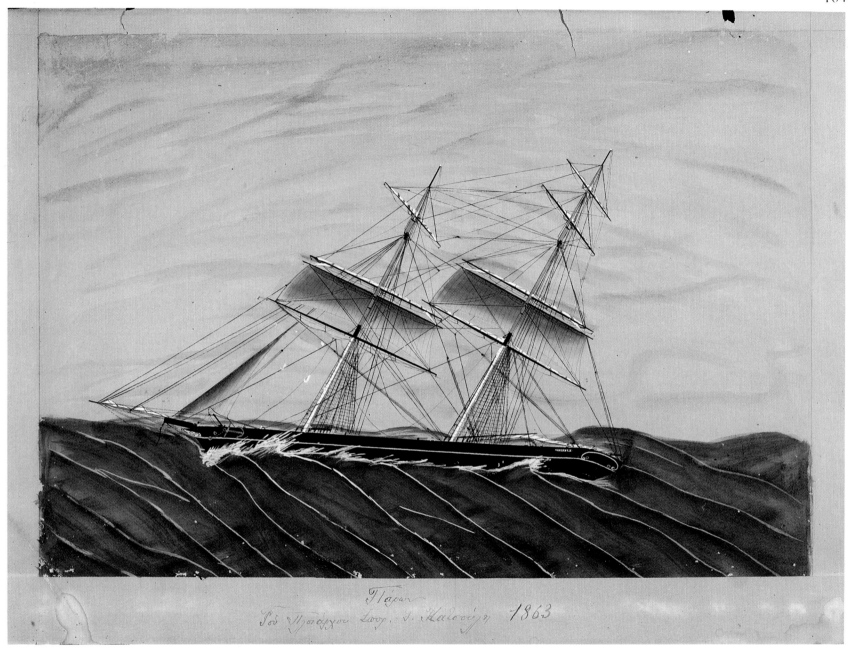

164 (261) PARON, watercolour, 35×75 cm. Brig of Spyros G Katsoulis. Built in Galaxidi in 1863

165 (412) EVANGELISTRIA, oil, 53×80 cm. Schooner of Andreas I Michalopoulos. Built in Galaxidi in 1885

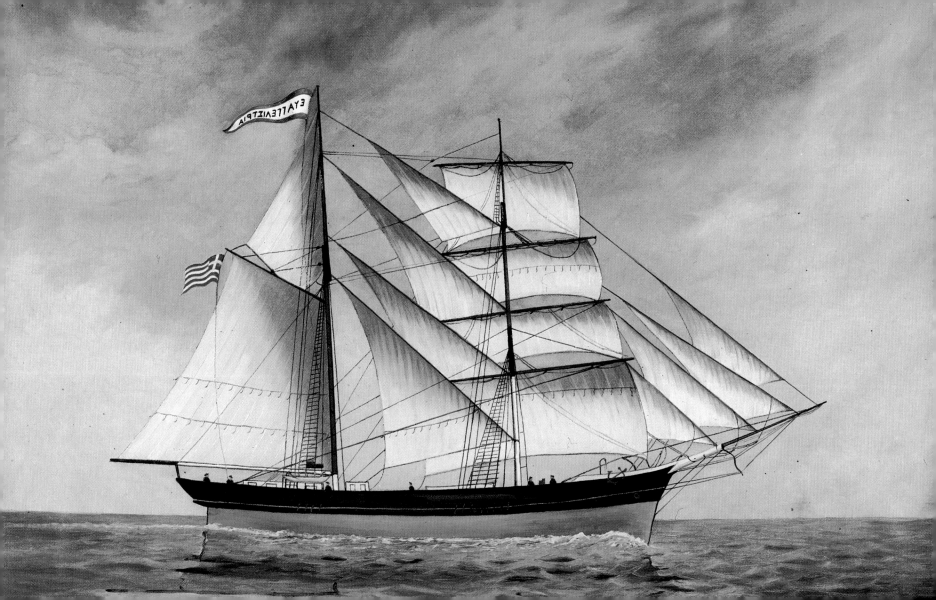

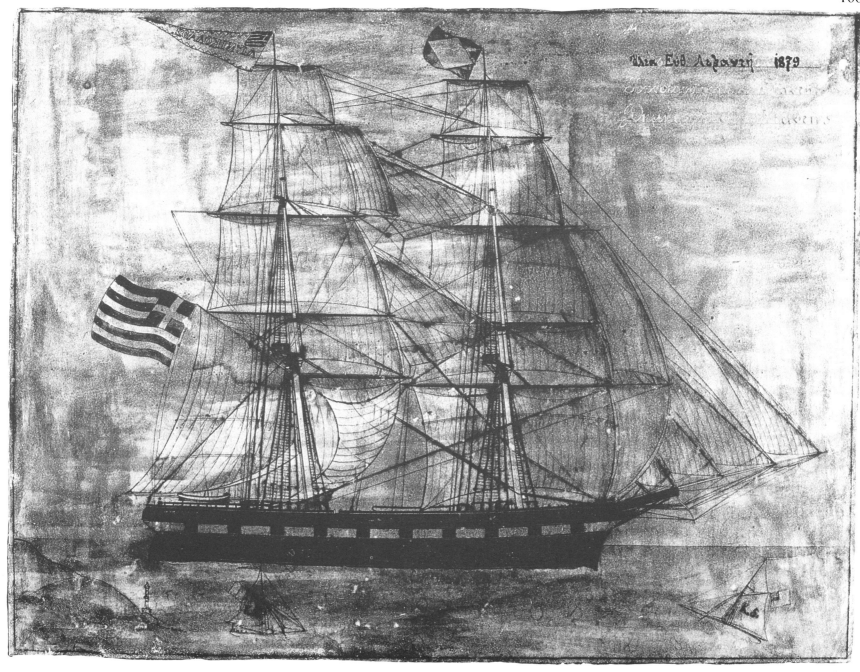

166 (265) *AGIOS NIKOLAOS*, watercolour, *46×62* cm. Brig of Ilias, Konstantinos, and Dimitrios Efth. Levantis. Built in Galaxidi
in *1879; 290* tons

167 (201) *ILIAS*, watercolour, *50×64* cm. Brig of S I Katikas. Built in Galaxidi in *1875; 326* tons

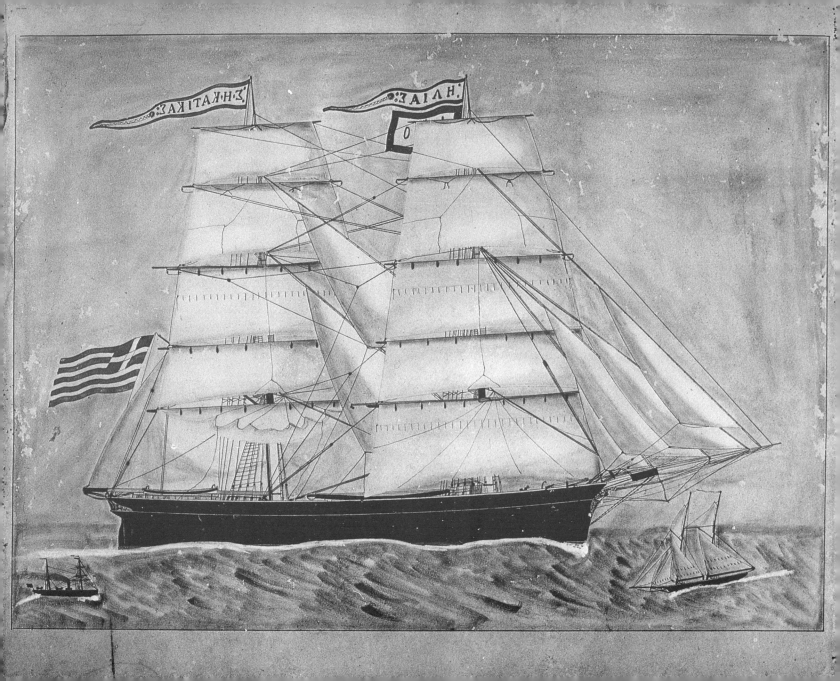

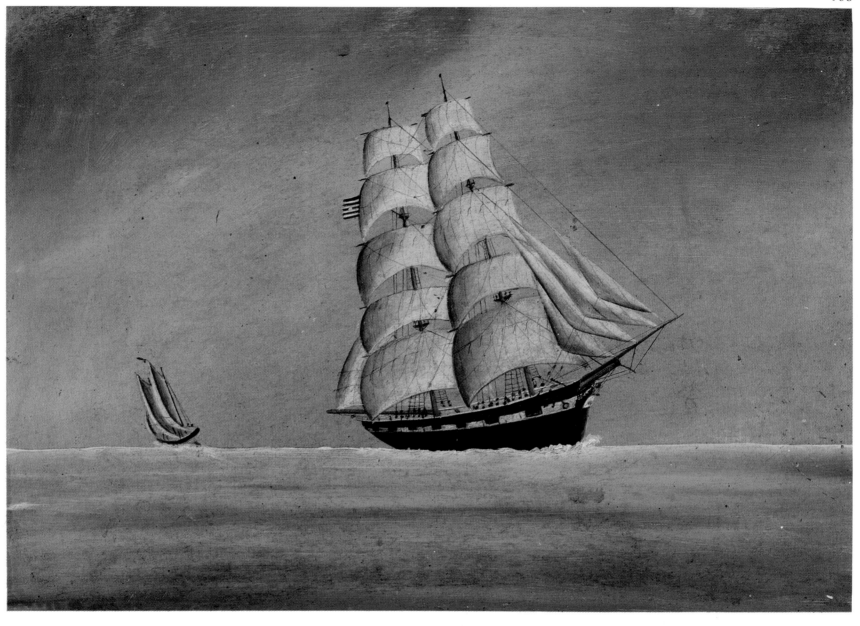

168 (334) Watercolour, 47×62 cm

169 (406) THE SINKING AND END OF THE SHIPWRECKED GREEK SHIP FROM GALAXIDI AT THE DESTRUCTIVE PLACE (THE ISLAND
OF) KOÚTALI, oil, 46×64 cm

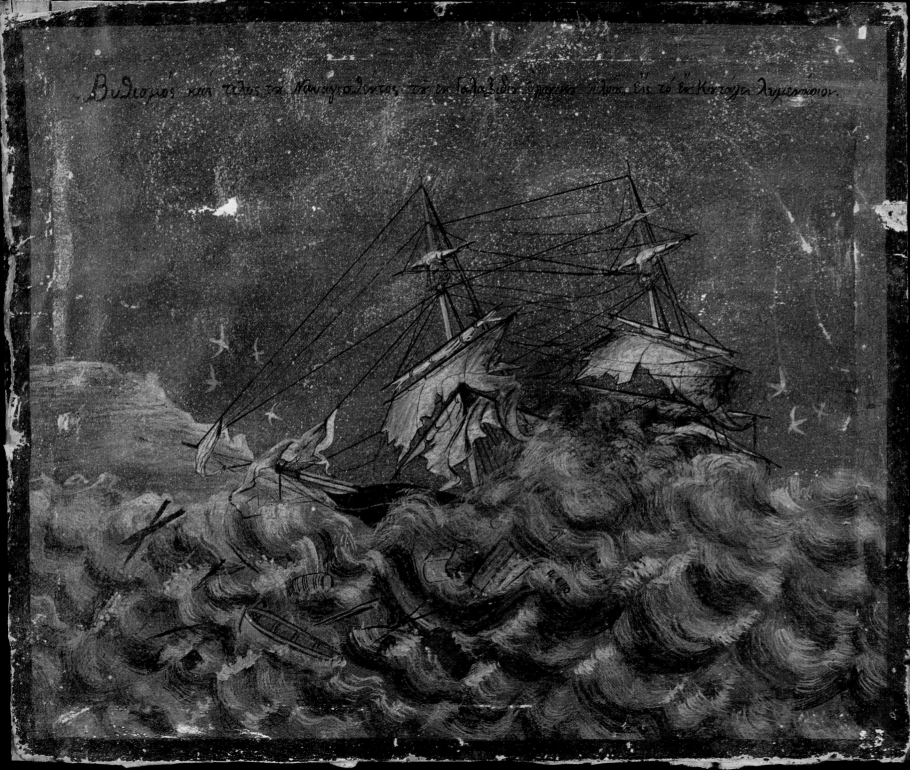

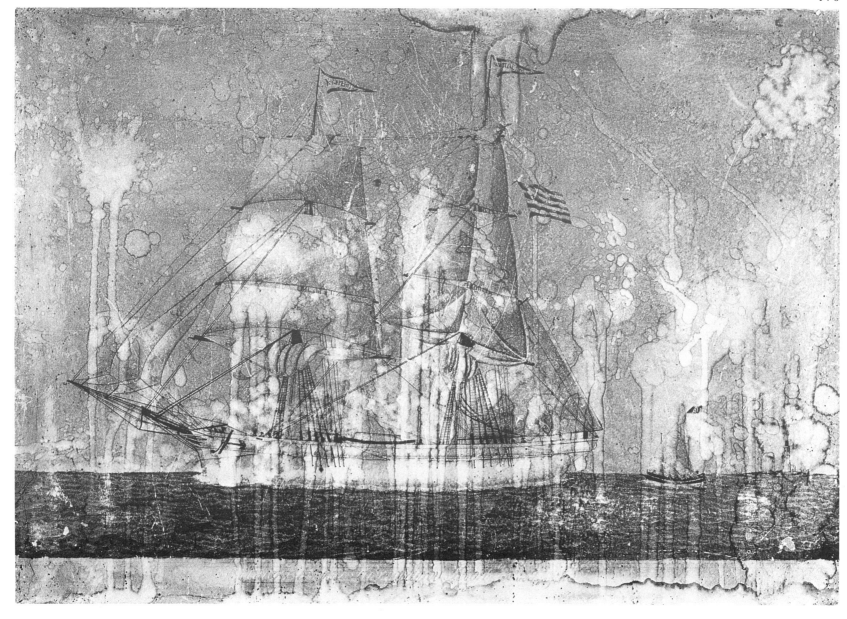

170 (286) PLESSA, watercolour, 60×85 cm. Brig of Konstantinos A Kourevelis. Built in Galaxidi in 1876; 210 tons

171 (232) KATINA, oil, 51×75 cm. Barquentine of Miltiadis and Athanasios Grigoriou. Built in Galaxidi in 1894; 372 tons

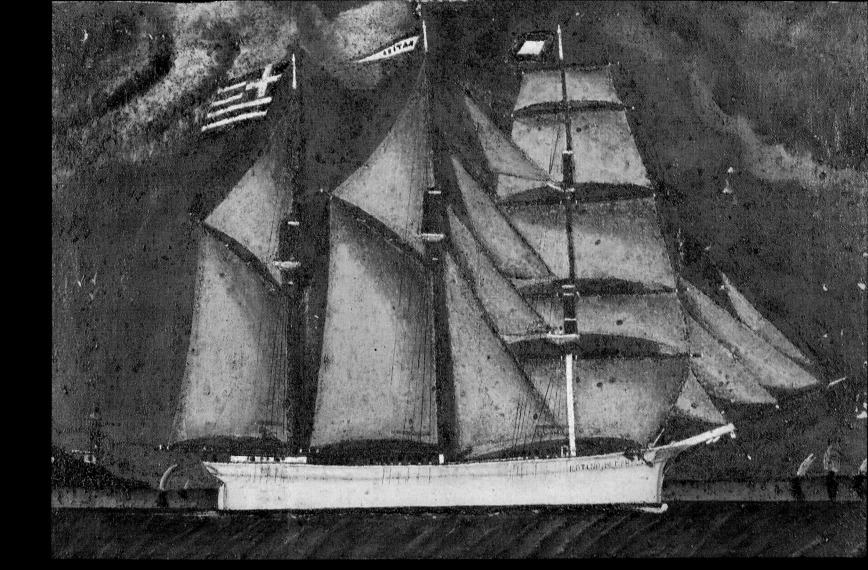

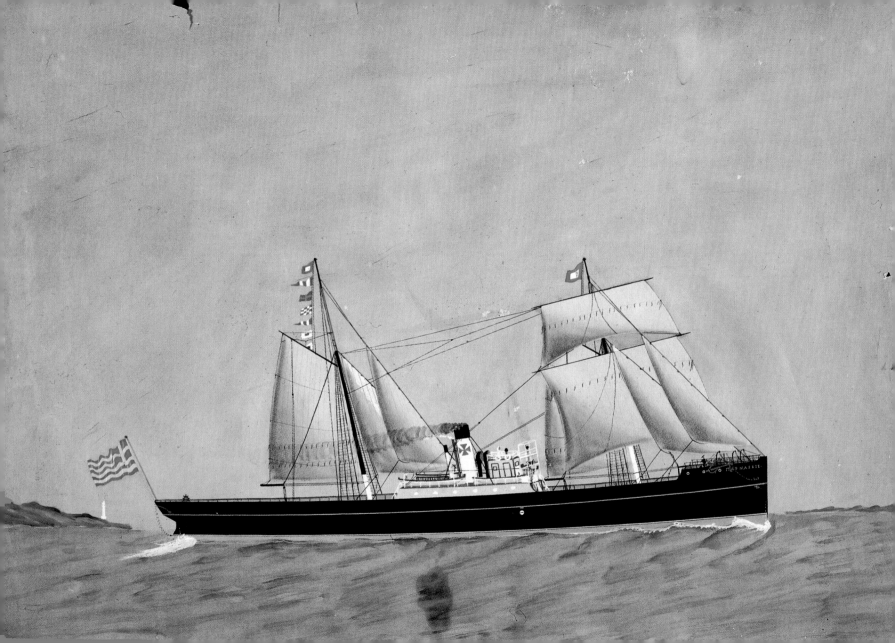

Steamships

The era of large sailing vessels in Galaxidi came to an end in the last decade of the nineteenth century. Decline set in, new ships were built only at increasingly longer intervals, the yards were gradually overgrown with weeds, and sails were eventually overtaken by steam.

Perhaps the people of Galaxidi were disappointed, because the first among them who had invested in steamships had not prospered. Perhaps they were unable to part with the sails, which for them were symbolic. At any rate, they did not go along with the times, writes Dedousis Chardavellas[1] in his book *Naftika*.

There were many Galaxidiotes, however, who tried to adjust to the new requirements and so they bought steamships. In 1883, the brothers E Koutsouleris, P Marlas, and K Tsipouras were the first to found a seamen's company[2] to buy the steamship PARNASSIS, pictures of whom we can see on Plates 172, 173 and 174. The same men bought the steamship ANNIKA (Pl 177) in 1885. In the unsigned picture of Plate 172 PARNASSIS, although a steamship, still preserves the sails and looks as if she had been painted by Greek hands, the style being reminiscent of M Theodosiou. While the picture on Plate 174 is also unsigned, it has the characteristic design of sea-waves and a large lighthouse at the stern of the vessel, which bring to mind foreign painters. We have the signature of L Roberto from Naples on the picture of Plate 173. Mount Vesuvius and the houses in the port are at the prow of the steamship. S/S PARNASSIS has in all three pictures the identification feature of Galaxidi sailing ships, as the lower parts of her masts the 'tourketa', are painted white. And so are the lower parts of the masts in the ANNIKA (Pl 177), whose picture was made by an unknown Greek painter.

The ANDROMACHI (Pl 175) carries on the tradition of white 'tourketa'. It does not have a painter's signature but could very well be the work of L Roberto again, as there is a representation of Mount Vesuvius in the picture. This steamship was also painted by Nina Angeli (Pl 176), and her picture is part of a private collection.

The steamship PATRIS (Pl 178) was painted by A Glykas; while it is almost certain that the AGLA·I·A KOURENTI (Pl 182) was painted by Antonio Luzzo in Venice, whose large buildings can be seen behind the prow. The white 'tourketa' stand out here, too.

The MINA (Pl 181) is the work of an unknown Greek painter, and so are the steamships ELENI I SIFNAIOU (Pl 180) and ZEUS (Pl 179). All three vessels had Galaxidi owners, and show the characteristic white 'tourketa', as does the unsigned picture of MARIA (Pl 185), which was painted by a foreign artist, showing Mount Vesuvius and Naples at the prow.

The three steamship pictures IONIA (Pl 184), THRAKI (Pl 183), and PANELLINION (Pl 186) do not have a painter's signature. The first two, which are painted on tin-plate and have representations of figureheads at the prows, could possibly be the work of the same artist. The PANELLINION is different in both style and palette from the other two. Although a steamship, she still has her sails and a female form as a figurehead at her prow. This steamship, belonging to the Greek Steamship Company (Elliniki Atmoploïki Etairia) or Steamships of Syros (Atmoploïa Syrou), together with steamships ARKADI and ENOSIS succeeded in breaking through the extremely tight siege the Turkish fleet was maintaining around the insurrected island of Crete in 1866, thanks to the bravery of their heroic captains Sourias, Kourentis, and Sourmelis. Having thus been supplied with provisions, men, and ammunition, the Cretans were able to fight on for another three years, at the end of which they gained many privileges.

Rodoula Stathaki-Koumari

NOTES

1 D E Chardavellas, *Naftika*, Athens 1948, p 63.

2 *Op cit*, p 88.

172 (323) PARNASSIS, watercolour, 54×77 cm. Steamship of the brothers Koutsouleris, P Marlas, and K Tsipouras

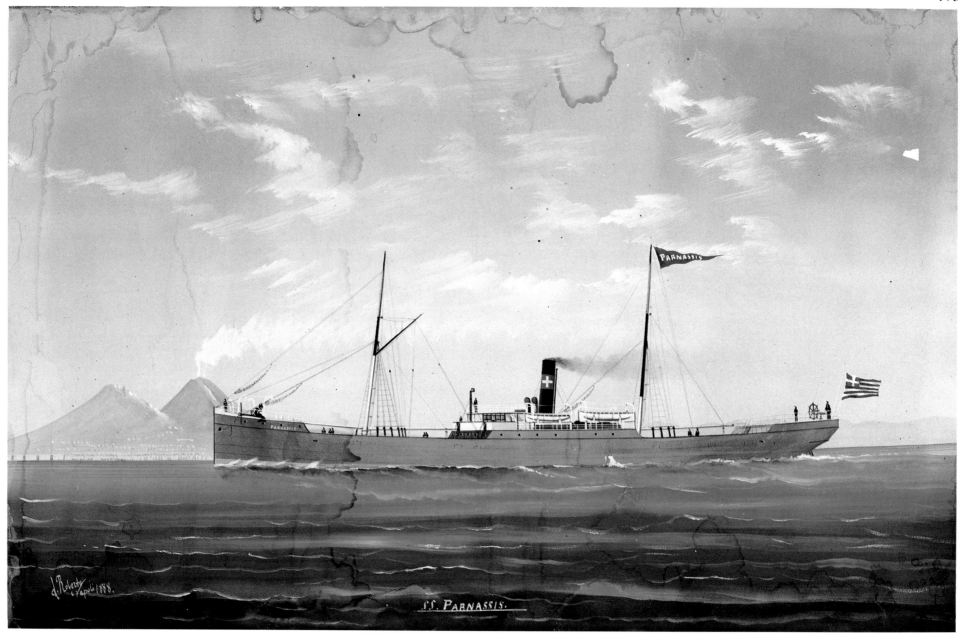

SS. PARNASSIS.

173 (325) L Roberto, SS PARNASSIS, watercolour, 51×74 cm, Napoli 1888. Steamship of the brothers E Koutsouleris, P Marlas, and K Tsipouras

174 (332) PARNASSIS, watercolour, 45×56 cm. Steamship of the brothers E Koutsouleris, P Marlas, and K Tsipouras

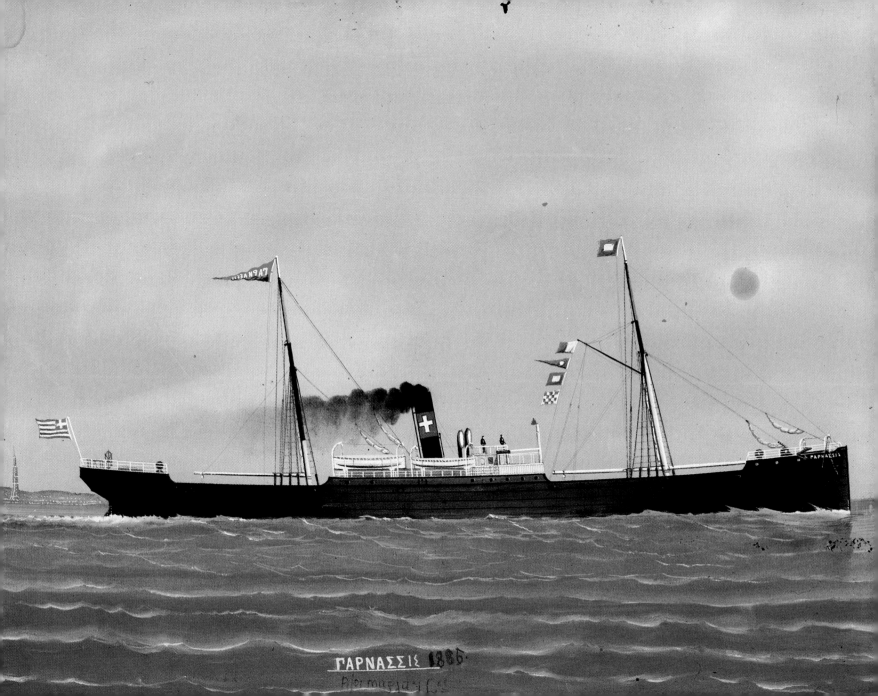

ΓΑΡΝΑΣΣΙΣ 1886
Πλοιον μιγλαγ (?)

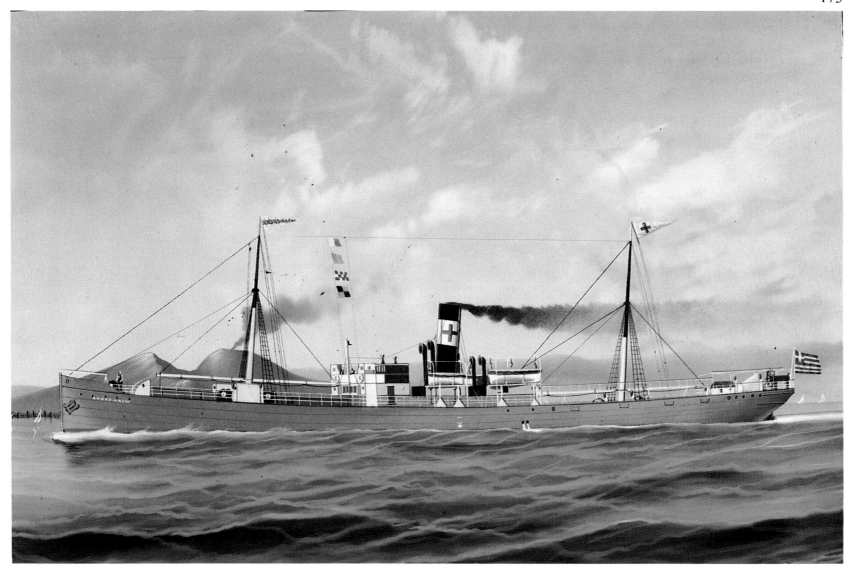

175 *(322) ANDROMACHI, watercolour, 48×72 cm. Steamship of E Chardavellas*

176 *Nina Angeli,* ANDROMACHI, *oil, 44×66 cm, Galaxidi. Steamship of E Chardavellas. Collection of R Stathaki-Koumari*

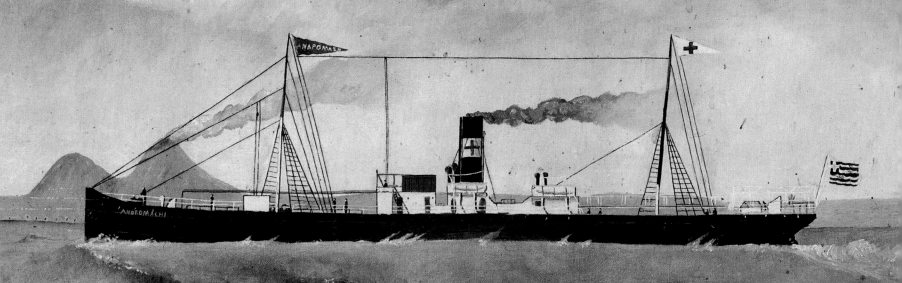

-ΑΝΔΡΟΜΑΧΗ-

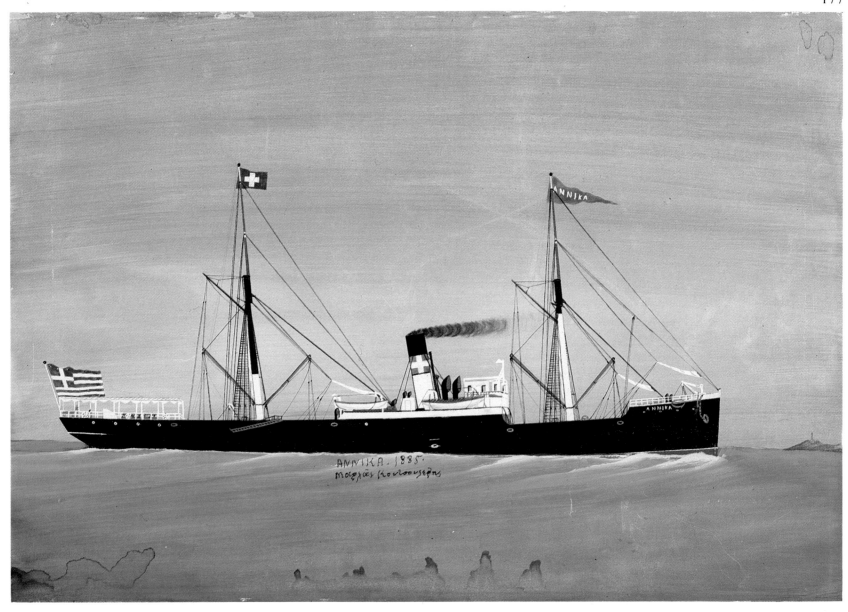

177 *(317)* ANNIKA, *watercolour,* 52×74 *cm. Steamship of the brothers E Koutsouleris, P Marlas, and K Tsipouras*

178 *(324) Aristeidis Glykas,* PATRIS, *watercolour,* 41×60 *cm, 1933. Steamship of A Bobogiannis*

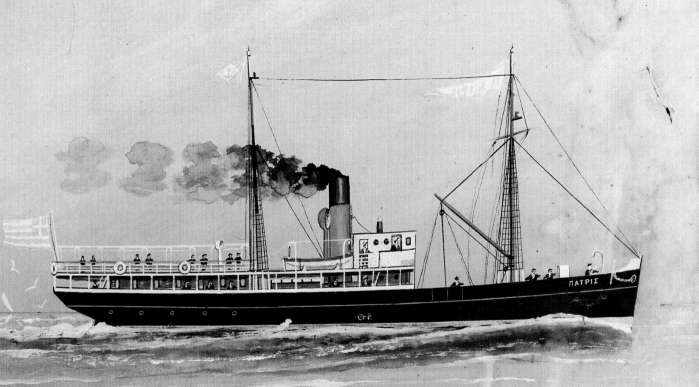

Α/π "ΠΑΤΡΙΣ,, Α.ΜΠΟΜΠΟΓΙΑΝΝΗ ΓΑΜΞΕΙΔΙΟΝ

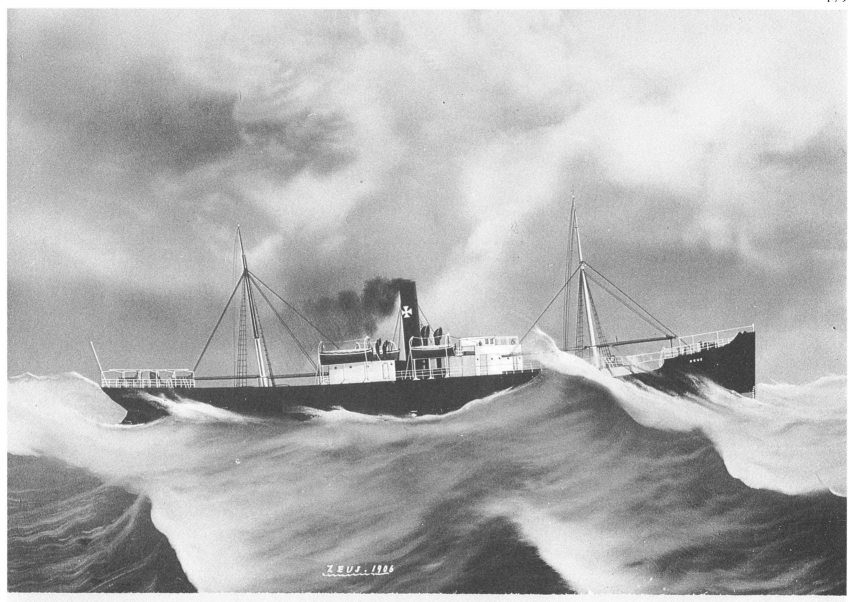

Ἰδιοκτησία Νικολάου καί Παύλου Ἰσιδ. Σιδηροπούλου καί Ἀδελφῶν Ἠλία Ζησίμου

179 (660) ZEYS, photograph of a painting from a private collection in Athens. Steamship of the brothers Nikolaos and Pavlos
I Sidiropoulos, and the brothers Ilias Zisimos

180 (319) ELENI I SIFNAIOU, watercolour, 49×72 cm. Steamship of E Vlassopoulos

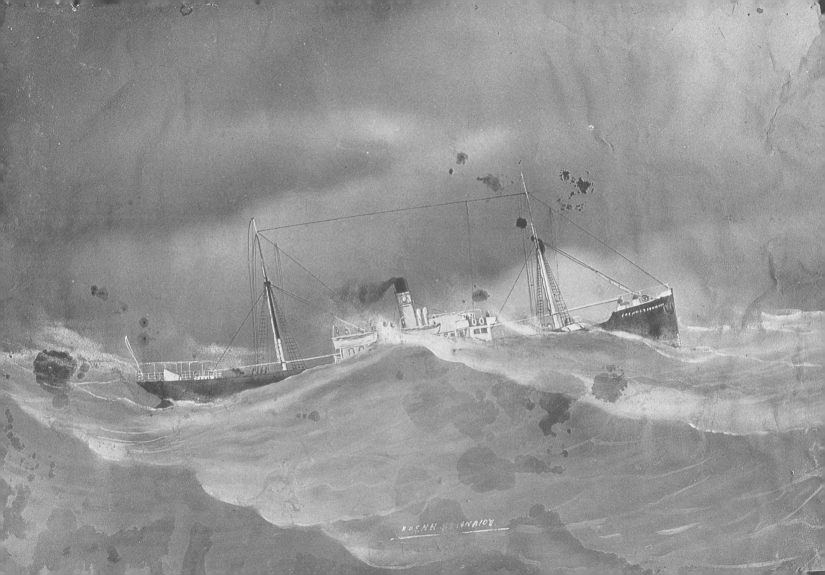

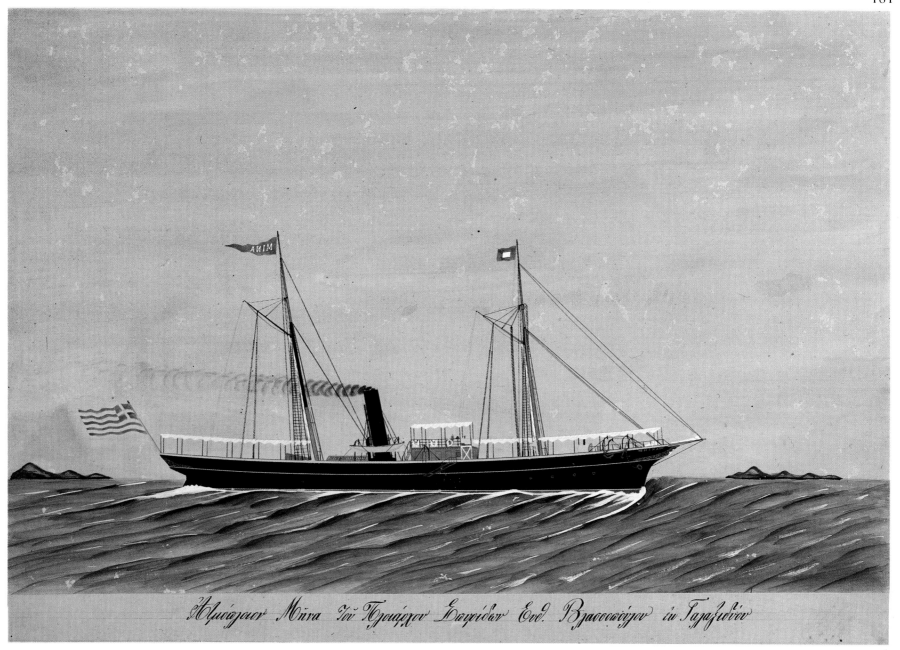

181 (327) MINA, watercolour, 49×63 cm. Steamship of Spyridon E Vlassopoulos

182 (331) Antonio Luzzo, AGLA·I·A KOURENTI, watercolour, 38×59 cm, Venice. Steamship

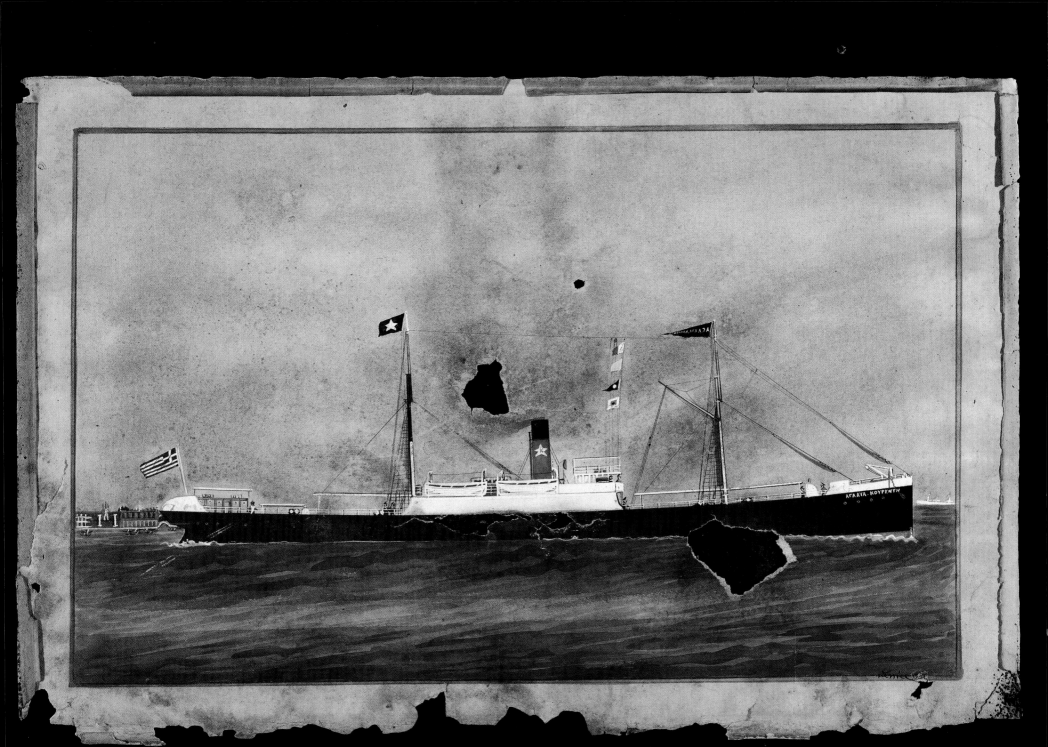

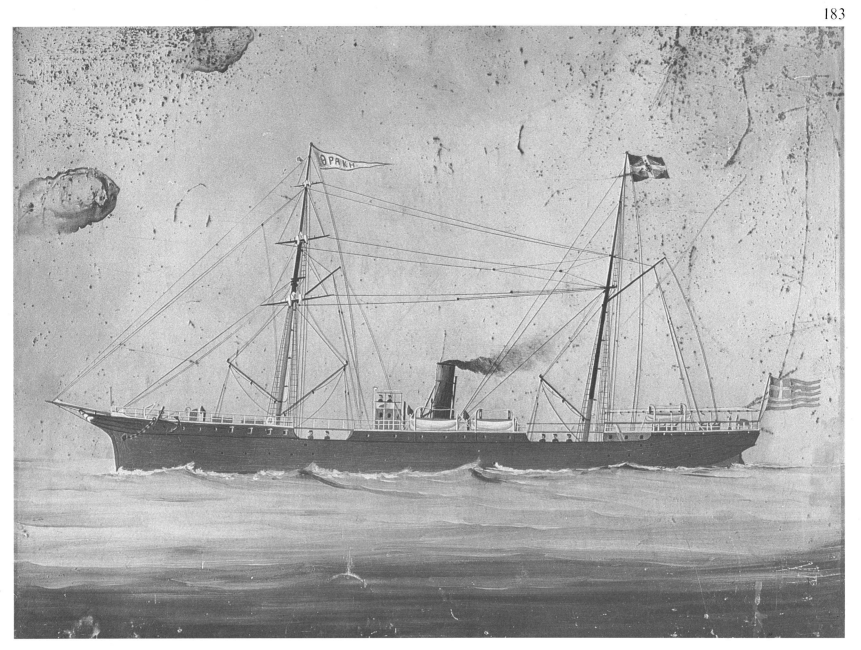

183 (603) THRAKI, watercolour, 45×61 cm. Steamship

184 (333) IONIA, watercolour, 42×55 cm. Steamship

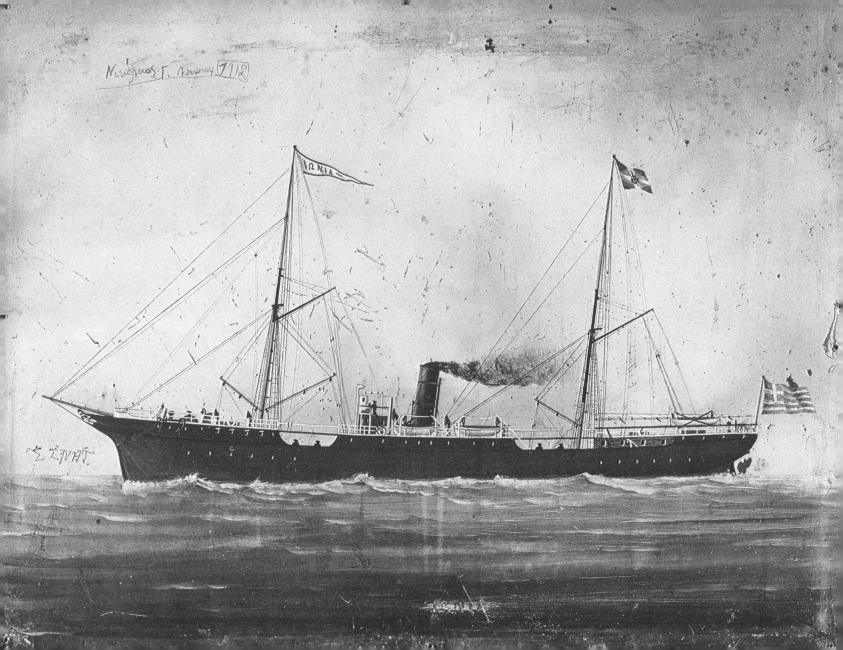

ΙΩΝΙΑ

Νικόλαος Γ. Δοντάς 1912

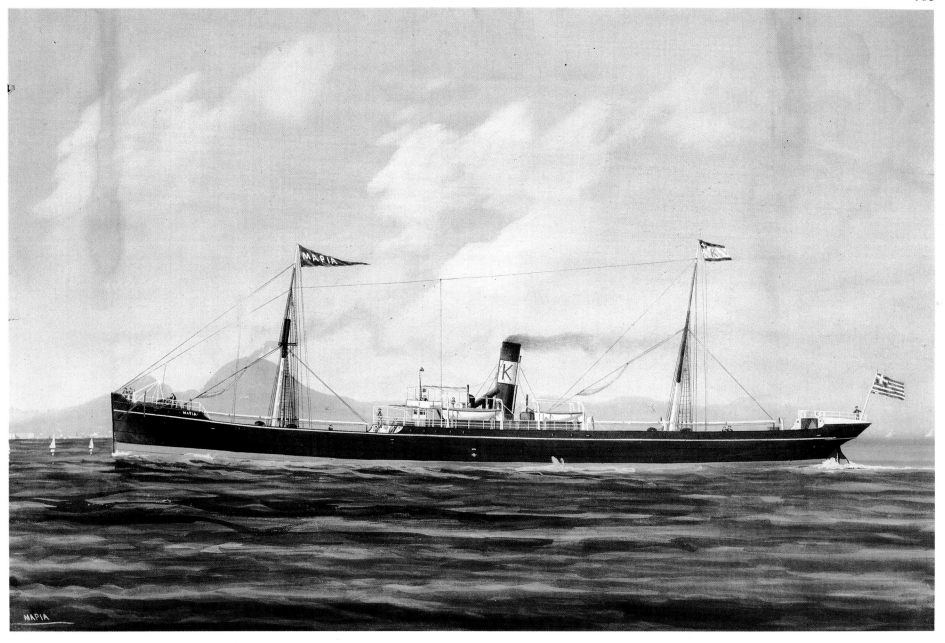

185 (320) MARIA, watercolour, 45×65 cm. Steamship

186 (557) PANELINION, watercolour, 37×54 cm. Steamship

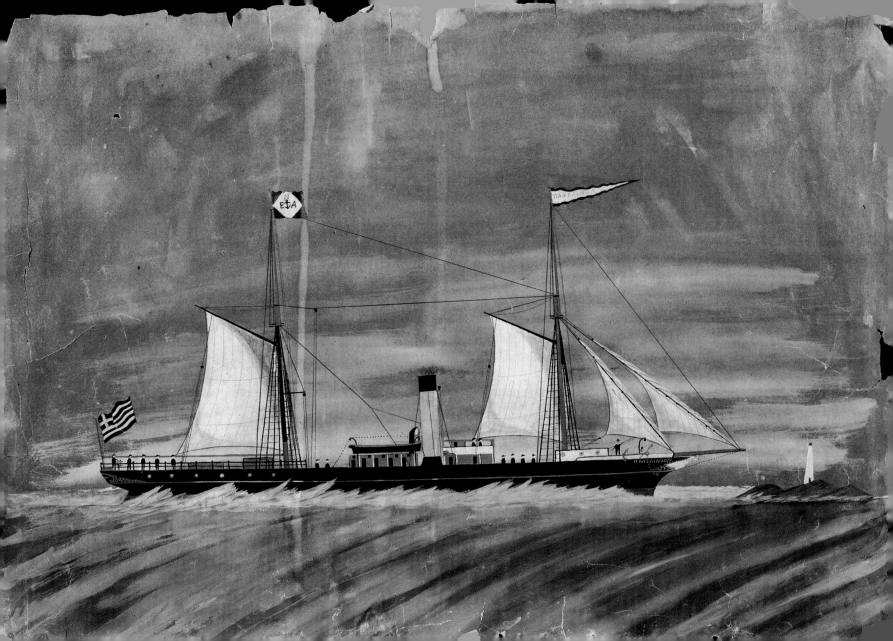

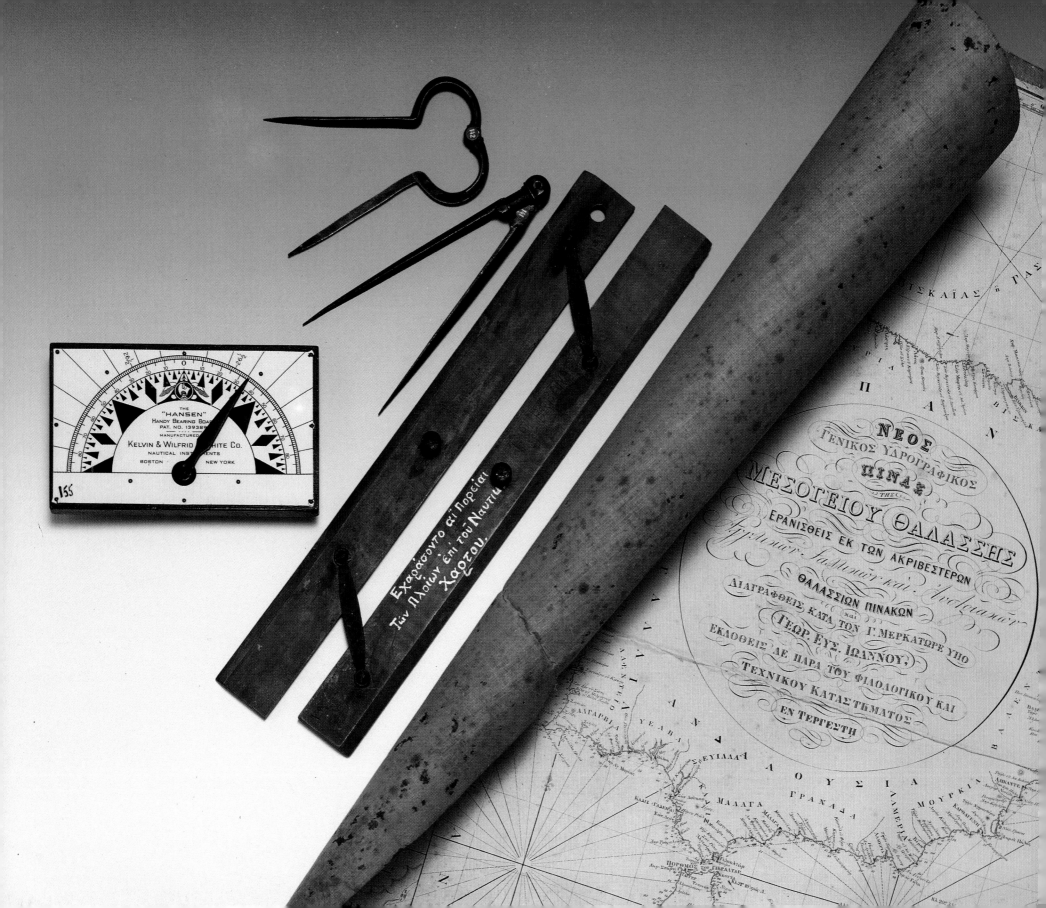

The development of navigation and navigational instruments

Navigation, as is well known, refers to the art, and later the science, by means of which a mariner leads his ship from one place to another, by estimating his position, selecting of appropriate course and speed, and regular checking of his vessels progress during the voyage at sea (and subsequently in the air or in space), and having thus orientated himself is able to avoid unnecessary straying.

The art of navigation was most probably first developed when man sailed on large rivers like the Nile or the Yang-Tsé, and along the coasts or in archipelagoes like the Aegean, areas where some of the great civilizations of early history had also evolved. Navigating in those times was relatively simple and empiric, as a mariner had to depend on visible points, like promontories, peaks of hills or mountains for his orientation. Later, however, with trade, civilization, and general human interests expanding beyond the coastal waters and onto the oceans, into the air, and recently into space, navigation has become progressively more complex.

When they were looking for solutions to the new and difficult problems, navigators would usually turn to mathematics and technology. The Babylonians appear to have been the first to chart the stars onto the inner surface of a heavenly sphere, which was thought to encompass the earth and to revolve around it. Very soon it was observed that stars close to the pole of such a sphere seemed to run shorter orbits than the rest. While in the extreme case of the polar star, itself visible only in the northern hemisphere, there was practically no displacement, since its position more or less coincided with that of the north pole. Because of that particular position, the polar star has a property which is useful for orientation: its altitude from the horizon is virtually equal with the latitude of the position at which the observer is standing. The mariner was thus able to estimate one of the two coordinates of his position, the other being longitude, and consequently to navigate latitudinally, i e in an E-W sense, with fair precision even if the shores were not visible.

FROM ASTROLABE TO SEXTANT

Ancient Greek astronomers were able to measure the angles between heavenly bodies, or their altitude from the horizon, by means of the astrolabe, an instrument which was later, in the fifteenth century, adapted by the Portuguese to become a nautical astrolabe for use in their ocean voyages. This in turn and for reasons of greater precision and practicality was progressively replaced by the Davis quadrant around 1725, the Hadley octant in 1731, and the Campbell sextant in 1757.[1]

The Museum of Galaxidi has among its nautical instruments a large variety of octants and some sextants estimated to have been made as from 1760 onwards. On the octant of Plate 193 can be seen engraved the name of its maker, his trade, and the place of fabrication: Antonio Wiglianovich, Ottico, Constantinople.

COMPASS

Ever since its beginnings, a basic need of navigation has been to have the means of steering the course of a ship towards its destination and measuring the direction of different objects around the ship. It was necessary, therefore, to be able to measure the direction of various objects (bearings) in relation to the North, and so to correlate the position of the vessel with the surrounding shores, especially if there were no visible landmarks in the direction of the vessel's movement. This need was first met by the Chinese inventing the magnetic compass[2] in the seventh century AD, the use of which seems to have spread among the Europeans through the Byzantines — there was a magnetic compass on board ship of AGIOS NICOLAOS in 1294, the Persians, and the Arabs. Ferrante from Portugal is thought to have been the one who in 1483 supplied the compass with a card (the compass-card), which made its use more practicable.

A compass-card is a lightweight disc of readings, marked with subdivisions and other symbols. It contains the magnetic needle of the compass and revolves with it. There are peripheral

187 *Nautical dividers (141 and 142). Parallel ruler (119). The Hansen Handy Bearing Board (155). A Greek general hydrographic chart of the Mediterranean, published by the Philological and Technical Office in Trieste, in 1875 (565)*

and quadrantal compass-cards with subdivisions in degrees, grades, quarterpoints, etc.

A magnetic compass has been, despite subsequent developments, one of the principal navigational instruments on every ship. Another kind, the gyro-compass, based on a different functional principle, was later used more extensively than the magnetic one. But the latter was never replaced completely, as it had proved quite reliable.

A compass acquires a different attribution to its name according to the principle on which it is kept pointing to the North, e g magnetic or gyroscopic; or, according to its use, as steering-, Azimuth-, or boat-compass.

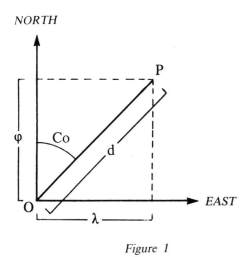

Figure 1

The invention of the compass gave quite a strong impetus to navigation, since it provided henceforth a means of ensuring that a ship could be kept on a relatively steady course without a visible correlation of its position and the surrounding land. We know that our position on a plane can be determined in relation to another position in two basic ways: either by means of Cartesian coordinates represented in Figure 1 by φ and λ; or, by Polar coordinates, which in the same Figure are angle Co and distance run d.

For navigation, correspondingly, a nautical chart is the plane, latitude φ and longitude λ are the Cartesian coordinates, and course or direction Co and distance run d are the Polar coordinates.

At about the end of the fifteenth century, a navigator had at his disposal charts that were both very general and of only approximate accuracy. By using the nautical astrolabe and measuring the altitude of the polar star, he was able to calculate his position's latitude φ with relative precision, but could not do the same for the other coordinate, λ; on the other hand, he could keep a course Co fairly accurately, or define a direction Co in relation to the North, but could not measure the other coordinate d, since he had no way of measuring the speed of his ship. He was therefore unable to determine his position P or plot it, since he had no detailed charts either.

That was the time too, when commerce developed internationally, as new markets were sought, sources of raw materials were being discovered, maritime nations expanded their dominion, and religions spread. The need arose then to devise more satisfactory navigational aids like the nautical chart (1569), the chronometer (1736), the octant and the sextant (1731-1757), and the log (dromometer). Thus, within two and a half centuries, acceptable technological solutions had been provided, which helped to overcome the above mentioned shortcomings in a way that became a watershed in the development of navigation down to our times.

THE NAUTICAL CHART

In the practice of navigation a mariner has always required drawings of the earth's surface on which to lay off his proposed course, fix the position of his ship, and find where he is in relation to the surrounding land and her destination. Moreover, since convenience demands that these drawings shall be flat, his problem is to show parts of the surface of a sphere, which has three dimensions, as a plane or flat surface, which has two dimensions. But a sphere cannot be unrolled into a plane surface as can a cylinder or a cone. Distortion is therefore inevitable when part of the earth's sphere is represented on a flat drawing; and if the area covered is large, that distortion can be consider-

able. As such drawings or surveys became supplied with more information, they were relatively more accurate, and hence useful for successive voyages, they were called charts, and in our case, nautical charts.

What was mainly required of a nautical chart, has always included the following: such details as are of interest to navigation, shores, shoals, depth of water, clearly visible points on the coast, must be represented in practical accuracy. It must provide scales for the measurement of distance, latitude, longitude, and direction. It must allow an easy measurement of distances. And, if possible, and in order to be serviceable, its projection onto the plane must be such as to present a rhumb line as a straight, steady course or direction with reference to the North, or a great circle arc, arc of maximum circle, or minimum distance between two points on the surface of the sphere.

It was quite a milestone in the development of nautical charts but also of navigation, when in the sixteenth century the Flemish mathematician Gerardus Mercator devised what we call today Mercator's Projection of the earth's surface onto a plane, whereby he was able to present a rhumb line as a straight line without distortion of the angles between rhumb lines; to preserve the correct shape of relatively small areas; and to provide a simple way of measuring distances on a scale identical with that of the latitude.[3]

188 *Magnetic Azimuth compass (75). Octant, Jones, Liverpool, beginning of 19th c (31). Nautical chart of the British Admiralty; area of the island of Paros (545).*

189 *Three types of nautical barometer combined with thermometer (82, 88 and 126)*

190 *Nautical Chronometer, R Webster Cornhill (111). A fairly old magnetic compass, Pietro Stolfa, Trieste (54). Bernard's Nautical Star Chart (375)*

OCTANT OR SEXTANT AND CHRONOMETER COMBINED

Although ways of deriving latitude φ at sea had been devised fairly early, longitude λ was still needed before the position of a ship could be determined. These two coordinates of the earth's surface and of charts are measured, as is well-known, in degrees, each of which is subdivided into 60 minutes, and each minute, into 60 seconds.

Determining the degrees of a given longitude λ at sea is inextricably connected with the measuring of time. As the earth turns on its axis, successive meridians cross the sun at an interval of 4 minutes of an hour for each degree of longitude. If we now compare a given local time with the agreed reference time, e g Greenwich Mean Time (GMT), we have a difference in time, which corresponds to the longitudinal difference between Greenwich and the position of the ship, which in turn is determined by converting the difference in time into degrees, i e: 360° = 24 hours; 1 h = 15°; 1° = 4′ of an hour. As astronomical observation takes place in local time, navigators need to know the precise GMT at the moment of observation before they can correlate the two and establish their ship's position. For GMT is a reference time independent of the observer's position and capable of being measured by a navigator on board a ship. And that is what a marine chronometer does: it indicates the precise Greenwich Mean Time.

THE MARINE CHRONOMETER

The first marine timekeeper was made by John Harrison, an English master carpenter, who was the winner of a competition proclaimed by the English Parliament in 1714 for the construction of a precision marine chronometer allowing for a maximum error not greater than 1/2° (or 2′ of the hour). Harrison constructed four models of marine chronometers (H₁-H₄), on the last of which (H₄) compensation was made for changes in environmental temperature. As a consequence this model made a voyage from London to Lisbon and back in 1736, when it showed a total error of one minute. It was tested again on voyages to the West Indies and back between 1761-62, and again in 1764, showing a

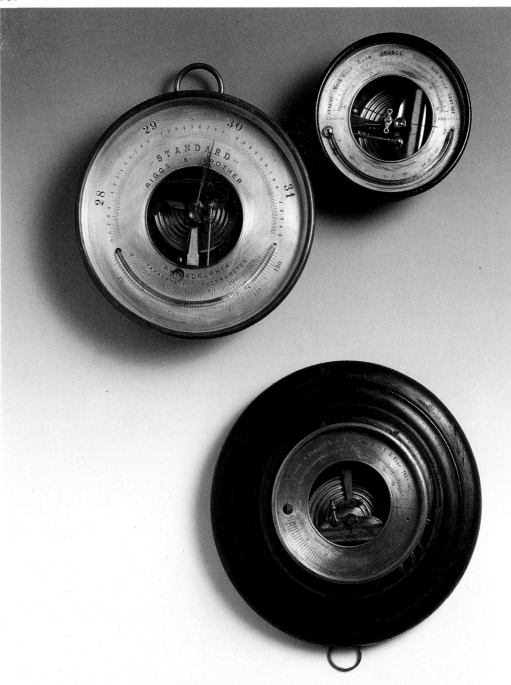

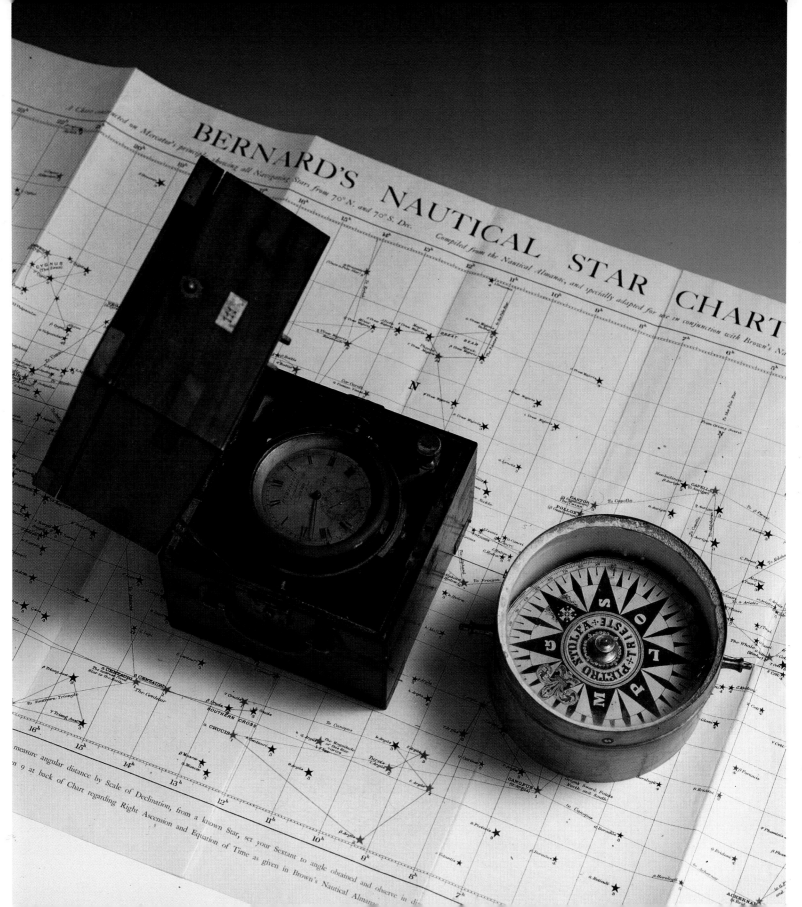

total error on only 54″ this time. 'It was not until 1772 that, at the age of 79, Harrison received his final award from the government for inventing a method for determining longitude at sea that was practicable and useful.' The invention of the marine chronometer is, together with the use of an octant and then a sextant for accurately measuring the altitude of heavenly bodies, one of the first turning-points, if not the first in importance, in the history of navigation. For, by their means, the position of a ship at sea can be determined without reference to the surrounding shores, which is in essence the foundation of celestial navigation.

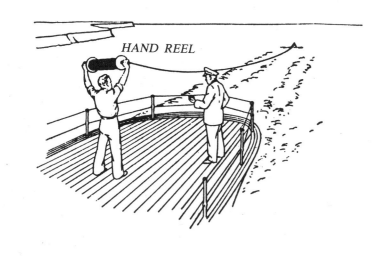

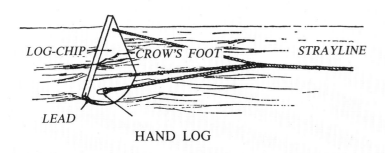

LOG-CHIP CROW'S FOOT STRAYLINE

LEAD

HAND LOG

Figure 2

Of the two polar coordinates *Co*, course or direction, and *d*, distance run (Fig 1) that determine a position at sea, only the first one was available, since a compass would indicate the direction. But the other coordinate could not be computed until it was possible to measure the speed of a ship, as: distance run = speed x time elapsed in the course between two points. Inventing the Log made it feasible to measure the speed of a ship and hence to establish the second of the two polar[4] coordinates.

An actual log of wood must have been used at first as a device for measuring speed. It was thrown overboard from the bow, and time was kept to see how long it would take for the stern to catch up with it, the length of the ship from bow to stern being a known factor.

But neither the log of wood could stay in one place because of the waves, nor was the distance between bow and stern long enough, especially with small vessels, for measurements to be accurate. That is when the first hand-log was invented, which was lowered from the stern as can be seen in Fig 2. When the log-chip was far enough away from the wake, the knots which had been made at regular intervals on the log-line passed over the rail of the stern at a rate that corresponded to the number of miles the ship was covering in a hour. And that is the reason why the term 'knots per hour' is used instead of 'miles' in connection with the speed of a ship. Time was measured by means of a sand-glass, the ancient 'klepsydra', or hourglass.

Several types of log were developed from that first hand-log, e g the patent log, or the self-registering towed log of the 'harpoon' type, which was also the oldest; and later, the hullfitted logs, that were permanently fastened on to the bottom of a ship.

There are two remarkable types of log (Pl 191) in the Museum of Galaxidi. One of these is Turkish, of the self-registering type, dated in 1277 AM (Anno Muhammad) as inscribed in Turkish, 'It was drawn in the year 1277' (1860/61 of our era). The other is a harpoon log, of a Thomas Walker Pattern, 1861. The oldest hourglass (Pl 195) in the Museum must date from around the middle of the eighteenth century (ca 1740).

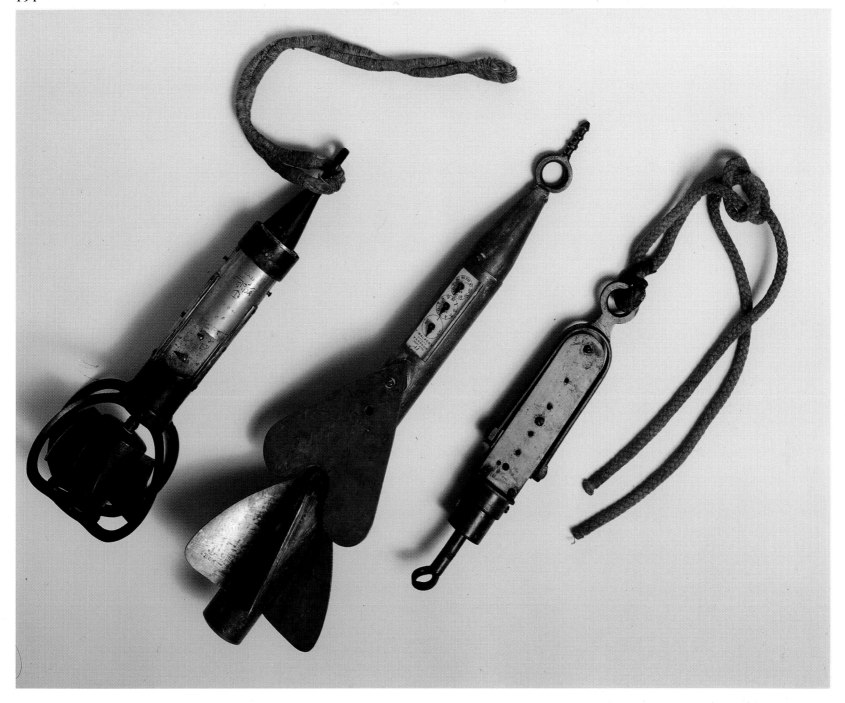

191 *Towed log counter mechanism (registers the revolutions of the rotator) (157). Rotator of harpoon type towed log with device for automatic registering of rotator revolutions (607), and a corresponding Turkish log type (130)*

The rapid development of methods and instruments of navigation that followed in the twentieth century has taken quite revolutionary proportions: radio-navigation systems, Decca, Loran, Omega, etc; the radar; inertial navigational systems applied to unmanned vehicles, cruise missiles, artificial satellites, etc; and finally, satellite navigation systems. For all that, however, and particularly in the case of ships, celestial navigation with its instruments, the chronometer, the sextant, the nautical almanacs cannot be replaced by anything as simple or as reliable.

Antonis Theoharis

NOTES

1 *Quadrant, Octant, Sextant:* these are two-mirror instruments for measuring horizontal and vertical angles that are useful in navigation. They are so constructed as to allow the user accurate measurings of angles even on rough seas. Their names are indicative of the width of the angles formed by the relative positions of their glasses: a quadrant, 1/4 of the 360° or 90°; an octant, 1/8 of the 360° or 45°; and a sextant, 1/6 of the 360° or 60°. Moreover, the octant and the sextant can be used for measuring angles of up to twice the width of their glass-angles. This is based on the easily demonstrable geometrical thesis, according to which if a ray of light, e g from a star, is reflected by two glasses upon the same plane, the angle between the first and second reflections is twice as wide as the angle formed between the planes of the glasses, Fig 3.

2 *Compass.* Its function is based on the principle of physics that a magnetic needle appropriately supported at its centre, with practically no friction, will line up with the horizontal component of the earth's magnetism, and hence will stay directed towards the magnetic north. Thus, when a ship alters course, it is actually turning around the magnetic needle.

The Greek term for a compass is 'pyxis', a name derived from the Ancient Greek designation of 'box' made of boxwood, where jewelry was kept. Since the compass needle was at first mounted in a wooden box, it took its name from that. Another name for it is 'busulas', derived, via the Italian 'bussola', from the Latin buxus, box-tree and objects made of boxwood.

3 Charts presenting a rhumb line as a straight line are called today *Mercatorial;* whereas the other charts, which present a great circle arc as a straight line, are called *Gnomonic.* A synoptic illustration of the difference between the two kinds of nautical chart is given in Figure 4.

4 *Polar coordinates.* Determining the position of a ship by means of these polar coordinates is a method of navigation called 'dead reckoning'. And it is perhaps the simplest procedure of all, as long as a chart, a compass, a log, and a timekeeper are available. On the other hand, in areas where there are tidal streams and currents, or drifts as happen to sailing ships, a fix cannot be determined with any satisfactory precision by the 'dead reckoning' method, since the surface of the water is 'drifting' compared with the bottom or the surrounding shores.

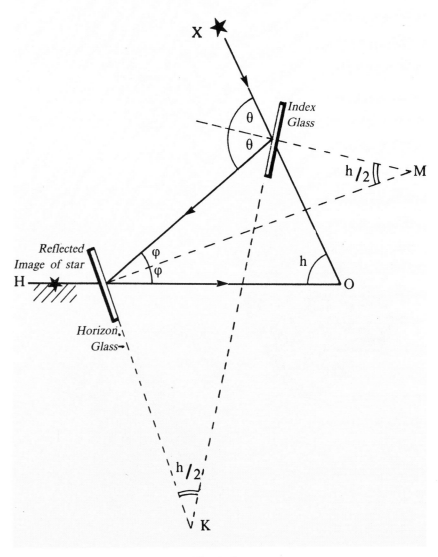

Figure 3

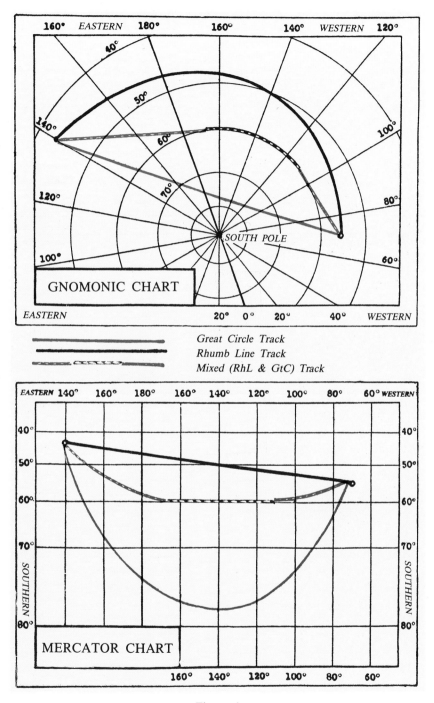

GNOMONIC CHART

Great Circle Track
Rhumb Line Track
Mixed (RhL & GtC) Track

MERCATOR CHART

Figure 4

192 *Mercurial type of nautical barometer combined with thermometer, made by J W Blakeney & Co, Hull & Sunderland* (19)

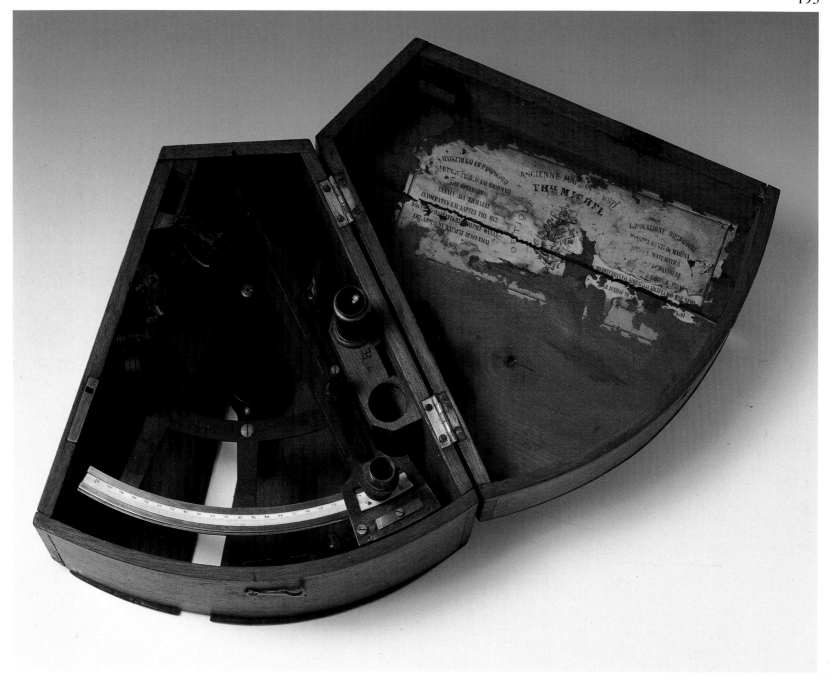

193 *Octant made in Constantinople by Antonio Wiglianovich, Optician, of unknown date, probably end of 19th c (33)*

194 *Book on Navigation in Greek, translated from the French and printed in Italy, 1806, (611). Octant of about the same period (522)*

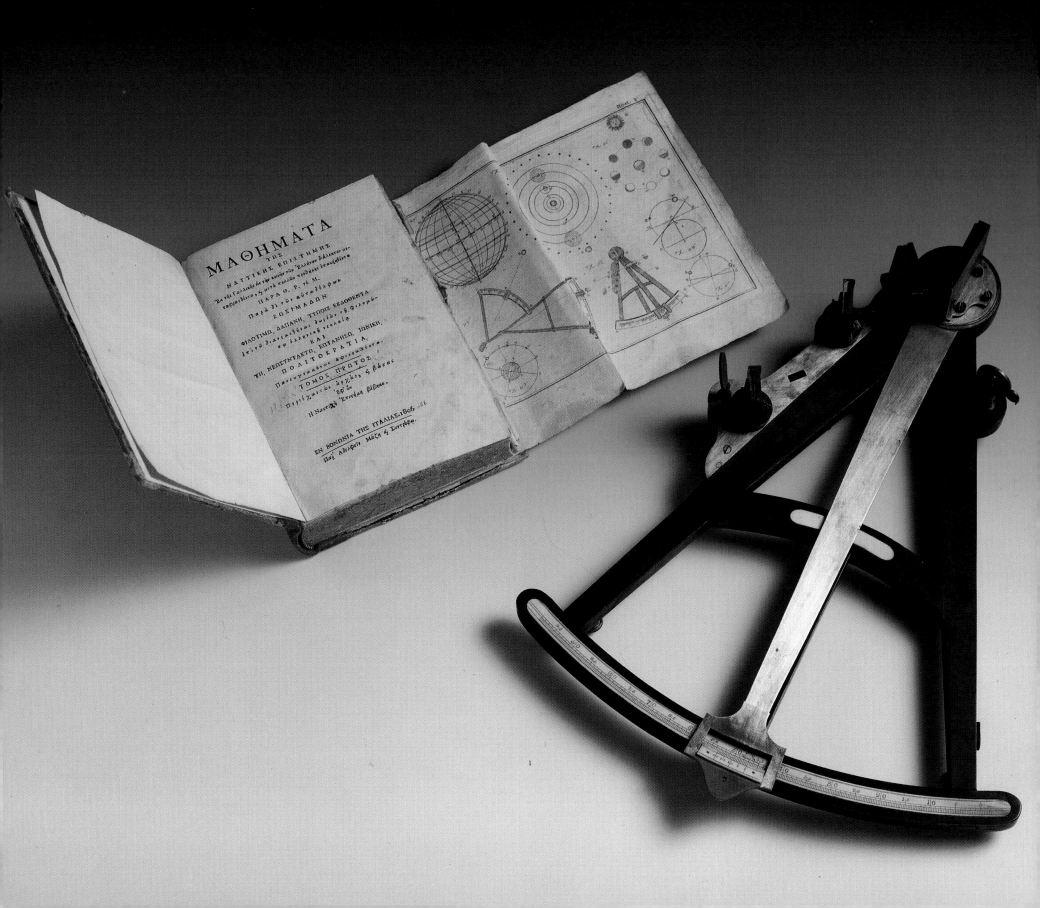

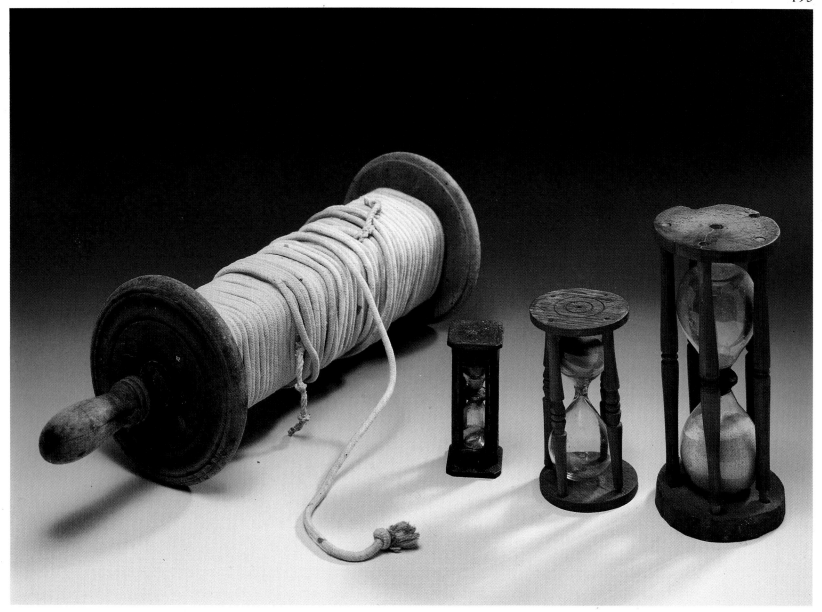

195 *Reel of hand log of sailing ships (112). Three log-glasses, each marking a different length of time (16, 17, and 19)*

196 *Two different types of towed log rotator (124 and 129). Apparatus registering rotator revolutions in the same type of towed log (115)*

196

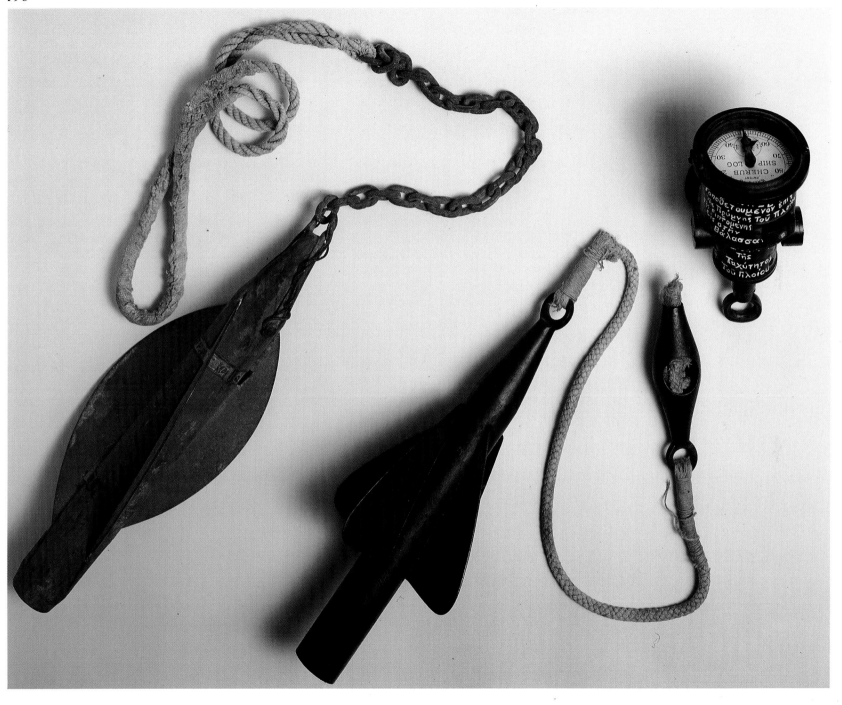

223

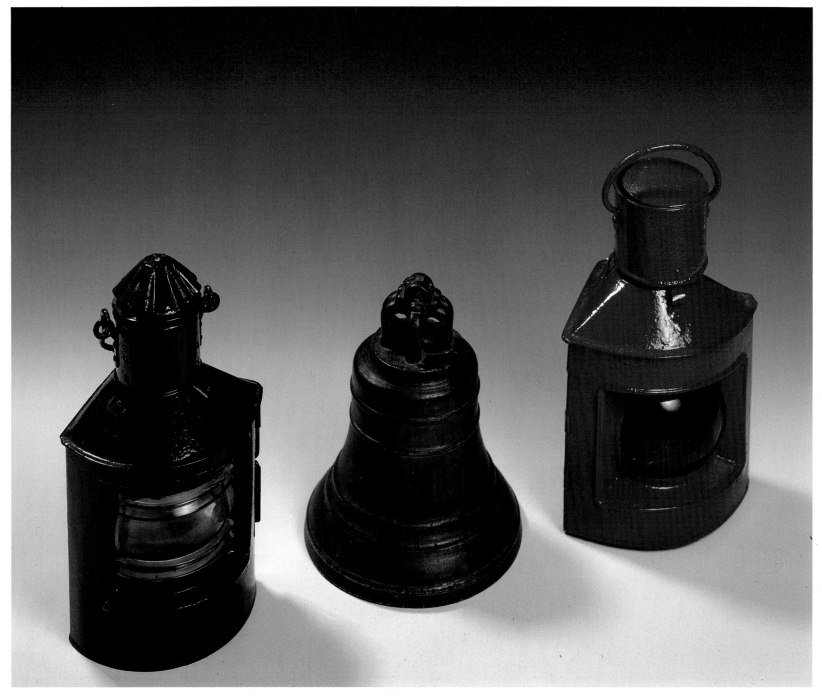

197 Side lights (lanterns) of a sailing ship (5 and 6). Ship's bell (7)

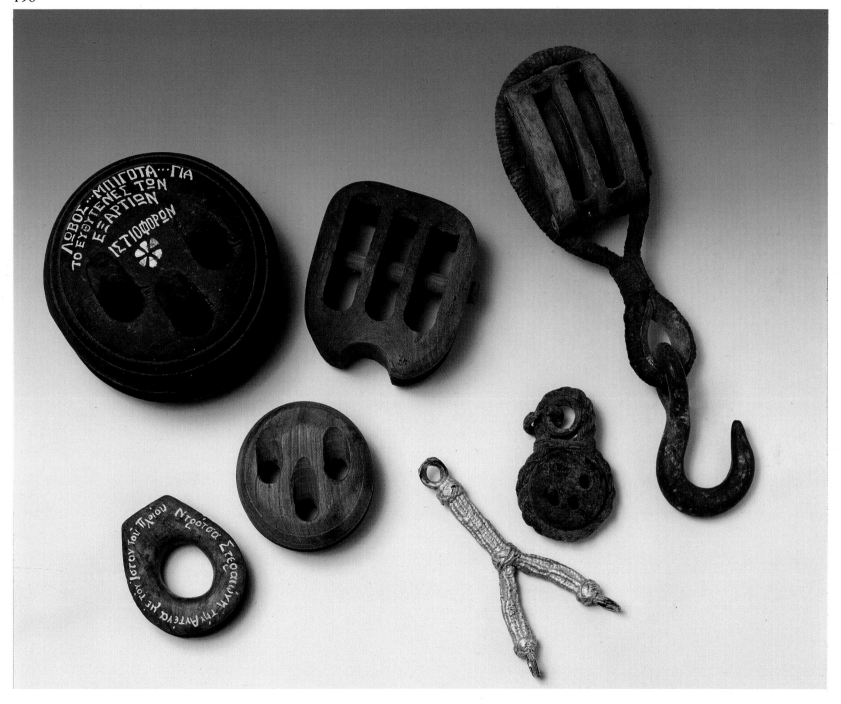

198 *Various kinds of gear and tackle used in rigging a sailing ship: bull's eyes (34, 38, and 160); blocks (47 and 590); wooden thimble (158); and difurcated braided rope (149)*

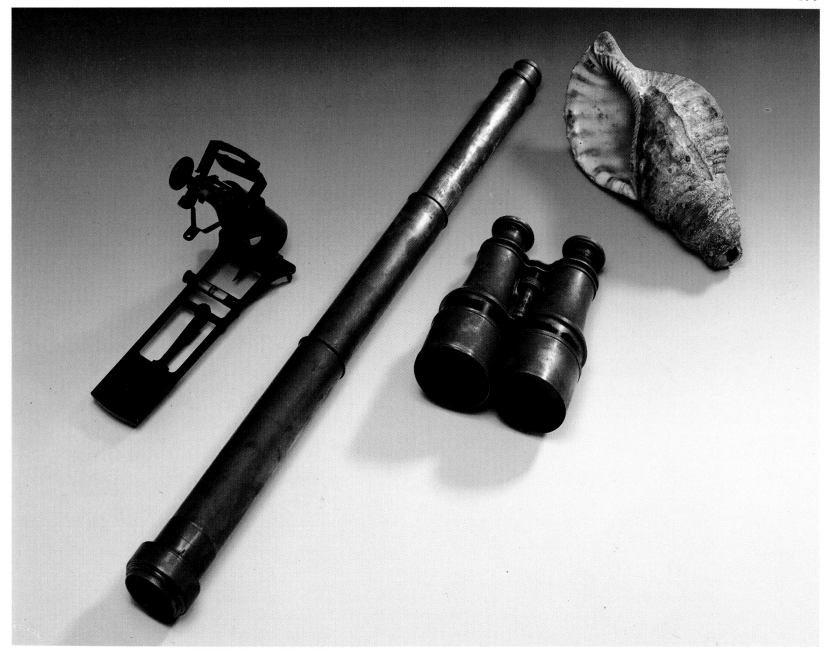

199 Azimuth circle of compass (173). Portable telescope (116). Binoculars (104). Fog horn of sailing ship (108)

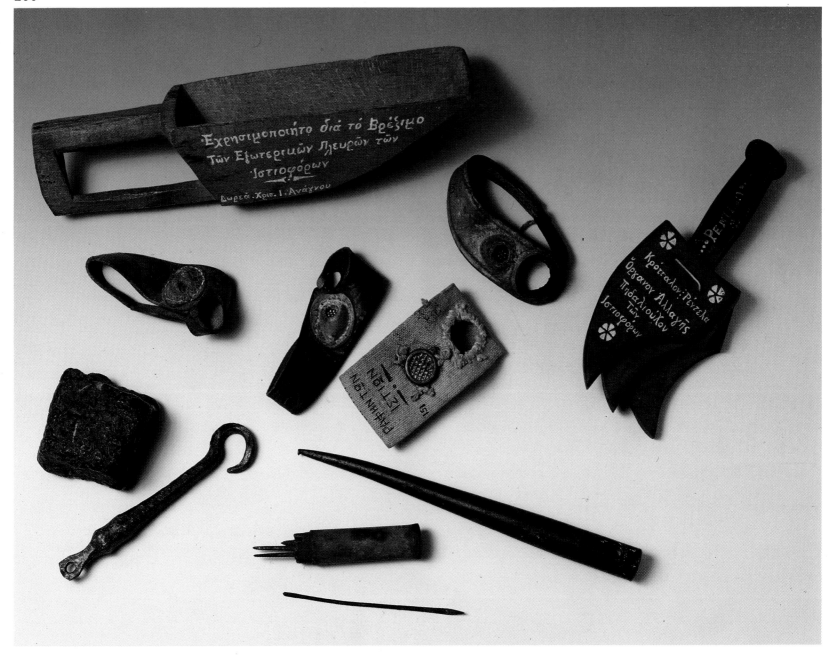

200 *Various tools of sailing ships: bailer (22); canvas needles (148); seaming palms (151, 152, 153, and 633); rattle used in sailing ships to signal change of helmsman watch (109); pricker (92); and tool used for twisting fibres into yarn (93)*

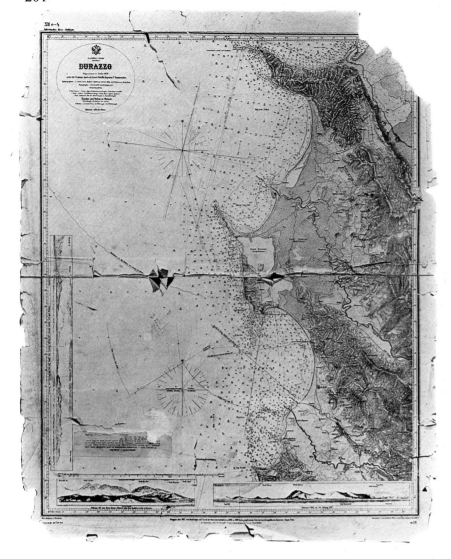

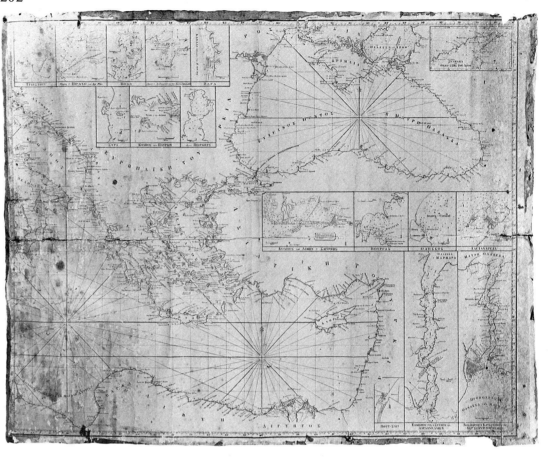

201 *Nautical chart of the Austrian Navy No 28 entitled: K.u.K. KRIEGS-MARINE, ALBANIEN. DURAZZO. It was surveyed in the year 1870. This edition, 1892, with additions. (A Mercator's projection) (489)*

202 *(554) Eastern Mediterranean and Black Sea. Cf Pl 203*

203 *(565) Western Mediterranean, as well as approaches to Gibraltar from the West. Two fragments of a nautical chart, Greek edition of the one by the Philological and Technical Office of Geor. Eus. Ioannou in Trieste, entitled New General Hydrographic Table of the Mediterranean Sea, compiled from the most accurate English, French and Austrian marine Tables and plotted according to G. Mercatore. Edition 1875*

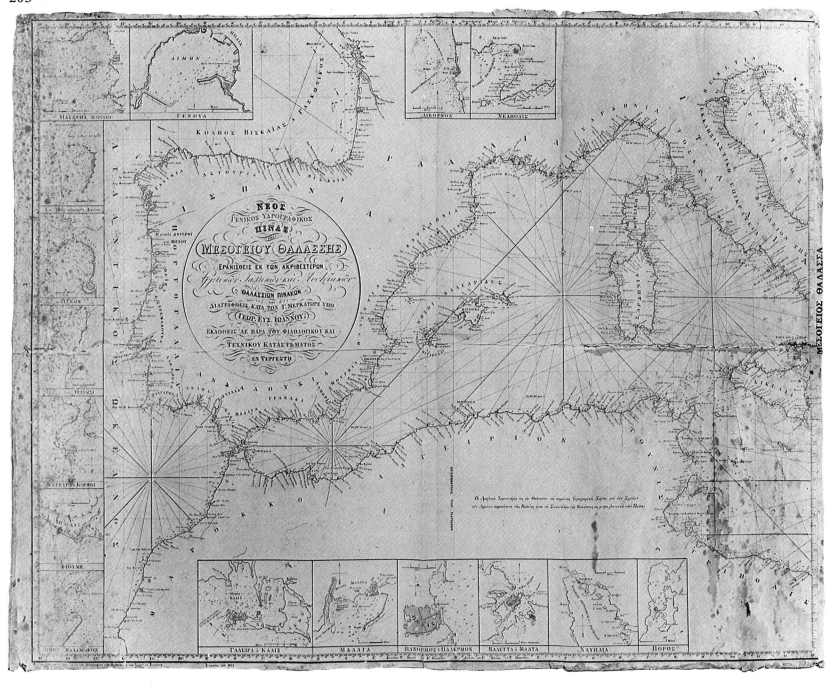

Formalities of ownership and nationality identification
Shipping affairs for Greek ships in the nineteenth century

In the nineteenth century when the modern Greek state was established, Galaxidi was starting to enjoy the last flourishing of its merchant marine. The formalities required for the identification of ownership and nationality at the registration of a ship were defined by the Royal Edict of 14th November 1836 'Regarding Merchant Marine'. Galaxidi was one of the main Greek ports where merchant ships were built and registered. On Plates 205 and 206, can be seen the 'Register of Sailing Ships Class A of Galaxeidion from 16 April 1878 until 20 January 1897.'

After 1858, Class A of sailing ships included those of tonnage up to 60 tons, while Class B, those of more than 60 tons.

REGISTRATION — OWNERSHIP IDENTIFICATION NATIONALITY OF SHIPS

According to Article 6 of the above RE/14.11.1836, the owner of a ship was required to submit to the 'Marine (Port) Authority' of Galaxidi the following documents before he could have her registered:

1 A Testimonial (Certificate) of identification and ownership of the ship issued by the Municipal Authority of the place where she had been built.

2 An affidavit of the owner sworn before a Justice of the Peace as to the number of shareholders (co-owners) of the ship and the percentage of shares (co-ownership) of each.

But the Mayor would not issue the testimonial until he had obtained an affidavit by the owner, as well as a Builder's Certificate by the Master Builder. After these documents had been turned in, a day was set by the 'Marine Authority for the Registration of Ships' to visit the ship in order to:

— Ascertain whether the ship was adequately 'outfitted' with the necessary 'rigging', 'equipment', and 'armament' according to the provisions in RE of 15 December 1836 'Regarding Policing of Merchant Marine'.

— Measure various characteristic features of the ship (length, breadth, draught, etc); determine her tonnage; ascertain that she was of good and safe construction; and determine her class.

Following that, the ship was entered in the 'Port Register' which corresponded to her Class. The 'Marine Authority' further saw to it that a Certificate of 'Identification of the ship as National Greek' (corresponding to the current 'Nationality Certificate') was issued by the Minister of Maritime Affairs; also, that a 'Measure Brief of Freighted Vessels,' what is currently called a Protocoll of Measurement, was issued by the Mayor, the Harbour Master, and the Chief Customs Officer. A 'Certificate of Nationality Identification' of 1864 can be seen on Plate 207; and on Plates 208 and 209, the pages of a 'Measure Brief of Freighted Vessels' of the same year.

204 *(414) Logs of ASIMOULA, 1882; (Pl 92) and (579) of ALEXANDROS III 1884, (Pl 58), which is a Crew List at the same time*

THE OFFICIAL SHIP DOCUMENTS

According to the provisions in force at the time, every ship was to carry the following official papers:
— Certificate of Nationality Identification
— Measure Brief
— Navigation Diploma
— Equipment Inventory
— Crew List (Pl 204 Ship's Log combined with Crew List)
— Log (Plates 204, 210 and 211)
— Bottomry Book
— Clearance Outwards
— Bill of Health (Pl 212)
— Bills of Lading and Shipping
— Manifest
— Acquittances from Customs, Consular, Harbour, and other Dues
— Personal Diplomas (Pl 213) and Discharge Books of the Crew (Pl 214).

OTHER SHIP DOCUMENTS

There were some other documents, beside the above, which concerned mainly book-keeping for the financial management of the ship, so that revenues, expenses, and profit incurred by her after one or several voyages were possible to calculate. Such documents included the following:
— Ledger (Pl 215)
— Master's Book
— Management Book of Sailing Ship (216), where the purchase of materials for the maintenance of the sailing ship was recorded, as were the wages and the corresponding names of carpenters, ship's carpenters, and caulkers who were carrying out the repairs, etc.
— Provisions Book (Plates 218 and 219)

Antonis Theoharis

For further details on this subject, see *To Galaxidi ston Kairo ton Karavion* by Efthymios N Gourgouris, Athens, 1982-83.

205 and 206 (582) Front cover and two pages of a Register Book of Sailing Ships, Class A, Port of Galaxidi, 16 April 1878 — 20 January 1897

207 (616) Certificate of Nationality Identification of the Brig AGIOS SPYRIDON of the year 1864

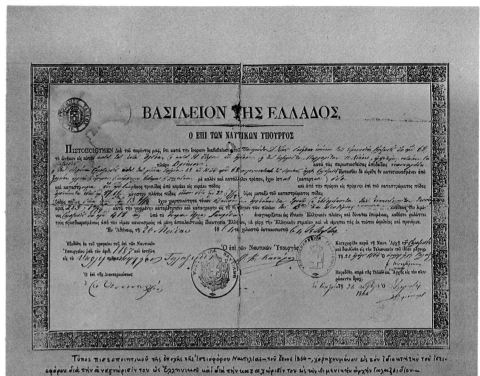

208 and 209 (376) *The three pages of a Measure Brief of Freighted Vessels pertaining to sailing ship* AGIOS SPYRIDON *built in Galaxidi in* 1864

210 and 211 (418) *Two pages and front cover of the Log from the sailing ship* AGIOS SPYRIDON, *Piraeus,* 6 January 1835

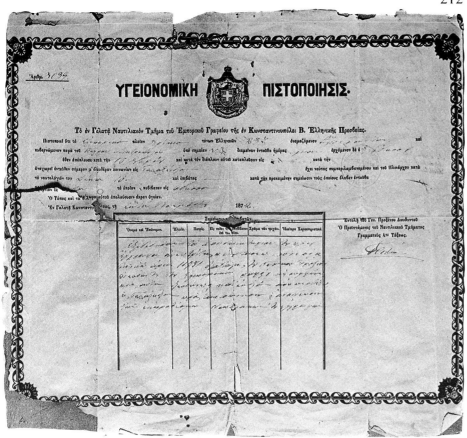

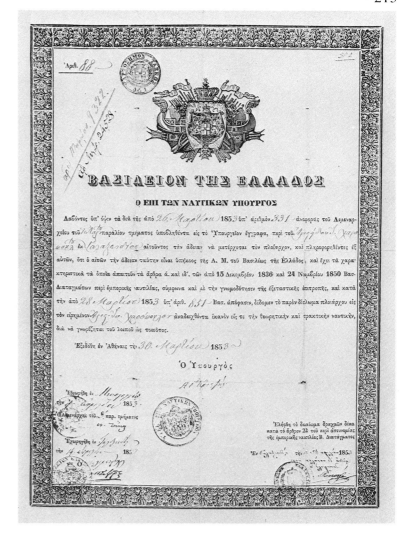

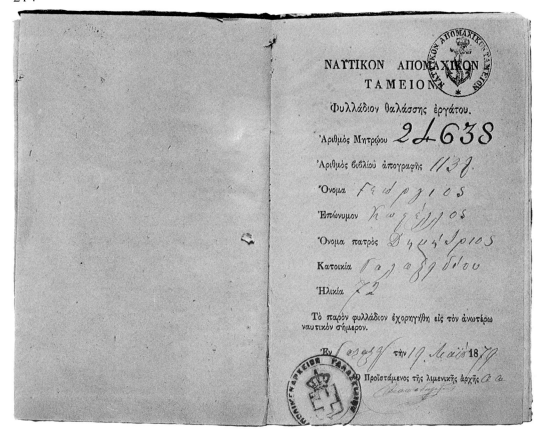

212 *(392) Bill of Health for sailing ship* AGIOS SPYRIDON *issued by the Commerce Section of the Royal Greek Embassy in Constantinople,* 6 November *1872*

213 *(389) Diploma of Captain of Merchant Marine, belonging to Aristeidis I Charopoulos,* 1853

214 *(426) Discharge Book of Shipman, belonging to Georgios D Kofellos and issued in Galaxidi,* 1879

215 *(691) Ledger of sailing ship* ALTANA *(Pl 67),* 22 October *1871*

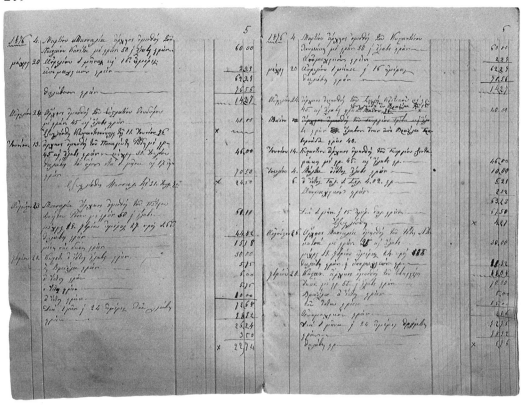

216 (424) *Management Book of Sailing Ship* 1872-1877, *without name of ship, under Captain Spyros F Papapetros*

217 (690) *Expenses Book of sailing ship* AGIA PARASKEVI, *Galaxidi,* 30 *March* 1838

218 *and* 219 (667) *Two pages and front cover of Provisions Book of sailing ship* AGIOS PANTELE·I·MON, 10 *October -* 20 *March* 1876; *besides accounts of provisions, it contains those of other items*

ΚΑΝΟΝΙΣΜΟΣ

ΤΗΣ

ΑΛΛΗΛΕΓΓΥΟΥ ΑΣΦΑΛΕΙΑΣ

«ΤΟ ΓΑΛΑΞΕΙΔΙΟΝ»

ΕΝ ΓΑΛΑΞΕΙΔΙΩ.

1887.

)(6)(

σεως καὶ κατὰ τοὺς μεταξὺ τῶν διασαφισθέντας ὅρους. Ἐὰν τὸ κοινὸν ἐξ αὐτῶν τῶν μερίδων τῆς συνεισφορᾶς σχηματισθὲν κεφάλαιον ὑπερβαίνῃ τὸ ἀναγκαῖον ἐπιστρέφεται εἰς τοὺς συνεταίρους, ἀναλόγως τῶν παρ' αὐτῶν γενησομένων πληρωμῶν κατὰ τοὺς μεταξὺ τῶν προσδιορισθέντας ὅρους.

Ἄρθρον 7.) Εἰς οὐδένα ἐπιτρέπεται νὰ λαμβάνῃ μέρος εἰς τὴν ἑταιρίαν ἂν δὲν ἦναι ἰδιοκτήτης, ἢ συνιδιοκτήτης πλοίου ἐγγεγραμμένου εἰς ἓν τῶν Νηολογίων τοῦ ἑλληνικοῦ Κράτους, καὶ ἐφωδιασμένου δι' ἑλληνικῆς σημαίας. Τὰ ξένης σημαίας πλοῖα ἀποκλείονται τῆς ἑταιρίας.

Ἄρθρ. 8.) Ὅταν ἡ ἰδιοκτησία ἑνὸς πλοίου ἦναι διηρημένη μεταξὺ πολλῶν συνιδιοκτητῶν, τὸ πλοῖον δύναται νὰ γείνῃ παραδεκτὸν εἰς τὴν ἀμοιβαίαν ἀσφάλειαν κατ' αἴτησιν τοῦ πρωτεύοντος, ἢ καὶ ὅλων ὁμοῦ τῶν ἰδιοκτητῶν· δύνανται ἐπίσης νὰ γείνωσι παραδεκτοὶ εἰς τὴν ἑταιρίαν οἱ διάφοροι συμμέτοχοι διὰ τὰ ἀφορῶντα εἰς αὐτοὺς μέρη.

Ἄρθρον 9.) Ὁ ἰδιοκτήτης περισσοτέρων πλοίων δύναται νὰ γείνῃ συνέταιρος δι' ἓν πλοῖον ἢ καὶ περισσότερα, ἢ καὶ δι' ὅλα κατ' ἀρέσκειάν του.

Ἄρθρον 10.) Αἱ αἰτήσεις παραδοχῆς εἰς τὴν ἑταιρίαν δύνανται νὰ γείνωσι εἰς οἱονδήποτε καιρόν· πᾶσα δὲ αἴτησις δέον ν' ἀναφέρῃ τὴν πλήρη τοῦ αἰτοῦντος παραδοχὴν καὶ συμμόρφωσιν αὐτοῦ τοῖς ὅροις τοῦ παρόντος συμβολαίου, καὶ ἐν γένει πασῶν τῶν τῆς ἑταιρίας διατυπώσεων. Πάντες ὅσοι θὰ γείνωσι δεκτοὶ εἰς τὴν ἑταιρίαν ὡς συνέταιροι μετὰ τὴν πρώτην σύστασιν αὐτῆς καὶ πρὸ τῆς πρώτης τετραμηνίας ἀπὸ τῆς πρώτης συστάσεως ὀφείλουσι νὰ πληρώσωσιν ὁμοίαν ποσότητα ἐκείνην ἣν καὶ οἱ συμβαλλόμενοι συμμέτοχοι θὰ πληρώσωσιν.

Ἄρθρον 11.) Ὁ ἰδιοκτήτης ἢ συνιδιοκτήτης πλοίων διὰ

)(7)(

νὰ γείνῃ δεκτὸς εἰς τὴν ἑταιρίαν ὀφείλει νὰ παρουσιάζῃ α) τὰ ἔγγραφα δι' ὧν ἀποδεικνύεται ἡ ἰδιοκτησία καὶ ἡ ἐθνικότης τοῦ πλοίου· β) νὰ διασαφίζῃ πόσον καιρὸν προτίθεται νὰ συμμετέχῃ τῆς ἑταιρίας· γ) νὰ προσδιορίζῃ τὸν τόπον τῆς διαμονῆς του δι' ὅλας τὰς ὠφελείας καὶ ἀποτελέσματα τῆς ἑταιρίας, καὶ νὰ διορίζῃ τακτικὸν πληρεξούσιόν του ἐνταῦθα. Ὁ χρόνος δι' ὃν εἰς ἰδιοκτήτης γίνεται δεκτὸς εἰς τὴν ἑταιρίαν δὲν δύναται νὰ ἦναι ὀλιγώτερος τῶν τριῶν ἐτῶν, οὔτε μεγαλήτερος τῆς ὑπολειπομένης πιθανῆς ζωῆς τοῦ πλοίου ἢ πλοίων δι' ὧν εἰσέρχεται εἰς τὴν ἑταιρίαν.

Ἄρθρον 12.) Ἡ παραδοχὴ εἰς τὴν ἑταιρίαν βεβαιοῦται δι' ἑνὸς πιστοποιητικοῦ ἐξαχθησομένου ἐκ τοῦ πρωτοκόλλου τὸ ὁποῖον θὰ ἀναφέρῃ τὸν τίτλον τὸ συνεταίρου. Ἕκαστος συνέταιρος πρέπει νὰ ἦναι ἐφωδιασμένος διὰ τοῦ τίτλου τούτου. Τὸ πιστοποιητικὸν τοῦτο πρέπει νὰ σημειώνῃ α) τὸ ὄνομα, ποιότητα, χωρητικότητα, τὸν ἀριθμὸν τῆς ἐγγραφῆς, τὸν χρόνον τῆς κατασκευῆς, τὸν πλοίαρχον καὶ τὰ λοιπὰ τοῦ πλοίου· β) τὸν χρόνον καθ' ὃν ὁ συνέταιρος συνεδέθη εἰς τὴν ἑταιρίαν· γ) τὴν ὁποίαν ὀφείλει νὰ πληρόνῃ συνεισφοράν, καὶ δ') ὅλους τοὺς ὅρους τῆς παραδοχῆς του. Ὁ ἰδιοκτήτης περισσοτέρων τοῦ ἑνὸς πλοίων πρέπει νὰ φέρῃ πιστοποιητικὸν ἰδιαίτερον δι' ἕκαστον παραδοχθὲν εἰς τὴν ἑταιρίαν πλοῖον· ὄπισθεν τοῦ εἰρημένου πιστοποιητικοῦ θὰ ἦναι γεγραμμέναι αἱ ἀρχικαὶ διατάξεις τῶν παρόντων ὅρων, καὶ ἰδίως αἱ ἀναφέρουσαι τὰς ὑποχρεώσεις τοῦ συνεταίρου καὶ τοὺς ἀπαρτίζοντας τὴν ἑταιρίαν κινδύνους. Τὰ παραδεχθέντα εἰς τὴν ἀμοιβαίαν ἀσφάλειαν πλοῖα ὀφείλουν νὰ φέρωσιν εἰς τὸ πὶκ, ἓν σημεῖον, κατὰ τὸ εἰς τὸ τέλος τοῦ παρόντος σχέδιον φέρον τὸν ἀριθμὸν τῆς ἐγγραφῆς των.

The insurance of ships in Galaxidi

Up until about 1860, Galaxidi shipowners used to insure their ships with Greek insurance companies e g the Achaiki or the Proodos of Patras or Athens, but also, though less frequently, with foreign ones, like those in Trieste. Ever since 1848, however, a movement had been started towards establishing their own insurance organizations, with the shipowners being both the insured and the underwriters. In 1860 they founded the 'Limited Company of Insurance against Risks To Galaxeidion, which was in operation for about five years. In 1866 the Mutual Aid Insurance To Galaxeidion (Plates 220 and 221) was founded. The establishment of at least six further mutual insurance companies followed, under the firms I Enosis, I Irini, I Adelfotis, I Omonoia, I Oianthi, and O Sotir which were in operation between 1870 and 1886. On Pl 228 can be seen the Register of Maritime Mutual Insurance of Galaxeidi I Adelfotis.

In order to have a ship insured, it was necessary for 'the owner or owners to file an application' (Pl 222) to that effect. There followed a valuation carried out by members of the Company, who in a special 'Report of Experts' (Pl 223) would indicate whether the vessel and her rigging were in a safe and seaworthy condition, give a precise assessment of the value of the ship, her rigging, equipment, and furniture, and estimate the length of the remaining span of the ship's life. After the ship had been admitted into the mutual insurance, her owners were issued with a 'Certificate' like the one in the photograph of Pl 224, by the Mutual Insurance I Adelfotis for the ship AGIOS GEORGIOS.

Sea risks covered by such mutual insurances included 'capture', 'shipwrecks', 'grounding with sprung bilge', 'inability of the ship to sail, due to an accident at sea', 'hindrance by a foreign power', and 'loss or damage of the ship, if this amounts to at least three quarters of her mutual insurance value. Losses incurred from particular average, whether total or partial, are assumed by the partner himself.'

In the case of shipwreck, or if there was cause from any of the other risks we have mentioned, the shipowner made an application for indemnity to the insurance company accordingly (Plates 226 and 227). On the basis of that application the Board of the Mutual Insurance convened a meeting. If the claim was judged fair, the Direction of the Mutual Insurance called on each of the members to deposit the amount of money that fell to his share, in order to indemnify the partner who had suffered damage (Pl 225), and issued relevant receipts (Pl 229) when the moneys had been paid in.

Antonis Theoharis

For further details on this subject, see *To Galaxidi ston Kairo ton Karavion* by Efthymios N Gourgouris, Athens, 1982-83.

220 and 221 (419) Front cover and two pages of the Regulations of the Mutual Insurance To Galaxeidion 1867

ΑΛΛΗΛΑΣΦΑΛΕΙΑ «ΤΟ ΓΑΛΑΞΕΙΔΙΟΝ»

Ἀριθ. 1183.

Αἴτησις ἀσφαλιζομένου

Πρὸς τὴν Ἀλληλασφάλειαν «τὸ ΓΑΛΑΞΕΙΔΙΟΝ».

Ζητῶ ἀσφάλειαν ἐπὶ μέρους ἀξίας τοῦ σώματος καὶ ἀποσκευῶν τοῦ Ἑλληνικοῦ Πλοίου _____ ὀνομαζομένου _____ χωρητικότητος τόνων 247 διακυβερνωμένου ὑπὸ τοῦ πλοιάρχου _____ ἡλικίας ἐτῶν _____ κατεσκευασμένου ἀπὸ ξυλείας _____ καὶ καρφικὴν _____ διὰ λογαριασμὸν τοῦ _____ συνεταίρου εἰς τὴν ἑταιρίαν ταύτην διὰ δραχμὰς _____ ἀριθ. 9000 ἀρχομένων τῶν κινδύνων ἀπὸ 13 Μαΐου _____ δι' ἔτη _____ ὑποχρεούμενος καὶ συμμορφούμενος πρὸς πάσας τὰς διατάξεις τοῦ ἀνὰ χεῖράς μου κανονισμοῦ τῆς ἑταιρίας _____ Ἐπισυνάπτων ἅπαντα τὰ ὑπὸ τοῦ κανονισμοῦ ἀπαιτούμενα ἔγγραφα, ἀναγγέλλω ὅτι _____

Ἐν Γαλαξειδίῳ τῇ 13 Μαΐου 1878.

Ὁ αἰτῶν _____

ΘΑΛΑΣΣΙΟΣ ΑΛΛΗΛΑΣΦΑΛΕΙΑ

«Ο ΣΩΤΗΡ»

ΕΚΘΕΣΙΣ ΠΡΑΓΜΑΤΟΓΝΩΜΟΝΩΝ

Προσκληθέντες οἱ ὑπογεγραμμένοι πραγματογνώμονες τῆς Ἀλληλασφαλείας «ὁ Σωτὴρ» ὑπὸ τῆς Διευθύνσεως, ὅπως κατὰ τὰ κεκανονισμένα ἐνεργήσωμεν τὰ προαπαιτούμενα πρὸς κανονισμὸν τῆς ἀξίας τοῦ πλοίου _____ ὀνομαζομένου _____ ὧν ἰδιοκτήτης _____ Ἐκθέτομεν ταῦτα

1) Τὸ εἰρημένον πλοῖον ἔχει χωρητικότητα τόνων Ἑλληνικῶν ἀριθ. _____ κατὰ τὴν καταμέτρησιν

2) Εἶναι κατεσκευασμένον καὶ διεσκευασμένον κατὰ τοὺς ἐν ἰσχύϊ πίνακας, ἐλλείπουσι δ' ἐξ αὐτοῦ τὰ ἑξῆς πράγματα. _____

3) Θέλει διατηρηθῇ πιθανῶς ἐν τῷ μέλλοντι ἔτη _____ Ἐκ τῶν ἀνωτέρω πειθόμεθα, ὅτι τὸ ἀνωτέρω πλοῖον δύναται νὰ γείνῃ παραδεκτὸν εἰς τὴν Ἀλληλασφάλειαν.

Ἐν Γαλαξειδίῳ τῇ 1 Σεπτεμβρίου 1894

Οἱ πραγματογνώμονες

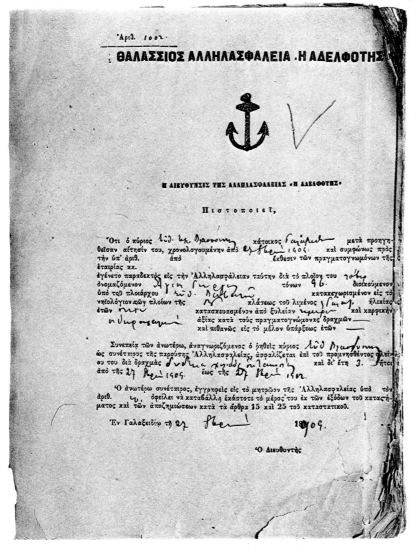

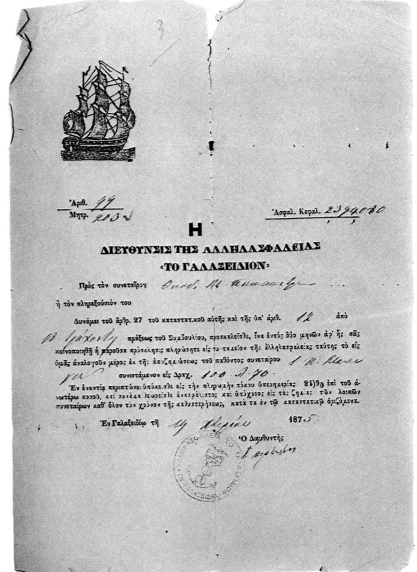

222 (710) *Application of insured member of Mutual Insurance To Galaxeidion,* 1878
223 (415) *Report of Experts of Maritime Mutual Insurance O Sotir,* 1899
224 (416) *Insurance Certificate of Mutual Insurance I Adelfotis for the sailing ship* AGIOS GEORGIOS, 1909
225 (712) *Letter by the Direction of Mutual Insurance To Galaxeidion inviting Partner Theod M Papapetros to contribute his appropriate share of Drs* 100 *and* 70 *Lepta towards idemnifying a partner who has suffered damage,* 1875

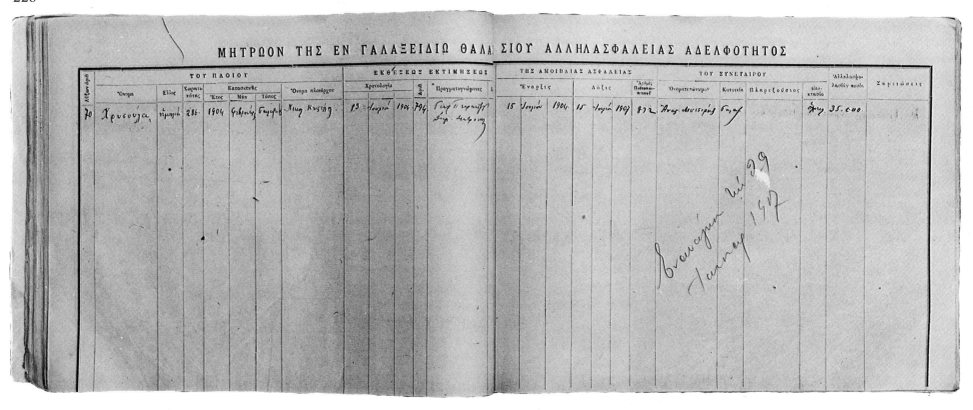

ΜΗΤΡΩΟΝ ΤΗΣ ΕΝ ΓΑΛΑΞΕΙΔΙΩ ΘΑΛΑΣΙΟΥ ΑΛΛΗΛΑΣΦΑΛΕΙΑΣ ΑΔΕΛΦΟΤΗΤΟΣ

226 and 227 (711) Application for indemnity to the Mutual Insurance O Sotir, 1888, as the shipowner had to abandon his sinking ship PAGONA

228 (417) A page from the Register of the Maritime Mutual Insurance Adelfotis in Galaxeidi, 1904

229 (713) Receipt for moneys paid into Mutual Insurance I Omonoia towards indemnifying a partner, 1888

245

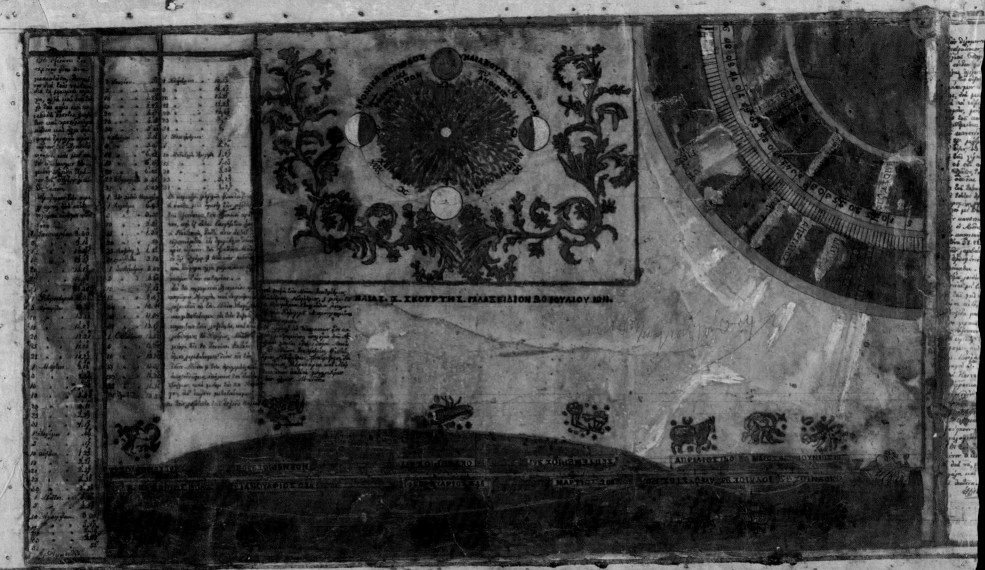

The 'Heliotropia' of captain Ilias Skourtis

Ilias S Skourtis of Galaxidi, was master of his own ship, the owner and skipper, at the turn of the century. As far as we know, he made three roughly similar pictures he called 'Heliotropia' — which literally means the turning of the sun. They are 'strange paintings', pleasing to the eye and to the heart, while being 'scientific drawings' that serve to illustrate the observations he made on certain aspects of 'Time' with a view to practical applications. Captain Skourtis was obviously fascinated by Time, that most difficult of subjects, which has such a long history, is of great use in both astronomy and navigation, and still remains enveloped in mystery.

The name Heliotropion is probably not an accurate designation of the content of his works, for *heliotropion* or *heliostasion* (solstice) are of a specific sense in both navigation and cosmography. But perhaps he chose that name for its magic.

All three works are concerned with the same major theme, although there are minor variations of detail and manner of presentation from one to another.

The first of the three known pictures, dated 20 May 1911, is in the Church of Agia Paraskevi in Galaxidi. It looks as if this work was essentially a draft with the calculations Captain Skourtis made to scale before tracing the Zodiac he then had carved on the stone-paved floor of that church. The whole design of the Heliotropion is in such a place, arrangement, and scale, that at twelve noon the ray of sun entering the church through a small, round opening at a well calculated spot of its roof will always hit the floor in the area of the current month. On the plan, the top right hand corner corresponds to the hole in the roof; the distance from that to the axis of symmetry of the Zodiac corresponds to the actual height at which the hole is made in the church roof; and so on. Thus we have a solar calendar.

The second picture of a Heliotropion (Pl 231) also has the date 20 May 1911, and is in the house of the Captain's grandson, Ilias Skourtis, in Galaxidi. And the third (Pl 230) has the date 20 July 1911, and is in the Museum of Galaxidi.

Let us now look at the particular aspects of time that are contained in the Heliotropia paintings of Captain Skourtis. In the upper centre of each picture there is a decorative design. In the first picture only, we see the title 'Heliotropion'. All pictures mention place and date of making, as well as his name. In the first and third pictures there is a drawing designated as Time Period of the Solar System, where the two equinoctial points, vernal and autumnal, and the two solstitial ones, summer and winter, appear on an ellipse representing the ecliptic[1] of the sun. Inside the ellipse are the symbols of the Signs of the Zodiac, and inside these are the names of the four seasons, approximately as is shown in Figure 5.

A table on the left explains the equation of time,[2] whose values are given in minutes and seconds for every fifth day in

TIME PERIOD OF THE SOLAR SYSTEM

Figure 5

The drawing corresponds to and complements the Curve of Solar Time at the bottom of the pictures in Plates 230 and 231 by indicating the equinox and solstice points which the Curve implies, while it has the same arrangement of the seasons as they appear at the Curve.

correspondence with the Julian Calendar, then still in force in Greece. The table on the right contains instructions on how to construct a Heliotropion.

230 (404) *The Heliotropion of Captain Ilias S Skourtis, which is at the Museum of Galaxidi,* 20 July 1911

The lower part of the pictures is taken up by a design illustrating what Captain Skourtis calls the Curve of Solar Time. In his own words,

'The curved line is the one that indicates the pattern of the equation of solar time ... finding the mean time ... we can find the longitude of the place ... and save our lives.

'By the winter heliostasion (solstice) we proceed on the left, go past the month of April obliquely, and go on to the right hand curve of the pattern, and follow April, May, and up to the 10th of June. But then we take up position in the same month on the left side and follow the rest of June, July, and up to the 20th of August. From there we go over to the ... right curve (which) counts the months September, October, November, and up to the 10th of December. Following that, we follow to the left, as we have mentioned before.

'The scale of distances (for each individual month) has been well calculated (according to the ray of sun which is on it) [and is] proportional to the obtuse angle of each month. The months September, October, November, December, January, February, and March have a radius [that is] longer than that of the other months.'

The whole Zodiac[3] is painted around the Curve, with the pictures of the Signs, which he calls Animals of the Horoscope, placed in correspondence with the months of the year, which are in turn accompanied each with the figure indicating its radius.

Finally, in the top right hand corner of the painting are noted the regions of the twelve months within the bounds of the solstices on a quarter circle (0°-90°), as a combination of latitude of place and declination of the sun (δ) in each month. Moreover, lines drawn between each of the regions and the top right-hand angle represent the inclinations of the rays of the midday sun in Galaxidi[4] in each season. Prolonged downwards and to the left as far as the Curve below, the lines will each meet the corresponding month in it. Thus, each Heliotropion, each picture, constitutes an integrated whole, where illustrations combine with verbal exlanations to present the 'pattern of the equation of solar time' as Captain Skourtis conceived it.

Even if we knew nothing else of Captain Ilias Skourtis, his Heliotropia alone would be enough to mark him as one of the Galaxidi seamen who had both feeling and reasoning — qualities so often met with in men of the sea. He was also perfectly knowledgeable in the then science of his profession, and had the sea under his skin, as it were. Captain Skourtis painted his pictures when, getting old, he had left ships and the sea to retire to Galaxidi (1911). He was a man of experience and wisdom, and he had respect for the nature and purpose of man, which is, according to one etymology of the Greek word anthropos, to expand upwards, and so to become finer. How can we wonder, then, if before a year was by, during the Balkan Wars, it was thanks to such men of high calibre and patriotism, that the borders of the home country were widened to make the Aegean Sea from end to end a Greek archipelago again.

Antonis Theoharis

NOTES

1 According to the Laws of Kepler, the orbit described by the path of a planet (hence of the earth also) around the sun is in the form of a ellipse, where the sun occupies one of the two foci. The plane of that ellipse for planet Earth — seen in impressionistic projection where the earth occupies the focus and the sun revolves around it — has been called ecliptic of the sun. It was called ecliptic because, in order for an eclipse of the sun or the moon to occur all three heavenly bodies, sun, earth, and moon, must coincide on that plane. The plane of the ecliptic does not coincide with that of the earth's equator, but they intersect at an angle of 23°27', which is termed 'inclination' on the 'equinox line' which extends between the equinoctial points, vernal and autumnal, that we have mentioned. The 'solstice line', which extends between the winter and summer solstitial points, is perpendicular to the 'equinox line'.

2 Equation of time is called the narrow angle (it never exceeds 16 minutes of a degree) which forms between the 'hour angle' of the true or apparent sun and that of the mean or hypothetical sun. The mean sun was set up after it had been proved that the shift of the hour angle of the true sun did not have a fixed angular velocity (when according to Kepler's second law, a line from the sun to aplanet sweeps out equal areas in equal time periods), and therefore the true sun was an inexpedient means for reckoning time with precision. The basic characteristics of the mean sun include: that it moves with a fixed angular velocity of hour angle; that its angular distance from the true sun remains minimal (the extreme values being + 14' and -16' of a degree); and that it coincides with the true sun (equation of time = 0) four times a year, namely, on April 15, June 14, September 1, and December 24 according to the Gregorian Calendar. (13 days must be added to dates reckoned by the Julian Calender in the 20th century; 12, in the 19th century, and so on). The equation of time was previously very useful, among other things mainly in off-shore navigation for the calculation of the longitude of a ship's position. In our days it can be found in the Nautical Almanacs that every twelve hours give out the value of the equation of time.

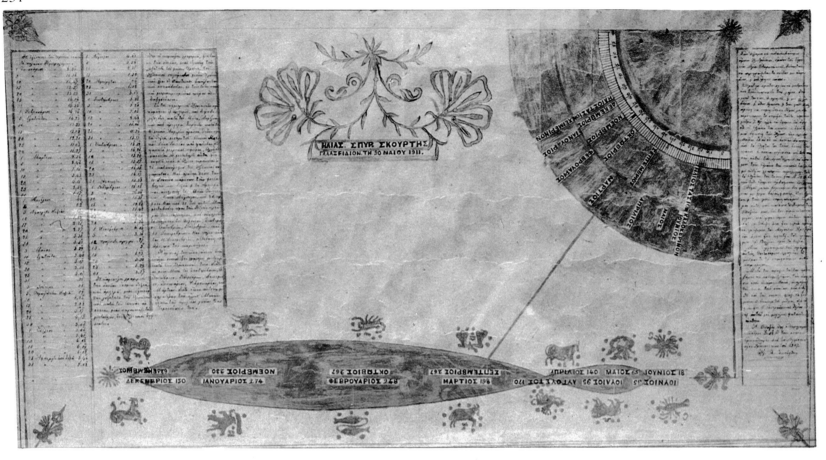

231 *The Heliotropion of Captain Ilias S Skourtis in the house of his grandson Ilias Skourtis in Galaxidi, 20 May 1911*

3 The Zodiac is a 17 degrees band of the celestial sphere extending 8° 5′ on each side of the ecliptic, within which fall the apparent paths of the sun, moon, and the planets. This band is divided into 12 equal parts (called signs), each 30 degrees wide, bearing the name of the constellation contained there at the time of Hipparchos (ca 150 BC), e g Aries, Taurus, etc. However, because of the precession of the equinoxes by a yearly 50′′2 in reverse order, each division contains at present the constellation west of the one from which it took its name. Thus, for example, constellation Pisces is today in the sign of Aries.

4 In Galaxidi, at latitude ca 38°22′ N, winter solstice (δ = 23°27′N of the sun on December 22) will have the rays of the sun at an inclination of 38°22′+23° 27′ = 61°49′ to the perpendicular; while summer solstice (δ = 23°27′N of the sun on June 22) will have the rays of the sun at an inclination of 38°22′-23°27′ = 14°55′ to the perpendicular. By similar calculations for places of a given latitude, and taking the value of declination of the sun (δ) for the first and last days of each month, we can trace the inclination bounds of the sun-rays to the perpendicular within that month, just as Captain Skourtis has done in his works. If we set a pole of a given height upright on a horizontal plane, then, on the basis of the above inclinations, we can derive the length of its shadow in the various months, or else make the kind of tracings Captain Skourtis had stone-masons engrave on the Church floor of Agia Paraskevi in Galaxidi by solving the corresponding right-angled triangles so formed.

Bibliography

Admiralty Manual of Navigation, vols II and III, London: 1960

Agis Editrice, *Rapallo Sacra Minore,* Genova: 1980

Anthologia Naftikon Keimenon (An Anthology of Marine Texts), Athens: Ministry of Marine, Transport and Communications, HQ Port Authority, 1972

Archibald, E H H, *Dictionary of Sea Painters,* Woodbridge, Suffolk: Antique Collectors Club, 1980

Carson, Lionel, *Seas and Seamanship in the Ancient World,* Princeton University Press, 1971

Chardavellas, Dedousis E, *Naftika* (Seafaring), Athens: 1948

Ciarrochi - Mori, *Le Tavolette Votive Italiane,* Udine: 1959

Colin, Ambroise, *La navigation commerciale au XIXe siècle,* Paris: 1901

Cordingly, D, *Marine Painting in England 1700-1900,* London: Studio Vista, 1974

De Negri, Carlo, *Vele Italiane del XIX sec.,* Milano: Mursia, 1974

Dodwell, Edward Esq, FSA, *Classical and Topographical Tour through Greece,* London: 1819, ch IV, pp 131-42

Elliniki Emporiki Naftilia 1453-1850 (Hellenic Merchant Marine) Athens: National Bank of Greece, 1972

Encheiridion Armenistou (Navigator's Manual) Athens: Ministry of the Navy, 1948

Fasoulakis, Sterios, 'I thematografia ton laïkon pinakon ploion' (Themes of folk paintings of ships) off-print from *Chiaki Epitheorisis,* vol 5, Nos 14-15, 1967
'O ek Vrontadou ploiografos Aristeidis Glykas' (Ship-painter Aristeidis Glykas of Vrontadou), *Chiaki Epitheorosis,* January - April 1968
'Laïkoi pinakes ploion' (Folk paintings of ships), *Chiaki Epitheorisis,* vol II, January 1964, pp 13-20

Ferrai, Gio. Bono, *Epoca Eroica della Vela,* Milano: Mursia

Gourgouris, Efthymios, *To Galaxidi ston kairo ton karavion,* (Galaxidi at the time of the sailing ships), 3 vols, Athens: 1982-1985

Green, Ph J, *Sketches of the War in Greece2,* London: 1828, Letter XIV, p 60

Greenhill, Basil, *The Ship,* The life and death of the Merchant Sailing Ship 1815-1965, London: Her Majesty's Stationary Office, 1980
National Maritime Museum, Schiffahrtsmuseum London, München-Firenze-London: Museen der Welt, C H Beck/Scala/Philip Wilson, 1982

Gropallo, Tomaso, *Il Romanzo della Vela,* Storia della Marina Mercantile a Vela Italiana nel XIX sec., Milano: Mursia, 1973

Hayet, Armand, *Vita e Costumi a Bordo dei Grandi Velieri,* Milano: Mursia, 1973

Hughes, The Rev Thos Smart, *Travels in Sicily, Greece and Albania,* London: 1820, vol I, ch XIII, pp 394-96

Humphreys, Captain W H, *Journal of the Greek War of Independence* (July 1821-Feb 1822) with an Introduction by Sture Linnér, Stockholm: 1967, 6, p 54

Istoria tou Ellinikou Ethnous (History of the Hellenic Nation) Athens: Ekdotiki Athinon

Ivancević, Vinko, *Nekoliko Slika Korčulanskih Jedrenjaka,* Rijeka: 1979

Konstantinidis, Tryfon P, *Karavia, Kapetanaioi kai Syntrofonaftai* (Sailing ships, captains and company-sailors) 1800-1830 Athens: 1958

Korré, Katerina, 'Ta Akroprora tou Mouseiou Galaxidiou' (The Figureheads in the Museum of Galaxidi), *Zygos,* No 25, Athens: 1977, pp 80-82

Kremmydas, V, *Elliniki Naftilia 1776-1835.* vol I, *Opseis tis Mesogeiakis Nafsiploïas* (Hellenic Marine 1776-1835; Aspects of Mediterranean Navigation), Athens: 1985

Ludwig Salvator, Erzherzog von Oesterreich, *Eine Spazierfahrt im Golfe von Korinth,* Prag: 1876

Luetić, Josip, *Kap B Ivanković, naji staknutija portrtist naših jedrenjaka,* Dubrovnik: 1974

Manioudakis, K, *Magnitikes Pyxides* (Magnetic compasses), Athens: 1970

Manual of Seamanship, London: vol II, 1951, vol III, 1964

Metaxas, K, 'Mia ikon apo to Galaxidi tou etous 1830' (A picture of Galaxidi in the year 1830), *To Galaxidi,* year I, No 1, Piraeus 1947

Mitropoulos, I D, *Galaxidi,* Athens: 1970

Morison, Samuel Eliot, *The Maritime History of Massachusetts 1783-1860,* Cambridge Mass: Riverside Press, 1961

Papakonstantinou, Mairi, 'Aristeidis Glykas, o laïkos zografos tou Vrontadou' (Aristeidis Glykas, the folk-painter of Vrontadou), *Oinousai,* 1982

Paparrigopoulos, K, *Istoria tou Ellinikou Ethnous* (History of the Hellenic Nation), Athens: 1932

Pomardi, Simone, *Viaggio nella Grecia fatto da Simone Pomardi negli anni 1804, 1805 & 1806,* Roma: 1820, vol I, ch IV, p 47

Pouqueville, François Charles H L, *Voyage de la Grèce^2,* Paris: 1826, vol IV, book 12, ch XI, pp 479-83

Sathas, Konstantinos N, *Chronikon anekdoton Galaxidiou* (unpublished Chronicle of Galaxidi), Athens: 1914

Simopoulos, Kyriakos, *Xenoi Taxidiotes stin Ellada* (Foreign Travellers to Greece) vol 1800-1810; vol III, 2, 1810-1821 Athens: 1985
Pos eidan oi xenoi tin Ellada tou '21 (How the foreigners saw the Greece of '21), vol I Athens; 1979

Skiadas, Anastasios I, *To Monastiri tou Sotiros Christou Galaxidiou* (The Galaxidi Monastery of Christ the Saviour) Athens: 1984
O Naos tou Agiou Nikolaou sto Galaxidi (The Church of Agios Nikolaos in Galaxidi), Athens: 1982
To Galaxeidi, mia Panarchaia Naftiki Politeia (Galaxidi, an age old maritime town), Athens: 1986

Stamelos, D, *Neoëlliniki Laïki Techni* (Modern Greek Folk Art), Athens: 1975

Stathaki-Koumari, Rodoula, 'Ta Archontika tou Galaxidiou' (Patrician Houses of Galaxidi) in *Nea Skepsi* No 64, Athens: 1968, pp 113-17
'History of our Museum' *To Galaxidi* Nos 327-29, Piraeus 1976-77

Stathaki-Koumari, Rodoula—Tsaousaki Aspa—Chaviara, Gogo, *Galaxidi, i politeia - ta spitia* (Galaxidi, the town - the houses), Athens: Makedos

Themelis, P, 'Schylla Eretriki' in *Archaiologiki Ephemeris* Athens: 1979, pp 118-53

Tomić, Antun, *Pomorstvo Dobrote na portretima brodova,* Kotor: Godišnjak Pomorskog museja Knjiga XXIV, 1976

Vasiliou, Spyros, *Galaxidiotika Karavia - Ta schedia kai ta istorika tous* (Galaxidi Sailing Ships - Their desings and their histories), Athens: Kastalia, 1934

Vlami, Eva, *Galaxidi - I moira mias naftikis politeias* (Galaxidi - The destiny of a maritime town), Athens: 1947
O Skeletovrachos, Athens: 1950

The following documents from the Museum of Galaxidi have also been consulted. The numbers within parentheses indicate reference numbers of the Museum:

'Maritime Mutual Insurance I Adelfotis', Report of Experts, 1899-1917 (415)

A List of sailing ships and steamships, Notes by A Bobogiannis, Galaxidi 1958 (720)

'Register of the Galaxidi Maritime Mutual Insurance I Adelfotis', 1886-1902 (417)

Register of Sailing Ships Class B, Port of Galaxidi, 13 Oct. 1903 (583)

Register of Sailing Ships of the Port of Galaxidi (584)

Register of Sailing Ships Class A, Port of Galaxidi, 16 Apr. 1878-20 Jan 1897 (582)

Register of Sailing Ships Class B, Port of Galaxidi, Apr 1880 - Aug 1904 (585)

Index

Page references in italics refer to illustrations

NB

Galaxeidi - Galaxidi: the latter spelling has been authorized by the Academy of Athens ● *Captions.* (a) The number within parentheses indicates the reference number of the Museum of Galaxidi. (b) Names of ships and titles of paintings are exact copies from the pictures. And (c) the identification particulars of indi-

vidual ships have been collected from various sources; any omissions are due to lack of information. ● *Ackowledgement.* The translator wishes to thank Thomas W Johnson, who read the whole of the manuscript and made valuable corrections, for which I am grateful. Whatever inadequacies remain are to be put at my door, not at his.

A K-S

THIS BOOK WAS PRINTED IN 1987
FOR THE PUBLISHING HOUSE
MELISSA, NAVARINOU 10, ATHENS.
IT WAS PHOTOSET BY
THE FIRM OF FRANGOUDI BROS.
THE REPRODUCTION OF PICTURES WAS MADE
AT THE STUDIOS OF MELISSA
AND OF KOSTAS ADAM.
IT WAS PRINTED AT THE INSTALLATIONS
OF MELISSA, AND THE BOOK-BINDING
WAS MADE AT THE FIRM GIANNIS MOUTSIS & CO